NORTHERN LIGHT

ROY MacGREGOR

NORTHERN LIGHT

The enduring mystery of
TOM THOMSON
and the woman who
loved him

RANDOM HOUSE CANADA

Copyright © 2010 Roy MacGregor

www.randomhouse.ca

Random House Canada and colophon are registered trademarks.

Photograph of cards Copyright © Darren Holmes
Canoe Lake map Copyright © E. Griffith
Algonquin Park map: Andrew Roberts

Library and Archives Canada Cataloguing in Publication

MacGregor, Roy, 1948–
Northern light : the enduring mystery of Tom Thomson and the woman who
loved him / Roy MacGregor.

Also available in electronic format.
Includes bibliographical references and index.

ISBN 978-0-307-35739-7

1. Thomson, Tom, 1877–1917. 2. Trainor, Winnie. 3. Painters—Canada—
Biography. I. Title.

ND249.T5M34 2010 759.11 C2010-901857-5

Design by Andrew Roberts

Printed in the United States of America

10 9 8 7 6 5 4 3 2 1

For Winnie

ALGONQUIN PARK AND SURROUNDING AREA

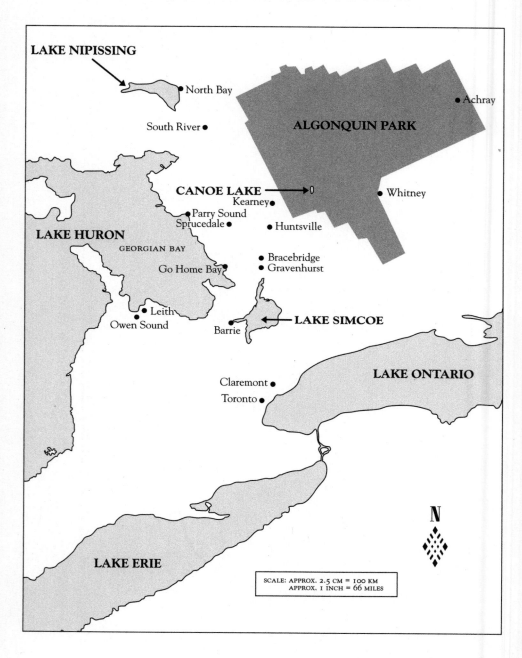

CANOE LAKE 1917

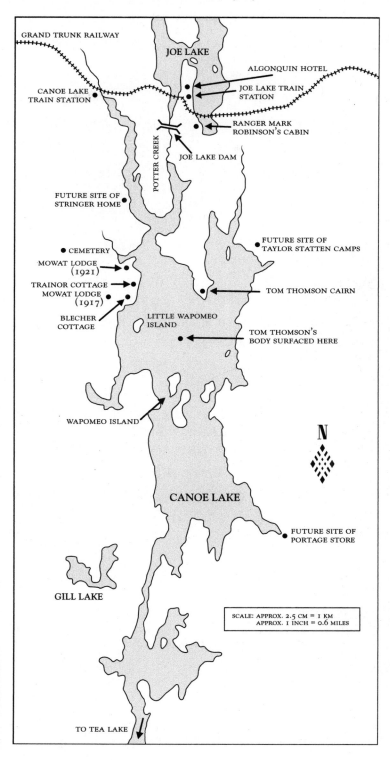

GRAND TRUNK RAILWAY

JOE LAKE

ALGONQUIN HOTEL

JOE LAKE TRAIN
STATION

CANOE LAKE
TRAIN STATION

RANGER MARK
ROBINSON'S CABIN

POTTER CREEK

JOE LAKE DAM

FUTURE SITE OF
STRINGER HOME

FUTURE SITE OF
TAYLOR STATTEN CAMPS

CEMETERY

MOWAT LODGE
(1921)

TOM THOMSON CAIRN

TRAINOR COTTAGE
MOWAT LODGE
(1917)

BLECHER
COTTAGE

LITTLE WAPOMEO
ISLAND

TOM THOMSON'S
BODY SURFACED HERE

WAPOMEO ISLAND

N

CANOE LAKE

FUTURE SITE OF
PORTAGE STORE

GILL LAKE

SCALE: APPROX. 2.5 CM = 1 KM
APPROX. 1 INCH = 0.6 MILES

TO TEA LAKE

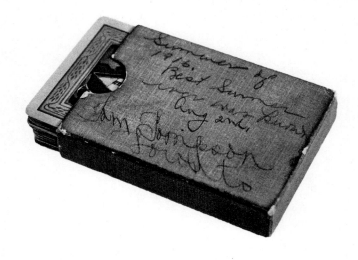

SUMMER OF 1916,
BEST SUMMER EVER WAS KNOWN
AUGUST 2ND,
TOM THOMPSON
TORONTO

Side 2 (not shown): TOM THOMPSON
CARL GODDIN*
CHARLOTTE ROCHE*
ALICE GREEN
FIVE HUNDRED PLAYERS

*Inscribed Congress Playing Cards, Courtesy of Douglas
(great nephew of Alice Green) and Helen Gurr.*

(Note: Handwritten by Alice Green; the misspelling of Thomson's name was constant by park rangers, residents, and friends.)

*Author seeks more information about Charlotte Roche and Carl Goddin.

KEY PERSONALITIES AND PLACES

Tom Thomson: August 5, 1877–July 8, 1917, Canada's best-known artist, who died mysteriously at Canoe Lake, Algonquin Park, in the summer of 1917 at age thirty-nine.

Winnifred Trainor: March 18, 1885–August 12, 1962, resident of Huntsville, Ontario, and Canoe Lake cottager, believed to be engaged to Tom Thomson at the time of his death. She never married.

The Thomson Family: John and Margaret Thomson of Claremont, Ontario, just north and slightly east of Toronto, and Rose Hill farm at Leith, Ontario, on Georgian Bay, and later of Owen Sound, Ontario, had ten children: George (1868), Elizabeth (1869), Henry (1870), Louise (1873), Minnie (1875), Tom (1877), Ralph (1880), James (1882), Margaret (1884) and Fraser (1886). Tom was born in Claremont. When he was two years old, the family moved to Rose Hill farm outside of Leith. The family plot is in Leith, including one grave that is said to contain the remains of Tom Thomson. Tom's eldest sister, Elizabeth, married Tom Harkness, who would act as executor of the Tom Thomson estate. In 1967, the Harknesses' daughter, Jessie Fisk, came across forty negatives from photographs Tom had taken on his first trip into the North Country

in 1912. The photos included, eerily, the Canoe Lake cemetery, where he would be buried five years later. Mrs. Fisk and two of Thomson's sisters, Mrs. Louise Henry and Mrs. Margaret Tweedale, would provide much information in later years on the relationship, from their perspectives, between Tom Thomson and Winnifred Trainor.

George Thomson: Tom's older brother, also an artist. Highly successful in business and ambitious in art, George was the responsible one the family turned to in times of difficulty. He would play a key role in what became of his younger brother's final paintings.

The Trainor Family: Hugh Trainor and Margaret Jane Bradley had two daughters, Winnie and Marie, and lived in Huntsville, Ontario, up to the time of Tom Thomson's death, then moved north to Kearney, Ontario. They returned to live in Huntsville around the time of Hugh Trainor's death in 1932. Marie married a medical doctor, Roy McCormick, brother of my grandfather, Algonquin Park chief ranger Tom McCormick, and they lived in Endicott, New York. They had four children, one of whom, Terence Trainor McCormick, inherited Winnifred Trainor's estate, which included several Tom Thomson originals.

Mark Robinson: Algonquin Park ranger, stationed at Joe Lake and Canoe Lake during much of the time Tom Thomson was there, and chief ranger in the years before Tom McCormick. Robinson's carefully written journals are considered the most factual evidence available for what happened during the summer of 1917. His daughter, Ottelyn Addison, later wrote a short biography of Thomson.

Painter Friends: While working in Toronto in commercial design prior to the outbreak of the First World War, Thomson made many artistic friends, including J.E.H. MacDonald, Frederick Varley, Arthur Lismer, Franklin Carmichael, A.Y. Jackson and Lawren Harris. In 1919, two years after Thomson's death, these six, along with Franz (Frank) Johnston,

formed the Group of Seven, the most influential art movement in Canadian history. They credited Thomson and his passion for painting in the wild with being a great inspiration to them. Other members— A.J. Casson, Edwin Holgate and L.L. Fitzgerald—joined over the years. The group disbanded in the early thirties.

Dr. James MacCallum: Wealthy Toronto ophthalmologist and art investor who served as a patron to Thomson throughout the painter's life. He acted on behalf of the estate in selling Thomson's works following the artist's death. MacCallum was friendly with all the artists in Thomson's circle, and his cottage on Go Home Bay in Georgian Bay was a frequent visiting and painting destination. Along with Lawren Harris—also wealthy, but through family holdings—MacCallum built the Studio Building beside Toronto's Rosedale Ravine, where several of the artists, including Thomson, completed their larger canvases.

Huntsville: A small town at the north end of the cottage-country District of Muskoka in Central Ontario. Founded by Captain George Hunt, who insisted on a temperance clause in his deeds, it largely grew into the surrounding hills, where no such clauses were demanded. Originally a timber town, it evolved into a major summer tourist destination after World War II.

Kearney: A small village on the western edge of Algonquin Park, north of Huntsville along the Grand Trunk Railway line that ran from near Ottawa through Algonquin Park to Georgian Bay near Parry Sound. The year following Thomson's death, Winnie Trainor went to work at the Shortreed Lumber Company at Kearney and stayed there with her aging parents until the early 1930s.

Scotia Junction: A small community twenty-five kilometres north of Huntsville and west of Kearney where the rail line going north from Toronto to North Bay intersected with the rail line coming out of

Algonquin Park. Passengers bound for Canoe Lake from Huntsville or other points south had to change trains here.

Algonquin Provincial Park: Canada's first provincial park, founded in 1893 in the Ontario highlands. Some three hours north of Toronto by car, it has now expanded to cover an area of 7,700 square kilometres. The park is internationally renowned for its beauty and canoe routes.

Canoe Lake: Algonquin Park's best-known attraction, because of Tom Thomson. The relatively small lake, approximately three kilometres long and somewhat more than one kilometre wide, was a stop along what became the Grand Trunk Railway line through the park, and once, during the height of the timber trade, it held a village, Mowat, of some five hundred people. In the early twentieth century it increasingly became a recreational lake, with leaseholder cottages (including the Trainors'), Mowat Lodge (where Tom Thomson often stayed) and the internationally famous Taylor Statten Camps, Ahmek for boys and Wapomeo for girls.

The Stringers: A well-known family residing on Potter Creek, at the north end of Canoe Lake. Two of "Pappy" and "Mammy" Stringers' dozen children, Jimmy and Wam, lived year round on the lake.

The Blechers: A German-American family from Buffalo, New York, who summered at Canoe Lake. They had a two-storey cottage located two cabins down from the Trainors'. Martin Blecher, Sr., and his wife, Louisa, had two children known to Canoe Lake residents and cottagers: Martin Blecher, Jr., who claimed to be a private detective, and Bessie. A second daughter, Louise, is listed in the 1920 U.S. Census as having been born in 1892, though her existence seems to have been unknown at Canoe Lake. Martin Blecher, Jr., and Tom Thomson often quarrelled over the progress of the war.

The Frasers: Shannon and Annie Fraser ran Mowat Lodge, where Thomson often stayed, as well as the post office and telegraph office. Shannon had a team of horses and cart that met the trains. Thomson lent Shannon Fraser money in 1915 so he could purchase canoes for the lodge.

The Stattens: Taylor Statten came to Canoe Lake at about the same time as Tom Thomson, and they became friends. Thomson even helped construct the fireplace in Statten's log cabin on Little Wapomeo Island. Statten and his wife, Ethel—who often went by the Native names "Gitchiahmek" and "Tonakela,"—founded Camp Ahmek for boys and Camp Wapomeo for girls on Canoe Lake. The family continues to run Taylor Statten Camps.

The Colsons: J. Edwin Colson and his wife, Molly, a nurse, ran the Algonquin Hotel on Joe Lake, a small body of water directly north of Canoe Lake. Edwin's sister, Annie Colson, ran a small outfitting store beside the Joe Lake station stop.

George W. Bartlett: The Algonquin Park superintendent who made many crucial decisions during the confusing days surrounding Tom Thomson's disappearance and subsequent burial in the Canoe Lake cemetery.

Lawrie ("Larry") Dickson and George Rowe: Canoe Lake guides, employed, on and off, by Mowat Lodge. They were friends of Thomson and renowned partiers.

Charlie Scrim: Florist and a park visitor from Ottawa, friendly with the guides and Ranger Mark Robinson.

Tom Wattie: Algonquin Park ranger stationed at North Tea Lake in the northwest corner of the park. Wattie and his family lived at South River, where Thomson liked to purchase special boards for his sketching. The

Watties also had a cottage on Round Lake, in the northwest of the park, where Thomson sometimes stayed.

Dr. Robert P. Little: Frequent Canoe Lake visitor from the United States. He was not there at the time of Tom Thomson's death but wrote remembrances of the times. He was not related to William T. Little, author of *The Tom Thomson Mystery* (1970).

Dr. Goldwin W. Howland: University of Toronto professor of neurology, who was vacationing at the Taylor Statten cabin on Little Wapomeo Island at the time of Thomson's death. Howland sighted Thomson's body and was the sole medical examiner of the body. He first noted that Thomson's body had a bad bruise on the right temple, but Algonquin Park ranger Mark Robinson's journal said left temple. Howland later changed his mind and said the bruise was on the left temple.

Roy Dixon and R.H. Flavelle: The embalmer and undertaker from nearby Sprucedale and Kearney, respectively. They were charged with preparing the body at Canoe Lake and with burying Tom Thomson in the little cemetery overlooking the lake. Roy Dixon was Algonquin Park ranger Mark Robinson's cousin.

Dr. Arthur E. Ranney: North Bay coroner called in to investigate Thomson's death. Ranney held a brief midnight inquiry at the Blecher cottage, declared death by drowning without so much as seeing the body and caught the first train out in the morning. His coroner's report, if it even existed, has never been located.

Franklin W. Churchill: The Huntsville undertaker assigned by Winnie Trainor, on behalf of the Thomson family, to exhume the body and ship it to Owen Sound for burial in the Thomson family plot at Leith. He insisted on working alone at night, casting suspicion on whether or not he had actually completed his task.

Charles Plewman: A Mowat Lodge guest pressed into service as a pall-bearer. He had never met Thomson, but many years later would make claims that would become a news sensation.

Lieutenant Robert ("Robin") and Daphne Crombie: Two guests at Mowat Lodge during the winter and spring of 1917 and again later in the year. In 1977 Daphne Crombie's revelations concerning Tom Thomson, Winnie Trainor and the Frasers would become a second sensation.

Blodwen Davies: Thomson's first biographer and the first, eighteen years after his death, to raise the questions that have haunted the Tom Thomson saga to this day. Her early-1930s love affair with Sir Frederick Banting briefly involved the famous inventor of insulin in the Tom Thomson mystery.

William T. Little: Family court judge and Canoe Lake regular, whose 1970 book, *The Tom Thomson Mystery*, became a Canadian bestseller.

The Diggers: Four men—William T. Little, Frank Braught, Jack Eastaugh and Len "Gibby" Gibson—dug where it was believed Thomson had been buried in 1917. They uncovered a skeleton with a hole in the left temple.

Dr. Noble Sharpe: Medical director of the crime detection laboratory of the attorney general of Ontario, who declared that the skeleton was, in fact, that of an Aboriginal person, who at one time had had an operation on his brain to relieve pressure, and could not, therefore, possibly be that of Tom Thomson.

Dr. Harry Ebbs: Ebbs, a physician, married Taylor Statten's daughter, Adele (usually called "Couchie"), and attended the 1956 dig with police following the discovery of the skeleton at Canoe Lake cemetery. He died in 1990, leaving behind notes that he had requested never be released in his lifetime.

Kelso Roberts: Attorney General of Ontario at the time of the 1956 exhumation. He was the lead government figure announcing that the remains did not belong to Thomson.

The McKeen Family: John McKeen had once lived next door to the Thomson family in Owen Sound. More than a half century after Tom Thomson died, two of John McKeen's elderly cousins, Agnes and Margaret McKeen, then in their nineties, claimed that their late cousin and John Thomson, Tom's father, had viewed the body in the casket that was delivered to the Thomsons' Owen Sound home in the summer of 1917. This claim was made in early 1969, at a time when a CBC documentary had raised doubts concerning the whereabouts of Thomson's final resting place. The *Owen Sound Sun Times* accepted the story at face value, noting that "Mr. Thomson expressed relief that he no longer had doubts as to the whereabouts of his son"—even though, at the time of burial, no such doubts had been raised.

Dr. Wilfred T. Pocock: 1895–1987, Winnie Trainor's physician and friend from 1919 until her death in 1962. He served as executor of her estate and passed away in 1987 at the age of ninety-two.

CONTENTS

PROLOGUE

A cold, steady rain was falling on the town the day Jimmy Stringer told me he had Tom Thomson's shinbone stashed in his woodshed.

It was the end of March, 1973. It had been raining off and on for several days, and the snow that had risen waist deep since the first streets had been ploughed back in November had all but washed away in the spring flush. The remnants of the tough winter could be found only in shaded backyards and in the deep bush surrounding this small community in Ontario's cottage country.

The town was in transition, that strange stretch between frozen ears and bitten, the time just before the ice goes out on the lakes and the leaves come out in the woods. Spring in Huntsville meant the little town on the western edge of Algonquin Park was perhaps the only place in all of Canada where both national sports—hockey and lacrosse—could be played at the same time. Goaltenders were first to switch from wooden hockey sticks to catgut lacrosse sticks, allowing them to catch and throw the ball rather than shoot gravel into the faces of attacking players. Once the crystallized snow banks melted away and a slapshot meant that goalies were also ducking small stones as well as the ball, all players switched to lacrosse equipment and with that one national sport blended into the other without so much as a time out.

The weather had become bigger small talk than the playoff prospects of the Toronto Maple Leafs or whatever outrageous comment Archie Bunker had come out with on the most recent episode of *All in the Family*. The combined melt and unseasonable rain had raised levels almost a metre on the Great Lakes, and the Muskoka River, which twisted and gently eddied through the town, was already clear and high. The ice remained relatively solid, however, on the two lakes that bordered Huntsville to the west and to the east, Vernon and Fairy—"Fairy" being an unfortunate accident of 1820s mapmaking and 1970s idiom. It had made the sign on Main Street identifying the weekly meeting place of the Fairy Branch of the Independent Order of Odd Fellows a standing joke among the local high school students who streamed down Brunel Road and onto Main Street at the end of the school day in search of chips and gravy and cherry Coke at Peter's Restaurant.

Several fish huts were still out on the surrounding lakes—one or two that were certain to be found floating and shattered once the winds came up and the ice went out completely. My oldest brother, Jim, was already counting down to opening day for speckles and lake trout. Our father, Duncan, then still working in Algonquin Park as a timber grader for the McRae mill at Rock Lake, would soon be walking out the copper line on his old banjo-reel trolling rod to mark off each fifty feet with a slice of Band-Aid. The closer summer came, the deeper down he'd have to get his minnow-tipped Williams Wabler, which he always spit upon just before he dropped it over the side of the boat, in the hopes of landing a big one.

Jimmy Stringer was also from Algonquin Park. The elderly bachelor with the leprechaun grin lived year round at Canoe Lake with his younger brother Wam, who also had never married. Jimmy had travelled the sixty-five kilometres to town by foot and thumb—the brothers owned no vehicle—to pick up supplies to take back to their ramshackle home on Potter Creek, at the north end of the lake. As was his custom, Jimmy had taken a nine-dollar-a-night room in the Empire Hotel for a few days, as his custom was also to turn the supply run into a bit of a bender.

"Laddie, Laddie," Jimmy said in a near whisper from his unmade bed. "D'you mind going for another drink for Ol' Jamie?"

First, however, "Ol' Jamie" needed some air. Or at least *I* needed some air. The stale smell of the room had been masked somewhat by the sickly sweet aroma of Amphora tobacco, as Jimmy had already smoked several pipes through the morning. And the only window in his third-floor room was shut and sealed with old paint. I yanked up on the sash as hard as I could, repeating the motion until, finally, it separated from the sill with a crack that sounded like a rifle shot.

Real gunshots were not unheard-of around the Empire, which stood on Main Street, where the town's business artery swept up from the river toward the theatre and the Gospel Hall. Not many months earlier, I had worked as a tap man at the hotel, drawing draft beer in the basement bar known locally as the "Snake Pit." I was there the night one of the locals got tossed out for starting a fistfight, only to come back later with a twenty-gauge shotgun, climb up onto the roof of the Huntsville Grill (the Lum family's "Chinese and Canadian Food" restaurant directly across Main Street) and nearly rip off a customer's shoulder at closing time with a blast of birdshot. That he accidentally shot the wrong person didn't count for much with the police.

The open window let in a cool breeze, offering welcome relief from both the tobacco smell and the stench of a corner sink that was likely used as much for urine as for water. With the window up, you could hear the odd car go by, tires sizzling in the cold rainwater, and the early spring runoff rolling in short waves down Minerva Street from the bush around Reservoir Hill where my family lived.

"What do you say, Laddie—will ya?"

Jimmy was already drunk at noon, and it was as much my fault as his. I was then a twenty-four-year-old recent journalism grad, trying to gain a foot in the door by freelancing an article to *Maclean's* magazine on the artist Tom Thomson and his various Algonquin Park and Huntsville connections, including some relatives of mine.

Before dropping in to see what, if anything, Jimmy knew about Thomson and his mysterious death at Canoe Lake in 1917, I had gone to the Liquor Control Board of Ontario store to pick up something that might help loosen Jimmy's tongue. Knowing well what he liked, I went immediately to the letter "S" on the master board. A twenty-six-ouncer of London Supreme sherry was selling for $1.50 and a twenty-six-er of Brights President, for $2.20; deciding to go for the good stuff, I pencilled in "562-B" for the Brights and took the order slip to the cash, where "Babe" Malloy, the store manager, took it into the back of the store and quickly returned with the bottle. He laid it down on the counter back of the cash wicket so I could confirm the label and then deftly slipped the bottle into a plain, brown-paper bag so no one would ever guess you'd been to the liquor store. It made you feel as though you were purchasing condoms.

Somewhat reluctantly, I set out to buy the requested second bottle of Brights. I was starting to worry I might lose Jimmy if he drank too much—a legitimate concern, since he was already snoring as I shut the hotel room door.

I'd known Jimmy was staying at the Empire because he'd already called in at our house three blocks away. My mother, Helen, had been born in Algonquin Park, at Brule Lake in 1915, and the Stringer family had later moved there. Her father, Tom McCormick, had been a fire ranger with Jack Stringer, Jimmy's father. Tom and Bea McCormick had five children: Mary, Helen, Roy, Irvine and Tom. Jack and Kate Stringer—always called "Pappy" and "Mammy"—had an even dozen: John, Dan, Cy, Albert, Wam (whose given name was "Wilmer"), Omer, Roy, Jimmy, Dellas, Moon (whose given name was "Stella"), Mabel and Marion. While both families eventually left the tiny railway depot at Brule for other destinations in Algonquin Park—the McCormicks building a log home at Lake of Two Rivers, the Stringers moving to their whitewashed board-and-batten home at Canoe Lake—the connection remained close.

In winter Jimmy and Wam often dropped in for a meal at our place before heading back to Canoe Lake, where they would haul their supplies

over the ice by toboggan. It was at our red Formica kitchen table, over a cup of sobering coffee, that Jimmy had first dropped hints that he'd not only known Tom Thomson, but also knew something about the enduring mystery that is the painter's life, death and even afterlife.

It was impossible to grow up in this area and not know about Tom Thomson. I cannot recall when I became aware of his existence, but it would have been close to when I learned to walk and talk. His story had interested me as a child—he'd painted in the park where, with my brothers Jim and Tom and sister, Ann, I spent every moment when not in school, my grandfather the ranger had known him, my great-aunt's spinster sister had been engaged to him—but the tale came to fascinate me as I grew older. Winston Churchill might have called Russia "a riddle, wrapped in a mystery, inside an enigma," but Tom Thomson's story struck me as equally unknowable. How had he died? Accident? Suicide? Murder? If murder, by whom? And where, exactly, was he buried—in the family plot, as family and the Ontario government claimed, or still at Canoe Lake, as the park oldtimers had always maintained? I was hooked as a child; obsessed as an adult.

Writing now in the early months of 2010, I can—to my own surprise—claim to have been actively researching Tom Thomson's life and death for nearly forty years, right back to that very first freelance feature for *Maclean's*. Over these four decades, I have accumulated dozens and dozens of interviews with various people directly or indirectly involved with the story, the majority of whom have since died. During these years I also wrote about Thomson from time to time in magazines and newspaper columns. In 1980 I published a novel inspired by Thomson's life called *Shorelines* (which was republished in 2002 as *Canoe Lake*). By 2010 I felt that the time had surely come for me to put together all the research and interviews and speculation and, indeed, scientific and archaeological evidence so fresh the book could not have been written even a year earlier. But all the same, forty years is a long, long time to sharpen a pencil.

I then recalled that my research had gone on even longer than that, for most of half a century, in fact. In the summer of 1963, a decade before this meeting with Jimmy Stringer in the Empire Hotel, I helped a cousin clean out the home and cottage of Winnifred Trainor, the Huntsville woman Tom Thomson was supposedly to marry the same summer he died on Canoe Lake. His body had surfaced not far from where her little summer cabin stood.

While I took no notes—I was a teenager dreaming then of a life in hockey, not journalism—the images stuck with me. It seemed Winnie had kept every newspaper and magazine that had ever come into her Minerva Street home, which stood, coincidentally, kitty corner to the Empire Hotel. The papers were piled so deep and high that there were mere rabbit runs between them to move about in. Her bathtub was filled with empty paint cans and partial cans of long-hardened house paint. My cousin Terry and I hauled out the newspapers and magazines, box loads of trinkets and souvenirs and letters and any furniture that could not be sold or given away. We took most of the stuff to the town dump and threw it all away. Then we emptied "the barn," the large shed on the corner of her lot, taking more papers and boards and canvas tarpaulins, old bed frames and broken furniture to the dump. We saved other letters and documents and a number of keepsakes—one being a World War I soldier's uniform that had likely belonged to Roy McCormick, Winnie's brother-in-law, who was also Terry's father and my grandfather's brother.

Once the contents had been tossed or taken away, Winnie's home was rented out—for a time to my grandmother, Bea McCormick. Eventually, the property was sold and the building was torn down.

It seemed appropriate that Bea McCormick would live for a while in the upstairs apartment where Winnie had lived out her final years. Bea and Winnie's sister, Marie, had married brothers Tom and Roy McCormick. But as Winnie never married after she lost her Tom, and as she had no other family, the extended McCormick family became hers as well.

There was also the Algonquin Park connection. Thomson first visited the park in 1912, the same year the Trainors took possession of an old ranger cabin on Canoe Lake. At the time the McCormicks were living at Brule Lake, about 10 kilometres north and slightly west along the Grand Trunk tracks. My grandfather knew Tom, but it would be wrong to pretend they were friends. Quite the opposite, in fact. For reasons he never expanded on to his grandchildren, Chief Ranger Tom McCormick would quickly dismiss Thomson as a "lazy bum" if a park visitor happened to ask about Algonquin's most famous personality. Thomson, after all, had not been famous in the park while he was alive; he had not even been well known. If pressed, the old ranger might further describe the painter as "a drinker," which in his temperate circles was considered a condemnation of the first order. If, when I was a child, he'd also called Thomson a "philanderer," as others did at the time, I would not have understood what such a strange word meant.

But it was more than just family connections that drew me to Thomson. On the landing heading up to the second floor of the red-brick Huntsville Public School, between Miss Parker's three-four-and-five class and Mr. Cairns's grade six room (both of which I passed through), there was a huge print of Thomson's famous *Northern River*. And there was another, *The West Wind*, on a wall on the first floor close by Principal Jack Laycock's office. Absurd or not, I felt the paintings were part of who I was, as they were of the park where, the moment school let out, I would go to live with my grandparents at Lake of Two Rivers until September. To me, those two prints were far more meaningful than the framed photographs of Queen Elizabeth II and, curiously, United States president Dwight D. Eisenhower that graced the main hall of the school. I felt I *owned* Tom Thomson the way other classmates might feel they had a claim on the captaincy of one of the town teams in hockey or lacrosse.

Yet if Tom Thomson was a presence in the 1950s as I was growing up, he'd become a celebrity in the years leading up to my rendezvous with Jimmy Stringer. In 1969 the Canadian Broadcasting Corporation had produced a TV documentary, *The Mysterious Death of Tom Thomson*.

And a year after that, Judge William T. Little's *The Tom Thomson Mystery* had become a national bestseller. The ingredients for fascination were undeniable: an overturned canoe when Thomson was said to be an expert canoeist, a missing paddle that should have floated and been found, a body rising from the water with fishing line carefully wrapped around one ankle, no water in the lungs, bleeding from the ear and a nasty bruise on one temple.

The television special and book did much to elevate the artist to the iconic status his life and work enjoy today. Tom Thomson was only thirty-nine when he died in the summer of 1917. He was just beginning to find recognition for his work and was unknown beyond a small artistic circle, mostly in Toronto. But he did not pass by unnoticed. He was handsome, tall and dark—and quiet in his ways. Though he was often described as shy, and sometimes as moody, women were easily attracted to him and he to them, though he'd never married. He'd been known to enjoy a drink. Little's book, in fact, had used an argument between Thomson and a Canoe Lake cottager that broke out at a drunken summer party as the pivotal moment in the longstanding puzzle the provincial family court judge believed he'd finally solved.

Little made extensive use of the daily journals kept in those years by Mark Robinson, the park ranger posted to Canoe and Joe lakes. Relying on the journals, later notes and interviews with Robinson, as well as his own speculation, he built a circumstantial case against Martin Blecher, Jr. (spelled "Bletcher" in Little's book). Little also contended that Thomson's remains had never been removed from Canoe Lake, as the Thomson family had requested and as the undertaker who had taken on the task swore. Little believed he had proof of this in a skull and bones that he and others uncovered at the Canoe Lake cemetery in the fall of 1956—only to have the Ontario government, with the backing of forensic science, claim the remains were not those of the painter. Little's book and the CBC special that was largely based on Little's work had the effect of turning Tom Thomson, the Great Canadian Painter, into Tom Thomson, the Great Canadian Mystery.

Actually, two mysteries in one—what had happened to him and where, exactly, his body was buried—and old Jimmy Stringer was about to tell me what he knew about the story.

When I returned from my second trip to the liquor store, Jimmy was still lying on the bed, snoring. He was in his long johns—greyish-white, mottled long underwear—the garb, it seemed, of all the men who worked in the bush. Every one of my grown-up male relatives wore them. Unlike my then-new "insulated" long underwear, which came in two pieces and had a thick, ribbed look, these long johns were thin, like a second skin. My father wore "educated" long johns—took them off when school let out and put them back on when school went back in.

Jimmy had an elfin look to him. His hair, black when I was a child, was now white. Having been born at the turn of the century—"I'll be seventy-three this coming month, Laddie," he told me when I asked— Jimmy looked his age only from the collar up, his hair a snowdrift over a deeply weathered face. From the collar down, however, he was thin and boyish, with not an ounce of fat on him, and he moved with the lithe grace of a man who could still paddle and portage a canoe to match any of the vain, young, tanned guides with the *bandito* headbands who led summer campers up Canoe Lake and into the park's interior.

Jimmy's eyes, a striking blue, were hooded but managed to look sympathetic and conspiratorial at the same time. He had the same hawk nose as my grandfather, though they were not related. It seemed at times that the McCormicks and Stringers were merely slight variations of an Algonquin Park subspecies, human fauna native to the environment. My mother and her siblings were all expert canoeists. Jimmy's younger brother Omer, master builder of the Beaver Canoe, was legendary for his ability to leap into an untethered canoe the way the Lone Ranger used to board Silver. With the canoe skimming out over the open water, Omer would then go into a headstand, using the portaging thwart for neck support.

But the best Stringer stories always seemed to involve Jimmy and Wam. The most famous tale, apocryphal perhaps, involved their own precious Tom Thomson painting, which they kept on the wall of the old home on Potter Creek. One dark, cold night toward the end of a very tough winter—the brothers were usually the only ones to spend all year at Canoe Lake—Jimmy and Wam were killing a bottle of rye and got into a furious brothers-only-will-understand debate over whose turn it was to go out to the woodpile and return with enough split wood to get them through the night. The argument became increasingly heated, though not heated enough to keep the windows from frosting over. Finally, to settle matters, one of the brothers—neither ever admitted to this—ripped the Tom Thomson original off the wall and hurled it into the woodstove.

Though both of the bachelor Stringers were now old, they were still known as "The Boys." They had lived hard. Jimmy and Wam had survived bush accidents and river tippings and winters that could be so bitter the brothers claimed their pee sometimes froze into icicles before it hit the ground. Joe Runner, a Canadian actor and Canoe Lake regular for many years, claimed Jimmy came back from the Portage Store at the south end of the lake one dark night so drunk that he stopped in the middle of the lake, stepped out of the boat and nearly drowned. Runner also claimed to have been a witness when Wam, who had passed out with his hand still locked around the throttle, ran his boat up onto some logs and stayed passed out as the bow tilted back down and lifted a screaming propeller clear of the water.

Jimmy liked to call himself "The Mayor of Canoe Lake" and once hosted a Labour Day weekend bash at the Stringer home. He borrowed a barge normally used to haul building materials about the lake to bring in a piano for Wam to play. Jimmy wore a chain of office constructed from the snap-off caps from beer cans and mix cans, sat in an ornate barber's chair that had been his father's and made a simple stump speech.

"All those who want Jamie to serve another term as mayor? . . .

"All those opposed?" . . .

Naturally, no one voted against.

The second bottle of sherry sinking fast, Jimmy put the stem of his pipe to his teeth, drew the zipper closed on a dark tobacco pouch, leaned over and pinched my forearm. "Alright, Laddie. Jamie does have some things to tell."

I asked him when he'd first met Tom Thomson. I knew the Stringers hadn't ended up on Canoe Lake until years after the artist's death, yet Jimmy had always maintained he knew the painter.

"In 1916," he said. "I was sent to stay with my Uncle Jack Culhane, who was a ranger at Lake Traverse. They were wallpapering when I was there, and I used some of the paper to draw and paint pictures of fish. I did a laker and a speckle. Well, Tom Thomson comes paddling up the lake and stops in, and Uncle Jack invites him to stay over. Tom seen my two pictures rolled up on the piano and he says to me, 'I'll swap you two of mine for your two,' so we agreed, and I had two little Tom Thomson paintings. And we painted a little picture together too. We left them all on the piano while everyone pitched in to finish off the wallpapering. And then they cleaned everything up—burned the paintings with everything else!"

One can only imagine what the two lost Tom Thomson sketches might have been—if, in fact, the story is true. Jimmy also said he had seen Tom Thomson's "ghost"—something others would claim over the years—but it is still possible that Jimmy and Thomson could have met that summer. That spring of 1916, Thomson had taken a job as a fire ranger, stationed at Achray on the southeast shore of Grand Lake, where he shared the ranger cabin with Edward Godin. Lake Traverse is northwest of Grand Lake, on the Petawawa River. So Thomson was definitely in the area that summer, when sixteen-year-old Jimmy Stringer went to stay with his mother's brother Jack. It was here, in the northeast corner of Algonquin, that Thomson sketched *The Jack Pine* and several of his best-known works in the final year of his life.

Jimmy had his own opinion about what had happened to Tom Thomson. "God knows I've fallen out of my own canoe enough times," he snorted. He was also quick to dismiss any suspicion that Judge Little's

then-recent book might have cast over Martin Blecher, Jr. "Martin Blecher," Jimmy said, "didn't have the guts to shoot anyone."

But he was saving the best for last. He had something to tell me, he said, about the never-ending debate about where Tom Thomson's body had ended up. Still in the shallow, "temporary" grave in the little cemetery on the hill overlooking Canoe Lake? Or removed by the Huntsville undertaker, F.W. Churchill, and reburied in the Thomson family plot in Leith?

In Jimmy Stringer's opinion, *neither*. Thomson wasn't in the original grave that had been dug at Canoe Lake the day after his body surfaced. Nor was he in the family plot at Leith.

"I tell you what, Laddie," said Jimmy after several more pulls on his unlighted pipe. "You and Jamie will settle this once and for all. Just the two of us, this summer. Tom Thomson may be a ghost, but he was never shot. And Jamie can prove it. 'Cause Jamie Stringer is the only one left that knows where the real grave is."

When I pressed him for further details, Jimmy became coy.

"I won't tell you," he said. "But I'll *show* you. And if you don't believe me that I know where the grave is, I can show you Tom Thomson's shinbone."

"His shinbone?"

Jimmy nearly cackled. "I keep it hidden in the woodshed. Tom Thomson's shinbone—I've got it right there."

I didn't know what to think. Well, that's not exactly true. I was thinking far too much. I was imagining the sensation such a story might be. I was thinking how amazing it would be after all these years, after all this national speculation, to find out, once and for all, where Canada's most famous artist was buried and, perhaps, how he died.

"Will you show me, then?" I asked.

Jimmy nodded, lighting his pipe one last time.

"You come in the summer. I'll take you to it and we'll dig him up and we'll settle this thing once and for all. You 'n' me, Laddie—just the two of us."

We made tentative plans for late June. I would be on holidays then. The worst of the blackflies would be over.

I returned to the city and my work. Jimmy Stringer sobered up and, early in the morning of March 30, 1973, he paid for his room at the Empire Hotel, walked down to the A&P and picked up supplies for Wam and himself. He then hired a cab to take him out to Canoe Lake, where he had his toboggan stashed to tote the supplies across the lake to Potter Creek.

When Jimmy failed to arrive, Wam got worried and started looking for his brother. Others joined in and, finally, someone found a hole in the ice near the eastern shore. They could see no body, but there were eggshells on the lake bottom, and they realized instantly what had happened. The Ontario Provincial Police scuba divers came in and recovered Jimmy's body. His hands and wrists were torn from trying to pull himself up onto the crumbling ice. More than two hundred people attended his funeral in Huntsville, where he was described, rather accurately, as "just a nice little guy."

Only days after James Grant Stringer had promised to "settle this thing once and for all," he himself drowned in the same waters that, fifty-six years earlier, had claimed Tom Thomson. If there really was a shinbone in the shed, I never did see it. The shed and the old Stringer home on Potter Creek have both been torn down long since and replaced with a modern cottage.

As Jimmy kept saying, "The truth's still not told, Laddie."

ONE TOM

Instead of a family tree, the Thomson family could be better represented by *The Tangled Garden*, a 1916 painting by Thomson's friend and contemporary J.E.H. MacDonald. Tom's paternal grandfather, Thomas "Tam" Thomson, was the offspring of a woman named Christian Davidson, who had been jilted and left pregnant by her lover. Tam had children with three different women, two of whom he might have been married to at the same time. The painter's paternal great-grandmother had two children out of wedlock until the church forced her lover to marry her—shortly after which he fled Scotland for North America and vanished, never to be seen again by the family. Roots of discontent.

Tam Thomson, described as "a charming talker and devilishly handsome," emigrated to Canada to seek employment, promising to support the two children—one named Thomas Thomson, Jr.—he was leaving behind with their mothers, Elizabeth Delgarno of Old Deer, whom he might have married but never divorced, and Sarah Allan of nearby Peterhead, who bore him Thomas. According to Angie Littlefield's self-published *The*

Thomsons of Durham, Tam came to this country and settled first around Whitby, where he courted and married Elizabeth Brodie, who'd also come to Canada from Scotland. It was in Whitby in 1840 that John Thomson, father of the painter, was born.

Tam Thomson later purchased a farm at nearby Claremont, northwest of Whitby, and the growing family—eventually joined by Tam's Scottish offspring—settled into a stone house there and prospered. Tam was a grand storyteller—"He was always the hero of his own story," a cousin said—but his willingness to work hard and the sheer force of his personality soon brought him financial success as well. Very quickly, the Thomsons became a family of substance in the newly settled area. Though he'd lived in abject poverty back in Scotland, Tam Thomson now ran a grand home with servants.

A nearby Scottish family, the Mathesons, had come from the Isle of Skye in 1841 following the failure of the potato crop, first settling on Prince Edward Island. The Mathesons were also considered a family of substance—one relative was John A. Macdonald—and in 1865 John Thomson and Margaret Matheson married. John took over the management of his father's growing farm operations, and one year after Confederation (a union brought about by their distinguished relative, privately referred to as "the old reprobate" by family members), they had their first child, George.

Elizabeth was born the following year, then Henry, Louise and Minnie—before a third boy arrived on August 5, 1877, and was given his grandfather's proper name, Thomas John Thomson. When Tom was only two months old, the family moved north and west to a hundred-acre farm called Rose Hill outside the village of Leith, near the southern edge of Lake Huron's massive Georgian Bay. Here, the couple produced four more children: Ralph, James, Margaret and Fraser.

Life at Rose Hill was, by the few accounts available, rather bucolic. The family was well off thanks to a considerable inheritance from Tam, who died March 23, 1875 (Elizabeth had predeceased him by seven months). John Thomson was able to easily afford the $6,600 price tag on

the Rose Hill property where he lived the life of a "gentleman farmer." He became far better known for his fishing than his crop or livestock pursuits. As a great-niece once said of John Thomson, "He might not have been a good farmer, but he liked to watch a sunset."

When Tom Thomson was five years old, his infant brother, James, died, cause not recorded. The nine remaining children, however, were healthy and thrived, though Tom is said to have suffered from "inflammatory rheumatism" at one point. In a 1931 letter, Thomson's sister Louise wrote that Tom's delicate condition led to the local doctor advising their parents to keep him out of school for a year. This, of course, delighted the boy, as it allowed him to spend most of that year outdoors. Louise said he was an amazing walker, once hiking fifteen kilometres through a blizzard to attend a party and another time travelling the thirty kilometres to Meaford on foot "rather than bother with a horse and buggy, though Father begged him to take them." She said he would walk with a shotgun while wearing a felt hat he would soak with water and shape to a point over a broom handle. He would decorate the hat with wildflowers and squirrel tails. It was a typical rural Ontario life for a boy, not all that different from how I spent my time more than half a century later—minus the silly hat, of course.

Young Tom spent considerable time fishing on nearby Georgian Bay and on the sound heading into the Owen Sound harbour. He became a fine fisherman and quite an accomplished swimmer, which would suggest either that his health had been fine all along or that the outdoors had had its intended effect.

Life on Rose Hill was privileged. The Thomson children had their duties, but there was always time for fishing in summer and for skating on the frozen sound in winter. The farm was a social gathering point for neighbours, often filled with music. Tom sang in the church choir, played the violin in the school orchestra and, at local dances, dabbled on the mandolin and cornet. And he read, wrote poetry and liked to draw. Though we know he missed that one year of school, no one has been able to find any mention of what grade he completed.

Young Tom had a genuine love of nature that was significantly influenced by an older cousin of his grandmother, William Brodie, whom the Thomsons would sometimes visit in Toronto. Brodie, a dentist, was also a renowned naturalist—his collected specimens are in the Smithsonian in Washington and the Royal Ontario Museum in Toronto—who had lost his only son, Willie, in a canoeing accident. William Brodie, Jr., only nineteen, had set out to collect specimens along Manitoba's Assiniboine River with some other young scientists, including the writer and naturalist Ernest Thompson Seton, but Willie's canoe had overturned in the spring current, and his friends had been unable to get a lifeline to him in time.

Tom, with his very evident love of nature, became something of a surrogate son to the elder Brodie, often going on day-long hikes through Toronto's ravines, with Uncle Willie pointing out the various flora and fauna they found there.

Tom grew into a lithe and handsome young man. One photograph, taken when he was in his late teens, shows a rakish figure staring hard into the camera, an unlighted cigarette carefully set in a corner of his mouth, a rather faint moustache reaching for maturity and both hands shoved deep into his pants pockets in an insouciant pose that belies his rather formal white-tie dress. He was, his niece Jessie Fisk (née Harkness) would later claim, a lady-killer, with thick, black hair that he initially parted in the middle, causing a hank of locks to bracket each side of his forehead and draw attention to his patrician nose. His chin had a small dimple, and, like others in his family, he had a straight right eyebrow and a slightly curved left, giving people the impression he was vitally interested in whatever they were saying. Tall, with dark eyes and fine features, he soon abandoned the weak moustache but took to smoking a pipe, which made him seem more mature. One of his favourite words, apparently, was "shoddy," which occasionally gave the impression that he was arrogant. At other times he seemed shy, which young women found attractive. Others took his reserve for brooding.

He certainly came early in life to the pleasures of drink. His childhood friend Alan H. Ross wrote a remembrance in which he said: "I have been with him on several occasions when I am now sorry to say that neither of us was very sober, but it is in such times men exchange real confidences and it was on one such occasion that I discovered how deeply sensitive he was and how he resented anything like public ridicule . . . I remember one night in 1901, in Meaford, when he embosomed himself, lamenting his lack of success in life in terms that rather astonished me. I began to think then that he realized his powers and that he also had secret ambitions. But one never knows . . ."

At twenty-one, all the Thomson children inherited $2,000 each from the estate of Tam Thomson—about $40,000 in today's money. Tom frittered this substantial inheritance away—he had a passion for expensive silk shirts among other things—in very little time, a harbinger of the fact that he would spend the rest of his short life in constantly recurring financial crises. His sister Louise claimed that the directionless young man tried three times to enlist to serve in the South African War, only to be rejected each time on the grounds of his having a badly broken toe from a football game played long before. This information comes from a letter she wrote in 1931 and may or may not be factual. I do not believe it. She might have been trying to come to terms with a deceased family member who had gone from being relatively unknown at the time of his death to being of increasing interest in the emerging world of Canadian art. Such a white lie, if indeed it was—no records were kept concerning those rejected—could have been concocted to smooth over whatever awkwardness the family felt regarding inquiries about Tom's later failure to enlist in the Great War, as A.Y. Jackson and other art contemporaries had done.

A longtime ranger in Algonquin Park, Bud Callighen, said that Tom had told him in the summer of 1915 that he'd tried three times to enlist but had been turned down. Callighen naturally assumed he meant the war raging in Europe. Callighen also said that Tom blamed fallen arches for his rejection, though others who heard this explanation were quick

to point out that Thomson was able to hike for miles through the woods, often carrying a canoe, without apparent suffering or complaint.

Thomson used part of his inheritance to purchase an apprenticeship so he could train as a machinist at family friend William Kennedy's foundry in Owen Sound, which manufactured ship propellers for the thriving Great Lakes shipbuilding industry. It seemed a responsible thing for the twenty-two-year-old to do, but it didn't last. The job quickly bored him, and the shop manager, a Mr. Munro, soured on his young charge, thinking him lazy and lacking commitment. Less than a year later, Tom had either quit or been fired.

He then enrolled in the Canadian Business College at Chatham, which his older brothers, George and Henry, had attended. But it, too, bored him. "I don't think Tom's stay in Chatham did him much good," Alan Ross claimed. "He seemed to me at the time to be drifting. He was clever enough at his studies but he lacked the faculty of concentration."

In 1901 Tom quit business college and struck out for Winnipeg, where he stayed a short while—no one seems to know in what capacity—and then moved on to Seattle, Washington, where his ambitious and enterprising older brother George and their cousin F.R. McLaren had started up the Acme Business College, clearly modelled on the Chatham school. Tom, now twenty-four and still directionless, took a room with a Mr. and Mrs. Shaw on Twenty-first Street and found work as an elevator lift boy at the Diller Hotel.

George's easy success in Seattle became a bit of a clarion call to the Thomsons of Rose Hill farm. Two other Thomson brothers, Ralph and Henry, soon joined George and Tom, but no brother was as closely tied to Tom as the eldest of the Thomson boys. George, in fact, appears to have been somewhat of an alter ego to Tom: driven, where Tom was distracted; successful, where Tom wandered; frugal and soon relatively wealthy, where Tom was spendthrift and often barely aware of the existence of money.

But George, too, harboured artistic dreams. He eventually sold his stake in the Seattle school and moved to New York to study painting,

later settling into a bookkeeping job in New Haven, Connecticut, and restricting his art to a weekend hobby. In the mid-1920s, George would return to Owen Sound to teach art and to paint the familiar landscapes. He had an admirable art career, but would never attain Tom's level of success. Knowing the dynamics of brotherhood, it's likely that Tom grated on George, and perhaps George grated equally on Tom. Yet it was George, ever the responsible one, who would hurry to Canoe Lake in July 1917, when word went out that Tom was missing.

Tom spent three years on the West Coast. Alan Ross, who visited him there, said he was popular and happy. "I never knew anyone who made friends more easily," Ross said. It seems the shyness of his youth had lifted. "He was one of the most companionable men it has been my fortune to hold friendship with," Ross wrote, "and there are scores of others, I venture to say, who will tell you the same thing."

Tom studied penmanship at his brother's college and finally seemed to accept that he could have a career in engraving. He liked commercial art and soon tried his hand at his own creations with pen-and-pencil drawings and watercolours. He was hired on by C.C. Maring, who had previously been an instructor at the Chatham business school, but Tom soon switched to the Seattle Engraving Company, which offered a better salary. It seemed he had found his calling.

He also fell in love in Seattle.

It would be more unusual if he had not fallen for someone in those years in which he was passing through his mid-twenties. Brother George later claimed that Tom became smitten with a Seattle woman who never appeared quite as smitten in return, but it is unlikely that Tom would have confided much in his stern and serious older brother. All the same, according to George, a shy Tom had edged up to a marriage proposal only to have the object of his affections laugh at the suggestion, causing the young man to flee in humiliation in 1905, never to return to the West Coast.

The facts were later fleshed out to some extent by Canadian art historian Joan Murray, who identified the woman as Alice Elinor Lambert. Murray thought that Lambert was about fifteen years old at the time and considered the relationship harmless, mere puppy love. But Lambert would have been nineteen when Tom supposedly fled Seattle, so the affair might have been much deeper than Murray has conjectured.

Alice was seven years younger than Tom, a common enough gap in those days between a man and woman who were romantically involved. She'd been sent by her missionary parents to board with the Shaws, where Tom was already rooming. Alice went on to become a published author, and there may be much to be read into her 1934 novel, *Women Are Like That*. The main character is Miss Juliet Delaney, and at one point Juliet is reminded of the one true love of her life.

"For one disturbing year," Lambert writes of her heroine, "she had been desperately in love with a tall, dark boy named Tom, a commercial artist, who in the summer used to take her on streetcar rides to Alki Point and in the wintertime to the dusty dimness of the public library, where he would pore over prints and reproductions of the masters. When finally, darkly morose and determined to succeed, Tom had gone east, the girl, unversed as she was in the art of pursuit and capture, had let him go, powerless to hold him back . . . Tom had been tall and slender, with thin, nervous hands and flashing eyes. Instinctively, since his death, Juliet had avoided men of similar build and appearance."

If this is an accurate reflection of whatever it was that Tom and Alice had felt for each other, it contradicts the family story. This "Tom" seems driven and depressed over his art and willing to sacrifice romance for a chance to prove himself back east. Alice might also have been the first woman hurt by his reluctance to settle down, the wanderlust and fierce independence that would mark his life and might even have contributed to his death.

Alice lived to the age of ninety-five before passing away in Marysville, Washington, in 1981. She had led a convoluted life, marrying a man with whom she had two daughters, then leaving him and

moving across the country, briefly writing a newspaper advice column and reconnecting with her husband before separating again and returning to Seattle, where, so long ago, she had met the real "Tom." In her later years, Lambert wrote to Joan Murray describing the end of the romance, from her point of view, and suggesting that perhaps Thomson considered her too young.

"Tom packed up," Alice wrote, "and . . . went east to save me. I used to long to write him, or find him, but a miserable experience prevented me—I married a man with whom I had no communication whatsoever. But I never put Tom out of my heart. We were two star-crossed young and innocent people who never should have parted."

In Toronto Tom took a room on Elm Street and threw himself into what he then thought would be his life career: commercial art. In June he joined Legg Brothers Photoengraving Company as a senior artist and engraver at the satisfactory salary of eleven dollars per week. He signed up for night classes at the School of Art and Design, where he studied drawing, and also took free lessons from William Cruikshank, an old-style artist who served as mentor to several young painters in the city. It was during this time that Thomson painted *Team of Horses*, but the less said of it the better.

By 1908 Thomson was working at Grip Ltd., the Toronto commercial art firm that would become the artistic percolator for Thomson and, in later years, the Group of Seven, who, curiously, eventually numbered ten. Original members J.E.H. MacDonald, Arthur Lismer, Frederick Varley, Franz ("Frank") Johnston and Franklin Carmichael all worked with Thomson at Grip. It was a time of great growth and vitality in Toronto, with much construction in the downtown core and the young city spreading quickly thanks to easy transportation provided by its streetcar lines. The young artists felt they were part of something new and important, socializing together at clubs and taverns and often spending weekends together painting in the nearby countryside. They fed off

one another, encouraged one another and quietly competed with one another. In 1920, three years after Thomson's death, MacDonald, Lismer, Varley and Carmichael were still linked artistically and socially and formed their legendary art group by adding Franz Johnston, Lawren Harris and A.Y. Jackson. When Johnston later resigned, A.J. Casson was added, and later, the group became more national when Montreal's Edwin Holgate and Winnipeg's L.L. Fitzgerald joined, not long before the group disbanded in 1933.

The most influential force at Grip never did become a member of the Group of Seven. The director of the engraving division, Albert Henry Robson, called his department a "university" for graphic arts. He created such an atmosphere of creativity that when he moved on to another firm, Rous and Mann Ltd., in the fall of 1912, several Grip employees, including Thomson, soon followed. Robson hired creative men and gave them structure—formal dress, be at your desk for the full workday—but also allowed them to have fun and encouraged them to be competitive in their work and painting.

Thomson was well liked by his colleagues but exhibited the contradictory personality traits that seem to have marked his entire life: considered shy and quiet but also one to play practical jokes on his friends from time to time—and a wit who entertained his fellow workers by mimicking managers and customers and whipping off comic caricatures in an instant.

The young artist also had a life beyond the workplace. During this time he became fast friends with John McRuer, who was then studying medicine at the University of Toronto. McRuer eventually moved north to take up private practice in Huntsville, but in early 1909, when McRuer married Edythe Bullock, the Huntsville *Forester* reported that the "groom was assisted by Mr. Tom Thomson of Toronto"

Tom was also a good friend of the McCarnen sisters, Elizabeth and Margaret. They had made their way to the city from the village of Phelpston, also near Georgian Bay, though closer to Collingwood than Owen Sound, and they at first kept house for a John Long, who lived on

Jarvis Street. "Maggie" was ten years older than Tom and "Lizzie" six, and it seems Tom was somewhat infatuated with the younger sister. Maggie moved on to make a living as a seamstress (among other things, she made uniforms for the nurses at the nearby Wellesley Hospital), while Lizzie continued to find work as a domestic.

The attraction may have been as much about Tom's homesickness for his big family and the Georgian Bay area as about Lizzie's personal charms. A hint of this is found in a letter his younger sister, Margaret, wrote after his death: "I often think now that he was many times lonely when all by himself and none of us did anything when he was away to cheer him up . . . His life meant so much to us here at home. He was alone and no one else was taking his affections and he always enjoyed his visits so much."

Tom obviously liked Lizzie well enough to give her a sketch; tellingly, it was of the countryside both had left for the city. Called *Scene near Owen Sound*, it hangs today in the Tom Thomson Memorial Gallery in Owen Sound. Lizzie's heirs say that the relationship was platonic, which is the way Lizzie would have wanted it, and that she found him rather "unkempt," though she clearly cared for the young artist. While Maggie later married John King, Lizzie never did marry. She and Tom lost touch sometime after 1907, when she returned to Phelpston to raise her two nieces, May and Rita McCarnen, following the death of her brother Bernard. According to family, she hung Tom's sketch over the beds of the two girls she raised, and Tom continued to send postcards he'd drawn. Lizzie kept those cards with all her letters in a purple satin bag that was locked in a cupboard—but, unfortunately, no one knows what became of them following her death in 1957 at eighty-six.

One Grip employee, S.H.F. Kemp, later recalled that Tom liked to paint all right but made "no noise" about his work: "He attached no particular value to it." MacDonald, the senior designer, and the British-trained Lismer, Varley and Carmichael were all much more serious about landscape painting, but they were not particularly adventurous in their search for subject matter. They stuck to the valleys of the Don

and Humber rivers that book-ended the growing city of Toronto and sometimes ventured out toward Lake Scugog to the northeast. There they found landscapes of soft English beauty—bucolic and pastoral—nothing like the brilliant fall colours, granite outcroppings and tangled bush where Thomson would find his calling.

Thomson's great discovery of "The North Country"—perceived as such by Torontonians of the time, as it was reachable only by settlement road, lake steamer and, in some instances, rail—began in May 1912. More of the area was actually in central Ontario than northern Ontario, covering Muskoka, Parry Sound, Georgian Bay, Algonquin Park and, to a lesser degree, the North Bay–Temagami area, known today as the "Near North." The find occurred somewhat by happenstance: Tom and another Grip employee, Ben Jackson, wanted to go farther afield than the Lake Scugog area and chose to head for Algonquin Park, since it would fit in nicely with a visit to Tom's doctor friend, John McRuer, and his wife, Edythe, in Huntsville.

In May 1912 Thomson and Jackson stayed at the Dominion Hotel, down by the bridge over the Muskoka River, and did some sketching around the town. Jim McRuer, John's younger brother, who would go on to serve as Ontario's chief justice, was articling with a local lawyer at the time, and he visited Thomson at the hotel. He was shown the paintings and told to "Pick any two you like," which the young law graduate did. (Many years later, those sketches would be donated to the McMichael gallery in Kleinburg, Ontario.)

It wasn't until the late 1960s that some undeveloped film from this trip was discovered by the Thomson family in Owen Sound. The film eventually made its way to the National Gallery in Ottawa, which developed the ancient negatives and declared the subjects "unidentified individuals." But when Chief Justice James McRuer saw the photos in 1970, he recognized his late brother, who had died of tuberculosis a few months after Tom, in the fall of 1917. He said the photos had been taken during a day trip that spring of 1912. They'd gone by train to Scotia Junction, twenty-five kilometres north of Huntsville, where they'd picnicked and

then wandered about the tiny village and surrounding countryside while Tom took photographs.

The parties split at Scotia Junction, the McRuers taking the train back to Huntsville, while Thomson and Jackson transferred to the line heading east into Algonquin Park. They would have stopped for water at the Brule depot, where my grandparents were then living, and disembarked at the Canoe Lake station. Ranger Mark Robinson, who met most trains at Canoe Lake, wrote in his daily journal for May 18, 1912, "Met MacLaren Party and T. Thompson Party at evening train." Thomson and Jackson camped and paddled about the various lakes— Canoe, Tea, Smoke, Ragged—and explored the Oxtongue River east from Tea Lake.

Tom carried new paints and brushes on the excursion but did more fishing than sketching. Ben Jackson's most vivid memories of the trip were Tom's ability to cook over an open fire and how he made fresh biscuits to go with their feeds of trout. When it rained, Jackson said, Tom was content to stay in camp, smoke his pipe and read Izaak Walton's *The Compleat Angler*.

"Tom," Jackson wrote in a 1930s letter, "was never understood by lots of people, was very quiet, modest & . . . a friend of mine spoke of him as a gentle soul." In Jackson's opinion, Tom "cared nothing for social life"— again the contradictory readings of Tom's complex personality—and was happiest with his pipe, his fishing pole or his sketching. "If a party or the boys got a little loud or rough," Jackson added, "Tom would get his sketching kit & wander off alone, at times he liked to be that way, wanted to be by himself [and] commune with nature."

Later that same year, Thomson arranged for a second break from work and headed off with another Grip employee, William Broadhead, for the North Country beyond Algonquin. For all of August and much of September 1912, they travelled by canoe, beginning at Biscotasing, near Sudbury, then paddling up the Spanish River and working their way through a series of lakes and portages. They eventually reached the Mississagi Forest Reserve and the Aubinadong River. If Jackson found

Thomson quiet, a bit of a loner and with no liking for the social life, Broadhead seems to have found him gregarious and open. They are said to have met a summer fire ranger named Archie Belaney on the way, never for a moment imagining that the tall man with the British accent would one day transform himself into Grey Owl, the most famous "Indian" Europe would ever know. They amused themselves with stories of other camping parties they encountered—particularly a group of Brits who were headed into the wilds with vast supplies that included carpet slippers and table napkins—and began to think of themselves as accomplished outdoorsmen.

But they were still novice canoeists. They dumped their cedar-strip canoe on Green Lake, blaming a sudden squall that caught them off guard and swamped them, and dumped it again trying to shoot some small rapids on the Aubinadong. Thomson was despondent because most of the photos he'd taken during his two trips north went overboard and were lost in the waters.

The two men started back for Toronto on the steamer *Midland*, which they caught at Bruce Mines, and disembarked at Owen Sound to visit Thomson's family. In a later reminiscence, Thomson's sister Louise Henry said that the two young men seemed quite full of themselves after their trip. "My husband asked Tom if he was not afraid to be so much alone in the woods with so many wild animals roaming about," Louise wrote in a letter dated March 11, 1931. "'Why,' he said 'the animals are our friends. I've picked raspberries on one side of a log, while a big black bear picked berries on the other side.' He also told him of one time he was tramping through the woods when he heard some animal coming towards him through the undergrowth and to his surprise it was a large timber wolf, one of the largest he had ever seen, its head, neck and breast were jet black and the body the usual grey color. He said it was the most beautiful animal he had ever seen. The wolf came so close to him he could almost have touched him with his hand"

"Local Man's Experiences in Northern Wilds," a long feature that appeared on the second page of the *Owen Sound Sun* on September 27th,

described Thomson and Broadhead as "bronzed and weather beaten from exposure . . ." and reported, "The young artists think it is a grand country, and are only waiting until next year when the call of the wild will take them back"

Once he and Broadhead returned to Toronto, Thomson wrote his friend John McRuer, apologizing for not calling in at Huntsville as planned on their way back to Toronto. His spirits were high, and he spoke, in the language of the day, of having had "a peach of a time."

Thomson had caught the bug of the North. He soon showed up at work carrying a new paddle, which he immediately tested out by filling one of the photoengraver tanks with water, then placing the tank beside his chair so he could sit down and practise paddling.

"At each stroke he gave a real canoeman's twist," recalled J.E.H. MacDonald, "and his eye had a quiet gleam, as if he saw the hills and shores of Canoe Lake."

TWO WINNIE

The two rolls of film rescued from the dumping on the Aubinadong River in 1912 were ignored for fifty-five years. The negatives were kept by the Thomson family as part of a general collection of Tom's belongings until 1967, when Jessie Fisk, the painter's niece, came across the negatives and donated them to the National Gallery in Ottawa. In 1970 the gallery put the developed photographs on display and reproduced them in a slim pamphlet with text written by the well-known Canadian art historian Dennis Reid.

The black-and-white photographs were hardly art in themselves, but they did show what Jackson and Thomson had seen during their spring visit to Huntsville, Scotia Junction and Canoe Lake. In addition to some canoe shots, there were photographs of a red squirrel, brook trout and lake trout, smallmouth bass, a beaver pond and lodge, a ruffed grouse, a loon egg, a mill yard, a camp, several people (some of whom are tagged "An unidentified man") and the Canoe Lake cemetery, where, five years on, Thomson himself would end up being buried.

Thomson was obviously taken, as all who visit the little graveyard are to this day, by the two lonely markers. One is over the remains of an eight-year-old boy who died of diphtheria in 1915 and whose family was refused permission to transport the body from the park for fear of spreading the disease. Thomson took a photo of the simple headstone, which reads:

ALEXANDER HAYHURST

1907–1915

OUR FATHER WHICH

ART IN HEAVEN

He also photographed the other marker, which stood over the grave of an employee of the Gilmour Lumber Company, which had operated, and ultimately failed, on Canoe Lake toward the end of the nineteenth century. Ja's Watson died, perhaps as a result of a mill accident, at age twenty-one on May 25, 1897. Thomson's photo is clear enough that most of the poem chiselled onto Watson's rock can be read:

Remember Comrades (when passing by)
As you are now so once was I
As I am now so you shall be
Prepare thyself to follow me.

There were also the photos taken during the trek to Scotia Junction with the McRuers. The village is identifiable, as is John McRuer. And there are two photos of a tall, dark, attractive woman in a white dress that shows off her slim waist and firm, squared shoulders. Her dark hair is swept back in a slightly boyish, carefree way. She's holding a catch of smallmouth bass in her right hand, a fishing pole in her left. Based on information from Jessie Fisk, the numbered photos were labelled as "38. Miss Winnifred Trainor, I" and "39. Miss Winnifred Trainer, II."

While the gallery pamphlet did not go so far as to identify the pretty young woman as Tom Thomson's fiancée, it did say that "the rumour

nevertheless persisted that Thomson and Miss Trainor were in fact engaged to be married."

Fisk had met Winnie Trainor only once, during a very brief encounter in Toronto in late August 1917, at a Canadian National Exhibition display of some larger works by the recently deceased artist. Her word that the young woman was indeed Winnie ensured that these photos of "Miss Winnifred Trainor" would be reprinted in dozens of book and magazine accounts of the Tom Thomson story, and they are among the only pictures of Thomson's fiancée that have ever seen print. But the pictures are not of her.

Dennis Reid had noted that this woman was wearing rings on her wedding finger, but he had trusted Fisk despite the anomaly, figuring that the Thomson family should know, after all. Some have even argued that the rings are proof that Winnie and Tom were engaged, but her immediate family knew it was not her; her extended family also knew, though no one has ever bothered to correct the record until now. Winnie never wore a wedding ring or engagement ring, she was darker and more solid than the woman misidentified as her, and her hair, tending toward frizzy and kept in a bun most of her life, was never as shiny and carefully sculpted as the locks of the woman in Tom's photos. By her own account, as well, Winnie did not meet Tom until 1913, the year after these images were shot.

There are few photographs of the real Winnie Trainor available, but enough to provide Montreal forensic artist Victoria Lywood, an international expert on facial reconstruction, to note the various differences between the real Winnifred Trainor in family photographs and the "false" Winnie identified in the National Gallery exhibition and in several books on Thomson. The real Winnie's nose is straight, the false Winnie's nose upturned. The real Winnie's face is oval, with soft jaw line and rounded chin; the wrongly-identified Winnie's face is rectangular with a sharp jaw line. Victoria Lywood later prepared a professional eight-page report on the discrepancies in facial features between Winnifred Trainor from verified photographs and the woman in the Thomson photograph that has long been identified as Winnie.

While various differences were noticed in everything from nose struc-
ture to brow, most telling is the hair, which in the known photographs
of Winnie is wild and unruly and usually kept in a bun that could have
been held down only with tent pegs. Lywood wrote:

> While my opinion regarding the hair is personal rather than
> forensic, as hair can certainly be changed, the three confirmed
> Winnie Trainor photographs show a female with what appears
> to be consistent hair texture, somewhat curly and frizzy in nature,
> during what appears to be three different seasons of the year at
> three different stages of her life. It is curious and unknown as to
> how she would be able to produce and maintain a straighter, yet
> wavy, natural-looking hairstyle in the outdoors for any period of
> time relying on products and methods produced in 1912 unless
> the style, texture and nature of the hair was indeed natural to
> the subject in [the photograph taken by Thomson in 1912].

Lywood also set out to determine the relative height of the woman by
using fashion references and involving research by Martin Cooper,
senior archaeologist at Archaeological Services Inc., in Toronto. By cal-
culating the length of the fishing rod in the 1912 photograph, Lywood
could estimate the height of the woman. Height measurements were
also estimated through period fashion as well as head-to-body propor-
tions. While absolutely accurate measurements proved impossible, the
photographs known to be Winnie Trainor indicate a taller woman than
the one in the 1912 photograph.

"It is my opinion," Lywood concluded, "that the facial comparison
combined with the stature comparison does not offer strong support that
the unknown subject in [the 1912 photograph] is Winnie Trainor."

Even so, in *Tom Thomson: The Silence and the Storm*, co-author Harold
Town (David Silcox is the other author) used the false photograph to
rhapsodize on what Winnie might have been like: "A surprisingly formal
Winnie Trainor displays the bony angularity of Katharine Hepburn and

from the strain evident in the sinews of her arms appears to be having some trouble holding what can't be more than twelve pounds of fish. She is thin of mouth—might have had bad teeth—and projects a tension that has me believing the Thomson family accounts of her strangeness." Poor Winnie, blamed for a "strangeness" Town finds in the photograph of an unknown woman. Victoria Lywood was happily able to use the available photographs of the true Winnifred Trainor to do an artist's interpretation of how she would have looked that summer of 1917, when she was 32, Tom 39, and she was in love. She does not seem strange, but lovely, with soft eyes and a barely hidden smile of mischief.

But who, then, is this other woman? Given the other photographs on the rolls, it would seem reasonable to assume that it might be Edythe McRuer, the young wife of Thomson's doctor friend. Thomson, after all, had been best man at their wedding three years earlier. But extensive correspondence with the McRuer family—and considerable help from Patrick Boyer, James McRuer's biographer—produced photographs of a young Edythe that quickly ruled her out. Nor do the images appear to be of the McRuer brothers' sister Margaret, who did not marry for some years following the death of Tom Thomson and, therefore, would not have been wearing an engagement ring and wedding band.

So we do not know who this woman is—only that she is not Winnifred Trainor, the woman she has been said to be for more than forty years.

Annie Winnifred Trainor was born in Bracebridge, the next substantial community to the south of Huntsville, on March 18, 1885. She arrived the day after St. Patrick's Day and in the midst of an extreme freeze that had settled over Ontario. She was the first child of Margaret Jane Bradley of Milton, Ontario, and Hugh Trainor, who had been born on a farm in New York state and who had come to Canada at seventeen and found work in the lumber industry. Hugh and Margaret had married in Bracebridge in 1883, and Winnifred arrived on her mother's twenty-seventh birthday.

When Winnie was two years old, her father landed a good job with a growing timber operation to the north, and the little family relocated to Huntsville. Hugh became a walking foreman for the fledgling business—which soon renamed itself Huntsville Lumber Company—overseeing much of its pine-cutting operations. He organized the winter cuts, when trees were felled deep in the various timber rights and the logs then drawn by horse team to depots near the Big East and Oxtongue rivers. From there they would be stacked until breakup and the beginning of the spring log drives.

The Trainors had arrived in a bush community where most of the early settlers had built on the surrounding hills rather than on the flat, more arable land along the river that ran between Vernon and Fairy lakes. This was because the town's founder, Captain George Hunt, had insisted on a temperance clause in the deeds he was offering on the better land, while Allan Shay, who owned much of the higher ground, asked only for cash for his rougher and rockier lots. Hunt was so determined to establish a proper Christian community that he insisted his ban on alcohol remain in effect not only for his lifetime, but for twenty years and ten months after the last grandchild of Queen Victoria had also died.

It's no surprise that Hunt eventually had to drop his restrictive clause and the development of Huntsville gradually crept onto the lands that might otherwise have been settled first. Still, deep Christian principles and temperance leanings would profoundly affect the town where Winnie was growing up. One of the first tasks of the first council—apart from banning the firing of guns in the village—was to pass Bylaw 4 concerning the "Preservation of Public Morals." Its eight subsections dealt with everything from the public utterance of obscenities or blasphemies to renting out a room to "persons of bad character." The final provision was that "no person shall indecently expose his or her person by bathing or washing near any public highway between the hours of seven o'clock in the morning and eight o'clock in the evening."

What a very young Winnifred Trainor thought of her town as she grew up is not known. Her mother was a strict churchgoer and a member

of the Women's Christian Temperance Union (WCTU), so it is fair to conclude that Winnie would have been as conservative and judgmental as most other inhabitants of the town. But we can only presume that this would be the case. If she left a personal diary or cache of letters behind—and I don't recall seeing them when I helped to clear out her house and cottage—none of these found their way to the town museum following her death in 1962, though some of her clothes and a few photographs were donated. And Marie, her only sister, has left us no sibling memories of a young Winnie. Unlike all the reminiscences of family, friends and acquaintances that followed Tom Thomson's death, there would be no later articles written by anyone who grew up with Winnifred to tell us how she wore her hair as a girl, what songs she sang, whether she played with dolls or, for that matter, what her dreams were for the future. All we know for sure is that she could not possibly have wished for what was to come her way later in life.

Shortly after Winnie turned nine, her little village all but burned to the ground when fire broke out on April 18, 1894, back of Harry May's hardware store on Main Street. One of May's hired boys had been clearing winter debris and ill-advisedly set a bonfire to clear up the mess. The wind came up, sending flames into the storage shed, where a new shipment of forty-gallon barrels of coal oil had been stored only days earlier. The oil exploded and fire roared into the wood-frame buildings that lined the street. Another merchant, George Hutcheson, moved his goods out to the lake steamer *Excelsior*, which was tied up at the dock directly behind Hutcheson & Sons, but this seemingly sensible action only exacerbated the disaster when flaming oil ran down through the ditches to the river and ignited the boat. In less than three hours, thirty-two buildings and the *Excelsior* were lost to flames.

The insurance covered less than half the estimated $110,000 in damages, but the town quickly rebuilt, this time mostly in brick, and Huntsville's now-considered-charming Main Street dates from this reconstruction. It was a time of relative prosperity, with the new railway transporting whatever timber the mills along the river could produce.

North Muskoka was renowned for its variety of wood: cedar and an array of pines and spruce from the lowlands; hardwoods—maple, oak, ash, beech—from the hills; birch and poplar from everywhere. A few sparse stands of magnificent white pine were still being logged, and even the lowly hemlock was being felled for siding planks and its bark, which was hammered into a "liquor" used to tan leather. The ready availability of hemlock bark led to a tannery being built on the lower side of town, where Hunter's Bay narrowed into the first stretch of the Muskoka River. By the turn of the coming century, the Anglo-Canadian Leather Company would be the largest tannery in the British Empire to produce sole leather. Even into the 1950s, when I was growing up, the tannery was still a major force. We kids all had key chains with miniature leather soles attached—embossed with the words "Anglo Canadian Sole Leather." We carried those chains around, even though we had no keys to carry, as no one locked their doors.

The tannery soon closed, though, and, in June 1961, it burned to the ground after a workman doing maintenance started a fire with his blowtorch. The entire town came out to watch as the chemicals from the old vats sent flames like northern lights high above the collapsing walls. The tannery was now gone, just as most of the mills along the river had vanished, leaving behind a single plant that produced hardwood flooring. Forestry was no longer the economic force it had been. Muskoka's economy was now largely based on the tourism that—at the time the Trainors came to Huntsville—was just opening up thanks to the new railway and the lake steamers that carried visitors to the various local lodges.

Winnie Trainor would have walked to a new two-storey wood-frame school that had been erected on a knoll overlooking Hunter's Bay. Children living in the surrounding hills no longer had to walk the length of Main Street and cross a small bridge over the river to get to school. Her trip would have been short but interesting, with the town rebuilding from the fire and Main Street busy with buggies and wagons, workers and shoppers. In spring she would have kept as much as possible to the

wooden sidewalks, as the road itself was all but impassable: the runoff turned the route to muck so deep buggies would sometimes sink to their axles in the sucking mud.

The new school was much larger than the original log building where the town children had received instruction, but, still, students could attend only to the end of the elementary grades. In later years the school that Winnie attended became known as the "White School," when siding became the rage in rural communities. My own grade one was the last class to occupy the White School before it was closed.

In the first edition of the Huntsville *Forester* to appear after the fire—the paper having shut down for three weeks—nine-year-old "W. Trainor" is listed as standing first overall in sub-arithmetic, with 82 per cent. A week later she stood first in spelling, with 95 per cent. She is listed with youngsters named Wattson and Scarlett and Kinton, all familiar names from the storefronts along Main Street. Following a rare and heavy snowfall at the end of May that year, the school was struck with the grippe, and Winnie was identified as one of the children too sick to attend.

All Saints' Anglican Church on the banks of the Muskoka River just downstream from the bridge would have played as significant a role as the school in her young life. The rector was the Rev. Thomas Llwyd, a stern man whose white-bearded visage seemed carved out of one of Moses' tablets. On the inside, however, he was hardly made of stone. He suffered a nervous breakdown from worrying about his wooden church catching fire (it didn't) and then collapsed again from the stress of building—at a cost of $6,196.73—the magnificent stone church that still stands today. Nonetheless, so formidable a force was the stern "Dr." Llwyd that the village lowered its flags to half-staff when he passed away in the summer of 1903.

Huntsville was typical of small Ontario towns in that it held several Protestant churches and a single Roman Catholic church, with a guaranteed rift between the two Christian forces. When Winnie was eleven years old, renowned Catholic-baiter Margaret L. Shepherd came to Huntsville to speak of a long-suspected Catholic plan to rise up and

massacre Protestants using weapons said to be hidden in the basements of Catholic churches. With rumours about that Shepherd would be arrested the moment she set foot in town, tickets sold out quickly, at a stiff fifteen cents a head. She claimed to be the daughter of an English nobleman and said her intimate knowledge of the Catholic mind came from her once studying to become a nun. Following an opening prayer, she laid out the diabolical plot to kill Protestants. A few weeks after she left town, news came that Margaret L. Shepherd, a.k.a. Margaret Herbert, a.k.a. Margaret Riordin, had previously been a prostitute in England and had served time in Bristol's Roman Catholic prison, where it was said she picked up an impressive knowledge of Catholic ritual.

Winnie's mother was active in the Anglican Church and was soon elected to the executive of the local Women's Christian Temperance Union, which in those days banned Catholic women from membership. Despite the town founder's failure to uphold an alcohol ban, the WCTU was a powerful force in Huntsville. The women's organization had its beginnings in Ohio in the 1850s and found great support in small-town Ontario. Members often wore a white ribbon on their dresses to signify "purity," and they would recite a poem about the ribbon that included the well-known line "Pure and unsullied as new driven snow." The organization reached far beyond mere temperance when it came to alcohol. It was against smoking and all for social purity, even establishing its own Department of Purity in Literature, Art and Fashion. The WCTU was most adamant that a family meant a married man and woman—"a white life for two," the WCTU called it—and maintained that "Every child has the right to be well-born." That meant not born to parents who drank, who smoked or who were socially impure and most assuredly not to parents not married in a Christian (preferably Protestant) church. Being born illegitimately—to a woman who could produce no husband— was unforgivable. Being an unwed mother was about as far as one could fall in a community like Huntsville in those early years.

And the sanctimony extended beyond the churches and the WCTU. On January 14, 1909, the Huntsville *Forester* reported that Fairy Lake

had frozen over solid and was clear of snow. Skaters could go all the way to the far end of the lake and back. Yet instead of celebrating this magical fluke of nature, the paper harshly pointed out that it had happened on a Sunday and had therefore "nullified a proper respect for the one day in seven which we are exhorted to spend in restful meditation . . . The example of adults indulging in such an open violation of the Sabbath will have a disastrous effect upon the younger generation."

Though Winnie's school records suggested that she was bright (and particularly with numbers and spelling), she had her academic weaknesses. Worst among them, ironically, was art instruction. In drawing class she could barely manage a 52 and later failed completely. Irene May, a friend of Winnie when Tom and Winnie were courting, told an interviewer years after the painter's death that "Tom could see beauty in the old shoe left on the side of the road. That is one thing . . . I will never understand, as Winnie could never see beauty anywhere. She and Tom were miles apart in this respect."

As Winnie moved up through the grades, her interest in her studies seemed to fade. Her early high marks in grammar soon plummeted to 50. Though she continued to be promoted, her marks slid to bare passes, even in the courses in which she had previously excelled. It is difficult to know what to make of this. As she was invariably described in her later years as "sharp" and "quick," it's unlikely that the marks reflect any dullness of mind; they're more likely to do with the dullness of the classes.

In the summer of 1897, when she would have been twelve, Winnie's name ceases to appear in the school listings. But there's evidence in the archives of the Muskoka Heritage Centre that Winnie's schooling in Huntsville continued at least until the turn of the century, when she turned fifteen. In a box containing a number of items that my cousin and I helped clear out from Winnie's home in the summer of 1963, there's a Primrose Exercise Book signed by Winnie and dated March 5, 1900. The box also holds handwritten notes on Canadian history, from earliest settlement to the 1885 Northwest Rebellion.

And there's a receipt showing that Winnie and Marie Trainor subscribed to the *Little Learners Paper*, indicating the high stock the Trainors put in knowledge.

Winnie's world, around the turn of the twentieth century, was one of ever-present danger. Accidents were common in the mills of Huntsville and area, the violence often harrowing. When a young worker, Robert Brady, died, the newspaper reported that he had been hoisting logs with a block and hook when he fell into the saw. The young man was sliced so quickly, his head, left shoulder and breast fell off to one side and the rest of his body to the other as he was "instantly ushered into eternity."

The Trainors had their own scare in the early spring of 1898 when Winnie's father, Hugh, was crossing Cripple Lake with fellow Huntsville Lumber Company worker John Ellis. The ice had formed but had not set hard enough, and both broke through in deep water. Fortunately, each was carrying a pike pole—a long pole with a sharp point and a hook at the same end, used for dislodging jammed logs—and Hugh Trainor used his to work his way through the ice until he found footing and pulled himself free. Ellis was not so lucky. In freezing temperatures, Winnie's father walked through deep snow to the nearby camp, and the loggers hurried back with a punt. They found Ellis's pike pole pointing straight up, and when they pulled on it, the man's body also rose from the bottom, his right hand frozen tightly around the pole.

As Winnie entered her teen years, Huntsville was changing. A vote on prohibition passed, which would have pleased Captain Hunt, but outraged the ever-increasing number of families who had been recruited from poor villages in Italy to work in the tannery and had brought with them a European custom of wine with the evening meal. Meanwhile, the tannery workers, both Italian and non-Italian, grew so disenchanted with their new, somewhat tyrannical owner, C.O. Shaw, that they went on strike, but they buckled after a week without wages and grudgingly went back to work. Shaw finally won back a portion of their

favour by starting up a small band of mostly Italian-Canadian musicians that, over the years, gained considerable notoriety as the Anglo-Canadian Concert Band, under the direction of Herbert L. Clarke, who had once played under the baton of the famous American conductor John Philip Sousa.

A window onto the world outside was finally opening. The band played at the Canadian National Exhibition and was part of the first big band radio broadcast when Toronto's CFRB aired a live concert by Clarke and his charges. Telegraphs and newspapers brought north on the daily trains carried news of the progress of the conflict in South Africa, commonly known as the Boer War. Huntsville held parades in support of the war effort, with schoolchildren singing "Rule, Britannia!" to celebrate the relief of the besieged town of Ladysmith. Huntsville was, of course, staunchly in support of all things British. When the *Toronto Daily Star* dared suggest that Huntsville might be a good destination for refugees from the conflict, as the town was known to be actively seeking new residents to take up jobs at the tannery and mills, the *Forester* shot back: "Boers ought to thrive in a good stock-raising country like Muskoka, but we have made a bid for a higher and more human class of settlers, and we are getting them."

Winnie was sixteen when Queen Victoria died after sixty-four years on the British throne. Later that year, in the fall of 1901, the Duke and Duchess of Cornwall passed through on the Royal Train. Winnie would have been among the villagers gathering before dawn in anticipation of sighting the visiting nobility. First, a train carrying Sir Wilfrid Laurier and the Earl and Countess of Minto arrived at 8:22 a.m. (Lord Minto was then serving as governor general of Canada.) They were greeted by a cheering throng and four hundred schoolchildren waving small Union Jack flags.

Winnie's former classmate, Miss Cora Shay, also sixteen, was presented to Prime Minister Laurier. She stood only thirty inches tall and weighed a mere thirty-two pounds. The daughter of Allan Shay (who had sold the hill lots where most of the town had been built), Cora presented Laurier with a bouquet of flowers.

Twenty minutes later, the Royal Train blew its whistle as it approached the station. The ten-car, two-engine train—the last coach named "Cornwall"—hissed to a stop, and the mayor, Dr. J.W. Hart, was invited on board to meet the royal couple. When he emerged moments later with the duke—later to rule as George V—a huge cheer went up. Wearing a black serge suit and a dapper, fawn-coloured felt hat, the duke spoke briefly in a deep, distinctive voice to convey the best wishes of his father, King Edward VII, who was said to be ill but recovering. The schoolchildren then sang "The Maple Leaf Forever."

The duchess appeared briefly at the doorway just as the locomotive started up again. *"The Duchess! The Duchess!"* a man in the crowd shouted as he tossed his hat into the air. *"Hurrah! Hurrah!"*

The crowd then literally picked him up and rolled him, hatless, over their hands toward the startled duchess—later to be Queen Mary—who smiled and offered a quick royal wave before ducking behind the door of the departing train.

Cora Shay's moment in the spotlight launched a career. The following year she was off to a six-month engagement with Bostock's Show in South Bend, Indiana, where she was advertised as "a most interesting conversationalist"—as if someone so small should somehow not even be able to talk. She returned home but was soon off again, this time to the Gaskell & Mundy Carnival, where she appeared as "Doll Lady" in a thirty-week tour of the United States. She was moved about in her own Pullman car, the parlour furnished to scale, and it was here that she would greet and speak with those willing to pay the cost of admission to see her with their own astonished eyes. For the next three decades or so, Cora Shay was an international celebrity known as "Princess Coritta." She returned to Huntsville in 1928 in triumph, selling out the King George Theatre two nights running. She sang songs, recited her own poetry and held the crowds breathless as she told about her tours and meetings with royalty.

Nothing quite so exotic awaited Winnie, but she, too, was about to leave town on her own, much smaller-scale adventure. Unlike most of the young women she had grown up with, she intended to have her own

life, rather than merely hope for marriage and babies. Instead of going to work for one of the wealthier families in town as a housekeeper or cook, or remaining at home to care for her parents, as was so often the life chosen for one of a family's daughters, she pursued her own independence. With her parents' blessing, she set off for Lindsay, Ontario, and St. Joseph's Academy, a small school run by the Loretto Sisters, to study bookkeeping. It was, for its time, an unusual career choice—bookkeeping being largely the province of men—but she was good with numbers and highly organized, and she graduated from the academy with ease.

In the fall of 1903, the eighteen-year-old Winnie was hired on as the bookkeeper for the *Forester*. A year later she switched jobs to take on more responsibility, handling the accounts and general office management for Tudhope's grocery store on Main Street. She continued to live at home with her parents and her younger sister, Marie, who was finishing school and had her own ambitions to become a nurse. Neither of them planned on being the child-servant who would stay home to care for her parents for as long as they lived.

The Trainor girls had their own minds. They were outspoken and opinionated and often argued with each other. Their belief that they had rights as women might have flowed easily from their mother, Margaret, who was becoming more and more involved with the WCTU. At one point the women's organization held a "Mock Parliament," and Margaret, playing the role of the member of Parliament for Glengarry, took part in a debate on "The Enfranchisement of Men," drawing attention to the absurdity of the principle that allowed only men to vote because only men could be trusted to cast votes sensibly.

There's another photo of Winnie, taken during this time—very likely at Richard Sylvester's photography studio on Centre Street. Someone has written in pen over the photograph: "Miss Winnie Trainor Huntsville Ont. Picture Taken in the Early 1900s." She is tall and dark and is wearing a magnificent flowered hat (likely an Easter hat); a full, formal coat; and a mink stole. Her hands are in a muff, also of mink, done in the style that makes the pelts seem alive as they wrap themselves around her hands.

She has high cheekbones and a finely sculpted nose, and her dark, difficult, jet-black hair is folded back into a bun under that magnificent hat. She doesn't look particularly comfortable being so dressed up. There seems very little vanity about her and a fair bit of impatience. Her eyes are her most striking feature: she appears to be staring down the camera, hurrying the uncomfortable moment along.

By 1912, the year Tom Thomson first visited Algonquin Park, Hugh Trainor's job with the Huntsville Lumber Company was going well enough that he was able to purchase a little cottage on Canoe Lake. This body of water was easy to reach from Huntsville on the Grand Trunk Railway line, requiring only one change, at Scotia Junction, to the line that ran through the park toward Ottawa. Canoe Lake was approximately three kilometres long, running north and south, and about a kilometre and a half across at its widest point. It had jagged bays, sand beaches, granite outcroppings, a number of small creeks (Potter being the largest) and several islands around the narrows that formed its "waist." It connected by channels to two much smaller lakes: Joe to the north and Bonita to the south. Bonita connected to Tea Lake, which took its name from the steeped colour of the waters of all the Algonquin lakes. Canoe Lake was surrounded by low, rolling hills, with white pines periodically reaching high above the treeline as if standing sentinel over the postcard landscape.

The Trainor cabin had originally been built as a mini-headquarters for Algonquin Park rangers on the northwestern shore of Canoe Lake. But when roomier headquarters were established at Cache Lake, the ranger cabin, with its large kitchen, porch and boathouse was rented out. By the time the Trainors took it over, it was already known locally as the "Manse," a name it acquired after a Presbyterian minister and his family had stayed there one summer.

There had once been a village close to where the Manse stood. At its peak, Mowat—named after Oliver Mowat, a Father of Confederation

and later premier of Ontario—boasted a population of five hundred. The community had grown with the establishment of the Gilmour Lumber Company along the northwest shore of the lake in the 1890s, when David Gilmour, who fancied himself a bit of a visionary, gained the timber rights to the Oxtongue River watershed. That area stretched from the waters of Canoe Lake all the way to Lake of Bays. Gilmour's grand plan—breathtaking in its scope, even if it would prove too ambitious— was to float timber cut around Canoe Lake some 400 kilometres to his mill at Trenton on the shore of Lake Ontario's Bay of Quinte. It involved building a series of dams and constructing complicated steam-engine-driven tramways. Although he did complete the project, it was of no use in the end, since, by the time the wood reached its destination, rot had already set in.

Gilmour's solution was to build a new mill right at Canoe Lake. By 1897 the mill was operational and so many workers were living in the area that the village of Mowat sprang up, with its own school and even a tiny cemetery on the hillside overlooking the lake. Gilmour unfortunately went bankrupt trying to pay the bills he'd incurred for his grand scheme. The mill shut down, the spur lines were taken up and Mowat largely vanished, though some of the buildings became summer cottages.

By the early 1900s it had become very fashionable in Ontario to have a summer place by the lake—even for those of limited means, as the Trainors were. Those who did not seek out shoreline property often preferred the comfort of lodges; it was a time of phenomenal resort growth in nearby Muskoka. Trains left Toronto's Union Station packed with well-heeled tourists, many of them American, heading for Gravenhurst, Bracebridge or Huntsville, where they could board steamers bound for their final destinations. By 1910 Muskoka boasted more than a hundred establishments, from the grandest hotels to simple boarding houses.

Algonquin Park was hardly as overrun, but it did have one spectacular showplace: The Highland Inn at Cache Lake. In a 1912 Canadian Pacific Railway poster advertising three great Canadian hotels, the inn was given equal billing to Ottawa's Château Laurier and Winnipeg's Fort

Garry. Rates at The Highland Inn ran from $2.50 to $3 a day or $16 to $18 a week. Today, it costs that much just to enter the park with the intention of stopping somewhere along Highway 60 to hike a trail.

Far more rustic, and less expensive, lodgings were to be had at Canoe Lake, where Shannon Fraser, who had been hired to dismantle the old mill machinery, had decided to stay on with his wife, Annie, and their young daughter, Mildred. The Frasers were converting the largest Gilmour building into Mowat Camp, which they expanded in 1913, changing its name to Mowat Lodge. It was here that Tom Thomson stayed when he returned to Canoe Lake that year for his second visit to the area. The Frasers—red-haired, freckled Shannon, with the broad hands of a ploughman, and dark, stubby and kindly Annie—would become familiar figures in Thomson's life. Throughout his remaining years, he made Mowat Lodge his base of operations whenever he was at Canoe Lake.

Tom and Winnie first met in 1913, according to a letter Winnie sent to the Thomson family following the painter's death. He would have been almost thirty-six and she, twenty-eight. It was well known by all who saw them together in the years thereafter at Canoe Lake and in Huntsville that there was something significant between the painter and the local girl—though certain members of the Thomson family later downplayed the notion.

A rare photo of Winnie at this time shows her standing outdoors in the sunlight with her young Huntsville friend, Irene May. Both are dressed similarly—in black leather boots; long, dark skirts; and white, long-sleeved blouses, and they're carrying wide-brimmed straw hats. The photo appears to have been taken in Huntsville, as they're standing in front of a stone wall, and in the distance over the water, some buildings can be made out. Winnie is tall, with long, elegant arms and a thin waist. Her posture is impeccable, confident. Her hair has been carefully pinned and positioned but still flares in places where it has sprung free of its restraints. She squints somewhat in the sunlight, but her face is friendly and inviting. Heads would have turned at her passing.

Dr. Robert P. Little, a former guide and longtime camper in Algonquin Park, wrote down some reminiscences in 1955, saying that he passed several times through Canoe Lake and remembered the small cottage owned by the Trainor family. Little dismissed the common notion that Tom Thomson was too wrapped up in his work to bother with women. "Tom did have a girl friend," Little wrote, "—the comely Winifred Trainor. They were frequently seen together, and Tom would go to Huntsville to visit her."

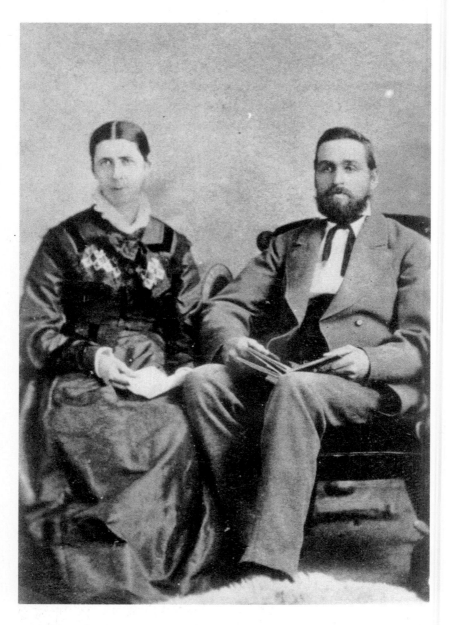

Tom Thomson's parents, John and Margaret Thomson, at Rose Hill farm, Leith, Ont.

The Thomson brothers—Tom, Ralph, George, Henry, with Tom Harkness.
Another brother, James, died in childhood.

As a teenager,
Tom Thomson was said
to be athletic and taken
with the outdoors
and nature.

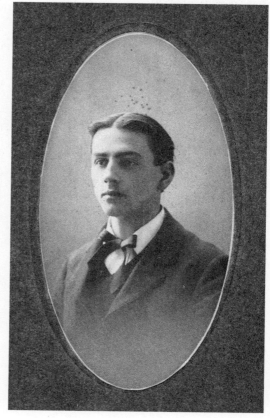

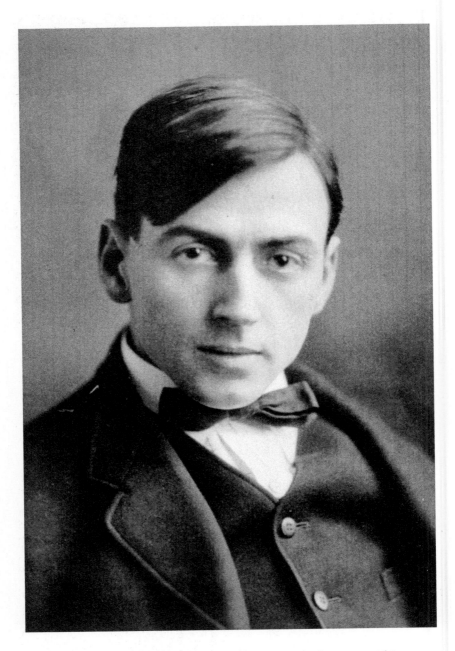

Young Tom Thomson had trouble finding his way, little interested in school or his first choice of career, training as a machinist with a propeller manufacturer.

Two of Algonquin Park's greatest characters: Jimmy and Wam Stringer of Potter Creek, Canoe Lake. Photograph taken circa 1960.

Chief Ranger Tom McCormick, the author's grandfather, at Lake of Two Rivers in the early 1950s. McCormick's brother, Roy, married Marie Trainor, Winnie's younger sister. He knew and disapproved of Tom Thomson.

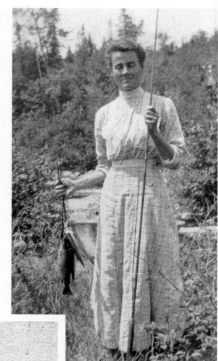

Tom Thomson photograph of a woman long identified as Miss Winnifred Trainor of Huntsville, Ontario, and Canoe Lake, Algonquin Park. It's not her.

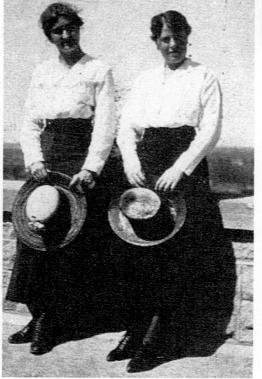

The real Winnie Trainor and her Huntsville friend Irene Ewing, circa 1915, photograph source unknown.

Winnie Trainor (identified with "x") at the St. Joseph's Academy, Lindsay, Ont., which she attended around age 17.

Photograph of Winnie taken in the early 1900s, likely at Richard Sylvester's photography studio directly across Centre Street from her family home in Huntsville.

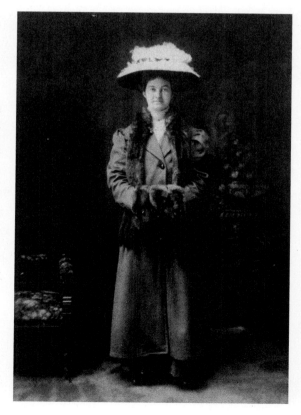

Tom Thomson's *Figure of a Lady, Laura*. The Thomson family has always believed this is Winnifred Trainor, painted on hill overlooking Canoe Lake. Previously said to have been painted in 1916, it is now dated as fall of 1915.

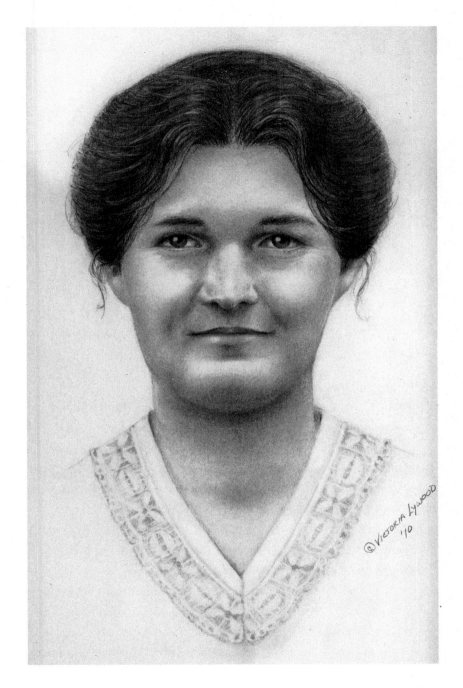

Winnie circa 1917, age 32, portrait by internationally recognized forensic artist Victoria Lywood.

THREE THE NORTH COUNTRY

During the winter of 1912–1913, Tom Thomson turned one of the small sketches from his first northern travels into a large canvas and called it *Northern Lake*. The painting was accepted for display at the Forty-first Ontario Society of Artists Exhibition, and, much to his surprise, it was purchased by the provincial Department of Education for the impressive sum of $250. Elated, Thomson took the cheque to the bank and cashed it in for 250 one-dollar bills, then hauled the bills back to the studio, where, in the presence of MacDonald and others, he tossed them in the air while dancing a jig of celebration.

At the time, the small group of friends was beginning to believe they might be able to become full-time painters. In fact, most of the illustrators at Rous and Mann Ltd., where workers such as Thomson were being paid seventy-five cents an hour, had the same ambition. They had the advantage of knowing J.E.H. MacDonald, who was a member of the prestigious Arts & Letters Club of Toronto. In the fall of 1911, MacDonald had succeeded in mounting a small exhibition there, featuring landscape paintings

from the Toronto and Lake Scugog areas. A few of the works were sketches by Tom Thomson, though at this point, he didn't really consider himself a painter. In fact, it was not until he set off to see the North Country in 1912 that he even allowed himself the small conceit of a new sketchbox.

It was through the Arts & Letters Club that MacDonald became friends with Lawren Harris, who would several years later join MacDonald in forming the Group of Seven. Harris, the scion of one of the country's wealthiest families (owners of the Massey-Harris farm machinery concern), was himself determined to be a painter of standing. He was also a philosopher, passionate about his view that Canada should foster its own remarkable identity—apart from mother Britain or neighbour America. And he was convinced that this distinctive identity was to be found in the North Country, far away from the buildings and roads and farms of settled Canada. Thomson, who was not given to philosophizing himself, would have heartily agreed.

Harris paved the way for MacDonald and others to meet Dr. James MacCallum, a Toronto ophthalmologist who would eventually become a great champion and patron of MacDonald, Lismer, Thomson and others. In a booklet prepared by the National Gallery in 1990, concerning murals once owned by MacCallum that the gallery had acquired, MacCallum is described as rather eccentric, a caustic nonconformist who loved sailing and canoes, as well as Chinese theatre and the opera. A 1917 portrait of the man by A. Curtis Williamson shows an arrogant-looking dandy wearing a fedora to cover his balding pate. MacCallum sports a waxed, Simon Legree moustache that gives him a rather diabolical look. The title is *Portrait of Dr. J.M. MacCallum* ("*A Cynic*"). MacCallum, however, was vitally important to Thomson during his life—and, it may well be argued, played an even more significant part in Thomson's afterlife, carefully nurturing the painter's legacy.

Born in Richmond Hill, just north of Toronto, in 1860, James MacCallum was seventeen years older than Thomson. His father had been a Methodist minister posted to the Georgian Bay area in the late nineteenth century—in the same general region as the Thomson family

farm. And young James, like young Tom, had become infatuated with the rugged landscapes and vast choice of outdoor activities in the area. He was a brilliant student, pursuing his higher education in London, England, and after he'd acquired his medical degree, he lectured in pharmacology and held the chair in ophthalmology at the University of Toronto for twenty years.

MacCallum was an early nationalist in a colony that flew the Union Jack, sang "God Save the Queen" (then "King" after 1901, when Victoria died) and, only a decade earlier, had re-elected Sir John A. Macdonald largely on the basis of a campaign speech in which he'd declared: "A British subject I was born and a British subject I will die." Five years after Macdonald's final campaign, and his death later that same year, a group of University of Toronto professors, all budding Canadian nationalists, founded the Madawaska Club at the mouth of Go Home River, where it empties into Georgian Bay. Their goal was to have a "wilderness" place with easy access—train to Penetanguishene, steamer to the camp—that would allow their various families to bring up "young men inspired with the Canadian affection for pioneering and the Canadian love of forest and stream." MacCallum joined two summers later, the year they built their clubhouse, and so liked the area that in 1905 he purchased Island 158 out in Go Home Bay, a mass of rock and pine that he would later rename West Wind Island.

Harris often visited MacCallum at his island retreat, and it was Harris who invited MacCallum, in the late fall of 1911, to attend the exhibition of sketches MacDonald was showing at the Arts & Letters Club in Toronto. To that point, the prosperous eye doctor had shown little interest in art, but it may be that something in those country landscapes appealed to his patriotism. Or perhaps his interest was piqued a month later when another club member, C.W. Jefferys, published a commentary on MacDonald's work in which he said: "In these sketches there is a refreshing absence of Europe, or anything else, save Canada."

Suddenly keen on Canadian art, MacCallum invited MacDonald and his family to Go Home Bay during the summer of 1912, along with

Lawren Harris. During those summer days, MacCallum and Harris pressed MacDonald to take up painting full time and leave behind his paid job as an illustrator. MacDonald, English-born, highly conservative and dedicated to his family duties, demurred, but the two continued to press him, and, with MacCallum offering to purchase his paintings and to grant him interest-free loans, MacDonald finally agreed. It was the beginning of James MacCallum's remarkable career as an art patron— the man who, as much as anyone else, created the Group of Seven, even though he was neither artist nor member.

MacCallum first met Tom Thomson when he was visiting MacDonald at his Toronto studio. He found the "tall and slim, clean cut, dark young chap" to be a man of few words, yet determined and independent, and he asked MacDonald to get him some of Thomson's sketches so he might see what sort of artist he was. MacCallum was entranced with the small paintings: "They made me feel that the North had gripped Thomson as it had gripped me when as a boy of eleven, I first sailed and paddled through its silent places."

MacCallum's importance to this fledgling group of Ontario artists cannot be underestimated—corroborating even MacCallum's own vain, self-serving claims. He was generous with his money, often staking struggling artists for months while they painted. His retreat at Go Home Bay was always open as a refuge for the artists, and often their families, who stayed there as his invited guests. A.Y. Jackson claimed it was MacCallum who kept the group together and in Canada, and that claim is reinforced by Jackson's account of a conversation MacCallum had with him about his own intention to head south to pursue a painting career.

"If all you young fellows go off to the States, art in Canada is never going to get anywhere," MacCallum protested.

Instead, MacCallum said, Jackson could have a place in a studio MacCallum and Harris were going to build in Toronto near the Rosedale Ravine. MacCallum not only promised that, but also guaranteed to cover Jackson's expenses for a year of painting. Jackson accepted—and stayed in Canada.

MacCallum also told Thomson he would stake him. Though the young artist was grateful for MacCallum's patronage, he wanted it to come in the form of helping him sell his work. Thomson remained fiercely independent, and some of his fellow painters felt that while he often benefited from his association with MacCallum, the relationship was sometimes strained. Thomson was never entirely comfortable visiting the MacCallums at Go Home Bay, as he felt more "owned" than welcomed there. He once wrote a friend to say that MacCallum's retreat was "getting too much like north Rosedale to suit me—all birthday cakes and water ice etc."

The money he earned from the sale of *Northern Lake* was his own, and the cash—once he'd gathered up the 250 one-dollar bills from the floor—gave him the courage to ask for a leave of absence from his seventy-five-cents-an-hour job at Rous and Mann. The leave was granted. He was now a painter. And he was headed once again for Algonquin Park.

That year, 1913, marked the twentieth anniversary of Algonquin Park, which had been founded in 1893 as the largest "national" wilderness reserve in Canada. "National" jurisdiction was soon after changed to "provincial." "Wilderness reserve" was a bit of a stretch—at least in those parts of the park reachable by train and increasingly populated by campers, cottagers and lodge visitors. Timber rights were also being granted throughout the reserve, so dozens of mills were being built from the Madawaska Valley to the Muskoka Lakes, with several appearing inside the park boundaries.

The two key players in the establishment of the park—James Dickson of the Ontario Land Surveyors and Alexander Kirkwood, chief clerk in the land sales division of the Department of Crown Lands—prided themselves on being "practical" men. Dickson saw no need to curtail the logging that had been going on for decades, and Kirkwood even envisioned a day in which the broader area of the park and surrounding communities might sustain a population of "a million or more people" engaged in

everything from farming to forestry. Today, there are not even that many summer visitors, and far fewer live in Algonquin Park proper than during the years Tom Thomson spent at Canoe Lake.

In the early days government officials were so unsure of what the park should be that they sent one James Wilson north to make suggestions. He was head of Niagara Falls' very tame Queen Victoria Park and, perhaps in keeping with his station, quickly recommended the eradication of the common loon—now a commonly recognized symbol of the Canadian wilderness—on the grounds that the bird was consuming the fish that would attract American sportsmen. The park's first superintendent made a similar recommendation—that all bears and fox "be destroyed without mercy" so that people would have no fear of coming to the park. George Bartlett, the walrus-moustached bureaucrat who became superintendent in 1899, felt the same way about wolves and encouraged early rangers to shoot them on sight and leave poison out for them. (Today, the "wolf howl" is the most popular tourist attraction the park has to offer.)

Always, the push was on to attract visitors. The royal commission that had led to the establishment of the park had specifically tagged Algonquin as "A Place of Health Resort." It was believed the park could serve as a natural "sanitarium," and it was hoped that the well-off who were being advised by their doctors to take leave would find the northern Ontario air "more pure and more invigorating than in either Europe or the States." The Ontario Board of Health sent a staff doctor to check out possible sanitarium sites at Canoe and Cache lakes, and he reported that he had found proof of an Algonquin cure for consumption in a railway engineer whose lungs were so affected that doctors had declared his case hopeless. "Now," the doctor reported, "he is hale and hearty and can travel by canoe all day, with his clothes wet half the time, without feeling any ill effects."

It was an era of "muscular Christianity," when "roughing it" was widely considered one of the great "manly virtues." The Owen Sound newspaper report of Thomson's 1912 trek to the Temagami region

reflected this popular sentiment. Ernest Thompson Seton—the young naturalist who had been with Tom Thomson's cousin Willie Brodie when he drowned on the Assiniboine River—had become a hugely popular writer with the 1898 publication of *Wild Animals I Have Known*, and Seton often visited Algonquin. In later years he even had his own cabin at Taylor Statten Camps. Seton, whose unruly hair and sagging moustache gave him the look of a young Einstein, was a most peculiar person, who had reacted badly to criticism that his books were overly sentimental and naïve. His readers did not know that he was a tortured soul who slept on boards and splashed his private parts with ice-cold water to prevent nocturnal emissions—or that he turned cross-eyed from stress when he actually found himself in the deep bush. They knew only what he preached: that living in the wild was the secret to mental and spiritual happiness. It was Seton's Woodcraft Indians movement that inspired Lord Baden-Powell to found the scouting movement, and the two of them, Seton and Baden-Powell, turned camping (which had been done largely by necessity) into a popular wilderness phenomenon. Algonquin Park could not have come along at a more fortuitous time.

Tourists came in by rail and stayed in lodges such as the Highland Inn on Cache Lake and the Algonquin Hotel on Joe Lake. Grand Trunk brochures of the time called the line through the park "The Highway to Health and Happiness." And though postcards sent home from the area often spoke of "roughing it," most visitors arrived and left quite comfortably by rail. Guests of the more luxurious lodges went on catered picnics and leisurely cruises on boats with outboard engines. They "dressed" for dinner.

But there were many, and Tom Thomson was one of them, who truly wished to "rough it," setting out with nothing but tent, pack, cooking utensils, an axe, a canoe, paddles and fishing gear. Tom clearly preferred the sanctuary of his bush life to any bustle around a busy lodge.

As soon as travel was possible in the spring, Tom would head for Canoe Lake, planning to arrive early enough to hear the rumblings and

moanings of the dying ice. Like everyone else, he marvelled at how quickly it broke up when the moment arrived. It was almost as if the ice sank.

On his way to and from Algonquin Park, Tom got into the habit of stopping off in Huntsville to visit his old friend Dr. John McRuer and, from 1913 on, his new friend Winnifred Trainor. That year McRuer had been diagnosed with an advanced case of tuberculosis, and he and Edythe left for Denver where he hoped to establish a new practice and perhaps find a cure in the mountain air. Tom continued to drop in regularly on the Trainors.

By 1913 the Trainors had fixed up the Manse to suit their own tastes. As the cottage was barely a stone's throw from Mowat Lodge, where Tom stayed, they most likely first met the artist at the lake that spring. While others around the area might have resented Tom for his seemingly idle ways, the Trainors obviously embraced him, as he was soon offered use of their cabin whenever they were not there. It gave him a good place, away from the lodge, to store and dry his art. Perhaps Hugh and Margaret Trainor were hoping for something to come of putting Winnie and Tom together. Their elder daughter, after all, was nearly thirty—well past the normal age for marriage.

There were cards and dances and music at Canoe Lake. The owners of Mowat Lodge, Shannon and Annie Fraser, were happy to have entertainment in their small "lobby," and the larger Algonquin Hotel on Joe Lake was busy and welcoming to visitors from around the lakes, as well as its own guests. Winnie and Marie were often out and about, and they were popular. Tom frequently canoed from his favourite campsite near Hayhurst Point across the lake to the Trainor cabin, where he hoped to arrive in time for a meal and was said to happily help with the dishes.

Tom and Winnie were soon considered a couple in town, as well as at the lake. The Sylvesters, who owned the photo studio in Huntsville and lived across the street from the Trainor place there, had vivid memories of Tom visiting the Trainors. So did their daughter Addie, who would join the Bell Telephone Company in 1922 and serve as the town's night operator from 1939 to 1960, when dial telephones were introduced.

"I met him when I was about ten," Addie told me in 1973. "Mrs. Trainor introduced me and made me shake hands with him, treated me like I was somebody. He was very handsome. Isn't it funny how I can remember him but couldn't tell you about other men I met at the time?"

Winnie was sort of an "older sister" to little Addie. She would sometimes take her young neighbour along to her work at Tudhope's store and let Addie draw while Winnie did the bookkeeping and ordering. As the grocer had one of the mere handful of telephones in town at the time, Winnie would sometimes ring up Wardell's, a fabric and general store farther down the same side of Main Street nearer the river, and let Addie speak to her older brother, who was clerking there.

"She was very clever," Addie said. "She was well educated. She could have really made something of herself if she had wanted to. She was a whiz with numbers."

For Addie Sylvester, there was never any question about Tom and Winnie being in love. "People around here generally did understand that they were to be married," she recalled. "I was a bit young at the time, but I knew he was her boyfriend. He must have felt something for her—*he came there enough.*"

But her most vivid Thomson memory is of a painting he did of the Sylvester home: ""It wasn't much to look at. Just an old brown-coloured building, nothing that you'd think was nice for a painting. He must have been just sitting at the [Trainors' dining room] window, and I think it was toward late afternoon when the sun shines here. And it was shining off the icicles and you could see it shining off the 'mountain' back behind the house. He was just sitting there and I suppose he had nothing to do, so he just painted the house.

"But, you know, you could look at that picture in the middle of summer and it would make you shiver."

That painting, if it still exists, has never been displayed. But it evoked the season when Tom would increasingly first head north, when temperatures were still freezing. In the spring of 1913, he saw the ice go out at Canoe Lake, sketched for a few weeks and then headed farther

north, to the Timmins area, where he worked a stint as a fire ranger. By midsummer, however, he was back at Canoe Lake and determined to paint through the autumn, capturing the spectacular fall colours of the park. He took a room in the two-storey clapboard building the Frasers had renovated to create their lodge.

Thomson found he didn't need much money. His painting was bringing in some, but he no longer hung onto his regular work as a commercial artist. Temporary jobs, such as the fire ranger work, helped and, of course, he had MacCallum's constant offer of financial aid. His expenses included taking a room while he wintered and painted in Toronto, his travel back and forth from the North Country and whatever it cost him to live around Canoe Lake. That was relatively cheap— eggs were 25 cents a dozen, beef 14 cents a pound and a steel fishing rod cost $1.25—and there was always the prospect of picking up a few extra dollars guiding guests from the lodges.

Ralph Bice, a lifelong trapper who lived at Kearney on the rail line heading west of Algonquin, came to work in the park in 1914, when he was fourteen. He became a legendary park guide and always claimed that Thomson's vaunted reputation as a guide was a pure invention of the painter's Toronto friends. Bice once told park historian Don Beauprie that Thomson "was not very proficient in a canoe, was not a licensed guide and liked the bottle too much." Bice, who with his wife, Edna, had been good friends of Winnie Trainor during the years after Thomson's death, also said that it was common knowledge that Tom had another girlfriend, in the Kearney area. But Bice, a churchgoing man known for his high moral values, would not name the woman for fear of damaging her family name. "The reason that he didn't marry," Bice revealed, "was that the lady in question wouldn't marry him unless he gave up drinking." But that is all the upright guide would say about that connection. He maintained, though, that the painter had several young women around the park convinced that he was going to marry them.

The Trainor family must have been oblivious to any such reputation. While Ralph Bice and my grandfather's brother, Tom McCormick, both

teetotalers, dismissed Tom as a "drunk," that seems a harsh judgment of someone who merely enjoyed a drink, as Hugh Trainor was also known to do. The Trainors would not, of course, have approved of Thomson's reputation, as Bice put it, as a "philanderer," but such a reputation was surely exaggerated—women all over the place thinking they were engaged to him. Around the Trainors, Thomson was always well behaved. Otherwise, he would never have had an open invitation to dinner whenever he was in town or at the lake, and they would not have given him open access to their cabin when they were not there. They saw him first as a suitor to Winnie, then as a potential son-in-law, of whom they obviously approved. To them, he was a good man, a fine painter and, like Hugh Trainor himself, comfortable and skilled in the wild.

The records show that Thomson did, in fact, once hold a guiding licence. He paid one dollar for it in 1917. In previous years, including that first long stretch at Canoe Lake in 1913, he might well have done some under-the-table work as a guide, but likely very little. When Thomson fished, it was usually for himself and by himself, except when a new friend such as Ranger Mark Robinson might join him.

Mark Robinson was the first person Thomson met, at the train station, when he arrived at Canoe Lake. Robinson manned the Joe Lake ranger station, which was only a short walk down the tracks from the Canoe Lake station. The ramrod-straight, moustached Robinson—who despite his military background rarely wore his formal ranger uniform— was a popular and much-admired figure in Algonquin. Though Robinson missed much of Thomson's time in the park—he enlisted to fight in the First World War at age forty-nine and went overseas, where he was wounded—he was at the park when Tom first arrived and led the search when Tom vanished. They were good friends, and Robinson's daily journals and later taped remembrances—the latter often contradicting the former—would become the main source for all future studies of Thomson.

Robinson recalled meeting a "tall fine-looking man" carrying a packsack at the Canoe Lake station. They introduced themselves to

each other, and Mark recommended that Tom take a room at Mowat Lodge. Robinson even introduced Thomson to Shannon, who also happened to be at the station with his horse cart. Shannon said he "might" be able to find a room for Thomson, but when Robinson piped up that the lodge had only two guests, off the two men went in Fraser's cart. Robinson said his initial encounter took place in 1912, but it would actually have been 1913, when Thomson returned to Canoe Lake alone after having first visited in the spring of 1912 with his friend Ben Jackson. Also, Mowat Lodge came into existence in 1913.

Robinson recalled that he was approached by the railroad section foreman two days after Thomson's arrival. "Look, Mark," the man said, "if I was you I'd keep my eye on that chap that came in the other night."

"Why, is there anything strange about him?"

"Well, he had three sticks stuck up, and a bit of a board on it and he was dabbing bits of paint on. I don't know what he was doing, but he's worth watching anyway."

"Well," Robinson asked, "is he an artist?"

"A what?"

"An artist."

"What kind of a thing is *that?*"

Apocryphal or not, it's a good yarn, and Robinson, who would go on to become chief ranger and superintendent of the park and then retire to many summers of telling and retelling Tom Thomson stories around the Taylor Statten campfires, told such tales well.

The story does illustrate how unusual it was to be an artist in those days in that setting. It also shows that Thomson was instantly noticed. The local men found him suspicious, while the women found him romantic. While other men worked, Thomson would sometimes be seen sitting by the water skipping stones or staring long and hard at a particular tree that almost anyone else would have dismissed as too ugly and scrawny even to bother cutting down. He liked his own company and sometimes could be so lost in thought that he would not respond when spoken to or waved at. Little wonder that some took an instant dislike

to him, while others, like Mark Robinson, found him polite, if shy, and interesting in what he did with his time in the park.

Robinson, who had joined the Algonquin Park staff in 1907 on the advice of his doctor following a serious illness, clearly had an appreciation of Thomson's art. In a taped 1953 interview with J. Alex Edmison, an early camper and later lifelong recruiter for the Taylor Statten Camps, the then-elderly Robinson—he died in 1955 at age eighty-eight—talked at length about Thomson's mysterious death and his recollections of what had happened thirty-six years earlier. But he also spoke eloquently of Thomson's paintings. In one encounter that Robinson said he witnessed in 1912 (though it is far more likely to have happened in 1913), he told about Thomson's exchange with the daughter of Charlie Ruttan, the sectionman at Canoe Lake. The girl was only sixteen, with little formal education, but was considered to be quite bright. Thomson was showing some sketches, and the young girl was particularly taken with one. She looked closely and squealed, saying it was "just like the alders were a week ago." Thomson's face, said Mark, lit up. Thomson said it was the finest compliment he'd ever received, that the girl had seen exactly what he'd hoped to capture.

"She saw it all there," Tom told Mark. "I knew I was going places."

His art was certainly going places. Tom Thomson, on the other hand, was now exactly where he felt he had to be.

FOUR CANOE LAKE

Thomson stayed at Mowat Lodge, for the most part, and took his meals in the back kitchen, usually served by Shannon Fraser's mother and sometimes by his wife, Annie, or even by their daughter, Mildred. Tom was considered well mannered and polite, putting down knife and fork while old Mrs. Fraser said a short prayer before starting into her own plate.

The Frasers had been at Canoe Lake for six years by then. They also ran the post office and telegraph, and had a team of two horses they hitched to an old funeral cart, which was widely used about the lake to carry people and supplies along the torn-up spur lines that had once served the Gilmour mill. They kept cows and chickens in order to have fresh milk and eggs for guests, and Annie had a growing reputation as a cook. If Mowat Lodge was rustic compared to, say, the Highland Inn, the rates and Annie's home-cooked meals made the place a welcome alternative and an immediate financial success.

While Shannon could be good company—like Mark Robinson, he loved to tell a story—many viewed his long-winded tales as his way of

avoiding work. The locals considered him lazy, and they feared his snap temper. According to Audrey Saunders in *Algonquin Story*, an official history of the park published in the 1940s, Fraser often had trouble keeping staff and would sometimes ask guests to take on duties in return for reduced charges. Thomson was known to patch the roof and put in the garden at the lodge, and if he did any guiding for money, it was likely through Fraser.

According to Saunders, Fraser's staff problems usually involved two local guides, George Rowe and Lawrence Dickson (better known as "Lawrie" but sometimes called "Larry"). They lived in little shacks on the mill property and took lodge guests out fishing. (Thomson painted one of the shacks, and that work, called *Larry Dickson's Shack*, now hangs in the National Gallery in Ottawa.) The two guides had notorious reputations for getting drunk at inopportune times, often when scheduled to take out a fishing party. Fraser regularly blew up at them, firing them and hiring them back, then firing and hiring them again through much of the season.

Thomson became a bit of a financial windfall for Mowat Lodge, as he continually persuaded fellow artists to come to Canoe Lake to paint. He and his cohorts were even becoming known, ever so slightly, as "The Algonquin Park School." A.Y. Jackson, whom James MacCallum had introduced to Thomson in Toronto, became part of the informal movement merely by showing up in the park to paint. Arthur Lismer came with Thomson mostly out of curiosity, wanting to see what was so special about a landscape dominated by grey rock, blue-to-black water, rusty pine needles, soft tamarack and forests filled with everything from lowly poplar to the majestic white pine. Lismer, like others, found the landscape compelling but the creative conditions difficult, as artists often had to sketch with one hand while using the other to swat away blackflies and mosquitoes. The arms determined to carry it through, the legs eager to bolt for cover.

Thomson's artist friends would often combine the trip to Canoe Lake with a stay at MacCallum's cottage on Go Home Bay. But Canoe

Lake was far more to Thomson's liking, even if not always so endearing to the friends he hauled up north with him. In one letter Jackson wrote from Thomson's beloved retreat in early 1914, he half-joked that the next news family and friends might hear of him would be "Artist devoured by wolves." He had not encountered wolves up close but had heard their howls in the distance when sketching outside one winter morning.

"You will notice my present address," Jackson had gone on in his letter, "far from the dust and din of commercialism. Mowat is a quiet unpretentious place. It doesn't bust itself to double its population every two years. Nor go crazy over selling building lots. No fortunes are made or lost and yet everyone is happy. The population is eight including me. Perhaps if I stayed on I could get a job as health officer. Or chief of the fire brigade. Our only means of locomotion are snow shoes. There is only one road to the station a mile away and it stops there. However the snow shoeing is good there are lots of lakes and all frozen. So you can walk for miles on the level. As soon as you get off the lakes you are in the bush which is very rough a very tangle of birch and spruce but very interesting wild animals abound. Tracks everywhere deer, foxes, rabbits and wolves mostly. Hunting is forbidden so they all congregate here. I expect to be here until the middle of April, getting some winter sketches."

A month later, Jackson wrote to MacCallum, saying, "The country up here is glorious. Heaps of stuff to paint. If the conditions would let you work. The first two weeks there was plenty of sunlight, but cold. 20 below zero was a nice mild day. And since March roared in the sun has never been more than a dim blur in the sky."

It was a new world for these Toronto-based artists, and though none embraced it with quite the enthusiasm of Thomson—who became almost fanatical about "The North"—the others took to it in varying degrees. Jackson could be described as lukewarm at best. Fred Varley (then signing his name as "F. Horsman Varley") wrote MacCallum from Mowat to let him know "what a great time we are having up here—The country is a revelation to me—and completely bowled me over at

first—We have been busy 'slopping' paint about and Tom is rapidly developing into a new cubist, but say, he has some great things up here. I'd like to tell you that you have given me the opportunity to wake up—I had given painting the go-by—but I'm going full tilt into it now."

MacCallum's generosity saved the British-born Varley from probable oblivion. Then happily married to Maud—whom he would eventually leave for a studio model—and with a growing young family to support, as well as being notoriously bad with his money, Varley had been thinking of giving up the painting dream for the more lucrative and steady employ of illustration and design. He felt if he had steady work, he could also take on portrait commissions to help pay the mounting bills that were a constant issue between him and his wife. MacCallum's offer of assistance was critical in persuading Varley to stick to his painting. He couldn't help but notice the dramatic effect MacCallum's small financial aid had had on Jackson and Thomson. With freedom to paint, Thomson had seemed to be transformed, almost overnight, from a part-time painter of little notice to a full-time artist of promise.

In the summer of 1914, Thomson set out on a remarkable canoe journey that, alone, should dispel any doubts about his increasing prowess with a paddle. After spending some time sketching around Go Home Bay, he made his way up through the French River to Lake Nipissing, then— likely by train—to South River, where he visited with a new friend, Algonquin Park ranger Tom Wattie. Thomson and Wattie had first met the summer before, when Thomson had passed through the South River and Trout Creek area on his way to paddle two of Algonquin's larger and more spectacular lakes, North Tea and Manitou. In the coming years, Thomson would visit Wattie and his family several times—in the village and at their island camp on Round Lake (now called Kawawaymog Lake). He also spent time at Wattie's ranger quarters on North Tea Lake, just inside the park's northwestern boundary. Wattie said he liked Thomson's partridge stew and dumplings. And Thomson liked Wattie's

friendly company and bush knowledge. Thomson also thought the sketching panels produced by the Standard Chemical–owned sawmill in South River were the best he'd ever found.

Thomson returned to Canoe Lake via North Tea and the string of lakes and rivers and at times difficult portages through the heart of the park, travelling, camping and painting for more than ten weeks. When Great Britain—and, by extension, Canada—declared war on Germany on August 4, 1914, Thomson was likely far back in the bush, oblivious to the harsh realities of the outside world.

That fall Thomson claimed—and Ranger Mark Robinson agreed—that the colours were the most spectacular ever seen in Algonquin. For a few weeks Canoe Lake seemed overrun with artists seeking to capture the rich reds of sugar maple and sumac, the golden stands of birch and the almost feathery yellow of the swamp tamaracks. Early park historian Audrey Saunders wrote that, as the paintings had to dry before being packed away for shipping, "Mowat Lodge would overflow with all these latest sketches. Guests and artists alike would share in friendly criticisms and unstinting praise of the most recent experiments."

Arthur Lismer was one of the artists who came north that autumn on Thomson's recommendation. He wrote MacCallum from Mowat Lodge on October 11, 1914, to say that they'd just had a glorious week of colour before a heavy rain put an end to the sketching. While Lismer was staying at the lodge, Thomson and Jackson were camped during the good weather across the lake at Thomson's favourite spot, near Hayhurst Point. "Both," Lismer wrote MacCallum, "are doing fine work & each having a decided influence upon the other." He thought Thomson's use of colour had improved from his earlier sketches.

Jackson found Thomson good company but strangely reserved. He remembered Thomson being reticent to show off his work and was such a perfectionist that, at one point, he tossed his sketchbox into the woods in frustration. Though Jackson was careful not to say so at the time, he must have been less impressed with Canoe Lake than the others were. In his later memoirs, he wrote, "The area around Canoe Lake at the time

was a ragged piece of Nature, hacked up many years ago by a lumber company that went broke. It was fire-swept, damned by both man and beaver and o'errun with wolves."

All the same, it is rather remarkable how much artistic activity went on in the park during those years. The 1914 journal of longtime Algonquin Park ranger Bud Callighen, who was posted at nearby Smoke Lake, indicates that he and other rangers saw artists as much as wildlife in their daily rounds. Callighen records that he shepherded Jackson around Smoke and Tea lakes for some late-winter sketching, took care of Thomson and Lismer in May when they portaged over to Smoke Lake and ran into Thomson and Jackson several times that fall as they paddled and camped around Smoke and Ragged lakes.

According to Callighen's journal (which, like Robinson's, always showed Tom's last name with a "p"), the rangers spent a fair bit of time with the artists. But more unusual is that Thomson appears to have been accepted as part of the small Canoe Lake circle, even though he never stayed through the winter. On April 28, 1915, after encountering a fishing party of four, Callighen wrote in his journal that the group included longtime guide George Rowe and "Thompson." He also noted two Johnston boys, whom he specifically called "(tourists)."

Thomson was accepted because he was, for the most part, quiet and polite, but also because he was a quick study when it came to survival in the bush. Callighen claimed that "Tom did everything in the bush country well." By most accounts penned by those who knew him then, Thomson arrived as an excellent swimmer—rare for men of that time—and soon became adept at paddling and tripping through the various routes, usually alone and with little equipment apart from tent, pack and a few cooking utensils. He told friends that if he could catch fish and pick enough of the blueberries and raspberries that grew along the shorelines and the portages, he could get by virtually expense free when deep in the woods.

Thomson seems to have had little regard for money, even when he often seemed desperately in need of some. There is an anecdote about

him pulling his hand from his pocket, spilling what little money he was carrying and not being willing to interrupt his fishing to try to retrieve the lost coins. Other anecdotes suggest that he felt duty-bound to pay his own way, once compensating a doctor who had lanced a boil for him by offering him several sketches, which were accepted with reluctance. Mark Robinson said that if you invited Thomson for a meal, you might see him come back the following day, to pay the debt, with a jar of wild raspberry jam or a fat lake trout. Annie Fraser said that when she lent him her washer so he could clean his blankets, he made sure to clean hers as well, and she also said he'd once washed the kitchen floors for the Frasers after a Mowat Lodge party.

In Thomson's four productive years in Algonquin Park, he completed approximately three hundred sketches and managed only two dozen larger paintings, which he finished in Toronto during the winters. In 1913 he returned to the city with thirty-some sketches, one of which, Lake, Shore and Sky, he gave to his increasingly close friend, A.Y. Jackson. Jackson and Thomson were now working in the Studio Building that MacCallum and Lawren Harris had constructed by the Rosedale Ravine. Sheltered from the sounds of the city, particularly under winter snow, it came as close to replicating the park experience as any location Thomson could find in the busy city.

If the small group of artists found acceptance in one another, they were also bound by rejection. The elitist Canadian art establishment wanted nothing to do with them or their art. When several of the young Algonquin artists exhibited some of the works they had completed over the winter of 1913–1914, the critics lunged. Henry Franklin Gadsby, writing in the Toronto Daily Star, tagged the colourful landscape work of the young men the "Hot Mush School" of art—a slur that produced a sarcastic rebuttal by J.E.H. MacDonald in the same paper. MacDonald asked Gadsby and other critics to have "an open eye" and enjoy the "Canadianness" of the paintings. Instead of maligning, MacDonald said,

the critics should "support our distinctly Canadian art, if only for the sake of experiment."

Undaunted, the artists, led by Thomson, headed straight back into the bush at spring breakup and sketched until the onslaught of winter brought them back to the Toronto studio. During that second winter, 1914–1915, Thomson painted his famous *Northern River*, a large canvas he self-deprecatingly called his "swamp picture."

Much to Thomson's surprise, the painting met with rave reviews when it was shown at the annual gathering of the Ontario Society of Artists in the spring of 1915. *Saturday Night's* Hector Willoughby Charlesworth said it was "fine, vigorous and colourful." The *Daily Mail and Empire* claimed it was "one of the most striking pictures of its kind in the gallery." The National Gallery purchased *Northern River* for five hundred dollars.

Flush with a new stake, Thomson soon headed north, likely stopping in at Huntsville to visit the young woman who was becoming convinced they might one day marry. It is notable, however, that none of the painters Thomson brought to Canoe Lake mentioned any relationship or ever named Winnifred Trainor as a special friend of Tom. This suggests either that Tom didn't think of the relationship as anything but casual, and therefore not worthy of mention, or that he feared his sophisticated city art friends might tease him for having such an unsophisticated, uneducated woman from the boonies as a girlfriend—however cruel and unfair such a description of Winnie might be. Yet, certainly, while in Huntsville, Tom made no effort to conceal the romance, often walking up and down Main Street with Winnie, meeting her after work and at times picnicking around the area.

The painter was once again at Canoe Lake for the going-out of the ice, and that spring of 1915 he sketched *Spring Ice* from Hayhurst Point. Over the following winter, the sketch would become another major National Gallery purchase. Thomson visited Tom Wattie in

South River, staying at the New Queen's Hotel, and at the same time used some of his newfound money to purchase a silk tent and a magnificently crafted Chestnut canoe. These canoes, built by the Chestnuts of Fredericton, New Brunswick, were treasured for their elegant lines and ease of paddling. With a small keel, they were ideal for the windy lakes of Algonquin, but were also quick and responsive for river travel and light for portaging. The lines are so distinctive a canoe aficionado can tell a Chestnut at a glance, yet Thomson made his even more noticeable by mixing a $2 tube of cobalt blue with a standard marine grey in order to paint his new canoe a "dove grey" colour—perhaps to distinguish his from the common reds and greens of the lodges and various cottages.

That fall Thomson claimed, in a letter he wrote to MacCallum, that he'd completed "about a hundred" small sketches on his preferred birch panels. It was a banner year: selling work in the spring, sketching well all summer and fall and now receiving an offer from MacDonald to make some extra cash on a painting commission that would free him up to do more of his own work in the spring of 1916. Dr. MacCallum had asked MacDonald to design and build murals along the walls of this cottage at Go Home Bay as a birthday surprise for his wife, and MacDonald quickly enlisted Thomson and Lismer to help with the project.

Jackson was unavailable. As Private A.Y. Jackson of the 60th Battalion, he was already in Europe, where, in June 1916, shortly after he reached the front, he was wounded in the Battle of Sanctuary Wood. He recovered well and was transferred to Canadian War Records as an artist and would go on to paint some of the most memorable works on the Great War.

Jackson's fellow painters stayed back and kept largely to their schedules of sketching in fair weather, finishing off large canvases in winter at the Studio Building and showing their work at the spring exhibition of the Ontario Society of Artists. In mid-March 1916, *Saturday Night*'s Charlesworth again took notice, accusing the OSA of letting "quasi-'futurism'" take over much of the exhibition. "Those who

believe that pictures should be seen and not heard," he wrote, "are likely to have their sensibilities shocked." Naming MacDonald the "chief offender," the critic railed that "it is hardly necessary to tear one's eyes out" in the performance of the artist's craft.

Speaking of MacDonald's now-iconic *Tangled Garden*, Charlesworth suggested the artist "certainly does throw his paint pots in the face of the public." The canvas was too large for the subject, he argued, and the colours so crude they mocked the "delicate tracery of all vegetation." Still, Charlesworth thought it a "masterpiece" compared with other MacDonald offerings on display, snidely suggesting that their titles be changed from *The Elements* and *Rock and Maple* to *Hungarian Goulash* and *Drunkard's Stomach*.

The *Toronto Daily Star*'s Margaret Fairbairn was much kinder. Three years earlier, she had argued in favour of giving these new young artists their space, but not at the "almost entire exclusion of the older element, in whose work are to be found dignity, serenity, sound draughtsman-ship, and all the solid qualities of good design and color which are to be found in the great art of all ages." In March 1916 Fairbairn specifically mentioned Thomson's *The Birches* and *The Hard Woods*, works that "show a fondness for intense yellows and orange and strong blue, alto-gether a fearless use of violent color which can scarcely be called pleas-ing, and yet which scoops an exaggeration of a truthful feeling that time will temper."

Thomson, however, seemed to be past caring what the experts or the art rivals thought. There are no records of him griping about any of the negative comments in the Toronto newspapers, and he thought Charlesworth's wordy analyses in *Saturday Night* magazine were nothing short of silly and pompous. Thomson was more the artist's version of the "I-may-not-know-art-but-I-know-what-I-like" school of thought on painting. He spoke with his brush. And, as far as he was concerned, only those who'd known frostbite on their ears, the annoyance of the May blackfly bites and, most significantly, the way wind seems to sing in the branches of high pines, could fully appreciate what he was saying.

"Thomson had but one method of expressing himself, and that one was by means of paint," his patron MacCallum wrote in a magazine article in 1918, the year after the artist's death. "He did not discuss theories of art, technical methods nor choice of motives. He never told about marvelous scenes, of how they had thrilled and held him. He merely showed the sketches and said never a word of his difficulties or of what he had tried to express. His idea seemed to be that the way to learn to paint was to paint. He did not choose some one landscape or some one kind of landscape. All nature seemed to him paint-able—the most difficult, the most unlikely subjects held no terrors for him—the confidence of inexperience it may have been. No doubt he put his own impress on what he painted, but the country he painted ever grew into his soul, stronger and stronger, rendering him shy and silent, filling him with longing and love for its beauties. His stay in the studio became shorter and shorter, his dress more and more like that of the backwoodsman. The quiet hidden strength, confidence and resource of the voyageur showed itself in the surety of handling in his work. He was not concerned with any special technique, any particular mode of application of colour, with this kind of brush stroke or that. If it were true to nature, technique might be anything."

That same year, Tom returned briefly to his training in illustration. He had read Rudyard Kipling's popular *The Light That Failed* and selected a quote that he set out in Old English letters and surrounded with elaborately drawn leaves. The quote was deliberately chosen: "I must do my own work and live my own life in my own way, because I'm responsible for both."

FIVE WAR

T homson became even more of a loner in the winter of 1915–1916. With Jackson serving overseas and the studio he had shared with him now rented to another artist, Thomson moved his operation into a small building that had served as a tool shed during the construction of the Studio Building. It became known as Tom's "shack" and was later moved to the grounds of the McMichael gallery in Kleinburg, north of Toronto. Tom paid the princely rent of one dollar a month to use the shack.

But once again, as the ice went out, Thomson went back into the North Country, this time spending part of the early spring exploring the northeastern portion of the park and canoeing the spectacular Petawawa River. Algonquin is different there, with quick, turbulent runs compared with the flat-water travel around Canoe Lake. It seems wilder, and Thomson, by all accounts, liked it hugely, sketching many paintings that would become his best-known canvases—including *The Jack Pine* at Grand Lake.

He also stopped, whenever possible, at Canoe Lake and at Huntsville, where he once again became a familiar guest at mealtime. It was during these years that neighbours such as Addie Sylvester became convinced that Tom and Winnie would end up together. When the Trainors spent weekends at the lake, and Tom was about, he would often take his meals with them there too. The rhythm of the lake began to take form over the spring—evening paddles, picnics, trail walks and gatherings (often with music) at nearby Mowat Lodge, where Tom would stay when the Trainors were in residence at the Manse. Apart from the bugs worsening as the days grew warmer, Canoe Lake was a quiet, picturesque escape—worthy of the name so many give to the one place that matters most to them: God's country.

Despite these summer idylls, the duty owed to a country at war was much on everybody's minds. Mark Robinson had already shipped out in the fall of 1915 with the Simcoe Foresters. Tom told people he would serve the wartime cause as a fire ranger. Such work, including anything to do with the lumber industry, was generally considered an acceptable alternative. He was assigned—surely much to Winnie's chagrin—to a ranger cabin near the Achray rail depot at Grand Lake, a large, wind-swept lake near the eastern boundary with easy portages into the Barron River and the spectacular granite canyon that twists and turns along the park's eastern boundary. There being no fires in the area, he had plenty of free time to explore and sketch. That summer, he travelled to Lake Traverse, where he stayed with Ranger Jack Culhane and his family and where he might have painted with young Jimmy Stringer, who was there that summer with his Uncle Jack's family.

At Grand Lake, Thomson stayed with Ranger Edward Godin. He got on well with Godin—Thomson even made a sign, "Out-Side-In," for the cabin they shared—and Godin later said he found Tom "a very fine fellow. Easy to get along with and always in good humour." Godin thought that Thomson did the sketch for *The Jack Pine* while there. He was equally convinced that Thomson's best-known work, *The West Wind*, was sketched out somewhere near Kiosk in the northwestern

part of the park. Others would prove to have different ideas as to the location of the painting Arthur Lismer would later call "the spirit of Canada made manifest in a picture."

There has always been controversy concerning the exact location of *The West Wind*. Godin said that it was first sketched out near Kiosk. Ranger Tom Wattie said it had been painted at Round Lake, where he had his family cabin and where Thomson sometimes stayed and sketched. In August 2009 I went by canoe to Kioshkokwi Lake and spent hours trying to match a copy of *The West Wind* to the shoreline and while there are angles that look persuasive, nothing quite convinces. Mark Robinson claimed that the original sketch had been completed at Achray on Grand Lake and further claimed that Thomson had tried to give the exquisite little painting to him but that he'd refused, telling Thomson to put it on a large canvas over the winter. Winnie Trainor once said that Thomson told her it had been painted at Cedar Lake, near the railway depot at Brent.

James MacCallum, however, claimed not only to know where it was painted but also to have been there when it happened. MacCallum said that he, Thomson, Harris, and a cousin of Harris's had been travelling that spring and Thomson decided to paint a gnarled tree growing near the shore of Little Cauchon Lake. To make the story more dramatic, MacCallum claimed, confirmed by Harris, that it was blowing very hard—as evidenced in the whitecaps in Thomson's painting—and that "the wind blew down the tree of the picture and Harris first thought that Thomson was killed, but he soon sprang up, waved his hand to him and went on painting."

A far less dramatic account comes from oldtimers in Huntsville who always claimed that *The West Wind* was painted at Fairy Lake and that Tom had been staying at the Trainors when, one day, he set out and found inspiration at the nearest lake from town. There is, in fact, a certain point where you can stand and, if you imagine that a gnarled pine once stood on the rocks, the round hills on the far shore rather neatly match Thomson's masterpiece.

Tom made several new friends during his time at Grand Lake. Each week he went by canoe and tote road to Basin Depot to pick up supplies and mail, where he would visit with Ranger Will Hughes and his wife, Charlotte, who was called "Lottie." Lottie Hughes had been the first ranger's wife allowed by park authorities to live in the park with her husband. She did wonderful crochet work, and Tom once sat down and drew an intricate pattern in pen for her to follow. The Hugheses had no sense that they were being honoured by an artist, since Tom never mentioned his true calling. Later that year Will and Lottie Hughes were transferred to Brent, on Cedar Lake, and never saw Tom again, learning of his artistic life only after he died. They had previously spoken of him as a welcome visitor who was "handy with his pen."

Lottie's sister, Alice Green, lived with Will and Lottie, and the three would often play cards with Tom. Alice kept a deck of Air-Cushion Finish Congress Playing Cards 606 from the U.S. Playing Card Company. Under the words "Summer of 1916, Best Summer Ever Was Known," Alice has written the date, August 2, 1916, and signed the name "Tom Thompson." On another card, four names—Tom Thompson again, Carl Goddin, Charlotte Roche and Alice Green—are written, along with the words "Five Hundred Players." It is clear, because of the "p" in "Thompson" that Tom did not sign it himself, but he was known to be a frequent visitor, and it appears that the writer was quoting him directly.

"Best Summer Ever Was Known," Tom apparently told his new friends. It would also be his last summer.

Pete Sauvé, a park local who later worked as a cook at Taylor Statten Camps, remembered meeting Thomson at this time and thought him "a perfect gentleman." Sauvé once watched Thomson sketch the log drive along the Petawawa River and was impressed, though not everyone else

was. "The other men thought the man was foolish," Sauvé said in a later interview, "out of his head, all his thoughts and everything, when he was bored. They didn't know anything about a painter."

There were now nine ranger stations in the park, including the fine cabin at Achray that Thomson shared with Godin, and thirty-two rangers employed. More and more private cottages were to be found, some newly built and some, like the Trainors', adapted from previous use. The lease on a place was $7.50 a year, with cottagers allowed a maximum of two acres. There was talk of building a road through the park from Whitney, on the eastern boundary of what is now the southern portion of the park, to Huntsville, west of that portion of the park, but Highway 60 would not become a reality for years (it was a special make-work project during the Great Depression). The eventual road would follow a trail blazed by my grandfather, Ranger Tom McCormick.

Somewhat ironically, while Thomson served as a fire ranger in a far corner of the park, seeing next to no action, a huge fire broke out at Canoe Lake when a Grand Trunk engine ignited a pile of wood chips and the fire spread to the hill back of the Canoe Lake station before it could be brought under control. Fortunately, no buildings or cabins were affected, including the Trainors' place.

It must have occurred to Winnie that fire ranger work was needed closer to Canoe Lake, yet Tom had been assigned to Achray. Had he asked for Achray? Had he not suggested Canoe Lake or, at least, one of the stops along the Grand Trunk line heading east and west? Achray was much too far for him to travel by canoe to see her in the little time he had off, and even letters were difficult to send. If, at this time, they were talking about the possibility of a life together, as she certainly came to believe in the coming year, she must have wondered what he was thinking. If the story on the cards is correct—"Best Summer Ever Was Known"—Tom must have been thinking of her rather less than she was thinking of him.

76

Meanwhile, Winnie and her mother were deeply involved in patriotic support of the war effort. Knitting socks was considered an important part of the "drive," as it was always called. All Saints' Anglican Church and the Women's Christian Temperance Union were both major forces behind that cause. Winnie was working with the church to raise money for the troops, as well as helping with a separate drive to knit for those serving at the front. She must have wondered whether Tom's work as a fire ranger was really enough war service for a man she knew to be in the prime of health and still, unfortunately, a bachelor with no family obligations.

Ranger Mark Robinson later claimed that Thomson had tried three times to enlist, but Ranger Edward Godin came away from that summer of 1916 with a decidedly different view. "We had many discussions on the war," Godin recalled. "As I remember it he did not think that Canada should be involved. He was very outspoken in his opposition to Government patronage. Especially in the militia. I do not think that he would offer himself for service. I know up until that time he had not tried to enlist."

All the same, Thomson must have been feeling the pressure to do what was endlessly described as "one's duty." Fred Varley said that the artist was bothered that "everyone was worried about him joining up." But the conflict in Europe could not be ignored, not even by a person who thought Canada should never have become involved—and Thomson's position was not endorsed by his friends. First it was Jackson, who was eager to sign up and fight. Then, in the fall of 1915, Ranger Mark Robinson, despite being in his late forties and having a family to support, enlisted in the 35th Regiment of the Simcoe Foresters. In light of his long service with the militia, Robinson was commissioned as a major. Lawren Harris followed in June 1916, joining the 10th Regiment of Royal Grenadiers. And Fred Varley was going as a war artist, even though he believed the world would be "forever tainted" with the war's "cruel drama." Thomson wouldn't have used such dramatic language, but his sentiments might certainly have been the same as Varley's.

According to one early biographer, Tom once told his sisters that "he would willingly serve as an ambulance man but could not face the prospects of killing."

Everyone else, it seemed, was off to support the great cause. Roy McCormick, my great-uncle and Winnie's future brother-in-law, enlisted on February 23, 1915, in Montreal, where he was a medical student. He was only twenty-two and might easily have avoided a uniform, but he was so determined to do his part that he'd already taken a six-week military course at Ottawa and Kingston the previous year. (His war record was impressive. He was wounded twice while fighting with the 39th Battery Artillery Corps in France and Belgium and served again in the Second World War in a medical capacity—as a lieutenant commander in the U.S. Naval Reserve in charge of examining draftees.)

Tom's sisters always maintained that he had tried to enlist but was turned down. Attempts to prove this have been futile. Library and Archives Canada in Ottawa has indicated that there are "no surviving lists of names or applications of those rejected by the Canadian military" for duty in either the Boer War or the First World War. Nonetheless, when Mark Robinson was in his eighties, he insisted in an interview that Tom had tried to join up. "Most of the boys with any blue blood in their veins enlisted at once," Robinson said. "Tom endeavoured to do the same thing. He was turned down and he felt very keenly about it, went to Toronto and tried it there. Turned down again. Went to some outside point in the country; was again turned down. Then he came back to the Park. I remember him looking around and counting the boys that had gone. A lot of them had become his friends, and he threw his heart right into painting . . .

"[H]e was back in 1915 and he came up to my place and he said, 'Well, I've done my best to enlist and I cannot but I'm going to go with the Fire Ranging. I've been to see them at the Department and I can get on Fire Ranging and if I cannot fill a place in the Army, I can fill a place here at home of a man who's gone to the Army,' and he seemed pleased that he could do that"

In spite of such claims, the controversy over Thomson's personal war effort has stuck to his story as long as it has been told. A tale has even persisted about Thomson being "white-feathered" by a woman while he was in Toronto riding on a streetcar—though there appears to be no solid evidence of the story's truth. White feathering was a ritual carried out by women who belonged to what they called the Order of the White Feather. Inspired by a British practice, these enthusiasts placed a white feather—the sign of a coward—on any able-bodied man they encountered who was not doing his duty during time of war.

Thomson left little evidence of his own thoughts on war apart from a letter he wrote to J.E.H. MacDonald after Jackson enlisted. "I can't get used to the idea of Jackson being in the machine," he wrote, "and it is rotten that in this so-called civilized age that such things can exist but since this war has started it will have to go on until our side wins out. and of course there is no doubt which side it will be, and we will see Jackson back on the job once more."

As for the "job" of painting for a living, it was certainly not as easy as Thomson might have first thought. He quickly spent the five hundred dollars he'd received in 1915 for *Northern River*—not only on his new camping equipment and canoe, but also by lending money to Shannon Fraser to help him purchase canoes for Mowat Lodge. When the cash was gone, Thomson was forced to swallow his pride and turn to MacCallum, admitting in a letter that "my account has gone broke." He asked for twenty-five dollars to be wired to him in South River so he could stock up on supplies and return to Canoe Lake. "I am stranded," he pleaded. And the prospects for selling new paintings suddenly seemed remote.

"With the outbreak of war in the summer of 1914," art historian William Colgate wrote, "all artistic effort ceased. The public, numbed by the suddenness of the cosmic tragedy, no longer wanted the work of the painter. Almost overnight, dealers' galleries were denuded of patrons." Nor was there much work for illustrators like MacDonald and Lismer.

With rail and steamship companies tied up with troop movement, tourism faltered. There was no call for brochures and posters. MacDonald, Lismer and Thomson had surely been grateful for MacCallum's commission to paint cottage murals over the previous winter of 1915–1916.

The wall murals are now on permanent display at the National Gallery, erected in a room built to resemble the interior of MacCallum's cottage. The project was overseen by MacDonald, who "sub-commissioned" Lismer to do six of the murals and Thomson, three. All three of Thomson's murals are entitled *Forever Undergrowth*. He did four more panels on the same theme for the MacCallum cottage, but they were not used, and it's easy to see why. All seven are uninspired, as if Thomson had been acting as no more than a workman getting through his day while thinking of all the other things he'd rather be doing.

Since MacDonald and Lismer were, first and foremost, illustrators, they appear to have taken this assignment to heart. Their murals feature skinny dippers and picnickers, steamers arriving, Aboriginal people, priests and the granite outcroppings of the local landscape. They seem to have been fully caught up in the spirit of the cottage decoration, while Thomson was not. They also sneaked images of Thomson into their work. MacDonald used him as his model for a large mural depicting a rugged lumberjack that was positioned to the right of the cottage's stone fireplace. And Lismer used him for the mural he called *The Fisherman*, in which Thomson looks like a cartoon character wearing a floppy hat and smoking a pipe while fishing from a rock. And he looks, well . . . stoned.

The financial collapse of the art world also hit Arthur Lismer, who decided he needed a regular, paying job. Lismer was married with a daughter and, unlike Harris, had no family means to fall back on. In the summer of 1916, he pursued and succeeded in landing a teaching post at the Victoria School of Art and Design in Halifax. He moved his young family to Bedford, Nova Scotia, and sent Tom a letter from there in January 1917. "How goes life in the old shack this winter?" he asked. ". . . hope you are keeping warm & fit & doing a little work

occasionally in between the records on the Victrola—Sometimes I wish I were back in Toronto. The atmosphere here is not an artistic one— but I have a 'job' & I like it & its great country & we have a fine little place on the edge of all the wild stuff one could wish—its very like the Park & a lot like Georgian Bay. — Civilization seems to have passed on & left the country in all its wildness"

In early spring of 1917, Thomson set out for his own little world of "wildness" for the last time. He stayed in Huntsville for a while, visiting with the Trainors, and, given that he was living at Mowat Lodge by early April or perhaps earlier, he would have passed through the town as the war effort was reaching fever pitch. The *Bracebridge Examiner*, which had originally editorialized against the war, was now onside, and the Huntsville *Forester* had been solidly behind Canada's involvement from the very beginning. The United States was also getting involved, with President Woodrow Wilson asking Congress in early April to declare war on Germany.

And finally the town's own 122nd Battalion was heading overseas. More than a year earlier, the authorization had come through, but hitch after hitch had delayed the deployment. A shipping-out date had already been missed in March, and morale had reached rock bottom. But now that the Americans were joining in, the 122nd was going to be commissioned at last.

Thomson's visit to the Trainors might well have coincided with the celebrations. The ice was late going out that spring (it didn't leave until May 1st) and though, that year, he was known to be sketching a daily record of the arrival of spring, no one has ever determined precisely when Tom arrived at Canoe Lake or when he stopped his daily record. It is believed that he arrived either during the last week of March or during the first week of April, so he would have passed through Huntsville at some point around this time.

Certainly Winnie and her mother would have been involved with the celebrations around the deployment and, if Winnie had had the

opportunity, she would have insisted that Tom come along to the huge sendoff the town was holding, complete with band and singers—and a dinner at the Anglican church's parish hall.

At the dinner it was announced that the Patriotic Fund had reached $7,400 in contributions from the townspeople. After the total was made public, Mayor W.E. Hutcheson gave a speech to inspire the troops: "Be strong, men," he told the soldiers, "and when the fight is over and you return to your homes, come back with pure hearts and wholesome bodies, and take the place prepared for you as representative citizens."

There were more speeches and impromptu cheers, and the parish hall gathering ended with a stirring rendition of "God Save the King." But the party didn't end there. Most of the town stayed up much of the night so they could cheer as their fifty local boys in uniform left on the troop train at 3:45 a.m. Those who wanted to see the boys off walked the streets until well after midnight, eventually coming together at the station to wait for the train's arrival. Then word arrived by telegraph that the United States had officially declared war—bringing a resounding three cheers for President Wilson.

Whether Tom was with Winnie that night or not, she would have wondered what was going through his mind. To her, there was no debating the matter of the war. She, like everyone else in town, would have been profoundly moved when, that same spring, Private Charles Catton had come back as Huntsville's first war hero. Nineteen years old and strikingly handsome, the young man had enlisted and been shipped overseas. He'd fought and lost his right arm in France. Wounded, he was said to have carried an unconscious mate two miles to safety, gripping the other soldier with his one good hand and clenching his teeth on the soldier's clothes.

What had Tom told Winnie about his attitudes to the war? The idea of "serving" as a fire ranger was the previous year's solution; he had no plans this spring but to sketch daily and capture the slow march of spring as it arrived at Canoe Lake. Perhaps Tom told her he'd tried to enlist but was turned away because of his supposedly bad feet. But no one knows.

What is known is that in the spring of 1917, when Prime Minister Robert Borden introduced his controversial conscription bill in the Canadian Parliament, Tom would have fallen under classification 7: "Those who were born in the years 1876 to 1882, both inclusive, and are unmarried or are widowers who have no child." As the war worsened in Europe, his classification would have moved to 5—ever closer to being called up if the government went ahead with conscription.

There were grave concerns over the progress of the war. When neither the French nor the British had been able to take Vimy Ridge, considered the key link in the Hindenburg Line, the Canadian troops were assigned to what many believed was an impossible task, a suicide mission. During an astonishing six days in early April, the Canadians—fighting together for the first time ever—took the ridge, but at a terrible cost. Canadian casualties numbered 10,602, with 3,598 of the soldiers killed. It was not only a pivotal moment in the war; it was a pivotal moment in the history of the country, which would emerge from the war experience no longer thinking of itself as a mere colony of the British Empire, but as a country that could stand on its own and had shown the world it could do so.

Perhaps to tune out the incessant talk about war, Tom arrived at Canoe Lake that spring with a monumental, rather manic, ambition. He would complete one painting a day to capture, in oils, the arrival and settling in of spring. Though he took out a guide's licence at the end of April, he had no intention of doing a lot of guiding, and there were few tourists looking for guides. His aim was to let such work interfere as little as possible with his art. When it was available, he would stay at the Trainors' cabin free of charge; when not he would take a room at the lodge. In May he put in a small vegetable garden for the Frasers out back of the lodge and a smaller garden for the Trainors at their cottage. And he sketched every day, each new painting marking the daily creep of the good weather.

Unbeknownst to Thomson, the *Owen Sound Sun* decided to write him up on April 10, 1917.

In a long article titled "Pictures by Sydenham Boy Worth Seeing," the newspaper heaped praise on Thomson such as he had never read or heard before. The local artist, the paper said, "has been spoken of by the highest art critics as a young artist who is on the threshold of an exceptionally brilliant career." The anonymous writer predicted that Tom Thomson would be a name "much before the public in coming years."

Thomson received the article, likely sent by his family, and wrote back to Tom Harkness, his sister Elizabeth's husband, saying, "I got a copy . . . and it seemed to be filled with bunk. However, the foolishness of newspaper matter is well known, and I knew nothing about it in time to have it stopped." Privately, he was probably delighted with the "bunk."

Thomson—who signed off as "your aff. brother," signalling how close the two were—also told Harkness that he had been there much of April and had already completed "considerable work." He said he anticipated the ice going out sometime in the coming week and that he had no intention of looking for work again as a fire ranger, "as it interferes with sketching to the point of stopping it all together." There was still snow on the north side of the hills, he said, but it was going, and he figured to have another good month of sketching "before my friends the blackflies are here."

In the only reference we have to his future plans for 1917, the painter then revealed to his brother-in-law that "I may possibly go out on the Canadian Northern this summer to paint the Rockies but have not made all the arrangements yet. If I go it will be in July and August."

Thomson also sent a letter to MacCallum, saying he expected the ice to go out soon. "Have made quite a few sketches this spring," he wrote, "have scraped quite a few and think that some that I have kept should go the same way. however I keep on making them." (He likely misspelled "scrapped" in the letter, but it is slightly possible he meant what he wrote, as he would sometimes scrape his boards clean and start anew.)

MacCallum wrote back a few weeks later with good news: "I have deposited to your credit a cheque for $25.00 given me by Bill Beatty for a sketch of yours which he had sold to some chap from South River . . . You had better send down a lot of those sketches of yours as soon as you start in guiding," he advised, "and see if I cannot sell some of them and increase your bank account" Bill Beatty is painter William Beatty, a former Toronto fireman who gave up his job to study art. He was friendly with several of those who went on to form the Group of Seven and had painted in Algonquin Park as early as 1909. It is likely that Beatty influenced Thomson in his decision to paint the North Country.

Finally, the painter wrote to his father as well, talking about the ice still being strong and snow still in the bush. He said he'd been fishing through the ice but caught only "ling," a cod- and eel-like fish held in contempt by the locals. He briefly mentioned his work, saying he hadn't sent any paintings to the OSA Exhibition that year "and have not sold very many sketches but think I can manage to get along for another year at least I will stick to painting as long as I can." He said he expected to get "a great deal" done that spring and signed off "your loving son, Tom Thomson."

Signing his full name in a letter home suggests he might have felt some discomfort or awkwardness in addressing his father. It might be that Tom was acutely aware that he would turn forty that summer and, unlike all the other Thomson males, had yet to settle down and take on the usual responsibilities of a middle-aged man.

SIX SPRING 1917

James MacCallum wrote back to Thomson that he would do what he could to sell some of the painter's sketches during the spring of 1917 and signed off with a request that the artist, then on his way from South River to Mowat Lodge to "remember me to the Frasers and their guests."

One of those "guests" was Daphne Crombie. If Thomson had passed MacCallum's greetings on to her, she would not have had a clue who the eye doctor was. Mrs. Crombie was a slim, striking beauty, still in her twenties, who had come to the Frasers' lodge during the winter with her new husband, Lieutenant Robert L. Crombie, who had been advised to go to Algonquin Park for health reasons. Robert Lionel Crombie—affectionately called "Robin" by his young wife—was almost twenty-six years old and had trained as a broker in Toronto before he signed up in December 1914. His war was short-lived, however, as the slight, newly commissioned lieutenant was soon struck down by tuberculosis, a common affliction during the war: for every 100 Canadian soldiers killed in action, 6 died of tuberculosis, and for every 100 pensioned off for wounds

suffered in the conflict, 25 were pensioned off because of the disease. Cool, fresh country air was the only known treatment at the time, so Algonquin Park was considered the perfect natural setting for healing.

The treatment specifically prescribed for Crombie was to be wrapped tightly in his heavy, feather-filled officer's quilt and positioned outside on a bed that was set up on the lodge's porch. That way he could take in as much fresh, spring air as possible. It meant long days of boredom for the vibrant Daphne, and when she tired of reading, she explored the trails around the lodge, becoming friendly with both Annie Fraser and Tom Thomson, the shy, dark artist who was also around the lodge. Often, she would sit and watch Tom paint as he sought to capture the daily advance of spring. They talked as he worked and, according to her, they got on wonderfully.

Thomson even painted Crombie at one point. The sketch, with both Annie and Daphne in the scene, became his well-known work *The Artist's Hut*. He also gave Daphne another gift: a sketch of the path behind Mowat Lodge.

In 1977 I visited Daphne Crombie at her apartment on Clarendon Avenue in Toronto. A print of *The Artist's Hut* was hanging above the mantel. "Tom told me it was the best one of the season," she said. She giggled while admitting that she thought his paintings might be fine for a cottage—"alright to show in the kitchen," she said—but hardly suitable for a sophisticated city home. But as his reputation grew, so did her regard for the small painting he had given to her. She began to fear that his gift might one day be stolen, so whenever she travelled, she'd wrap it in a blanket and lock it away in a cupboard. Then she decided to sell the original and use a small portion of the $1,200 the work brought in to replace it with a simple print of the sketch she and Annie Fraser had appeared in.

At the time I interviewed her, Daphne Crombie was nearing ninety, but her beauty and grace had hardly been diminished. She had enormous presence, a charming sense of humour and a razor-sharp memory for detail. She remembered returning to the lodge one afternoon

in the spring of 1917 with a mittful of pussywillows and trying to fit them into a small jam jar. The jar was inadequate; the long branches needed a vase.

"I'll make you one," Tom offered.

"I'd like one with pussywillows painted around it," she said.

He made and painted the vase exactly as she'd envisioned it. "It was beautiful," she remembered, "but Annie broke it accidentally when she was cleaning. Tom said, 'I'll make you another one'—but, of course, he never did. When I got back, he wasn't alive."

Daphne Crombie's remembrances of Thomson painting are revealing. He would sometimes talk to her about the tone he was trying to capture. He told her once, "Now I'm trying to get the light just right—because it's a different light from over here if you'll come and see."

She thought he was kidding.

"I'm serious," he protested. "Go over."

She did, and saw that he was right—the light was different in the spot where he had told her to go and stand.

Another time when he was working on a sketch, she happened to say, slightly puzzled, "Those shadows are very blue, aren't they?" He told her to go out the next day at a certain hour and see for herself. "I did," she recalled, "and he was right."

She remembered the day a wild storm broke out over the lake. "He came running down to the gallery," she remembered, saying 'I'm going to paint!'" They went out onto the verandah, where Robert Crombie, tightly wrapped in his quilt, was also staring out over the water. It was an extreme spring storm. The sky had broken, and shafts of light were coming down in the most spectacular manner.

"'I'm going to get that!'" Thomson shouted as he began to sketch. "'Look! Look!' he was shouting. And you know, he did get it. Exactly. Later on he showed it to Dr. MacCallum, who said, 'My God, Tom—were you tight when you painted this?'

"I said, 'I can assure you it was not the case.' And Tom looked at me with a smile as if to say, 'Thank you.'"

Daphne's recollections of a somewhat manic Tom are in line with Mark Robinson's descriptions of the man. "Tom was a study at all times," Robinson wrote in a 1930 letter to Thomson's first biographer, Blodwen Davies. "[O]ne day he was Jovial and Jolly ready for a frolic of any kind so long as it was clean and honest in its purpose. At times he appeared quite melancholy and defeated in manner. At such times he would suddenly as it were awaken and be almost angry in appearance and action. It was at those times he did his best work."

Robinson noted what a perfectionist Thomson was, insisting on getting the "snarles" right in birchbark, obsessed with different shades of grey in wood, determined to be "true to nature." While some art experts have suggested that Thomson, through Jackson, was increasingly influenced by the European Impressionists, those more familiar with the natural world, such as Robinson, saw only a true and accurate portrayal of nature in his works. As Thoreau MacDonald, J.E.H.'s son, wrote in his foreword to a slim 1969 biography written by Ottelyn Addison (daughter of Ranger Mark Robinson), "Thomson's work would be a fine study for some competent critic, but anyone attempting it should be familiar, not only with every phase of his work, but with the country too. He must know the trees, rocks, lakes, rivers, weather; to have them in his bones"

Phil Chadwick, an Ontario artist and meteorologist, has created a PowerPoint presentation demonstrating Thomson's remarkable fealty to nature and the skies. Using graphs and overlays, Chadwick shows how a Thomson painting such as *Clouds* (*"The Zeppelins"*) is accurate by every conceivable measure: direction, cloud buildup, windsWhen Thomson painted a night sky, Chadwick says, he placed the stars—even the planets—exactly as they were in reality. He was an accurate witness to all that he saw and painted.

But there were also times when the artist seemed too sullen and moody to observe the world around him. Daphne Crombie recalled that Tom would sometimes disappear to his room or drift off into a corner with a book. "Tom was very quiet," she said. "There were times when he

was not wanting to talk to people." To her, he seemed "a very lonely man at times."

Somewhat surprisingly, Crombie claimed to know nothing of any romantic interest the artist had, even though the Trainors were sometimes at the lake that spring and Tom would visit at their cottage, where he hung some of his spring paintings to dry. "Tom never mentioned Winnie to me," she told me. "He didn't seem interested at all at that time."

The notion would likely have shocked Daphne Crombie, but in today's nomenclature, it might be suggested that Tom was "hitting" on her. She was, the few grainy photographs of the time suggest, petite and beautiful, a young woman positively glowing with good health and a love of life. Her sick husband was, for most of every day, completely removed from the picture as he lay on the verandah or on the wind-protected sides of the lodge wrapped in his heavy cover. Tom's failure to mention his friend Winnifred Trainor might have been less oversight than a calculated move.

The truth about Tom Thomson the romancer—perhaps even serial romancer—is difficult to nail down. That he fell in love in Seattle is largely accepted through the memories of those friends and siblings who were there at the time, as well as in the later writings of Alice Lambert. It was well known in Huntsville that Tom and Winnie were courting. Yet he made no mention of Winnie's existence to Daphne Crombie. Nor was Daphne aware of any other romantic interest Thomson might have had in the area, though the trapper Ralph Bice of Kearney claimed there was a young woman there and another in Kiosk—and each one thought she was Tom's intended. As Bice put it, "He got around."

There was also Florence H. McGillivray, a Toronto painter of some reputation who had visited Thomson at his shack studio near the Rosedale Ravine the previous winter. She was thirteen years Thomson's senior and much admired by the artistic community. According to David Silcox and Harold Town, writing in *Tom Thomson: The Silence and the*

Storm, McGillivray even visited Mowat Lodge during the spring of 1917, and Thomson introduced her to Mark Robinson as "one of the best." Art historian Joan Murray has also written that, after Tom's death, McGillivray's calling card and an invitation to her upcoming art show were found in his sketchbox. This may, of course, merely be evidence of the mutual admiration of two rising Canadian artists. But it is undeniable that Thomson attracted the attention of a great many women. What we don't know is how much of that attention he returned.

Although Daphne Crombie came to know most of the characters around Canoe Lake, the intriguing exception is Winnie. If there was an opportunity for the two young women to meet, Thomson did not take it to introduce them. The Crombies were at the lodge through much of the winter and spring of 1917, and while the Trainors were largely summer cottagers, they did come up on weekends whenever possible. An entry in Mark Robinson's journals confirms that, on at least one occasion, the Trainors were at Canoe Lake at the same time as the Crombies. The Manse and Mowat Lodge were close enough together that you could shout an introduction, yet Tom made no effort to connect Daphne with Winnie.

Daphne did meet Martin Blecher, Jr., the son of the German-Americans who had a cottage close to both the Trainors and the lodge. She considered him "an unattractive blasé sort of fellow" and thought he was boorish as well. She also wondered how he could possibly be allowed to keep the pet groundhog he often carried around. As for later suggestions that Tom and Annie Fraser had something going, Daphne indignantly said, "*Never!*" during my 1977 interview with her. Daphne adored Annie's simple, friendly personality, and the two became fast friends, regularly walking and talking together along the many trails spreading out from Mowat Lodge.

Daphne's impression of her new friend's husband was not kind, however. Like so many others, she found Shannon Fraser a bit of a blowhard. He liked to talk and didn't listen well. He drank, she said, and she found him physically intimidating. "He had hands as big as hams," she told me,

and owned "a furious temper" that frightened everyone around the lodge. She found him "a devious kind of a creature."

Mark Robinson had been away from Canoe Lake since he'd enlisted in the fall of 1915, so he, too, would have missed the more serious court-ship between Tom and Winnie in the year and a half. He was now on his way back—and thankfully not headed off to the devastating battle for Vimy Ridge—because he had been wounded and discharged. Robinson's grandsons told me he was hit in the hip by shrapnel that killed several nearby horses and that he used a cane for the rest of his life. Leslie Frost, who had served in the same battalion and later became premier of Ontario, told the family that Robinson had served well, despite being nearly fifty, and he had acted as a father figure to the younger soldiers. Robinson was back at the Joe Lake ranger quarters by April 12th.

He recorded that the ice went out on Canoe Lake on May 1st. At about that time the Trainors left for Huntsville. The Crombies also left, as Lieutenant Crombie's health had improved dramatically after so many weeks of fresh, cold Algonquin air. Robinson himself left to be with his family in Barrie for nearly three weeks in June—during the worst of the blackfly season.

Thomson stayed on, determined to complete his opus on the arrival of spring. At the end of June, Mark Robinson returned from his family vacation and Thomson soon paid him a visit. "He came to my house one day and looked around," Robinson recalled years later in a taped inter-view. "'You know,' he says, 'I have something unique in art that no other artist has ever attempted,' and I can hear him, 'I have a record of the weather for sixty-two days, rain or shine, or snow, dark or bright, I have a record of the day in a sketch. I'd like to hang them around the walls of your cabin here.' Well, Tom and I had a little talk and I assured him that he'd be welcome to do so if he'd accept the responsibility as I couldn't do so, as I wouldn't be present probably all summer—never knew when I'd

be called away and some of them might disappear and I wouldn't feel that I could be responsible.

"He said, 'I'll accept all responsibility and I'll hang them around the wall here one of those days.'"

Thomson never followed through. With the Trainors back in Huntsville, he decided instead to keep the bulk of his spring work, as well as his pack and canoe, at their cottage, which was so much closer to the lodge, where he took his meals.

Thomson appeared to be in good spirits, Robinson thought. In a letter the artist wrote to MacCallum on July 7th—his last known correspondence—he said, "I am still around Frasers and have not done any sketching since the flies started. The weather has been wet and cold all spring and the flies and mosquitoes much worse than I have seen them any year and the fly dope doesn't have any effect on them. This however is the second warm day we have had this year and another day or so like this will finish them. Will send my winter sketches down in a day or two and have every intention of making some more but it has been almost impossible lately . . . Have done some guiding this spring and will have some other trips this month and next with probably sketching in between"

The evening after Thomson wrote to MacCallum, there was, by all accounts, a raucous drinking party at guide George Rowe's rundown cabin on the old Gilmour mill site. Among those in attendance, and drinking fairly heavily, were Thomson, Rowe, guide Lawrie Dickson, Shannon Fraser and Martin Blecher, Jr.

According to almost all versions of the Tom Thomson story, Blecher and Thomson got into an argument about the war. William Little, author of *The Tom Thomson Mystery*, said that the two "were actually prevented from coming to blows only by the good-natured efforts of the guides."

It is entirely plausible that the two got into a spat over the war. While Vimy Ridge had been an enormous victory in early April, the Hindenburg Line was still holding for the most part, and the Allies were suffering huge losses in the trenches. The Russians had sustained so many losses that

they had withdrawn and were now caught up in a violent revolution. Thomson was said to be despondent about the war, though it is not known if this was connected to his possible rejection if he had tried to enlist, his possible conscientious objection to war as a peace resister, or even his sharing of the widespread sense that the war was not going well. Whatever caused it, Thomson's moodiness could easily have gotten him into an argument with a man who might have been mocking the Allied effort. Blecher had a reputation around the lake for belligerence.

The party broke up without further incident, but not before the loudmouthed Blecher is said to have threatened Thomson: *"Don't get in my way if you know what's good for you!"*

The following morning—Sunday, July 8, 1917—is considered pivotal to the Tom Thomson mystery, yet it is filled with its own mysteries. The day began overcast and drizzly, with the wind at times gusting and bringing harder rain. Mark Robinson's journal records that he and his young son Jack, then eleven, and Ed Thomas, the local station master, had headed east on the rail line to Source Lake, where Robinson had been asked to examine some wood that had been cut and piled near the siding. To rebuff the periodic rain, he had dressed his son in his own old trench coat. It was, apparently, not a pleasant day at all.

Robinson recorded nothing about Tom Thomson that particular Sunday in his carefully kept journals, but in the early 1930s, he wrote a letter to Thomson biographer Blodwen Davies describing a specific scene involving Shannon Fraser and Tom—and he gave more elaborate detail about that same episode in his long 1953 taped interview with Alex Edmison who did the interview at the request of Taylor Statten Camps to preserve Robinson's memories.

The ranger remembered that he had been preparing lunch for himself and Jack when he happened to see Tom and Shannon walking along the trail toward the Joe Lake dam. They had apparently walked the considerable distance from Mowat Lodge, a trip Shannon would normally

take by horse and cart and one Tom would usually take by canoe. Robinson said Tom was carrying a fishing rod.

He recalled watching through his binoculars as Tom cast again and again for a large trout that was known to live below the dam. He snagged it once but lost it. Then, Robinson said, he overheard Tom remark to Shannon that he planned to head down toward Tea Lake and, either at the dam or in one of the smaller lakes along the way, catch a big trout. "I'll bring it home," Tom went on, "and I'll put it on Mark's doorstep; he'll think I've got the fish."

In his letter and interview, Robinson claimed that as Tom went back up the bank, he turned and caught sight of the ranger spying on them.

"Howdy," he said. "That's the last time Tom Thomson spoke to me," said the former ranger.

This scenario—held by William Little and the CBC to be critical and irrefutable evidence that Tom was still alive that morning—is troublesome in many ways. First, in Robinson's retelling, it seems such a pleasant, relaxed morning, whereas in his own journals, he'd described miserable weather as he and his son headed up the tracks to Source Lake and back. Second, it seems unlikely—but not impossible—that Shannon and Tom would have taken such a long walk together with no real point other than to try to catch a fish. Third, if Robinson required binoculars to make out what they were doing, how could he have overheard every single word the two men were saying, especially since they were standing close together and would have been deliberately quiet so as not to spook the trout?

But there is much more. The big trout itself is a huge problem, one that leaves those familiar with Algonquin Park and the habits of the wily trout scratching their heads. A big trout in the shallow, warm waters of July and one that Thomson was able to snag by casting? Not likely. For a short period after the ice goes out, it is indeed possible to catch lake trout in shallow waters and close to the shores, but by late June, even in a spring considered cool, the lake trout have invariably sought the much deeper waters and trenches off the islands. A speckled trout might linger in shallows, but tiny Algonquin speckles could never be

described as "big trout." Besides, smallmouth bass had been introduced to these waters and were thriving, the most muscular bass taking over the more shallow and warmer waters, thus making it even less likely that trout would be discovered there.

A younger Mark Robinson would have been among the doubters himself. Before he retired as a ranger, he had once been told by head-quarters to ensure that a British travel writer found good fishing. It being late July, Robinson noted, he figured "the water was too warm for trout in most places." Longtime park naturalists Ron Tozer and Rick Stronks agreed in 2009 that it would be "extremely unlikely" that a lake trout would be found in such a location on July 8th in any year. "Lake trout," said Tozer, "would almost certainly be in deeper water at that time."

"I don't believe that Mark Robinson saw him," Daphne Crombie told me. Of course, Daphne wasn't there at the time, so that is only her opinion. Yet Robinson's own daughter, Ottelyn Addison, who revered her father as did so many others in the park, doubted the story was any-thing but an old man's faulty remembrance or perhaps evidence of his eagerness to keep the attention of an interested interviewer.

And yet, a far more important reported sighting that July 8th was still to come.

At precisely 12:50 p.m. early that Sunday afternoon, Thomson apparently set out from the Mowat Lodge dock in his dove-grey Chestnut canoe for a day of fishing. Shannon Fraser said he'd seen him off and took careful note of the time, checking his own pocket watch as the painter paddled away.

It has always been said that this was the last time anyone saw Tom Thomson alive. But was it? Or did someone see him later that evening?

Or, even more curiously, was Thomson already dead by the time Fraser said he carefully checked his timepiece—dead and disposed of the night before under cover of dark?

Which would make the "big trout" more of a "red herring" than evi-dence that Tom Thomson was still alive when Fraser claimed he watched him paddle away.

The Jack Pine, 1916.

Portrait of Dr. J. M. MacCallum, patron of Tom Thomson and several other artists who went on to form the Group of Seven. This 1917 work by A. Curtis Williamson is titled *A Cynic*.

Canoe Lake guide George Rowe (far right) was one of the guides who discovered Tom Thomson's body floating in Canoe Lake on July 16, 1917.

Tom Thomson posing with trout catch.

The Trainor family purchased an old ranger's cabin at Canoe Lake in 1912 and changed it into a summer cottage that has changed little over the years.

Tom Thomson shaving in the bush.

Tom Thomson in canoe, smoking pipe.

Tom Thomson fly-fishing.

Tom Thomson and Arthur Lismer, Smoke Lake, Algonquin Park, 1914.

SEVEN THE SEARCH

Tuesday, July 10, 1917, began with the sort of weather that keeps the loons calling late and makes the water feel warmer than the air. It had rained during the night, and Canoe Lake was still covered in shifting mist when, around 9:15 a.m., Shannon Fraser made his way to the Joe Lake ranger station and, as Robinson recorded in his journal for that day, "reported that Martin Bleacher had found Tom Thompsons Canoe floating upside down in Canoe Lake and wanted us to drag for Mr. Thompson's body."

Robinson was certain that whatever had put Tom Thomson's canoe in the water would soon be explained. Perhaps Monday's wind had blown it free from a shore where Thomson might have lodged it—though Thomson was familiar enough with canoes that, surely, he would have hauled it completely out of the water and turned it over, particularly as there had been signs it would rain. Perhaps, thinking he would be only a short while, he had left it sitting partly in and partly out of the water at one of the portages, the bow pulled up on the shore but not tied or not

tied securely. The waves could then have slowly rocked the canoe, sucking it back off the roots and muck and out into the deeper water. It happened sometimes, even to those who should know better. Maybe Tom was stranded somewhere, embarrassed, as he should be. But drag for a body? Hardly—it simply made no sense.

Fraser said he'd last seen Thomson paddling away from the Mowat Lodge dock shortly before one o'clock on Sunday afternoon. He later added that he'd given Thomson some food from the lodge: a fresh loaf of bread, two pounds of bacon, a dozen potatoes, one pound of rice, one pound of sugar . . . which seems a considerable amount for an afternoon fishing trip. Perhaps Thomson was taking some necessary supplies to the Trainor cabin before setting off. The amount, however, would have suggested to someone like Mark Robinson—already skeptical that anything might have gone wrong—that Tom had intended to be gone a number of days, as was often the case with the painter.

More information kept arriving. Martin Blecher, Jr., and his sister Bessie said that, shortly after 3 p.m. on Sunday, they'd set out on a motorboat excursion down Canoe Lake to Tea Lake and had seen an overturned canoe about five minutes after leaving their dock near the Trainor cottage and the lodge.

As three o'clock was about two hours after Tom had supposedly paddled away from Shannon at the Mowat Lodge dock, it's always been assumed that the overturned canoe was Tom's. (Within those two hours, he would have had time to stop off at the Trainor cabin for his fishing equipment and perhaps also his paints.) And this assumption has led to the supposition that Tom met with ill circumstances that afternoon, sometime before three o'clock.

But the overturned canoe, like the big fish, poses problems. If it is true that the Blechers came across a canoe and, as Robinson recorded in his journal, "They investigated no further," this would go against the "code" of the waters of Algonquin Park—or any other body of water, for that matter. If you see an overturned canoe, you check, and you check very carefully. But Martin Blecher, Jr., later suggested that he and his sister

assumed the canoe was not a sign of distress but one recently reported missing by the Colsons, who owned the Algonquin Hotel on Joe Lake. He said he thought he and Bessie would tow it back on their return, only to find, on their return, that it had vanished.

It is baffling that this canoe has so often been taken to have been Tom's. Fleets of canoes belonging to camps and lodges tended to be painted one colour—either red or green or sometimes yellow—for convenient identification. But Tom had deliberately painted his beloved Chestnut canoe a dove colour (actually a pale bluish white) precisely so it would be seen as unique. The canoe was known by everyone on Canoe Lake, and it would have been especially recognizable to the Blechers, since they would have seen him paddling it daily as he came and went from Mowat Lodge and the Trainors' cottage. If indeed it was overturned, the distinctive colouring would have been most prominent. So too would have been the metal strip on the keel side that Thomson had installed to save wear and tear when he pulled the craft up on shore. Most on the lake also knew about the metal strip and how fussy Thomson was about the care of his familiar canoe.

The Blechers had mentioned the Sunday afternoon canoe sighting to Shannon Fraser on Monday morning, yet Fraser said nothing to the nearest authority, Mark Robinson, for a full day. And as Robinson's journal entry is ambiguous—Fraser telling him that the Blechers had found the canoe "and wanted us to drag for Mr. Thompson's body"—it is impossible to say which of them had suggested the dragging: Martin Blecher, Jr., or Fraser?

How could the Blechers ignore an overturned canoe, assume it belonged to the hotel up on Joe Lake, not recognize it as the distinctive canoe that most everyone knew well and then later decide that Tom must have drowned and was now at the bottom of the lake? It makes no sense.

The canoe they saw was far more likely the one missing from the Algonquin Hotel. On Friday the 13th, five days after the canoe sighting, Robinson recorded in his journal that he and his son Jack had found "Mr. Colsons Canoe or Canvas Boat" abandoned on the Gill Lake

portage. But there is no mention as to whether Robinson thought that this was the canoe that the Blechers had ignored on Sunday the 8th. It could have drifted there or been hauled up by someone who'd found it floating in Canoe Lake.

No matter what canoe the Blechers saw that Sunday afternoon, there is no doubt that on the morning of Monday, July 9th, Tom's dove-coloured canoe was found. There are conflicting tales as to whether the canoe was found floating upside down or right side up, but no disputing that it was his and that Tom was really missing. Ottawa florist and park visitor Charlie Scrim and Mark Robinson noted that Tom's "working" paddle—the one he preferred to paddle with, using other paddles tethered to the seats and thwart to form a shoulder support for portaging—was missing. If Tom had flipped, the paddle should have been easy enough to find floating, but it never was discovered despite searches that went on for years afterwards. This was, in fact, the first evidence that cast real suspicion: if Tom had not been paddling, how did his canoe end up floating on the lake, upside down or right side up, and he at the bottom?

Shannon Fraser sent telegrams to the Thomson family in Owen Sound and to Dr. James MacCallum in Toronto, informing them that Tom's canoe had been found and that Tom had not been seen since Sunday at about noon. Robinson reported the situation to Algonquin Park superintendent George Bartlett at the Cache Lake headquarters, and Bartlett instructed his ranger to begin a search of the nearby woods. Robinson and his young son hiked trails to the south and west and walked in to Gill Lake but could find nothing, not even fresh tracks after the rain. Robinson tramped through the portages and along the paths every day that week but found no trace of Thomson.

On Thursday the 12th, Fraser wrote to MacCallum: "Dear Sir. Tom left here on sunday about one o'clock for a fishing trip down the lake and at three oclock his Canoe was found floating a short distance from my place with both paddles tied tight in the canoe also his provision were

found packed in the canoe. The Canoe was up side down We can find no trace of where he landed or what happened to him Everything is being done that can be done his brother arrived this morning Will let you know at once if we find him."

George Thomson, who was on vacation in Leith, visiting his parents and his wife's parents, was dispatched by the family to look into matters at Canoe Lake. George arrived on Thursday morning, and Mark Robinson took him around the lake in wet weather, introducing him to various people and going over, again, what little was known about the situation. Robinson also used the crude rangers' telephone line to ring up Ranger Albert Patterson and have him go into Huntsville "to search into matters there."

What "matters"? Patterson was stationed at Moose Lake, now called McCraney Lake, near the western boundary of the park, so he was in the handiest location for making such checks, whatever they entailed. Perhaps Robinson merely wanted to find out whether anyone in Huntsville had seen Thomson or whether he had been seen at the station at Scotia Junction, catching a train north, for Robinson still believed that Tom would show up and all, eventually, would be explained. The ranger's journal entry also raises questions. He usually wrote in brief, straightforward terms, so why would he not say the ranger had gone to Huntsville to find out whether Tom's friends the Trainors knew anything? "To search into matters there" seems to suggest an avoidance of mentioning what those matters might be. Could it be that there was gossip around the lake about a marriage the artist might be trying to avoid? Was there some sense that perhaps Thomson— having stocked up on supplies from Mowat Lodge—was not off for an afternoon fish but on the lam from responsibilities he was not in any financial position to face?

In letters and in conversations, Thomson had suggested that he might head west at some point in 1917 to do some painting. In April he had written that letter to his brother-in-law Tom Harkness, saying, "I may possibly go out on the Canadian Northern this summer to paint the

Rockies but have not made all the arrangements yet. If I go it will be in July and August." It was now early July.

George stayed at Canoe Lake only two days—a remarkably short time, considering that his younger brother was missing and the discovery of his dove-grey canoe suggested that something terrible might have happened to him. Surely George must have been deeply concerned—to think otherwise is simply impossible. But he might also have been a bit miffed over being forced to take on an onerous family responsibility that so often falls to the eldest son. As George was also a painter, and a good one, he may well have been envious of his younger brother's growing success. It can be fairly assumed that he profoundly disagreed with Tom's irresponsible lifestyle. George Thomson—who looked more like a banker than an artist with his close-cropped, thinning hair and carefully trimmed moustache—frowned on drinking and believed a man should support a family with a real job, even if that person believed himself to be an artist—as he did himself.

So after two nights at the lodge, George apparently gathered up his younger brother's sketches, that remarkable day-by-day record of the spring of 1917, and caught the next train west out of the park. His actions seemed most curious.

"I have never understood or read any plausible explanation why George Thomson visited Canoe Lake immediately after Thomson's disappearance," art expert David Silcox wrote in *Tom Thomson: The Silence and the Storm*, "and then not only left while everyone else continued the search for his brother, but took most of Thomson's sketches away with him. If he presumed him dead, why did he not take all of Thomson's belongings? And if he thought he might still be alive, why would he not have helped with the search, and why did he take away work that Thomson might have wanted? His behavior was odd, to say the least."

News of the painter's disappearance had found its way into the papers. The *Globe* reported that Thomson was "missing." The *Owen Sound Sun* suggested he had "likely drowned." Yet while the newspapers

were hinting at the worst, Robinson carried on the search for his friend. He and his son began checking the islands and portages into other lakes. There is no indication in his reports or in any other recollections that they ever dragged for a body. Dr. Robert P. Little, who had been on a canoe trip in the area at the time, later wrote a small essay in which he claimed that "Dynamite was exploded in the lake without result," but this is difficult to imagine, as Robinson makes no mention of this in his journals, and he would have had to authorize its use. He had stuck to his original belief that Tom was not in the water but was somewhere else. Hurt perhaps, but alive.

Ranger Patterson returned from Huntsville with no news of Tom's whereabouts. Robinson and his son kept searching, now moving deeper into the surrounding bush where Robinson would blow his whistle and even fire the odd shot in the air without getting any response. Curious about the missing "working" paddle that should have floated, he went around the Canoe Lake shoreline on Sunday, searching in vain for any sign of it.

Monday, July 16th, produced a fine and clear morning. Robinson noted in his journal that he baked bread before heading out once again to look for the painter. He was beginning to wonder if they'd ever find out what had happened or where Tom was.

But in an instant all that changed.

"Charlie Scrim come walking to the door, tears running down his cheeks," Robinson later recalled.

"Mark," Scrim said, "they've found Tom's body."

"What?"

"They've found Tom's body."

"*Where?*"

"Dr. Howland," Scrim sputtered. Dr. Goldwin W. Howland, a neurologist at the University of Toronto, had taken over Taylor Statten's cabin on Little Wapomeo Island for a couple of weeks while the Stattens

spent the month of July at Springfield College in Massachusetts, attend-
ing the YMCA Training School. Statten and his wife, Ethel, would not
be coming back to their island cabin on Canoe Lake until August.

Howland had apparently been sitting at the front door of the
Stattens' cabin early that morning when he saw something rise in the
water not far off the shore. Lawrie Dickson and George Rowe, the two
guides who lived on the old Gilmour mill property, were paddling down
the lake, and Howland called to them to shift direction and check on
whatever it was that was bobbing in the water. Rowe called back that it
was probably a loon, but Howland persisted until they turned slightly
and paddled over. It didn't take long for a shocked Rowe to shout back,
"It's Thomson's body!"

Howland later said he believed his young daughter might have loos-
ened the body from whatever had held it down so long when they'd
been out fishing the previous evening and the little girl had snagged
something solid while trolling through the channel between Wapomeo
and Little Wapomeo islands.

Whatever had caused the body to rise, it was now on the surface,
badly bloated, with the flesh tearing in places, yet the guides knew
from the hair and clothes and circumstances that it had to be Tom. It
could be no one else. Howland suggested that they tow the body over
to the shore and tie it to some tree roots that were hanging over the
rocks. Being a medical man, he knew better than to haul a bloated
body out of the water into the sun. After days of overcast and drizzle, it
was finally brightening up, and on land, in the sun, the bloating would
worsen and the rotting flesh split and tear. Once they had secured the
body, they went to notify the authorities, beginning with Robinson,
the local ranger.

The affidavit signed by Dr. Howland on July 17, 1917, said: "I saw
body of man floating in Canoe Lake Monday, July 16th, at about 10 A.M.
and notified Mr. George Rowe a resident who removed body to shore. On
17th Tuesday, I examined body and found it to be that of a man aged
about 40 years in advanced stage of decomposition, face abdomen and

limbs swollen, blisters on limbs, was a bruise on right temple size of 4" long, no other sign of external marks visible on body, air issuing from mouth, some bleeding from right ear, cause of death drowning."

The grisly scene of a bobbing body lashed to tree roots was disconcerting to all who saw it. Robinson recorded that Hugh Trainor helped cover the body with a blanket. Hugh and Margaret Trainor were staying at their cabin—he likely helped with the search—and they would have sent word to Winnie, at work in Huntsville and surely dreading bad news, that Tom had been found, dead.

At this time the Thomson family was aware only that Tom had been found. A badly worded telegram from Fraser left confusion at first as to whether he had been discovered dead or alive. A second telegram made it clear and asked Tom Harkness for directions to be telegraphed back as to what the family wished done with the body. They, of course, wanted their son returned home for burial and Harkness sent a telegraph to the attention of Shannon Fraser at Mowat Lodge requesting this. For whatever reasons, that telegram of instructions never reached Canoe Lake—or, if it did, was ignored.

Had telephone service been available, the confusion might have been avoided, but the only existing phone lines ran along the railway track, connecting several ranger cabins to park headquarters. It was impossible to phone outside the park or to call in. The only way to send messages was by telegraph or by letter.

Mark Robinson said later that the quick burial was his suggestion. "He was my friend," he said, "and that was getting under the skin pretty badly, and I called the Superintendent in the morning and I said, 'Look Mr. Bartlett, Thomson was my friend and I hate to think of him lying there.' I said, 'It's not right.' He said 'I agree with you.'"

Bartlett had already requested, by telegraph, the presence of the coroner from North Bay, Dr. Arthur E. Ranney, but Ranney had yet to arrive. As Bartlett considered himself to be the near-total authority in the park, he decided to act as ex officio coroner, signing the required papers for burial and telling Robinson to have the undertakers embalm

the decomposing body so that a small funeral and burial might take place in the Canoe Lake cemetery behind the old Gilmour mill property.

R.H. Flavelle, the undertaker who took on that grisly task, claimed that Bartlett, in the capacity of coroner, "sent over a certificate of accidental death by drowning." The official conclusion, then, was already set in motion before the coroner even arrived from North Bay. Robinson later claimed that Bartlett told him directly, "You'll have to handle it for the government."

Robinson telegraphed his cousin, Roy Dixon of Sprucedale, a small village on the Grand Trunk line as it passed Scotia Junction and continued west toward Georgian Bay. Dixon was trained as an embalmer, and he, in turn, contacted Flavelle of Kearney, a furniture dealer who also sold caskets and acted as the village undertaker. The two men headed for Canoe Lake, Dixon staying with his cousin at the Joe Lake ranger quarters, while Flavelle stayed at Mowat Lodge. The two guides who had found Thomson's remains, Rowe and Dickson, had apparently stayed up all night, keeping guard over the body that still lay lashed to the roots and covered with a blanket. It would have been stomach-churning to watch, with the waves lightly lapping and the steady sound of their friend's body rubbing against the roots and the rocky shore.

Robinson arranged for the body to be taken to the nearby point on Wapomeo Island and laid out on planks so that Dixon and Flavelle could do their work. The ranger and Dr. Howland oversaw matters, Robinson noting that the body had a bruise over the left eye and fishing line wrapped multiple times around the left ankle. This struck him as curious because Thomson's fishing rod and line had not been found in his canoe, though other provisions had been stashed safely and survived. Dixon asked whether Robinson had a knife he could use to cut off the line. The ranger cut the line himself, counting as he unravelled the coils. The fishing line had been wrapped—carefully, Robinson thought—sixteen or seventeen times around the ankle. It was not, in his opinion, Tom's regular fishing line.

Robinson's journal suggests that, right from the beginning, there was suspicion and disagreement among the locals as to what had happened to Thomson. By Wednesday, two days after the artist's body had been found, Robinson wrote in his journal: "There is Considerable Adverse Comment regarding the taking of the Evidence among the Residents."

Robinson kept his own strong suspicions to himself, not noting them in his journal. But he did have his doubts. In an interview with Rory MacKay for the Algonquin Park archives, Robinson's younger son, Mark Robinson, Jr., said, "I don't think that he ever felt that it was an accident. My [older] brother [Jack] was there with him and he was old enough then to remember, and the way the twine was around the legs, I don't think there could be any doubt that he was done in for one reason or another."

Some two weeks later, Robinson wrote down a rough inventory of the known facts concerning Thomson's disappearance. Tom Thomson's canoe—whether found floating upright or upside down—contained a stash that included a rubber sheet, a one-gallon can of maple syrup and a large tin of jam. At the Mowat Lodge dock, from which Thomson apparently set out on July 8th, three old tin pails were found, along with a pair of buckskin moccasins (Thomson had more than one pair), three trolling spoons, some fishing line and an axe. According to Charlie Scrim, Thomson left carrying three small pails containing a small quantity of rice, sugar and flour, a half-dozen potatoes, a small frying pan, a rod, a reel and a landing net (a different tally from what Fraser had listed). He was wearing khaki trousers, white canvas shoes, a lumberman's grey woollen shirt and no hat.

It is difficult to say what, if anything, this list means. It does not include the supplies that Shannon Fraser said he fetched for Thomson just before the painter paddled away from the dock at precisely 12:50—according to Fraser, who claimed to have carefully checked his timepiece. It suggests that Thomson did not take his axe, which would be most peculiar, given that he clearly planned to make a meal or meals in the bush, which would require kindling and wood for a campfire. In such a setting, an axe would be considered almost as important as the canoe

and paddle. The working paddle, Robinson noted elsewhere, was not found. On the other hand, if the canoe was found floating upside down, as some claimed it had, the axe would have been the first thing to sink had it been loose. Thomson's familiar paddle, however, would have floated and, almost certainly, been found.

Whatever had happened—accidental drowning? murder? suicide?—the one undeniable fact was that Thomson was dead.

On Tuesday, July 17th, very early in the morning, a distraught Winnie Trainor arrived alone by train. Ten-year-old Rose Thomas, whose parents ran the Canoe Lake station, saw her step down from the coach. Decades later, Rose claimed to recall exactly what Winnie looked like when the train pulled in: she was wearing a beige coat with matching beige hat, and her black hair was smartly braided. "I asked her in but she said she'd rather not," Rose told park historian Rory MacKay in 1976. "So she went and stood on the bridge . . . I can always remember her standing on the bridge and looking down into the water."

After a few minutes staring into the calm, tea-coloured waters of Potter Creek, she turned and headed down the pathway toward Mowat Lodge and her family's cottage, and from there she went by boat to the island where Tom lay. She insisted on being allowed to view the body. She wanted to know on whose authority Tom was to be buried at Canoe Lake. She wanted to know whether the family had been informed and whether they had made their wishes clear. She wanted to know why they were not going to wait for the coroner's arrival from North Bay. She was very upset and later told the Thomson family that she had "suggested things but was refused."

She was given no answers. Mark Robinson was the only authority present, and park superintendent Bartlett, who had already approved the burial, was acting on behalf of the coroner. Undoubtedly, Robinson and the other men present, Winnie's father included, thought they were protecting a distraught woman by keeping what they felt were her

sensitive feminine sensibilities from an image she would never forget: the swollen and decomposing cadaver of her special friend. Young Jack Robinson had seen the body and, years later, said he could never get the memory of that shocking moment out of his mind. But the refusal angered Winnie Trainor even more—she would never forgive Mark Robinson for this—and she became very agitated, but the ranger would not change his mind, and the men proceeded with the plan to bury the body as quickly as possible.

Shannon Fraser had said nothing about receiving a telegram from the Thomson family, though he had himself requested one and Tom Harkness had sent instructions.

Winnie had her reasons for demanding to see the body. There were certainly physical matters to puzzle over, and the small Canoe Lake community would already have been buzzing with talk about the bruised temple—Dr. Howland saying the bruise was on the right side, Robinson noting in his journal that it was on the left side—and the fishing line wrapped around the left ankle. Robinson said the line was a cord that was easily cut with a sharp knife. The preferred method of fishing for summer lake trout in the early years of Algonquin was to weigh down such line with sinkers or lures to get down deep enough, to where the trout would have moved by July. Those who fished alone in canoes would sometimes wrap their line around a notched board that could be worked by hand and foot, sometimes a bare foot. But Robinson noted that the line appeared to have been wrapped carefully and deliberately, which meant it would not have been the result of Thomson going into the water and having the line spin around his ankle as he rolled toward the bottom or in the light currents of the lake. Robinson did not believe the line he cut belonged to Thomson. He concluded that it had been wrapped so neatly and tightly that it could not possibly have happened accidentally.

While Robinson cut the line free, Dr. Howland examined the body. The undertakers drained what fluids they could, to reduce the swelling, and washed the body clean. Though Robinson was intrigued by the gash on Thomson's temple—saying later it looked as if he had been struck by

a paddle—he kept his suspicions to himself. Howland, for his part, never even considered the possibility of foul play. He signed a Province of Ontario Medical Certificate of Death and recorded the date of death as July 8, 1917, and entered the "Disease causing death" as "drowning." There seemed no doubt in Howland's mind.

On the 17th, Dixon and Flavelle embalmed the body right there at the shore of Wapomeo Island. Robinson said they used double the amount of embalming fluid that would normally be required, and the Thomson family was presented with bills that claimed the same. The body was placed in the wooden casket that the undertakers had brought in on the train. They then hauled the coffin up to the little cemetery, where guides Rowe and Dickson had already dug a deep grave just to the north of where the Hayhurst boy and Watson, the mill worker, had been buried years earlier. The guides had already placed the wooden shell for the coffin in the grave.

"We placed the casket in it," Robinson recalled later, "there was a funeral service read, I had taken my little Anglican Prayer Book that was given when I was a boy—I generally carried it with me—and he, Mr. Blecher Senior, read the service from it, and a very nice funeral was held. There was several from the hotel in attendance and around about."

One of those was Charles Plewman, a young man who was a guest at Mowat Lodge and who was pressed into duty as a pallbearer, even though he had never met the painter. He helped those who actually knew Thomson lift the coffin and place it on the back of Shannon Fraser's horse-drawn cart—ironically, it had originally been a funeral wagon and was known about the lake as Fraser's "hearse"—for the trek across the flats of the former mill site and up through the pines and aspen to the cemetery.

"Tom Thomson's burial was a sad and forlorn affair," Plewman wrote many years later. "The sky was overcast and the rain was falling. It had all the earmarks of a backwoods funeral."

Apart from the two undertakers, just eighteen people attended. The Blechers all came: father, mother, sister and brother. Robinson,

Dickson, Rowe, Scrim, the Frasers, the Trainors (mother, father and Winnifred), the Colsons (three, as Colson's sister ran the store) from the Algonquin Hotel and Mr. and Mrs. Edwin Thomas from the Canoe Lake train station. None of Thomson's painter friends were present. Jackson, Harris and Varley were off at war. Lismer was living in Nova Scotia. As for the others who were closer at hand—MacDonald, Beatty and MacCallum—none of them had come. And there was no one at the graveside to represent the Thomson family.

Winnie was the closest person there to a family representative, as subsequent details would prove. In some strange and very sad way, she had become a widow before she even married.

EIGHT THE HAND OF WINNIE TRAINOR

The instructions that Shannon Fraser had requested from the Thomson family were sent but either never arrived or were deliberately ignored. It was not until the next day, July 18th, that Fraser decided to write a letter—not send a telegram, which would have been much faster—to Tom Thomson's father informing him that "We found your son floating in Canoe Lake on Monday morning about nine o clock in a most dreadful condition the flesh was coming off his hands. I sent for the undertaker and they found him in such a condition . . . he had to be buried at once he is buried in a little grave yard over looking Canoe Lake a beautiful spot. The Dr found a bruise over his eye and thinks he fell and was hurt and this is how the accident happened."

Fraser appears to be justifying the quick burial, which would suggest he had, in fact, received the telegram of instructions from Tom Harkness, the painter's brother-in-law, but chose instead to let the burial go ahead and inform the family of what had happened by letter. However, by the time Fraser had mailed his letter, they'd already received a late-night telephone

call from Winnifred Trainor, letting them know that Tom had been buried. Somehow, perhaps at the Canoe Lake station, she'd found out about the family's wishes that the body be buried in the family plot at Leith. In a letter she sent on August 11th to Harkness she made reference to a "telegram of instructions" that she saw while catching the evening train. "I had quite a hard struggle even to see it," she wrote to Harkness. She offered no other insight, so he must have known to what she was referring.

In retrospect, she wrote, "I'm sorry I did not go up the day before." She said she had suggested things at Canoe Lake—surely referring to her confrontation with the men over her right to see the body for herself—"but was refused." She wrote that once she got to the lake and realized plans were in the works to bury Tom, with an embalmer and undertaker already there, "I did everything in my power to get things righted. I was told there it could not be done, but I thought I'd have a try and that time was precious."

She said she got off the train at Scotia Junction to make the connection to Huntsville, but instead of taking the next train she stayed on to contact the Thomson family and, it would appear, another undertaker in Huntsville. The wires were down, she said, but she was able to find the agent and managed to send out some messages "all free of charge, & perfectly lovely about it all." She said she worked until around 3 a.m. on July 18th. She would have contacted the Thomson family around midnight. A letter that Tom's sister Margaret wrote to another sister, Minnie, five days after the burial said that "Miss Traynor, a friend of Tom's" informed them at twelve o'clock by telephone—she says by telephone, while Winnie's letter suggests by wire—that "the body had been buried and wanted to know if we would like anything done. We told her we wanted him home, so she did everything in her power and stayed up all night to help us. She called George at three o'clock that night again and in the meantime she was doing everything she could to help make arrangements."

Winnie was quickly suspicious of Shannon Fraser's role in Tom's swift burial. When she happened to meet Tom's sister Margaret a few weeks later at a small Toronto memorial exhibition of his works, she told

Margaret that Fraser had indeed received Tom Harkness's telegram of instructions but "didn't let on to anyone." Winnie said she could not understand why anyone "would want to keep that to himself."

Once Winnie made it home to Huntsville early on July 18, she went to the telephone exchange there and made six calls at a total cost of five dollars. We know this precise figure because the Thomson family ended up with the bill, which suggests she was not only working on their behalf, but was also reimbursed for her expenses. The bill was paid by Miss W. Trainor on July 25, 1917. The six calls are all dated July 18, the day after Thomson was buried at Canoe Lake.

She made two calls to "Mr. Thompson, Owen Sound," one that cost $1.10, and another, longer one, for which she was charged $2.50. The remaining four calls were all to "Mr. Flavelle, Kearney," the furniture-dealer-cum-undertaker, who had been present at the embalming of Thomson's body. The four calls to Flavelle—one long discussion at 70 cents, one at 35 cents and two brief, perhaps abrupt, calls at 20 cents and 15 cents—were likely followed by her second call to the Thomson family, during which she reported on her failure to convince Flavelle to exhume the body he had just buried and then ship it back to the family in an appropriate, sealed casket. He may not have had such a casket in Kearney. Winnie suggested that the family not bother with Flavelle any longer and turn, instead, to someone she knew who would do the job the family required. The family agreed.

Winnie then got in touch with the Huntsville undertaker, F.W. Churchill. The only account of events we have from Churchill came in an interview he gave nearly forty years after Thomson's body was buried. He was seventy-three years old at the time and suffering from a faulty memory. He told the reporter who contacted him: "Mr. Thomson's relatives and friends were not happy with the burial spot. Miss Blodwen Davies, a friend, wanted him buried at Leith. She phoned the undertaker in Kearney, who had been in charge of the funeral near Canoe Lake, but he refused to exhume the body. Then she phoned me in Huntsville. I was not anxious to do the job, but she begged me and finally I said yes." He

said that the woman would not take "no" for an answer and was deter-
mined to "get things righted." Of course, Churchill is confusing Thomson's
first biographer, Blodwen Davies, with Winnie Trainor.

Sixty years after Tom Thomson was buried, notes on the events of
1917 compiled by Charles Plewman, the young Mowat Lodge guest
who had served as a pallbearer, appeared in the *Gull Rock Gazette*, pub-
lished by the alumni association of a summer camp Plewman had
founded in the Haliburton Highlands in the early 1930s. Plewman was
now dead, but his remembrances confirmed that Winnie had acted on
behalf of the absent Thomson family. He believed, accurately, that the
Thomsons had learned of Thomson's Canoe Lake burial only when
Winnie called them from Huntsville. He believed the family then
asked her to make the arrangements for the exhumation of the body
and its return to Owen Sound.

"Apparently," Plewman wrote, "because Winnie was familiar with
what had happened, the family agreed that she should represent them by
making arrangements to have the body removed. She phoned the origi-
nal undertaker at Kearney and tried to persuade him to act. He refused.
She contacted Mr. Churchill the undertaker in Huntsville pleading
with him to act. He could come down on the evening train, get the job
done that night, and return the next morning. She offered the help of
several men who were staying at the Lodge."

We know that Winnie had taken the evening train out on July 17,
immediately after Tom Thomson had been buried, so she was no lon-
ger at Canoe Lake when the coroner, Dr. Arthur E. Ranney, finally
arrived from North Bay later that same evening. After Ranney's train
pulled in at about 10:30 p.m., he had a quick meeting, over tea, with
Mark Robinson while the ranger filled him in on the essentials.
Robinson then took the coroner to the Trainor cottage, where they
were met by Martin Blecher, Sr., who invited them to repair to his
larger cottage nearby for dinner. Dr. Ranney, who had not eaten since

boarding his train, accepted enthusiastically. The various witnesses and interested persons assembled there were Dr. Goldwin Howland, Martin Blecher, Sr., Martin Blecher, Jr., Shannon Fraser, Mark Robinson, J. Ed Colson (who owned the Algonquin Hotel), guide George Rowe and one person identified as "Tourist" (who was likely Charlie Scrim, the Ottawa florist who hung around with the guides). After a hearty meal was served by the Blecher women and eaten by the men, the gathering then turned to holding an official inquest, Dr. Ranney presiding.

Dr. Howland told the coroner that the body had been in an "advanced state of decomposition" when it was discovered, that there had been bleeding from the right ear and a bad bruise on the temple. Though Ranney never viewed the body himself, he wrote in a 1931 letter to Thomson's biographer Blodwen Davies that there was a ". . . bruise on the right side of head, temple region, about four inches long, this no doubt caused by striking some object, like a stone when the body was drowned." He was merely repeating Howland's observations.

In Robinson's journal entry for July 17th, the ranger noted that he and Howland had examined the body. "We found a bruise on left temple about four inches long," he wrote. "Evidently caused by falling on a Rock"

The coroner, apparently, did not question whether the bruise was in fact on the right or left temple but quickly accepted that the injury was most likely caused by Thomson striking his head on a rock, either before or after he slipped into the deep waters off Little Wapomeo Island. Not long after midnight, Ranney called an end to the inquiry, endorsing the original assessment made by Superintendent Bartlett: death by drowning. Bartlett hadn't seen the body either. Nor had he made the effort to attend the inquest.

Mark Robinson was troubled both by the verdict and by how superficial the inquiry was. As he remembered in 1953, "almost before we had time, Dr. Ranney said, 'Clearly a case of accidental drowning. Accidental drowning is the verdict.'" Robinson claimed one of the "old guides"—he

did not name him, but we can assume it was George Rowe because Lawrie Dickson was not present—attempted a weak protest but got nowhere. Robinson, too, held his tongue. In the letter, he wrote: "Dr. Ranney of North Bay conducted what inquest was held. Tom was said to have been drowned. It may be quite true but the mystery remains."

At about one in the morning, Martin Blecher, Jr., ferried Dr. Ranney and Mark Robinson to Joe Creek in the Blechers' boat. They walked from the landing to the ranger's shelter house. Robinson noted in his journal of Wednesday, July 18th, that they arrived back at around 2:30 a.m. and that Ranney slept briefly before catching the 6 a.m. train to Scotia Junction, where he boarded the train back to North Bay.

"Later in the day," Robinson recounted, "S Fraser received telegram that a steel casket was being sent in and Thom Thompsons body was to be exhumed and taken out By whose Orders I am not at Present aware."

They were confusing times. The telegram to Fraser concerning the exhumation could have come from Churchill, the undertaker who had been assigned by Winnie Trainor to exhume the body; from Winnie herself; or from the Thomson family in Owen Sound. No matter, Robinson clearly felt that he should have been informed, as he remained the official voice of authority for Canoe Lake.

Dr. Ranney supposedly filed his report back in North Bay, but research by William Little for his 1970 book could not find it; nor has it turned up since if, in fact, it ever existed. All that survives of Ranney's work during his quick visit to Canoe Lake is a "Warrant to Bury After A View" document, granting lawful permission to bury the body to "the person in charge or control of burying grounds" at Canoe Lake, and a "Coroner's Warrant to Take Possession of Body." The latter was issued to "the Chief Constable" of Canoe Lake, Mark Robinson, giving the okay to "forthwith take in charge the body of Thomas Thompson deceased now lying dead at Canoe Lake Ont." Both documents are signed and sealed "this 17th day of July 1917"—the day Thomson was buried. Ranney, therefore, was granting official approval for acts that had been carried out before he had arrived.

Anyone who has grown up in a relatively remote, "wilderness" area that is also a tourist destination knows that a "colonial" psychology runs strong among those who live and work there. Algonquin Park was no exception to this custom. Enormous emphasis is placed on "serving" others—rich tourists, city visitors, the politically connected—who come and go. Even when I was growing up in the area in the 1950s and 1960s, the many grandchildren of Chief Ranger Tom McCormick had the sense that the Junior Ranger Program, where youngsters aged seventeen were taken on for summer employment, was not for them but for privileged kids from the city. These youngsters usually came from families with some connections, even if only minor. Dr. James MacCallum was well connected because of his work, his wealth, his prestige and his many friendships through the elite Arts & Letters Club of Toronto. The Thomson family was well connected through George Thomson and also through Tom's brother-in-law Tom Harkness. However, it is unlikely that the Thomsons ever sought to exert such influence in trying to have a fuller examination of the matter than had already been attempted through Ranney's quick inquiry. It's far more likely that others in positions of power chose to act on their behalf, believing they were protecting a highly respected and important family.

As an administrator, Bartlett, the park superintendent, tended to take the line of least resistance or least complication. When he had been named to the post in 1898, he recorded that "[t]he job included the position of Postmaster, Commissioner in the High Court of Justice, Police Magistrate, and Chief Coroner in the District of Nipissing. The Premier of the Province told me that the Park had been a blot on the Government and asked me to make it a credit."

Bartlett was determined to make his bush fiefdom "a credit" and to stay clear of any complaints from Toronto. It was Bartlett who, considering himself to be ex officio coroner, immediately declared that Tom had

died by drowning without so much as seeing his body. It was Bartlett who approved the quick burial. And it was likely Bartlett who hand-cuffed the real coroner, Dr. A.E. Ranney, who arrived to find the body embalmed and already buried. Ranney might also have been asked to sign documents that predated his arrival.

Ranney might even have been outraged by what Bartlett had done to him, which could explain his hasty, sloppy and disinterested official inquiry at the Blechers' cottage and the speed with which he got away from Canoe Lake in the morning. It may even explain the lack of a coro-ner's report. That report was always said to have been lost, but perhaps Ranney never bothered to file one, since the conclusions had been reached before he even started his inquiry.

Once Ranney arrived, courtesy alone should have required Bartlett to travel the short distance from his Cache Lake headquarters to attend. Perhaps Bartlett regretted bringing in Ranney in the first place, having sent the telegram to North Bay before he realized that this whole unfor-tunate affair would be best concluded as quickly as possible.

There were legitimate questions about the legalities and ethics of the shabby inquest—and also about the legalities concerning the paint-ings Tom Thomson left behind.

Mark Robinson might well have been frustrated with his superior, Bartlett, but he had been trained throughout his adult life—militia, park ranger, service in the war—to follow orders no matter what he might feel about the orders themselves. Later in life Robinson carefully said that, while the search had still been on for Thomson, he had been "instructed" (obviously by Bartlett) to go to "the little house" (the Trainor cabin) and see what was there that belonged to Thomson. He said he and Hugh Trainor found about forty of the spring series of sketches "laying around there" (though he maintained that the original number had been sixty-two). Robinson said he gathered the sketches up, as instructed, for the Thomson family.

This version of events is at odds with park historian Audrey Saunders's account, in which George Thomson was said to have entered

the Trainor cabin during the days before Tom's body was found and to have taken some thirty-five paintings without asking permission of either the Trainor family or the park authorities. As the responsible older brother, he would have felt well within his rights to do so, even if those rights might be open to question, especially given that the fate of his younger brother was still unknown. While Saunders's book is often said to be the "official" history of the park and was paid for by government funds, it suffered from tampering and is not considered definitive in all aspects. If Robinson's count is accurate (and if Thomson worked at a pace of a sketch a day that spring), he would have arrived at Canoe Lake around the last week of March. At the same speed of production, if Saunders is correct, he would have arrived nearly a month later. The first mention of his presence that spring in Mark Robinson's journal is May 3: "Tom Thomson called this afternoon." I believe he arrived in early April and painted until the blackflies became impossible around the end of May. It is also believed that he gave a number of the sketches away, so an exact total is impossible to calculate. Whatever the actual count, a significant number of the sketches ended up with the Thomson family and formed part of the Tom Thomson art estate, which was carefully overseen in subsequent years by Dr. MacCallum.

Before his 1953 interview, Robinson had never made mention of the visit to the cottage with Hugh Trainor to clear out the sketches—and his 1953 interview, completed when he was eighty-six, does suffer from inconsistencies with his own 1917 daily journal. It seems equally possible that Saunders got it right when she claimed that George Thomson had simply gone to the Trainor cabin alone and relieved it of thirty-five or so paintings. Before Thomson's death, those paintings were his to do with as he wished. But if they were taken from the Trainor cabin by George Thomson before his brother's body was even found, or simply handed over to him without question, what does that say of ownership? What if the paintings—even some of them—were intended to be a gift to Winnie? Or was the painter merely storing them at the Trainors' cottage, planning to ship them south himself,

to be used as inspiration for his larger canvases during the winter? We cannot know.

Winnie Trainor would raise her own questions about the paintings later, but at the time of the hasty inquest, which she did not attend and was not asked to attend, she was busy arranging, on behalf of the Thomson family, the exhumation of Tom Thomson's body by Churchill, the reluctant undertaker from Huntsville.

In the notes pallbearer George Plewman left behind, he claimed that when Churchill arrived at Canoe Lake, Shannon Fraser had transported the undertaker and his casket to the cemetery and had offered further assistance, but Churchill turned him down. Plewman claimed that Fraser was highly dubious of Churchill, who worked alone, under lamplight, and completed the task in about three hours. How, Fraser wondered, would it be possible, in that timeframe, for one man to dig up a coffin from a six-foot-deep grave, remove the body from the casket, place it in the metal casket, seal the casket and be ready for transport back to the train station? Fraser, Plewman wrote, openly doubted that the coffin that left on the train the following morning was heavy enough to contain a body. So, too, did the men who transferred the metal casket to the train heading south from Scotia Junction and on to Owen Sound.

Mark Robinson was also mystified by Churchill's behaviour. He had originally puzzled over whose "orders" Churchill was following, but it seems that, by the following day, he was satisfied that it was indeed the Thomson family who had requested the exhumation. "Mr. Churchill undertaker of Huntsville, Ont., arrived last night," Robinson noted in his journal of July 19th, "and took up the body of Thomas Thompson under direction of Mr. Geo Thompson of Conn. U.S.A."

The wording "under direction of" is somewhat vague, suggesting that George had returned to Canoe Lake, and a letter signed by him and sent to Dr. MacCallum was postmarked from Mowat the same day that the body was supposedly exhumed. Yet, much later in life, George claimed he had not been there a second time. The Owen Sound paper

did report that he had accompanied the body home, and it may be that he joined the train at some point, possibly even arriving at Canoe Lake, where he would have met Churchill and the sealed casket, posted the letter he had written on the train and then immediately caught the next train leaving. In a July 22nd letter to her sister Minnie, Tom's sister Margaret wrote that "George went the next afternoon to Canoe Lake and brought Tom's body on the Friday night train to Owen Sound." We know from Robinson's journal entry that Churchill arrived the night of the 18th, Wednesday, and was ready to catch the morning train on the 19th, Thursday, which raises questions about the "Friday night train." Did she make a mistake, that the body had arrived on the Thursday night train? Or was there a day's delay, which might explain why George Thomson said he was never at Canoe Lake a second time and had joined up with the body at one of the transfer points? No one had seen him either arrive or leave and he himself denied ever returning; but the posted letter and Margaret's letter both suggest that he must have been there, even if briefly.

On July 21st, Tom Harkness, who was handling the estate, paid out certain expenses to George Thomson, including $37.75 in rail fare, another $8.15 fare for the casket, $1.80 to purchase "Cigars for Rangers," $1.50 to ship the sketches, 60 cents for a telephone call to Toronto (likely to Dr. James MacCallum, whom the family had asked to handle Tom's art inventory) and $4.40 in "Expenses to Churchill Undertaker." Given that this suggests that George Thomson had already paid the undertaker, who had returned to Huntsville, it seems probable that George did accompany the body home.

Mark Robinson did not see George Thomson at Canoe Lake after Tom was buried. In his long 1953 interview, Robinson said he had known nothing of the exhumation having taken place until he went to the train station early Thursday morning and found a man standing beside a steel coffin that had been soldered about the edges. Robinson went on to describe his conversation with the undertaker:

I looked at it. I said, 'What's the idea?'

The gentleman standing there said, 'What's so and so to you?' I showed him my badge.

'I'm sorry,' he said. 'I have Thomson's body in there. It's being taken to Owen Sound for burial.'

I asked him, I said, 'Should you not have reported to the authorities before you touched a grave?' I said, 'That's an official cemetery over there.'

'No,' he says, 'it's not necessary; when I get instructions to remove a body, I do so.'

Robinson said he went to the ranger's crude telephone and immediately reported this transgression to Superintendent Bartlett, who told him: "'Now, Mark we've had enough trouble over that thing. I hope that you'll let it settle. Say nothing about it—if they want to take the body, let them take it.'"

Robinson, of course, obeyed. Once the train had left with Churchill and the metal casket, Robinson says he was called by Bartlett, who wished him to go to the cemetery and make sure everything was filled in. "Close it up," he instructed the ranger.

Robinson said that when he got there, he was surprised by how little there was for him to do. He found a hole no bigger than what "any ground hog would make"—a scooped-out hole about twenty inches deep.

"God forgive me if I'm wrong about it," Robinson said, "but I still think Thomson's body is over there. And I may state right here . . . I think Thomson was struck on the head with a paddle by some person that afternoon (referring, of course, to the afternoon of Sunday, July 8th, which was taken to be the last time anyone had seen Tom thanks to Shannon Fraser's testimony).

"I don't think Thomson died a natural death from drowning."

NINE THE SEALED CASKET

Nearly forty years after this remarkable week at Canoe Lake, undertaker F.W. Churchill was indignant to think that anyone could question his ethics. But this is exactly what happened in 1956 in the days following the discovery of human bones in the spot where he had supposedly exhumed Tom Thomson's body. He was then living in Kirkland Lake, Ontario, and had been contacted by the Canadian Press for comment following the news report of a skeleton being uncovered at Canoe Lake. The retired undertaker was adamant that he had, indeed, exhumed and shipped the body to the Thomson family in Owen Sound. He claimed that four men had been assigned by Ranger Mark Robinson to help him. Robinson could neither verify nor deny this claim, as he had died the previous Christmas, and Churchill was adamant that the job had been done properly. No matter that Robinson had never noted this in his careful journals—or in subsequent letters or interviews—and had, in fact, expressed great surprise when he first encountered Churchill and his casket on the Canoe Lake platform, preparing to leave the park.

"We opened the grave and took the coffin and the rough-box out of the grave," Churchill told the Canadian Press. "The body was badly decomposed but still recognizable as Tom Thomson. I transferred the remains into a metal box which I could seal. The empty coffin and rough box were put back into the grave and the grave was filled again.

"We placed the metal box with the body in a coffin and shipped it to Owen Sound, as Miss Davies [he meant Miss Trainor] had requested. One of Mr. Thomson's brothers accompanied the coffin on the train to Owen Sound.

"There my instructions ended, but I heard that the undertaker from Owen Sound saw to the burial of the coffin in the cemetery at Leith."

The question of the sealed casket has long been its own mystery. If, indeed, Churchill had placed the body in a sealed casket for the train journey, he would have had to bring the necessary tools along to solder the casket shut—and this would take considerable time. He might have arrived, and departed, with an already-sealed coffin.

Proof that Churchill had, in fact, completed his assignment was said to lie in the contention that there had been a "viewing" of the painter's body once the casket arrived back in Owen Sound. This claim dates mostly from interviews with two elderly sisters, Agnes and Margaret McKeen, for a 1969 story in the *Owen Sound Sun Times*. They likely stepped forward in reaction to a CBC documentary on Thomson aired at about that time, which had suggested that the body had never been moved from Canoe Lake. The sisters wanted it to be known that their late cousin, John McKeen, had been a neighbour of the Thomsons and had had the difficult task of accompanying the painter's father, as the casket top was removed at his insistence.

"Mr. Thomson," the paper reported the elderly sisters as saying, "expressed relief that he no longer had doubts as to the whereabouts of his son."

This all seems rather strange. In the first place, no one back in 1917 had any reason to doubt that the coffin contained anything but the remains of Tom Thomson—so why would there be "relief" regarding

"the whereabouts of his son"? No questions had yet been raised about the whereabouts of Tom Thomson's remains. Decades later, when William Little published *The Tom Thomson Mystery*, he noted in his acknowledgements a debt to a "Mr. John McKeane (deceased) of Leith, Ontario." Surely this would be the same John McKeen who supposedly viewed the body. It seems beyond belief that McKeen, while alive, would not have mentioned this critical witnessing of the body to Little, as Little's book was arguing that the body had remained at Canoe Lake and had never been transported to Leith as the undertaker Churchill had so vehemently claimed.

But there are other questions concerning the McKeen sisters' remarks. First would be the state of the body. "*The stink!*" Mark Robinson's daughter Ottelyn said in a conversation with me in 1977. "*No one* would transfer it if they could avoid it."

"I can't imagine anyone un-soldering the metal casket in Owen Sound to see the body," says Phil Chadwick, a weather scientist who has long studied Thomson's work. "It would be just a horrible memory—and smell. One couldn't re-solder it fast enough. And to get a good look, more than three-quarters of the soldering would have to be melted away. What a mess it would have made: bent metal, melted solder, pungent odours and maybe even leaking fluids sloshing around from the handling of the casket. Not nice."

After the casket had arrived in Owen Sound, Tom's sister Margaret wrote that "None of us wanted to see him even if the body had been fit to see." She said in her letter to sister Minnie that the body had remained at the undertaker's on Friday night and that they'd held a very quiet private funeral at the Thomson home Saturday morning (July 21st). "At one time," she confessed, "we dreaded the time when he would be brought home but when the time came, it seemed so good to have him with us." She noted that "Mr. and Mrs. Fraser of Canoe Lake" had sent flowers—"but we were glad that there was not an overabundance of them. People no doubt understood his tastes and knew he would not like a display."

Four years after the 1969 *Sun Times* story appeared claiming that the family had indeed viewed the body, Toronto researcher Iris Nowell

travelled to Owen Sound to interview the McKeen sisters for David Silcox and Harold Town's book *Tom Thomson: The Silence and the Storm*. Margaret, known as "Etta" to the family, was then ninety-four and Agnes, ninety-six, yet both were eager to talk. Etta even offered the perplexing nugget that a small child was also buried in the family grave at Leith, along with Tom Thomson's casket, which was said by some to be "Tom's by some Indian woman—but who would bury it with Tom?" To the sisters, it was just one more example of the many lies that kept sticking to the late artist.

"It's not right the way people say things," Agnes McKeen told Nowell. "Not at all right when you think of the nice boy he was."

The McKeen sisters held to their story that a cousin had viewed the body with John Thomson. Nowell also went to see Wilson Buzza, whose brother had later lived on the Thomson farm following the Thomsons' move to Owen Sound.

Buzza claimed the story of the viewing was true, and yet it struck Nowell as notable that several times in the conversation he repeated, "Just keep him buried in Leith" as if idle gossip alone were capable of shifting the ground where the painter supposedly lay.

One possible explanation for the "viewing" myth is that John McKeen and old Mr. Thomson might have *said* they had seen the body, to provide comfort to the family at the onset of the earliest rumblings about whether or not the body had been returned. If telling white lies to protect loved ones were a crime, there would be no one left to sit in judgment. The other possibility, of course, is that the McKeen sisters, having reached such ripe old ages, were either misremembering or deliberately concocting a story in the hopes that it would put an end to the gossip.

There was no viewing.

Charles Plewman believed that Winnie Trainor had been directly involved and therefore knew the truth about where the body lay—which was, in his opinion, at Leith.

"Fraser and Mark Robinson did not know that Winnie had made separate arrangements with Churchill for the exhumation of the body," Plewman wrote in his posthumously published notes. "She desperately wanted to see the body to determine if indeed foul play had occurred. Personally, I believe that she got her father and brother to help Churchill, and at the same time inspected the body for foul play. From their cottage close by, they would watch Fraser return from the cemetery after leaving Churchill there. They could then go over and help him. This may be one of the reasons they took the body out of a new coffin to put it in a steel one. But why all the secrecy? Miss Trainor did not want the Chief Ranger, Mark Robinson, who had so recently thwarted her efforts to see Tom's body, to know."

This is a most peculiar statement, given that Winnie had left for Huntsville following the discovery of Tom's body and, as the Bell telephone charges to Winnie and the letter from Tom's sister Margaret both show, immediately set to work handling affairs as much as possible on behalf of the Thomson family. Also, Winnie did not have a brother. And while it might have been possible for someone at the Trainor cottage to notice Fraser and his wagon returning from the cemetery, it is hard to imagine Winnie and her father making their way in the dark to the cemetery, which is a considerable distance to hike.

Plewman argued that Winnie Trainor must have been correct in her stated belief that Tom's body had been removed for burial as "it was her habit years afterwards to remove flowers that had been left in his memory in the little cemetery on Canoe Lake." I agree with Plewman that she thought, or at least prayed, that Churchill had done his job. After all, it was she who had engaged Churchill on behalf of the Thomson family, and Winnie took enormous pride in being dependable and trustworthy.

She *had* to be sure that he was buried in Leith; otherwise, she had failed the family, and by extension, Tom.

Both Owen Sound papers reported on the artist's demise four days after Thomson's body was found. The *Times* report was formal and straightforward, simply saying he had "drowned in Canoe Lake" on July 8th, giving family history and offering some complimentary background to the artist's landscape work:

> Every year he went to Algonquin park for six months. Here he went far into the wilds, traveling at times by way of canoe and at other times on foot, and often entirely alone, so that he could study nature in its different aspects. He was with nature so much that he became a part of it, and this enabled him to paint just what he felt.
>
> In the winter months he enlarged his sketches and he had a wonderful collection in his studio in Rosedale, Toronto. His work was steadily growing in esteem and he had a very bright future before him. His pictures were steadily sought for, for the collections of the Ontario and Dominion governments. He had a bright and cheerful disposition and was filled with kindness for all. He was loved by all who knew him . . .

But the *Sun* did not shy away from the central issue. One headline read "Still a Mystery as to How the Drowning Took Place." Even so, the paper declared that "the finding of the body clears up all the uncertainties."

The *Sun* went on to say that Thomson had:

> . . . possessed a rare charm and promised to become famous amongst art lovers of the Continent for the excellence of his work. He not only painted nature, but lived and felt and understood the great beauty of the wilds. His work possessed a truth and fidelity that could only come from direct and sympathetic touch with his subject and that he had died on the threshold of fame makes his demise the more to be regretted. He was one of

the fine type of young manhood that the country has every rea-
son to be proud of . . .

Referring to the work of the late Mr. Thomson, Eric Brown,
in a recent article in the London 'Studio' says: 'Critics look to
him to carry forward the Canadian landscape painting far
beyond anything at present realized. Wandering alone the best
part of the year in Algonquin Park, inured to hardship and
reputed the best guide, fisherman and canoeman in the district,
he lives with these wonderful seasons and they live through
him. Here, again is the decorative sense . . . developed and vis-
ible in every composition. There is no loss of character; the
northland lies before you, whether it is a winding river fringed
with spring flowers seen through a screen of gaunt black pines,
or whether the green blocks of melting ice float on blue liber-
ated waters of the lake.

The newspaper reports at the time shied away from suggestions of
foul play, but speculation was rampant around Canoe Lake, as confirmed
in Mark Robinson's journal entry concerning "adverse comment" about
the gathering of evidence. To the residents of Canoe Lake, Dr. Ranney,
the North Bay coroner, had seemed more interested in Mrs. Blecher's
home-cooked meal than in taking issue with Superintendent Bartlett's
quick declaration that the cause of death was accidental drowning. Nor
did he show much patience in sorting through all the contradictory evi-
dence concerning lost and found canoes, the state of the canoe when
truly found and, most curious of all, the state of the body: blow to temple,
left or right side, air in lungs, fishing line wrapped, apparently deliber-
ately, about the left ankle . . .

Yet if Coroner Ranney had no complaints about the manner in which
the affair had been handled, Winnie Trainor certainly did. She had acted
in haste, and presumed fury, in arranging for the body to be exhumed and
taken to Owen Sound. While she had every reason to believe that her
chosen undertaker, Churchill of Huntsville, had carried out the orders she

had conveyed on the family's behalf, she remained convinced that Flavelle of Kearney had botched matters when he came to Canoe Lake with a casket that did not meet the strict shipping requirements of the railway. His refusal to correct the situation despite her numerous phone calls to him on July 18th served only to increase her distrust of him—a distrust she must have passed on quickly to the Thomson family.

Tom Harkness, the brother-in-law who handled the details for the Thomson family, wrote to Flavelle on July 23rd, less than a week after the Canoe Lake burial, to question the bill Flavelle had sent on behalf of himself and Dixon. "I may say," wrote Harkness, "that I think your account is exorbitant and I will not pay it in full, but will deduct $15.00 off price of casket and $10.00 off embalming fees, and if you are not satisfied, I will pay amount of account less $25.00 into court and you may proceed to collect the balance."

Harkness went on to explain that he was making such a large deduction only after first consulting with "competent undertakers" in Owen Sound. "I might say," he added, "that the man we got to furnish metallic lined caskets to bring the body home only charged $75.00 for his work and the casket." As for the wooden casket that Flavelle had supplied, Harkness added that it would still be at Canoe Lake—he naturally presumed empty—"and it may still be of some use to you."

Flavelle immediately responded to Harkness's tough letter, writing from Kearney on July 26th that "it is an utter impossibility to alter prices." The casket he supplied, he said, "was the best I had," and he said "the buyer" (not identified) had chosen the $75 model rather than cheaper ones he had available for $50 or $60. The model used, he added, was a 619C—sarcastically adding "for the benefit of your competent undertaker."

As for the embalmer's fees, he said he was "well aware that $10 is the usual charge for any ordinary case in town or near vicinity, but this was no ordinary case, requiring double quantity of fluid otherwise necessary." He told Harkness that the estate would have to take into consideration Dixon's railway costs (eighty-five kilometres return), meals and lodging—forgetting, perhaps conveniently, that Dixon had stayed with Robinson.

"As I said before," Flavelle continued, "this was no ordinary case. We had to go 1½ miles through the woods after leaving train, then another mile by water, taking casket with us. We then took body to an island where we embalmed it and brought it back to Mowat Lodge Cemetery where we buried it."

On August 11, 1917, more than three weeks after the burial, Winnie Trainor wrote to Harkness and confirmed his suspicions about Flavelle. Winnie told Harkness that she'd been to see Churchill, who did not wish his name used in any dispute with Flavelle but agreed to speak to her in confidence. "I know nearly everyone for miles around," Winnie boasted, "and I'm not refused anything I try. So I asked him plain questions." In Churchill's considered opinion, she wrote, Flavelle's "bill was steep." Flavelle forced the costs up when he took along Dixon, the embalmer from Sprucedale. (More likely, as Robinson and Dixon were related, it was Dixon who "took along" Flavelle.) Considering the type of casket Flavelle supplied, she was convinced he was overcharging the Thomsons.

"A copper lining costs more than the casket itself," she wrote. "So you see he is billing a good [illegible]. I would suggest to use your own judgment as you know the contents of the first telegram. Thought [illegible] composed—and you know the tangle now that has to be unraveled—owing to the thoughtlessness of not having a sealed casket—which anyone knows is needed in a case of that kind and also required by law."

She castigated Flavelle for cheap material—the rough box, she said, "I don't think had any handles on it"—but portrayed Churchill as honourable.

She also appeared to cast some doubt on charges levied on the estate by Shannon Fraser of Mowat Lodge. "If you knew Mr. Fraser," she wrote, "I think you would use your own judgment. This is strictly confidential as the Frasers are all right in their own way." She closed off by saying she would "certainly love to visit the grave at some future date," obviously meaning the grave at Leith, where Churchill's steel casket had been buried, and where she absolutely believed Tom Thomson now lay.

Though Winnie dropped numerous hints to the Thomsons that she would like to visit and perhaps have members of the family visit her family's place at Canoe Lake, no invitation was ever extended or taken up. Very quickly, the Thomson family began distancing itself from the one they had turned to in their time of need.

Winnie's letter to Tom Harkness also contained some information about letters that she and Tom had sent each other shortly before he died. She said, "Five weeks ago to-day I wrote to Tom—but he did not receive it. He also wrote to me—& our letters crossed and to-night a sad note to his brother-in-law. It seems to me almost unbelievable."

Winnie knew that Tom had not received the last letter she had written to him because Mark Robinson had given her father a number of her letters, so he could return them to her, including one that the ranger had opened himself before passing it on. "They were just ordinary boy and girl letters," Robinson said in 1953. "There was nothing extraordinary about them, and there was nothing in any way to think there was any-thing wrong with them, so I read them. There was one still to be opened. I opened it and I handed them back to Mr. Trainor. I said, 'Your daugh-ter's letters to Tom,' I said, 'keep them, give them to her,' and I expect he did so. We never asked for them afterwards for there was nothing in them in any way to cause any feelings of any kind, one way or another." Mark's interpretation of the letters he claimed to have read would one day prove to be wildly out of sorts with the interpretation of Annie Fraser, who admitted to having "snooped" on some Winnie-to-Tom letters she'd seen on the dresser of the room Tom kept at Mowat Lodge.

On September 17th, two months after Thomson was buried at Canoe Lake, Winnie wrote another letter to the Thomson family. This one was addressed to George Thomson, who had written to her, likely to thank her for her assistance in arranging for Churchill to exhume the body and deliver the sealed casket to Owen Sound. Winnie had gone to Toronto to spend several weeks with Mrs. Irene Ewing (her much younger friend,

formerly Irene May of Huntsville) and Irene's new husband, and on
August 31st they had gone to the "Ex" to take in a hastily arranged
showing of some of Tom·Thomson's works. That's where Winnie ran
into Tom's sister Margaret, who was attending the show with her niece,
Jessie Harkness, and a little boy Winnie identified as "Charles."

In their brief conversation, the subject of money and Shannon
Fraser came up, with Winnie informing Margaret that a $250 loan Tom
had made to Fraser two years earlier had not yet been fully paid back.
This would be the loan Fraser wanted to purchase canoes for Mowat
Lodge. At the time of Fraser's request, Winnie had considered the loan
"risky," as she had been aware that Fraser had been unsuccessful in bor-
rowing the money in Huntsville. She herself had refused to lend the
funds to him, only to discover that Tom, who could far less afford it, had
gone ahead and put up the cash.

The subject of the loan set her off on the subject of the Frasers, who,
she claimed, had been charging Tom too much for his board at the lodge,
among other things. "You see," she wrote, "the Frasers were money grab-
bing as usual but it will all come back to them. It was awful of Shannon
Fraser to charge cartage on the casket. When Tom the day he was
drowned helped to cadge a boat for Shannon to rent. Never mind they'll
get it yet. As far as Frasers good faith he has none. Mark Robinson the
Ranger hates him."

This out of her system, Winnie then added that earlier in the spring
of 1917, Tom had told her and her parents that he had gotten most of
the $250 back from Fraser, though it had all come in small payments.
She said it was a shame, because if she had known Tom had been this
generous, she could have intervened and, through her store connec-
tions, obtained the canoes at wholesale prices and perhaps earned Tom
$50 on his goodhearted loan.

George Thomson must also have inquired about Tom's belongings,
because Winnie enclosed a snapshot she'd taken of Thomson in the
spring, showing him wearing a green plaid Mackinaw, which must have
been recently purchased, since she added, "He also bought the Mackinaw

trousers, socks & shoepacks he has on." Her advice to George was simple: "I would think the best way would be to have the executor send for all his belongings, saying the estate required them, as Shan [Fraser] will sell the things & keep the money."

As for anything that the Trainors themselves might still have from Tom's numerous stays at the cabin on Canoe Lake, she said they could all "be had next year when we go back." She told George that she had lost her letters from Tom "after our home was burned" but added nothing in explanation. It appears she was speaking of the Trainor house in Huntsville, not the cabin at Canoe Lake, but the extent of the damage is unclear. She did indicate, though, that among the lost letters was one "where he left the Frasers dissatisfied but he did not tell the reason till the Fall 1915. Then again Tom did not care for Martin Blecher." Her letter is frustrating to read now: she hinted at so much without the slightest elaboration.

In closing, Winnie wrote that "Mrs. Fraser I think would see you got everything should you request it. I do not think Frasers deserve one thing. Tom no doubt was paying his board well, supplying fish work & etc. His canoes can be easily stored at the Lake. Tom ploughed and planted their garden & ploughed Larry Dixon's garden too." It seemed important to her that Shannon Fraser not have any of Tom's possessions. "Tom," she wrote in her final sentence, "would be greened if he knew all now." Then she signed off, simply, "W.T."

Winnie's anger over the events of July 16–17 at Canoe Lake simmered on. A considerable time after the burial, Robinson bumped into Winnie at the Kearney train depot as he was heading for Brent, where he had been transferred, and, as he wrote later to Blodwen Davies, "she understood to give me a gentle calling down for something about opening the grave at Canoe Lake. I inquired Just what was troubling her and was told nothing at all. She is Very Blunt."

Robinson seems oblivious to any possible reason for such bluntness, but in Winnie's mind he would have been the one who denied her the right to view the body. He would have been the one who pushed for the quick burial of his friend and gained permission for that burial from

Superintendent Bartlett. He was the one who had called in his cousin, Dixon, who brought along Flavelle with his casket to do a job Winnie considered completely botched. And finally, given the reference about "opening the grave at Canoe Lake," it may be that the Canoe Lake gossip that the body had never been removed had reached her ears. As Robinson had been suspicious from the beginning that Churchill had failed to do his assigned job, she might well have blamed the ranger for any rumblings there might have been about opening up the gravesite to see if the body had indeed been removed. As the one most responsible for arranging the exhumation on behalf of the Thomson family, she would have been outraged over any such suggestion that she had failed the Thomsons.

For reasons that perhaps only he understood, Shannon Fraser soon began a whisper campaign about the lake that Thomson had committed suicide. Plewman made mention of it in his notes: "Shannon Fraser did say to me, and to others at Mowat Lodge that he believed Tom had committed suicide. He was engaged to Winnie Trainor, but had become so enamoured with the northland and his love of painting, that he would not make a good husband. She was coming up from the city to have a 'showdown'. Tom, with his sensitive nature could not, as Fraser stated, 'face the music.'"

Plewman's observation that Fraser was openly promoting a suicide theory was mentioned by others over time. Perhaps this was a strategic move by Fraser, as he knew some of what was contained in those "ordinary boy and girl letters" Robinson referred to and which his wife, Annie, had snooped into. No matter what the possible interpretation—a baby coming or Thomson wanting out of a promise to marry—a suggestion that there was going to be a "showdown" between Winnie and Tom might help cover the tracks of what really happened the day Thomson went missing.

A bigger topic of conversation around the lake was the notion that Martin Blecher, Jr., might have had something to do with the tragedy.

At the wild Saturday night party at the guides' cabin, Thomson and Martin were said to have tangled at least verbally over the progress of the war. Others knew of the bad blood between Blecher and Thomson and, as mentioned earlier, it was claimed that Blecher had said to Thomson, *"Don't get in my way if you know what's good for you!"* as the party was breaking up. That exchange had been reported by some of the partiers. Then there was the curious case of the overturned canoe, which Martin and Bessie Blecher did not recognize—impossible, when you think about it—and did not investigate. Not to do so would have been highly irresponsible if, indeed, the canoe they saw was Thomson's, which I do not believe it was.

George Thomson later wrote to biographer Blodwen Davies that he "had heard that there was some ill feeling between Tom and some man in that region. It was somewhat casually referred to by some one at Canoe Lake possibly one of the Rangers, but as this was while we were still looking for Tom and I was still hopeful of his safe recovery, I didn't at the time attach any serious importance to the report." He regretted that he had been on vacation when word came that Tom was missing and, given the more than a week it took to discover the body, that "I was obliged to return to work with little opportunity of investigating conditions surrounding his death." As for the suicide theory, George dismissed it outright, saying that Tom had loved painting and was then beginning to enjoy "outstanding recognition."

He then offered up his own theory as to what had happened. The key, he thought, lay in what had caused that blow to the temple "which I believe rendered him unconscious so that drowning ensued. Of course it is hard to say what caused the bruise. It probably was an accident though it is possible to have been foul play. Personally I have always favored the accident theory though I realize the possibility of foul play. The one thing clear in my mind is that Tom could never of his own impulse have put that bruise there and any conclusion based on a group of facts omitting this one is not a sound or justifiable conclusion to my mind."

Viewed from the long-distance advantage of the present, these words from George Thomson seem increasingly relevant in terms of what happened in the weeks, months and early years following Tom Thomson's death. "In any event," he told his brother's first biographer, "speaking for the family, we would very much deplore any discussion of the matter before the public. Such a discussion would do no good and would likely result in much harm to Tom's name."

TEN POINTING FINGERS

Conspiracy theories often take some time to get rolling. Not every mysterious death of a known person comes with a grassy knoll. It took more than a century for the idea that Napoleon might have been poisoned with arsenic rather than dying of stomach cancer to gain much traction; same for the argument that Beethoven might have died of lead poisoning, even if accidental. Speculating on the death of Tom Thomson obviously began early but it took decades before the various theories found their legs.

The North Bay coroner's declaration of "death by drowning," in which Dr. Ranney confirmed the opinion of Algonquin Park superintendent George Bartlett, was the accepted explanation in the early days, months and years following the artist's death. It was embraced by those who truly did believe, or perhaps preferred to believe, the coroner's findings—and among these were Thomson's immediate family, his friends and those with a vested interest in the value of his art.

Much has been said about the impossibility of his merely drowning, first argued by biographer Blodwen Davies in 1935, as there had been air

NORTHERN LIGHT

in his lungs after the body was found. But it isn't as simple as that. Science now accepts that there is no precise anatomical proof of drowning, that the old clinchers—water in the stomach, lungs, sinuses—are strong hints but not absolute signs. "Drowning" is often merely the last thing left when a person dies in a body of water and all other possible causes appear to have been eliminated.

Accidental drowning *with extenuating circumstances* was the chosen explanation for those with some familiarity with the situation. Annie Fraser, who may well have known far more than she was letting on, once even suggested Thomson had drowned while trying to hold onto and land a huge lunker of a lake trout that might have wound Thomson in his own fishing line. Dr. Taylor Statten II, who at three years of age was at Canoe Lake when Thomson died and has spent his entire life surrounded by the story, has a more familiar take on the death. "Dr. Tay," as he is known to the Taylor Statten campers, bluntly told me in the summer of 2008 that, in his opinion, Thomson "was drunk, fell out of his canoe and drowned." (That was the same opinion Jimmy Stringer offered up that day in the Empire Hotel before he himself drowned in Canoe Lake.)

But others were not convinced. Mark Robinson clearly had some mild suspicions at the time, and his suspicions only intensified over the years. The puzzle really began to grow in the early 1930s, when Blodwen Davies began collecting documents and materials concerning the death of the artist and became increasingly suspicious.

Since the official coroner's report—which might never have existed—could not be located, Davies turned to Dr. Howland, the professor of neurology who had sighted the body off Little Wapomeo Island. He was the only medical person who examined Thomson's body after his death. When Davies asked for Howland's statement, the office of the provincial crown attorney sent her the following copy, signed "George" Howland:

Canoe Lake July 17–17.
I saw body of man floating in Canoe Lake Monday, July 16th, at about 10 A. M. and notified Mr. George Rowe a resident who

removed body to shore. On 17th Tuesday, I examined boyd [sic] and found it to be that of a man aged about 40 years in advanced stage of decomposition, face abdomen and limbs swollen, blisters on limbs, was a bruise on right temple size of 4″ long, no other sign of external marks visible on body, air issuing from mouth, some bleeding from right ear, cause of death drowning.

Curiously, Davies received another copy of Dr. Howland's statement in the same week, this time sent to her by George Thomson. While the first statement would appear to be what Howland said as a witness at the coroner's inquiry, the one sent to the family appears to be one he signed at or immediately after the inquiry:

July 17. 1917
Body of Tom Thomson, artist, found floating in Canoe lake, July 16. 1917. Certified to be the person named by Mark Robinson, Park Ranger. Body clothed in grey lumberman's shirt, khaki trousers and canvas shoes. Head shows marked swelling of face, decomposition has set in, air issuing from mouth. Head has a bruise over left temple as if produced by falling on rock. Examination of body shows no bruises, body greatly swollen, blisters on limbs, putrefaction setting in on surface. There are no signs of any external force having caused death, and there is no doubt but that death occurred from drowning.

G. W. Howland
538 Spadina Av.
Toronto

The discrepancies are baffling. In the first, his given name is shown as "George," though, in fact, it was Goldwin. The misspelling of "body" led Michigan lawyer Neil J. Lehto, author of *Algonquin Elegy: Tom Thomson's Last Spring*, to conclude the error was made in transcription. Howland, after all, would know his own name. However, Howland's

original contention that the bruise had been on the "right" temple remains in the report signed "George," whereas, in the copy sent to the Thomson family, the bruise is said to be over the "left" temple. Lehto believes that Howland, in fact, likely wrote both and someone else wrote "George Howland" on the first. The first he might have written for Ranney, the latter for the Thomson family when Tom Harkness requested an official report on the cause of death.

George Thomson did not tell Blodwen Davies about information that might have come to the family concerning the inquiry. But Harkness, the executor, had written to Dr. James MacCallum, Tom's patron, on November 3, 1917, saying, "I at last received the burial order from the coroner at North Bay, and I am going to write him about the letters produced at the inquiry."

It would appear that either Harkness never did follow up on that or that the coroner's office did not respond to his request. The "letters" might have involved any matter at all, and the natural inclination is to presume they were those "boy and girl" letters between Tom and Winnie that Mark Robinson had dismissed as unimportant. However, my feeling is that, as Robinson had already given Hugh Trainor the letters to return to his daughter, these were not the letters in question. Harkness's letters to Flavelle and others indicate a man concerned with an accurate accounting of finances—Harkness was a successful farmer—and his correspondence with Winnie Trainor shows an ongoing interest in any outstanding loan that might have been due Thomson from Shannon Fraser. He would have been greatly interested in any letters concerning debt or property. However, it appears that Harkness never did acquire the letters he had hoped to receive from the North Bay coroner's office, if, in fact, any had been collected there.

In 1931, early in her investigation, Davies petitioned Ontario attorney general Colonel William Herbert Price to exhume the grave at Leith. She included an eleven-page summary of events, as she understood them, and asked in a cover letter if the attorney general's office would act on her request. "[T]he important thing to Thomson's friends,"

she wrote, "is to know whether or not he still lies in Canoe Lake, and to clear his name of the charge of suicide."

To add clout to her unusual request, she copied Sir Frederick Banting, the famous Canadian discoverer of insulin. Banting had become fast friends with several members of the Group of Seven. After his huge success in research science, which he struggled the rest of his life to equal, Banting had turned to the arts, hoping the group could help him learn to paint. And he also hoped that Davies could help him learn to write. According to historian Michael Bliss's 1984 work *Banting: A Biography*, Davies and Banting were romantically linked at the time. (In 1932 their affair would break up Banting's marriage, sending him to divorce court.) Banting became caught up in the Tom Thomson story and developed such an interest in the painter that by 1949 he claimed in the *Toronto Telegram* that "Canadian art is gradually reaching a national and distinctive manifestation, and its inspiration is Tom Thomson." At one point he became so convinced that Thomson had been murdered that he spoke to a park ranger—likely Mark Robinson—about what had transpired in 1917, but said the ranger could provide no concrete details.

On July 10, 1933, Davies wrote to Banting, stating, most intriguingly, "Now I am in trouble, the worst trouble I have ever known & you have neither pity nor tenderness, even though I have begged you for help to get me over this difficult time . . . If I am to carry out the thing I should do in the next six weeks it must be without any recurrence of the distress I feel tonight." Bliss wonders in a footnote whether this curious reference concerns an unwanted pregnancy and the necessity of an abortion. Given that Banting gave Davies three hundred dollars at approximately this time, such speculation is only natural. Whatever the full details of Davies' relationship to Banting, the affair quietly died and they never married.

It is curious that when Davies published her biography on Thomson in 1935, she made no mention of Winnie, even though Mark Robinson, whose advice she followed on every other count, specifically directed her to seek Winnie out. We now know from Davies' papers that she

was wholly suspicious of Martin Blecher, Jr., but that she refrained from openly saying so in her book. As she had relied so heavily on Mark Robinson's recollections, such suspicions likely came from the ranger. Robinson's journals from 1917 include a May 14th note that Blecher had departed Canoe Lake for St. Louis. "I am of the opinion he is a German spy," the ranger wrote. Four days later, he noted that Blecher returned to the park via the train from Renfrew. Davies questioned Blecher's draft status in her submission to the attorney general, perhaps thinking that the possibility he was avoiding the draft, and perhaps even sympathizing with the enemy, might intrigue the authorities to look into his possible role in the artist's death. None of this suggestive material, however, had any effect—the attorney general's office showed no interest in re-opening the case—and when the book appeared there was nothing in it along these lines. She had no proof, of course, and Blecher was still alive when her book came out. He died of a heart attack at his Canoe Lake cottage three years later, in 1938.

Blodwen Davies was hardly alone in her suspicions that Thomson had not accidentally drowned. An article by Kenneth Wells in the *Toronto Telegram* on February 3, 1934, had broadly hinted at the possibility of foul play a year before Davies' book appeared. And in the fall of 1944, nine years after her book was published and well after Martin Blecher's death, Edwin C. Guillet published an essay strongly suggesting that Thomson was murdered. Dr. Guillet, a historian with the Ontario Department of Education, was a prolific writer, renowned for his fifty-volume series on famous Canadian trials. In his essay, called "The Death of Tom Thomson, Canadian Artist: A Study of the Evidence at the Coroner's Inquest, 1917," he concluded that, given the condition of the body when discovered, there were two potential causes of death: foul play or suicide "during temporary mental derangement." He dismissed the notion that such an experienced canoeist and swimmer could ever have fallen from his canoe and simply drowned.

Guillet believed the four-inch bruise over the right temple—right, as Howland recorded, rather than left, as Robinson had noted—might have come from a blow struck by a stick, rock or paddle. The bleeding from the right ear he took as proof that it occurred before death, as corpses do not bleed. He cited a Thomson acquaintance, Jack Christie of Sundridge, as believing the artist had been murdered; however, he added: "The suicide possibility is not unreasonable, for Thomson is known to have been moody and morose at times, though usually when he was in the city, not in the wilds. Sudden derangement might have led to his diving from his canoe into shallow water and striking his head upon a rock, but it seems unlikely."

Guillet mentioned Banting's interest in the case and also wrote about a minor investigation conducted some time after Thomson's death by Albert Henry Robson, Thomson's former employer at Grip, who was unable to find definite proof but believed that "Thomson and a guide or forest ranger were in love with the same girl, possible a half-breed, and that through jealousy Thomson was murdered by his rival." He found that Thomson's fellow artists, people such as A.Y. Jackson, were "reticent to discuss the tragedy. The writer does not know whether this is entirely due to the weight of sad memories, or bears some relation to the mystery of his death. His family, too, while recognizing that there are serious discrepancies between the condition of Thomson's body and the recorded cause of death, prefer that there be no resurrection of the issue at this late date."

Guillet went no further in his published essay, but Neil Lehto, the Michigan lawyer, uncovered a typewritten postscript by Guillet in which he speaks of a "German-American" on the lake who is rather obviously Blecher, even if unnamed, and notes that the murder suggestion came from a conversation with A.Y. Jackson—most unusual, given that Jackson always seemed far more interested in downplaying such gossip than in promoting it.

Guillet's theory, however, spins off base when he claims Thomson's work as a guide that spring had cut into the earnings of this "German-American guide" and set the two against each other. He ignores the

fact that there was precious little such work for Thomson in 1917, who took out his first guide's licence that year and complained about the lack of tourists. The war had significantly reduced the number of visitors, and those who did arrive often had loyalty to the more established local guides. It was also a particularly virulent spring for blackflies—and, most significantly, Blecher never did guide in any capacity.

Still, Guillet notes that "The theory is that the two men met and that, during an altercation, Thomson was knocked from his canoe by a severe blow from a paddle." A later addition says his subsequent investigations "all point to the same direction—that he was murdered. A guide who objected to his activities—for he was always in demand in that capacity—seems to have been responsible for his death; and opinion in the neighbourhood suggests that there was a love angle in the tragedy."

Blecher was never actually *named* in print as the number one suspect until 1970, when William Little published *The Tom Thomson Mystery*. Little relied heavily on Mark Robinson's journals and, significantly, on the later taped interviews with the ranger, who, as he grew older, became increasingly sure that Thomson had been done in by some assailant. By 1930, in correspondence with Blodwen Davies, Robinson had been blatantly suggestive: "You Might interview Martin and Bessie Blecher, but again be careful, they Possibly Know more about Tom's sad end than any other Person." If that isn't a broad hint, what is?

Little took all these ingredients—the drinking and supposed confrontation at the Saturday night party, the hint of a love triangle, the sordid details concerning the condition of the body—and constructed a scenario. He concluded that Thomson was struck and killed with his own paddle while preparing to portage to Gill Lake—which explains why his working paddle was never found—and that Thomson's assailant had weighted the body down by tying one leg to something heavy, using fishing line, then dumping the body and canoe off Little Wapomeo Island. When Dr. Howland's daughter snagged something the evening before the body surfaced, the yanking motion dislodged the body and allowed it to break free of the weights and surface.

Little, who did much admirable research for his book, settled easily on Blecher as the culprit. "Martin Bletcher was considered a bad-tempered man," he wrote, "a condition not improved by his heavy drinking. He was alleged to have been staying long periods of time in Canada to avoid involvement in the American war effort." Little's reliance on Mark Robinson is total: as mentioned, Robinson had become convinced that Blecher was a German spy and he also claimed that a U.S. agent had travelled to Canoe Lake looking into Blecher's situation, leaving the distinct impression that Blecher was a draft dodger.

"Mark was not known to embellish or distort facts," Little wrote, though many a Taylor Statten Camps graduate who had once sat around the bonfires listening to the highly respected ranger weave his stories would argue that much of Mark's considerable charm was found in his ability to string out a story.

Little seized, rightly, on the relationship between Tom and Winnie as being important in understanding what might have happened. He then sought to tie in Blecher. "Did Martin Bletcher resent Tom's visits to Winnie Trainor, just next door to him, during those summer evenings?" he asked.

"Did Tom resent Martin's presence so close to Miss Trainor's cottage?

"Had anything ever been said between them, or had the resentment lain beneath the surface, awaiting the inevitable final provocation?"

Little remained convinced that the suspect he had named was the killer of Tom Thomson. To Little's credit, he did much to convince the curious that this was far more likely a case of murder than one of accident or suicide, but the curious increasingly began to wonder if perhaps the perpetrator was someone other than Blecher. Even Mark Robinson's daughter, Ottelyn Addison, came to believe that her father's suspicions and Little's conviction were off track. "It's gone through my mind more than once," she told me, "that Little's got the wrong man in Martin Blecher."

Peter Webb of the University of Ottawa argued in a 2004 essay that Blecher was a suspect of convenience. In "Martin Blecher: Tom Thomson's Murderer or Victim of Wartime Prejudice?" he wrote that

Blecher would have been an obvious target of suspicion, given the extreme prejudice against Germans and also the testiness against Americans who were still balking at engagement in a war in which most Canadians believed American help was needed. The War Measures Act had already revoked many rights for Canadians of German descent, and Germans were required to register with regional offices. German Canadians could not vote or carry arms. A German American, by extension, might be held in even more suspicion.

The prejudice was so strong that Webb concluded Blecher was also a victim in the Thomson tragedy. Blecher, it would turn out, was not quite the draft dodger the small Canoe Lake community had presumed he was. U.S. war records established that Martin H. Blecher, Jr., of Buffalo, New York, "registered on November 27, 1917" and was ordered to report on August 24, 1918. When he failed to report, he was declared a "deserter," but later the so-called desertion was found to be "nonwilful" and he was discharged from the service without punishment. No explanation was offered for the reason he first failed to report, though it was more than a year after Thomson's death. Furthermore, there was never any hint or gossip that Martin Blecher, Jr., and Winnifred Trainor had been involved with each other. And, similarly, there had never been any evidence that Blecher viewed Thomson as a rival in matters of the heart.

Though there might have been some doubt, following the publication of Little's book, as to who might have killed Tom Thomson, it was from that point on widely accepted that Thomson had indeed been murdered. Little even quoted Irene Ewing, who was still a friend of the Trainor family, as saying, "I truly believe . . . Tom was done away with (do not like the word murdered)—but for what purpose I do not know."

There are any number of theories—some persuasive, some dubious, a few positively wild—concerning Thomson's death. It was said that he had come upon some "German operatives" along the portage and been

dispatched by the spies to protect their espionage as they tracked troop trains passing through Algonquin Park from the West. (A train had derailed near the Joe Lake bridge in 1916, with no injuries, and some were convinced it was the work of saboteurs hoping to destroy a troop train.) It was also suggested that Tom might have run into poachers who killed him, rather than lose their valuable pelts. And, of course, there was the theory that he had fallen and struck his head on a rock near the portage entrance and drifted out into deeper water in the light wind blowing that day—or that he'd simply fallen out of his canoe because he was drunk. Blodwen Davies thought someone had met him on the lake and knocked him out with a single blow of a paddle blade. Judge Little thought Martin Blecher, Jr., had lain in wait for Thomson and either shot him in the temple or struck him a fatal blow. David Silcox and Harold Town put forward the theory that Thomson had stood in his canoe to pee and fallen and struck his head on the point of the stern.

People have explained the fishing line found wrapped around Thomson's ankle as evidence that a murderer had weighted down the body or that Thomson had been treating his own sprained ankle. Again, we enter the region of the preposterous here. No one had noted Thomson favouring an injured ankle. Plenty of witnesses saw him walking about in the days before he went missing and did not mention a limp. Nor would any woodsman treat an injured ankle in such a fashion unless he hoped to give himself gangrene poisoning. If Thomson had wrapped the fishing line around his ankle to hold a splint in place, as others have suggested, the splint would still have been in place, given that Mark Robinson had to use a knife to cut away the line. And while it is always possible that the line was twisted onto his ankle by the rolling of Thomson's body, it was only around the one ankle and, in Robinson's recollection, seemed deliberately and carefully wound. This makes it highly unlikely that his ankle became entangled in the line while he was at the bottom of Canoe Lake.

One intriguing theory as to how the line came to be wrapped around the ankle is found in a Discovery Kids television program, *Mystery Hunters*, and in a 2002 article by S. Bernard Shaw in *Country Connections*

magazine. Shaw suggests that Thomson might have been killed by a whirlwind that suddenly picked him and his canoe out of Canoe Lake waters and spun the artist like a windmill before dropping him, unconscious, back into the drink.

Shaw refers to a study by meteorologist Bernard A. Power, who saw a *tourbillon* on a Quebec lake and was fascinated by its power and brevity—a hissing wind sucked spray into its vortex for ten seconds or so, then instantly vanished. Power calculated that the wind force could have been enough to pick up a normal-sized man—in a hundred-mile-per-hour wind, the centrifugal force would be two hundred times the force of gravity. Thomson could have been surprised by one of these instant whirlwinds and spun in the air while fishing line wrapped about his ankle and his twirling paddle clipped him on the head. The G-force power of the vortex could even have caused the noted mysterious subsequent bleeding from the ear. Unconscious, Thomson would then have been dropped back into the water to drown while the whirlwind simply vanished, leaving behind no evidence that it had ever occurred. Shaw provides past examples of such instant whirlwinds, including two on Algonquin's Lake Opeongo, and suggests that, in addition to the ones noted, "there are the ones unseen and unreported—like, perhaps, the one that killed Tom Thomson."

The problem with this fascinating theory is that Canoe Lake was relatively populated in those days, particularly in mid-July. That something so dramatic could have happened and not be noticed is unlikely. Meteorologist Phil Chadwick is highly doubtful about the waterspout theory. "I am a big enthusiast of the power of nature," Chadwick says, but he cannot see how the necessary conditions would have been present on the cool, damp day that Thomson went missing. Waterspouts are usually caused by cold air moving over much warmer water, and, Chadwick adds, they're "most common in the fall of the year in the wake of an Arctic cold front." Such was not the case in early July 1917. Nor does Chadwick believe that a tornado would be possible, as "There was no mention of any severe weather in any of the many climate reports taken on July 8, 1917."

The suicide theory first put out in whispers by Shannon Fraser has often been dismissed as improbable, given the successes Thomson had had just before his death. David Silcox considered suicide "the most unlikely possibility" in that "Thomson's frame of mind, his melancholy days notwithstanding, was very positive." Neil Lehto, however, strongly endorsed the suicide possibility in *Algonquin Elegy*, published in 2005. Lehto became fascinated by the number of times those who knew Thomson spoke of his moods or his sometimes manic drive to paint. "Tom's moods seemed to react according to the weather," Irene Ewing had said of the artist she met when she was twelve. "When a storm was brewing he became restless and when the electric storm would be at its height—his eyes would glow."

Lehto believes that Thomson had a mental condition, given that his friends said he "suffered fits of unreasonable despondency. Many described him as a creature of depression and ecstatic moments, his melancholy giving way to outbursts of great passion and energy during his travels, paintings, and bouts of heavy drinking. Today they would say he suffered from bipolar disorder or manic depression, a chronic and progressive mental illness that often ends in suicide if left untreated. Few biographers have dealt with this critical part of his story. It is irrefutable from what he did and what happened at Canoe Lake on July 8, 1917, that Tom was suffering from severe depression in the days before his drowning. All of the events preceding his death point to this sad conclusion."

Lehto carefully lays down his evidence. Robinson had once said Thomson could be "jovial" one day and yet at "times he appeared melancholy and defeated in manner. At such times he would suddenly as it were awaken and be almost angry in appearance and action. It was at those times he did his best work." Robinson's observation is partly corroborated and partly called into question by Thomson's employer at Grip, Albert Henry Robson. He left notes saying he once received a call from a previous employer of the artist "belittling Thomson as an erratic and difficult man in a department," though Robson himself found this to be untrue and absurd: "Thomson was a most diligent,

reliable and capable craftsman. Nothing seemed to disturb the even tenor of his way."

Lehto gathers a litany of comments from Thomson's artistic friends—Jackson saying Thomson had "fits of unreasonable despondency," Lismer calling him "a creature of depression and ecstatic moments"—and says such comments run counter to the impression that the public has had of Thomson as a contented and successful man at the time of his death.

"Anyone acquainted with Thomson's violent mood fluctuations and wild drinking would question the feelings of his friends," Joan Murray wrote in *Tom Thomson: The Last Spring*. "His hell-raising, anarchic individualism may have been the side of a depressive personality. But his fellow artists did not know, it seems, his dark side, certainly they have not recorded it, and it appears only in the records of youthful companions." In another instance, however, Murray argued that "any suspicion of Thomson's death as suicide should be dispelled" by the series of sketches Thomson produced that final spring at Canoe Lake. "They are," she wrote, "the best and most trenchant works the artist ever created, and are pervaded with a calm serenity and certitude of mood which no potential suicide could possibly capture."

Lehto, intriguingly, uses precisely the same evidence—the incredible daily output of that final spring—as an argument for Thomson's manic behaviour in his final weeks and proof that he was, at that time, suffering from bipolar disorder. He quotes from the seminal works of Dr. Kay Redfield Jamison of Johns Hopkins University, who has dealt herself with the manic depression that comes with such a disorder. "Cycles of fluctuating moods and energy levels serve as a background to constantly changing thoughts, behaviors, and feelings," she wrote in 1993. "The illness encompasses the extremes of human experience. Thinking can range from florid psychosis or 'madness' to patterns of unusually clear, fast and creative associations . . . Behavior can be frenzied, expansive, bizarre, and seductive, or it can be seclusive, sluggish, and dangerously suicidal."

Jamison makes much of the progression of the seasons as it pertains to the mental health of those suffering from bipolar disorder. She offers

evidence that, throughout history, creative energies among artists of all sorts tend to peak in late spring and autumn. "So, too," she writes, "the seasons have become metaphorical for life, and the creative process itself, its barren winters and hoped-for springs, and its mixed and disturbed seasons, so beautifully captured by T.S. Eliot." Jamison offers an excerpt from Eliot's "Little Gidding," the powerful last section of his famous *Four Quartets*:

> . . . In the dark time of the year. Between melting and freezing
> The soul's sap quivers. There is no earth smell
> Or smell of living thing. This is the spring time

Tracy Thomson, the artist's great-grandniece (great-granddaughter of George) and an artist in her own right, says her famous uncle worked "at a fever pitch" for a five-year period. She believes he worked with "extreme focus" and could become totally immersed in whatever project he was doing.

"He was beyond just a moody guy," she says, relying on family lore for her sense of Thomson's personality. "He would produce these brilliant pieces, and he just couldn't see it. He wrecked pieces. He burned them. He was really unhappy with *The West Wind*. I always wonder what exactly was in his mind's eye? He always came up short in his own opinion. It makes me wonder where was he going from here? Abstractionism? What was that elusive vision he had that made him move toward it at such a frenzied pace?"

His pace toward the end was truly astonishing. Tom's output in "the spring time" of 1917 consisted of several dozen daily sketches—the precise number is unknown—until the final week of May, when the black-fly season got under way and Thomson wrote to MacCallum that they were so bad that painting in the open was impossible. He gave away some of the sketches from that period to Daphne Crombie and others at the lake, but while this might simply have been a result of Thomson's well-known generosity, it could mean, Lehto speculates, that he was

getting rid of his stuff. Then there was the Saturday night party of July 7th, the heavy drinking and the possibility of a fight.

"People with bipolar disorder often become suicidal, especially when symptoms of mania and depression occur together," Lehto writes. "Increased energy and some form of anger, from irritability to full blown rage, are the most common symptoms. Symptoms may also include auditory hallucinations, confusion, insomnia, delusions, racing thoughts and restlessness. Alcohol may trigger such individuals. The view that a swing from mania to depression to suicide is unthinkable because no artist, who created such joyful, life-affirming landscape paintings in that last spring series would have killed himself, simply ignores such evidence."

There was certainly alcohol at Canoe Lake. It was regularly brought in by train. Nearly a year before Thomson's death, the Ontario government had passed a Temperance Act prohibiting the sale or serving of alcoholic beverages, wine excepted, and all bars and liquor stores were to be closed at least for the duration of the war. There were, however, enormous loopholes allowing sales for a great many other purposes, including sacramental and medical, and many heavy drinkers simply continued to drink courtesy of a friendly family doctor and a local pharmacy.

Mark Robinson's journals of 1917 indicate that alcohol was a concern in the park, as he okayed a shipment of three barrels of 2.5 per cent beer for the Blechers "for personal use" and, following the Saturday night party that preceded Thomson's disappearance, carried out Superintendent Bartlett's "instructions this morning to have Mr. S. Fraser have no more booze come in." It would seem from this that the lodge had supplied the "booze" for the wild Saturday night party. Yet not all alcohol arrived by train. The regular binges, firings and rehirings of the guides working for Mowat Lodge suggest that there were many other ways—raisin wine being just one—of getting drunk without paying freight charges.

When it came to how, exactly, Thomson might have killed himself, Lehto theorized that perhaps he simply let nature take its course by overturning his own canoe in deep water. The "weapon" of choice would have been hypothermia. Lehto says that the spring of 1917 had been

uncommonly cool and wet—true enough—and that if Thomson had let himself morosely slip into water that was 21°C "within a few minutes, he would have suffered fits of shivering and fumbling hands and legs. The cold water flowing across his body would have rendered him drowsy, incoherent, unconscious, and drowned in ten minutes. By swimming well ahead of the drifting overturned canoe, he would have confounded searchers as to what happened.

"As his dying body sank to the bottom, his right forehead and ear struck submerged lumber, a fallen tree, or logging machinery. The head-down position of his corpse caused the injury to bleed, complicating later efforts to determine whether it happened before or after the drowning."

Much as I respect Neil Lehto's diligence in investigating the Thomson tragedy, I have to say as one who grew up in Algonquin Park that we would often swim for hours in such cool July waters. In fact, in the cool summer of 2009, the water at our summer place on Camp Lake, which is fed directly by Algonquin Park waters, stayed at about 20°C, sometimes lower, for all of July and much of August. And yet swimmers, once they got used to the cool water, would stay in for long stretches—long enough, in some cases, to swim distances that would have taken them across the width of Canoe Lake several times. After ten minutes, swimmers would merely be getting used to it; they would not be drowsy in the least.

One medical expert finds the suicide theory lacking. Dr. Philip Hall, a Winnipeg forensic specialist, had previously worked in Ontario and, coincidentally, was a colleague of forensic scientists directly involved in the examination of the skeleton uncovered at Canoe Lake in 1956. That experience gave him a fascination with the Tom Thomson story that lasted right until his death in 2008. In a presentation titled "Mystery and Myth" that he prepared for a service club in Winnipeg, he took on the suggestion of suicide directly.

"There was no evidence whatsoever of suicide," Hall told his audience. "No threats, no sustained depression and no note. The day before

he died, July 7th, Tom wrote in a letter to Dr. MacCallum '. . . will send my winter sketches down in a day or two and have every intention of making some more . . . Have done some guiding for fishing parties and will have some other trips this month and next with probably sketching in between'"

Hall points out that Thomson had recently sold a painting for the impressive sum of five hundred dollars. He would have been full of life, Hall argued, not looking for death. "Even if there had been reason to suspect suicide," he wrote in his notes for his talk, "consider the inanity of the idea given the circumstances. It is preposterous to suggest that Thomson would have killed himself by weighting his ankle with a fishing line and rock, first hiding or tossing away his paddle, tent and fishing gear, then diving into the lake taking care to strike his temple on the gunwale or a rock on the way down, while holding a finger in his ear perhaps to keep the blood from washing out. As an aside, it is equally preposterous to have suggested that a canoeing expert with the understanding of water so clear in his work would stand up in his canoe, minutes from shore, to urinate, wave at a passing fellow loon, or for anything else, or that splinting a sprained ankle with 16 or so loops of fishing line is anything other than a silly idea." In Hall's opinion, the suggestion first put forward by Shannon Fraser that Tom had done himself in was not only an impossibility but very likely "a malign attempt to cover something up."

But cover up what?

ELEVEN DAPHNE

In the winter of 1976, I received a letter from Ron Tozer, then Algonquin Park's interpretive services supervisor, in response to an inquiry I had made concerning any information the park archives might hold on Winnifred Trainor. Ron, one of the country's great naturalists, responded that they had a taped interview in the archives that might be of interest to me. The interview had been done not long before by Tozer's employee Ron Pittaway, and if I cared to drop in anytime at the park museum at Found Lake—this was years before the Visitors' Centre was built—he'd gladly set me up to listen.

I was mesmerized by what I heard when I finally got to the basement of the old stone building and began listening to the tape. As noted earlier, Lieutenant Robert Crombie and his young wife, Daphne, had stayed at Mowat Lodge during the late winter and spring of 1917 while the lieutenant recuperated from tuberculosis. During this time Daphne had become close with both Tom Thomson and Annie Fraser. While the Crombies had not been there when the July tragedy occurred, they had

returned the following November in the hopes that the Algonquin air would further benefit Robert Crombie's health.

Daphne and Annie immediately renewed the close friendship they'd enjoyed during the Crombies' first stay at Mowat Lodge. Early in the interview, Ron Pittaway asked Daphne, then well into her eighties and a widow, if she could shed any light on the relationship between Tom Thomson and Winnifred Trainor. Perhaps because she later knew tragedy herself—her son Charles had died at twenty-three while serving with the Royal Canadian Air Force in Gambia in the fall of 1942—she felt that now was the time to say what she knew about Canoe Lake back in 1917.

"I could start in," she said, "by Annie and I having a walk, and about the letter she said she had read about Winnifred's desire to come up [to Canoe Lake] the following week. 'Please, Tom, you must get a new suit because we'll have to be married.' Now this came right from the mouth of the horse, if you will. She read this letter you see. Anyway, [Winnifred] did come up and when she came up, Tom had been drowned in the lake." Here was someone who had actually known Tom Thomson suggesting that he and Winnifred Trainor *had* to get married.

Crombie went on to talk about the Saturday night party but in a far different manner than Little had pursued in the book he'd published seven years earlier. Little claimed that Martin Blecher, Jr., had threatened Thomson at the party after the two had quarrelled over the progress of the war. But Daphne Crombie spoke about events that followed the party that had nothing whatsoever to do with Martin Blecher, Jr.

Crombie said that Annie Fraser had told her that the men were "all tight" after the party and that Tom had confronted her husband over money Fraser apparently owed him. Tom insisted on the money "because he had to go and get a new suit. Well, of course, the family doesn't like all this to come out. Anyway, they had a fight and Shannon hit Tom, knocked him down by the fire grate, and Tom had a mark on his forehead—I don't know where it was—anyway, Annie told me all this and [she told] Dr. MacCallum, as well.

"Anyway, Tom was knocked out completely and, of course, Fraser was simply terrified: he thought he'd killed him."

Crombie insisted this was all her "conception" of what had happened and she did not know or care what others believed. She chose to believe Annie, whom she trusted completely. Why would her friend lie about something so profoundly incriminating of her husband and, ultimately, of herself? Daphne had never been impressed with Fraser's personality, considering him "timid" when it came to such aggression even though he was a large and strong Irishman. Far more than dangerous, she considered him "devious," and she believed from what Annie had told her that Fraser had tried to cover up what had happened by staging a drowning. It was Fraser, she claimed, who had taken the deeply, perhaps fatally, injured Thomson, placed him in his canoe, towed it out and dumped it over in Canoe Lake.

"I know he hit him," she said, "but I don't think that he was dead. I think he might have been unconscious. Shannon Fraser was terrified that he was dead. I believe that Annie helped him pack the canoe and he went off into the lake with Tom's body."

Crombie said the Frasers' daughter, Mildred, was away, so wouldn't have been witness to any of this. And she refused to entertain any suggestion that Annie might make up something as sensational as this. "She was kind, decent, and very honourable," Crombie said of her Canoe Lake friend. "She never told me lies, ever."

As for Martin Blecher, Jr., Crombie had little use for him. She knew of the rumours and had read Little's book, but she was adamant in saying, "I don't think Blecher had anything to do with it. It was simply a myth to me. They never saw one another during the day, and they didn't seem to have any antagonism towards him. I'm damned sure that Winnifred never went with Blecher. He was an unattractive, blasé sort of individual. He had a German accent. Why he was living up there, I don't know."

As far as a love triangle went, in Daphne's opinion, there was none. Tom's only connection was to Winnie. Though he never mentioned her

existence to Daphne in the months the Crombies were at Mowat Lodge, Annie Fraser made it clear to Daphne that it had been a serious relationship. "He was with her all the time when she was there," Annie had told Daphne. And when Winnie was not there, she wrote regularly to Tom. Annie had happened to pick up one of these letters while cleaning Tom's room at the lodge, which was how she made the discovery that the two had to get married and that Winnie was pressing Tom to get his money back from Shannon to purchase a wedding suit. "Annie told me from her own lips, having read the letter," Daphne said.

She was speaking out now, she explained, because the Frasers were both dead: Shannon died in 1946 at age sixty-two and Annie suffered a stroke in 1953, leaving her partially paralyzed and unable to speak until she died the next year. Their daughter had never known anything of the secret.

As for the Trainors, after Tom died nothing was said about any official engagement and most assuredly nothing that might suggest a wedding was a necessity. "The family was like that," Crombie said in the interview. "They didn't want anything repeated at all, according to Annie."

As for the story of the two graves and the coffin that may or may not have contained the body of Tom Thomson, she had no opinion. "I don't know what happened after they picked him out of the water," she said, "because I wasn't there."

When I went to Daphne Crombie's apartment in 1977 to conduct my own interview, I was met at the door by her son, David—not to be confused with the Toronto mayor of those years. He cordially invited me in to a neat apartment that held the trappings of old money, but not too much, and a modest display of stylish grace, just the right amount. Daphne wore a plain print dress, hair and powder perfect, eyes clear and sparkling above a slightly pursed mouth that was quick to smile. She was a small woman made even tinier by age, as she was slightly stooped, and yet, even though she was approaching ninety, you could see the beauty

that Tom Thomson could not have failed to notice. In the backwoods of Algonquin during the Great War, this striking, privileged young woman from the city with the sickly husband would have attracted as much notice as the weather.

Daphne talked about *Path behind Mowat Lodge* and how Tom gave it to her. She was slightly embarrassed to confess that she had sold it for a fraction of what it might have fetched on the open market in 1977—let alone the $2 million that it might bring in today.

She talked about the replacement vase—decorated with pussy-willows—that Thomson had promised to paint for her but didn't because he never did see the next spring. "If I ever meet him up in heaven," she smiled, "I'm going to ask him, 'Tom, you never made me that other vase—where is it?'"

She said that she herself had been part of another painting that final spring. She and Annie Fraser had been walking around the old Gilmour mill site on a fine, clear, spring day, the lake mostly open, when Thomson suddenly shouted for them to "Stop!" as they neared Larry Dickson's cabin. Thomson was sketching on a nearby knoll and, with a few deft strokes, he placed Daphne, in her blue coat and white hat, and Annie, in her red coat and pink hat, in the foreground of the now-famous *Larry Dickson's Shack* that hangs in the National Gallery in Ottawa.

The reference to Annie Fraser made the conversation easy to open. She knew that her words could be made public, since she was speaking to a reporter, as opposed to giving information for archival records that might never be publicly displayed during her lifetime, if at all, but she was adamant that her story needed to be told before it was too late. She had clearly avoided the topic in past interviews—art expert Joan Murray had interviewed Crombie years earlier without the slightest hint of any possible "scandal" being mentioned. She repeated the story of the walk with Annie Fraser and Annie's confession about the letter from Winnie Trainor that she'd read and the necessity for marriage.

"But," she emphatically added, "the baby never materialized."

In her talk with me, Crombie was even more specific about a possible baby than she had been in the archival interview. Annie, she said, was "very gossipy" and simply had to tell her what she had found. "'You know,' Annie said, 'I went up to Tom's room and I found a letter there and I read it. It said, 'Tom, we *must* get married—because a baby is coming.'"

In the letter, Winnie pressed Tom to get the money back that he had lent Shannon. Tom would have to buy a suit for the wedding. "This is all gospel truth," Daphne claimed, though she had not seen the letter herself and was taking her friend Annie at her word.

Apart from the specific mention of a baby, the story Daphne Crombie told me that summer day in her Toronto apartment was very much in tune with what she had told to park employee Ron Pittaway. Thomson demanded the money that Fraser owed him, they argued over it and began to fight: "Shannon hit Tom a blow," she told me, and Tom fell and hit his head on the fire grate. Annie told Daphne that "he wasn't dead" but her husband panicked. "Fraser ran out and got his canoe," Daphne said Annie told her, "and they put Tom in the canoe. Fraser then took Tom's fishing tackle and hid it in a room."

Daphne Crombie's sparkling eyes went on fire when she began talking about Shannon Fraser's role in putting it about that Thomson had killed himself. "I'd swear on a Bible," she said, "that he didn't commit suicide." He was happy in his work, happy to be in his beloved park, and "his paintings were starting to sell . . . That's not suicidal."

In her opinion, if Shannon had accidentally injured, or even killed, Thomson in a fight, he should have confessed immediately and perhaps nothing at all would have come of it if Thomson had recovered. If he had died, the worst scenario would have been a manslaughter charge, but in the circumstances—in a tight-knit, isolated community, with a powerful park superintendent determined not to cause any trouble for his bosses in the provincial capital—it might not even have come to that.

Daphne repeated her tale about Annie helping to set up the canoe to fake a drowning, She said Annie told her that Fraser then towed the canoe out into deeper water and dumped it.

"Annie thought he was dead," she said. "She only found out later he was not dead yet."

This, of course, would be a reference to the argument put forward by Blodwen Davies and taken up by William Little that Thomson could not just have "drowned" as his lungs were filled with air and blood was flowing from one ear. Daphne believed, as many others do, that Thomson was alive, even if unconscious, when he slipped below the surface of Canoe Lake.

In Daphne's opinion, Annie Fraser was "a little country girl—honest and kind," who got caught up in something she would otherwise never have had anything to do with. Daphne said her memories of her times at Canoe Lake were "all so vivid in my mind—I was just married" and that those memories were not only clear but accurate. She swore to me that she was speaking "only of things that I'm absolutely terribly sure of" and considered the "official" interpretation of Thomson's death by accidental drowning nothing but a cover-up of the truth.

"Such an utter lie," she said, dismissing everything from accidental drowning to suicide.

Yet if the argument between Tom Thomson and Shannon Fraser did occur, as she said, following the much-mentioned drinking party at the guides' cabin, then what about Mark Robinson's tale that he had seen Tom trying to catch that big trout below the Joe Lake dam the following morning?

Daphne Crombie had an answer for that.

"I don't believe that Mark Robinson saw him."

The *Canadian Magazine*'s publication of my interview with Daphne Crombie begat a whole new round of speculation and claims concerning the tragic death of Tom Thomson. It had long been whispered about

Canoe Lake that the cause of death had been murder, and it had long been suggested that several locals knew the culprit but had formed some sort of secret agreement to stay quiet. Ann Prewitt, who spent more than a quarter century running Camp Northway on nearby Cache Lake, wrote to me in late 1980 to suggest that the cover-up had involved one of the park's most respected figures. She told me that she had tried her own hand at a play about Thomson's death—"my no-good play," she jokingly referred to it. She also said that after she had spoken about the experience to a gathering of summer camp directors at Toronto's exclusive Rosedale Golf Club, another longtime director of an Algonquin Park camp, whom she identified in her letter, came up to her afterwards and said, "You know, of course, who killed him, don't you?"

Prewitt went on:

> I answered that I didn't know that. I understood the truth couldn't come out yet because some relatives that might be affected are still alive.
>
> 'That's right,' he agreed. Then I added that the Thomsons would soon all be dead.
>
> 'It's not the Thomsons,' he said.
>
> 'Who then?' I asked.
>
> 'The Stattens,' the man answered. He then proceeded to detail how Thomson and Taylor Statten had fallen out, fought and Taylor had killed him.
>
> I was dumbfounded.
>
> 'Everyone knows around Canoe Lake,' he said.

Prewitt was more than dumbfounded. She was shocked, particularly because this had all been said to her loudly enough that others at the club dinner might have heard, including Dr. Harry Ebbs and his wife, Adele Statten Ebbs, Taylor Statten's sister. If they did hear, they gave no reaction. Perhaps they were simply used to speculation and knew the facts: that Taylor and Ethel Statten had not even been in the country

when Tom Thomson died, but at Springfield College in Massachusetts, where Taylor was taking an extended YMCA course.

How such confusion could reign might be explained by euphemism. It had often been said around Canoe Lake that the suspected murderer was a well-known and respected figure, and in later years no one was better known or more respected than Taylor Statten, who had built a summer cabin on Little Wapomeo Island in Thomson's time—Thomson had even hauled gravel for the building of the large stone fireplace. But Taylor did not open his first camp on Canoe Lake until 1920, three years after Thomson's death. Statten's Camp Tuxis ceased operations after two summers, and Camp Ahmek became the boys' division of Taylor Statten Camps, with Camp Wapomeo for girls beginning in 1924. In the years since, it had become perhaps the best-known summer camp in the country, with graduates including the likes of Pierre Trudeau, who had been sent there by his parents to improve his English as well as develop his now legendary love of canoeing.

The suspected well-known lake figure from the summer of 1917 had to have been someone else. Dr. Philip Hall, the forensic specialist at the University of Manitoba who had long been studying the mystery, wrote to me after the *Canadian Magazine* article to argue that Little had fingered the wrong man in Blecher. Hall's familiarity with a number of longtime Canoe Lake residents, including contemporaries from 1917, had convinced him—as I also came to believe—that Little had relied too much on Mark Robinson's recollections.

"Apparently," Hall wrote, "Mr. Bletcher [sic] was well known for his obnoxious personality, had few close friends, and a number of people despised him. It was suggested that he was implicated by character assassination, but in fact had nothing to do with the murder other than finding Thomson's canoe, and hosting the impromptu inquest. No one has come forward to defend him because of his lack of support, and because all of the Bletchers are dead.

"The story I was told was that Thomson was having an affair with the wife of his murderer, and that he was killed by a man who was

perhaps 'the most respected person in the community.' My sources claim that the facts were known to several people, but that everything was hushed up due to the status of and esteem for the murderer."

If this sounds like Taylor Statten, it is not. If it is anyone, it is Shannon Fraser. Fraser's credentials certainly described a well-respected and power-ful local figure—lodge owner, postmaster, telegraph operator—even if he had his disparagers.

"It does not take a great deal of insight into the Mowat community," Hall went on, "to identify the implicated couple as the Frasers."

In Hall's interpretation, Annie Fraser, whom he described as "some-what flighty," was the only steady female inhabitant of the lodge, and Thomson was well known as a philanderer. "Shannon Fraser was well thought of and respected," Hall wrote, "except for episodic 'binges.' Also, the people I talked with felt that Thomson was likely shot in the head, but that this was covered up by the chaps who found him [when the original grave was dug up in 1956] to avoid publicity and scandal-sheeting in the Toronto papers, and identification ultimately of the murderer. They believe most strongly that Thomson is still interred at the Canoe Lake site"

For three decades, Dr. Hall gathered material for a book he intended to write, which he told his friends would detail, for the first time, exactly what had happened. In the meantime, he produced his own talk on the topic, which he tried out on a Winnipeg audience not long before his death.

"Beginning in later 1917," Hall wrote in notes that were graciously offered to me by Judith Hall, his wife, "there were rumours separate to those made up by the Frasers, that Tom's death was over, or had some-thing to do with a woman. One interpretation was that the woman was Winnie Trainor. But there is another. In early fall 1977, I spoke with a respected Algonquin Park citizen, three years old when Tom died and still alive, alert and vibrant today, who told me who that woman was. He told me as well that Thomson's family and closest friends knew what had happened, but decided to cover up the truth to avoid scandal for the

families concerned and probable prosecution and conviction if the truth became known. Considering all of the evidence, it is not hard to make the correct guess as to who provoked Shakespeare's *'green-ey'd monster'*, and caused blood to *'Burn like the mines of sulphur'*. Although others came to and left the Lodge and their cottages, there were only two continuous female residents in Mowat in summer 1917, Winnie Trainor and Annie Fraser. Jealousy can enrage a spouse, as Shakespeare wrote about in *Othello*. Guilt can cause people to reveal truths or partial truths. Respect for others can make people hide the truth and accept and believe that some acts, even criminal acts, are better left secret.

"Sometime in early July 1917," Hall continued in his highly descriptive re-creation of what he believed had happened, "perhaps on Saturday July 7, Annie Fraser admitted to her husband, or gave him reason to believe that she had been having an affair with Tom Thomson. There may have been an argument that night after much drinking, but there was no fight resulting in Tom being injured. The following day, Mark Robinson saw Tom with Shannon Fraser at Joe Lake Dam around midday. Tom collected bread and bacon from Mowat Lodge soon thereafter and stowed it in his canoe in a rainsheet. That food was found untouched in Tom's canoe when the latter was recovered later that day. He was apparently seen by at least three witnesses including Shannon Fraser paddling off in the direction of the portage to Gill Lake, where he was headed to fish, with his ankles most likely in good shape. Tom was using his favourite ash paddle, which had it dropped into the lake, would have floated ashore somewhere near his canoe, and very likely been found in the ensuing months of repeated searches for it.

"As an extremely adept woodsman and canoeist, he did nothing stupid, such as standing up in his canoe to urinate less than 15 minutes from the portage, or pulling himself ashore while standing. But he came ashore somewhere, because an assault from one canoe to another is implausible, and noises travel a long way across water. Shannon Fraser had followed him, and wherever Tom landed, probably at the portage to Gill Lake, sometime between 1:45 and 2:45 p.m. based on when Tom

was last seen, Fraser either confronted or ambushed him, and knocked him out or killed him with a violent blow to his right temple, possibly using Tom's paddle as a club.

"Whether he killed Tom outright or not, Fraser had a body, gear and a canoe to dispose of because if any of those had been found on land murder would have been suspected rather than accidental drowning. By about 20 minutes the blood in Thomson's right ear would have formed a firm clot and as more time elapsed become progressively more resistant to being washed out. Fraser wrapped Tom's ankle with his own fishing line weighted perhaps with Tom's axe, took the body out onto Canoe Lake and sank it along with most of Tom's gear. Fraser then upended Tom's canoe to make it look as if he had tipped and drowned, and released it on the lake, disposing of the bloodstained somewhat less recognizable paddle later, possibly by burning it in his own fireplace.

"Whether he felt that the corpse would have remained underwater is moot, but perhaps he did. He returned to Mowat Lodge and was central to the events of the subsequent two weeks. As local Postmaster, Fraser had easy access to telegraph and mail notification, but it is striking that he telegraphed John Thomson and Dr. MacCallum so promptly that the artist, who frequently disappeared for days to paint, was missing. Sometime between then and November he admitted to Annie what he had done. Beset by guilt over what had happened and her role in its causation, Annie made up contrasting stories of need for a suit, need for a wedding, demand for repayment of money, and the fight that really occurred elsewhere the following day. In the process she told part of the truth to her good friend Daphne Crombie exposing her husband to potential embarrassment and criminal proceedings while he lived, and his reputation to being destroyed after he was dead. Annie felt guilty until the day she died."

Dr. Hall's conjecture is certainly that Shannon Fraser struck the blow—in whatever fashion—that led to Thomson's death. But the reason given for that blow is quite different from the previous theory, based on Daphne Crombie's statements, that Thomson, under pressure

to marry Winnie Trainor, whether she was pregnant with his child or not, had demanded that Fraser pay him back and the two had fought. Daphne Crombie completely dismissed any suggestion that Thomson had any interest whatsoever in the plain, short Annie Fraser apart from benefiting from her homecooked meals and a clean room at the lodge. "*Never!*" she told me.

There is another theory—never before made public—concerning how and why Shannon Fraser might have struck the fatal blow. It comes from a man who grew up in a house at 5 Minerva Street in Huntsville, next door to the Trainors. Brad McLellan, who was born May 31, 1937, and died at age sixty-nine on November 22, 2006, spent much of his retirement working on his memoirs of growing up in Huntsville during the 1940s and 1950s. Winnie Trainor often babysat him. And following the death of her husband in 1946, Annie Fraser, in a remarkable coincidence, came to live on the same short street, taking up residence with the family of her daughter, now Mildred Briggs. Annie also babysat Brad.

Many of McLellan's reminiscences had to do with school and his part-time job as bellhop at the nearby Empire Hotel, as well as local characters such as Art Eastman, who owned the nearby stables on Centre Street, and Preston Gerhart, who also lived on Minerva and had a blacksmith shop near the public school. His memories of Winnie, then well into her seventies, were of a good, dependable neighbour. "I always had a soft spot in my heart for her," he wrote to me in a 2003 email. "She was always kind to me and got along well with my folks."

He said that he and his family had seen the Thomson sketches that Winnie owned several times. They were kept wrapped in old newspaper and packed away in a six-quart basket. Addie Sylvester, the daughter of the photo-studio owner on Centre Street, to whom Winnie had been like an "older sister," also remembered seeing the sketches stored in this way. McLellan was unsure of the number but believed some of the sketches had been sold to an art dealer in Toronto. "She told my Dad,"

McLellan said, "that [the proceeds from] some of them were used to put in a furnace and also to put a roof on her house."

McLellan was brought up to believe that his neighbour, always referred to as "Miss Trainor" to her face but as "Winnie" in mention, suffered from some mysterious "delicate condition" and was not to be upset, if at all possible. He said the murder of Thomson— "and I have no doubt about that"—had a bearing on Winnifred Trainor's state of mind. In an early email, he hinted at knowing something deeper. "I can't say why," he wrote to me, "but I think it was Mrs. Fraser that I overheard speaking with my dad and mom . . . My folks always kept tight lipped about what they heard, but I overheard some of these things and they stuck in the back of my head." But he would not say what "these things" were, even though I pressed him for months.

McLellan stewed about this for some time, eventually writing to me again on April 28, 2003, stating: ". . . I mentioned Mrs. Fraser's comments that I overheard as a kid . . . these staying in my mind all these years. Have never discussed them with anyone and I don't think my folks ever did either. They frequently discussed the possibilities with themselves but never made public their thoughts."

This was proving most frustrating. I had shared with McLellan my own theories as to what had happened, including my belief that Shannon Fraser had killed Thomson and that Annie Fraser had been involved, probably against her will, in a cover-up. I had told him what Daphne Crombie had said and speculated with him about where Daphne was very likely right and where she was also very possibly wrong.

"Your views have a soundness to them," he eventually responded, "and I am inclined to agree." And then, finally, he told me what he had kept secret for nearly half a century: the conversation he overheard as a young boy between his parents and Annie Fraser.

"What was related to my folks," he wrote, "was that Winnie's family were extremely upset about her pregnancy and had put 'someone' up to teaching Tom a lesson. Mrs. Fraser did not say that a murder was the intent, just a 'lesson'"

I was thunderstruck to hear this secret that Brad McLellan had kept all his life. That it was a childhood memory was not to be ignored, but much of it did parallel Daphne Crombie's account. Both had Shannon and Tom getting into a fight and Shannon hitting Tom but not intending to kill him. Both had Annie involved in the cover-up. Both implied that Winnie had been pregnant and pressing for marriage. The source of both accounts was Annie Fraser, who would have been unlikely to implicate her husband twice to different people if she was not telling the truth. Where they differed—Daphne having them fight over money; the McLellan version involving a "lesson" being taught Thomson—is obvious, but either interpretation is plausible. In Daphne's version, Tom was seeking money to carry through with a promise, or an obligation he felt, to marry Winnie; in Brad McLellan's version, frontier justice was being meted out—very much in keeping with the rough-hewn world of Canoe Lake and Huntsville in 1917.

It is also entirely plausible that Tom was trying to get out of marrying Winnie, whether or not a pregnancy was involved. Despite the convictions of the Trainor family and the McCormicks (Winnie's sister, Marie, and her family) that Tom and Winnie had been engaged, and despite the belief, never documented, that Tom had reserved the honeymoon cabin at Billie Bear Lodge on Bella Lake, near Huntsville, there was no actual date set and no church or minister booked.

"We think the Billie Bear story is probably true," says Valerie Kremer, who chairs a small historical committee for the rustic lodge that still operates on Bella Lake, just beyond the western boundary of Algonquin Park, "but we can't prove it." Booking records have survived only from the 1940s on. One longtime visitor, John Vanduzer of Toronto, says that his aunt, Mabel Gavin, began going to Billie Bear in 1912 and always claimed that Thomson had made the booking, even if no paper trail could ever be found.

Most intriguing in all this speculation is that Thomson had earlier written to his brother-in-law Tom Harkness that sometime in July or

August he planned to head west to paint the Rockies. It may be that when he died, Thomson was in the process of putting that plan together.

Thomson had long been friends with ranger Tom Wattie, who lived in South River and kept a cabin on Camp Island in Round Lake (now called Kawawaymog) and manned the ranger station on North Tea Lake, just inside Algonquin Park's western boundary. (Today, there's a cairn to the memory of Wattie where L'Amable du Fond River dumps into North Tea.) Thomson liked to purchase his sketching panels in South River and, over several trips, he and Wattie had struck up a close relationship. In her September 17, 1917, letter to George Thomson, Winnie Trainor said that two years earlier Tom had purchased a new canoe and a silk tent while journeying through South River. While in South River, he would often stay at the hotel and visit the Wattie farm on the river, but he also sometimes stayed over at the Wattie island cabin. Some believe he sketched *The West Wind* at Round Lake in 1916 before turning it into a major canvas over the winter of 1916–17.

Ken Cooper, now seventy-seven, is the son of Amelia Christina Wattie, known as "Tootsie" to the family, and the grandson of Tom Wattie. Tootsie was seventeen the summer Thomson died and, apparently, a great favourite of the painter. According to Cooper, Thomson gave his mother four paintings, three of which now hang in major Canadian galleries. One was lost to a thief who simply walked into the unlocked Wattie cabin on Round Lake and took it from the wall while the artist was still alive. "Tom Thomson told her after that that she'd better keep them safe somewhere," says Cooper.

The Wattie family has its own lore about Thomson. They joked about how he had, over time, become revered as an expert outdoorsman. "He was *not* an expert canoeist," says Cooper. "He hadn't even *seen* a canoe until he got to the park." But Thomson was game and generous, and the ranger Wattie took him under his wing, even at one point lending Thomson his Winchester .30-.30 so the painter could

guide some hunters along the park's northwestern boundary. The family always believed that Thomson had drowned after becoming tangled up in his fishing line. In all his visits, they never heard him mention Winnifred Trainor or any intention to get married and settle down in the summer of 1917.

In fact, they perhaps had proof that he had no such plans at all—proof that lay in storage in the old Wattie home through most of the rest of the twentieth century with no one but immediate family and close friends being aware that it even existed.

Eight decades after Thomson's death in 1917, Cooper persuaded his uncle (Tom Wattie's son Gord), then into his nineties, that the family should donate their Tom Thomson belongings to the Algonquin Park archives. Some in the family were reluctant to part with the material, but eventually Gord Wattie agreed, and the family handed over their Tom Thomson treasures.

Ron Tozer of Algonquin Park received the Wattie material. His handwritten notes from August 19, 1998, list the items:

1. Tent: said to belong to Tom Thomson
2. Sleeping bag: said to belong to Tom Thomson
3. Waterproof pants: said to belong to Tom Thomson
4. Sleeping cot: unused, but intended to be used on 1917 trip by Tom Thomson to Temagami (which never happened due to Thomson's death).

There were several other items as well, all associated with camping. When Tozer examined them, he found that someone had written "1915" in ink at the bottom of the sleeping bag and, at the top, "Tom Tompson 1915." On the outside of the bag, "Wattie" is written twice. Tozer does not believe that Thomson would have misspelled his own name, but it remains possible that someone in the Wattie family, perhaps Tom Wattie himself, wrote on the bag so that future generations would know what it was. Certainly family lore all the way back to 1917 held that

these items had been the painter's. "No one else knew about it," Cooper told me in 2009.

The only written reference to the camping gear had been in a local column published in 2002 by area historian Doug Mackey. The information had not been available to any of the many previous biographers of Thomson. Gord Wattie, who died in 2001, provided notes claiming that the equipment had been forwarded by Thomson to the family in anticipation of a canoe and fishing trip that the two Toms, Thomson and Wattie, had been planning to take to Temagami in northern Ontario later that summer. The equipment had arrived just before Thomson's death.

It seems highly unusual that someone would ship his camping gear—the very definition of travelling light—ahead when it would have been a simple matter to bring it along by train or by canoe and portage from Canoe Lake. But Thomson might have been thinking of slipping away unnoticed from Canoe Lake, catching a train at the last minute and picking up his camping gear at South River. It may also be that, after his fishing trip with his ranger friend Tom Wattie, he planned to keep on going, following the plan he'd mentioned to Tom Harkness when he said that, sometime in July or August, he planned to head west and paint in the Rockies.

No one in the Thomson family had ever been made aware of this cache of equipment that was claimed to have belonged to Tom. The information was a shock. The easy assumption that he may have been planning a getaway, whether skipping out on a promise of marriage or an unwanted child, would paint him "as a bit of a cad," says Tracy Thomson, "and if so, I and others would be terribly disappointed." Still, this is a possibility, given his own stated intentions of heading west to paint and the Wattie family's absolute conviction that the gear shipped to them had belonged to Thomson.

It could be that someone at Canoe Lake learned of the pre-shipped camping gear, made various assumptions and decided that Thomson needed to be "taught a lesson." You do not skip out on a marriage. You

live up to your promises, especially to a woman who so very clearly believed they would be fulfilled, who may also have been in desperate need to have that promise kept.

It might have been a lesson that went terribly wrong.

There is, of course, one enormous problem with Daphne Crombie's story. I have no doubt that she recounted, twice, an honest rendering of her exchanges about Tom and Winnie with Annie Fraser. If we accept that Annie told Daphne the truth—and Annie not only was held to be a reputable, dependable woman, but in this case was also incriminating herself—and that Daphne fairly reported what she had heard, then it is obvious that Shannon Fraser was a prime suspect in the murder of Tom Thomson.

The problem lies in the timeline. From her interviews, it seems that Daphne Crombie believed the fight between Fraser and Thomson occurred after the Saturday, July 7th evening drinking party at the guides' cabin. But if so, how can the events of July 8, 1917, be explained?

Tom Thomson—who, according to the interpretation that follows from Crombie's account, would have been tangled in fishing line at the bottom of Canoe Lake by Sunday morning—was seen by witnesses that morning. As mentioned previously, Mark Robinson claimed some years afterward that he had seen Tom with Shannon Fraser by the Joe Lake dam as they plotted to pull a practical joke on Mark with a large trout Tom would catch elsewhere. Two others stepped forward nearly sixty years after the painter's death to say that they, too, had seen Thomson that Sunday morning. Their claims were made during an Algonquin Park archives interview conducted by Rory MacKay on February 11, 1976. The two were Rose Thomas and her cousin Jack Wilkinson, whose families lived at various places about the park— Cache Lake and Canoe Lake among them. The summer Thomson died, they had been living at Canoe Lake. Rose Thomas was ten and Wilkinson, five.

In response to MacKay prodding them about their memories, they produced a variety of childlike remembrances—both believed there had been a train wreck a day in the time they were at Canoe Lake—and a tremendous amount of confusion concerning events, places and people, particularly the recollection of names. And yet, surprisingly, when MacKay turned the questioning to the week Tom Thomson went missing, their memories suddenly became crystal clear.

"In the morning it was very muggy," Rose Thomas said, "and a fine, warm drizzle rain." Wilkinson remembered seeing Thomson when both children were with Rose's mother. "He came up with Shannon Fraser in the morning before he got drowned in the afternoon," said Wilkinson. "He came up, didn't he walk up and walk to the section house?"

Rose Thomas corrected him, saying they hadn't spoken to the artist, but that "him and Mr. Fraser walked up the track."

It seemed odd that the two would remember such detail—right down to the "drizzle" in the morning—of a day many years in the past that at the time would have been remarkable for nothing. Thomson, after all, hadn't even gone missing at this time. And yet they remembered everything from Tom and Shannon walking together to the weather. And then it struck me. Possibly what the two were remembering was the CBC documentary on Thomson that had been aired only a few years earlier and perhaps remembering, as well, what they had read in William Little's book, which was still popular. As the conversation with MacKay continued, the two argued about places and locations and events but then again later, when the topic returned to the exhumation of Thomson's body from the Canoe Lake graveyard, their memories were identical and vivid, right down to a description of the undertaker working in the light of a single lantern deep into the night—exactly as the scene had been portrayed in the CBC television documentary.

Daphne Crombie told me in 1977 that she didn't believe Mark Robinson saw Thomson that morning. She might have been right. Robinson's story about the binoculars, the eavesdropping and the big

trout is hard to square. Memories dating from when Rose was ten and Jack was five are even easier to dismiss.

But still, for the sake of argument, let's assume that Tom Thomson was out and about that drizzly Sunday morning.

July 8, 1917, has always been accepted as the day Tom Thomson died, by whatever means. It was a dull, wet Sunday, and three witnesses—regardless of what we make of their stories—claim to have seen Tom and Shannon Fraser walking up around the Joe Lake dam. After they returned to Mowat Lodge, Fraser said that he provided the artist with some supplies and watched him paddle away from the Mowat Lodge dock—the last time, it was assumed, that anyone ever saw Tom Thomson alive. Shannon Fraser testified that he had even checked his timepiece and saw that Thomson had left the dock at 12:50 p.m.

This has always struck me as most peculiar. Why would anyone check his watch at such a moment and, even if Fraser did, why would he make such a careful mental note of the time? Exact times are rarely noted in such settings. Was Shannon Fraser wondering if he was too late for lunch at his own lodge? Or was he, in retrospect, building a case for Tom Thomson disappearing that afternoon as opposed to his vanishing in the predawn hours of the day?

The next bit of "evidence" relating to the time of Thomson's death has been the reported sighting of an upturned canoe by Martin Blecher, Jr., and his sister Bessie as they rode their little "putt-putt" motorboat down toward Tea Lake—ostensibly in the same direction that Thomson had taken from Mowat Lodge.

The canoe has always been yet another enigma within the mystery. The Blechers also apparently noted the exact time of their sighting of the canoe—3:05 p.m.—and said they did not investigate. As mentioned earlier, this goes against all convention for a place like Canoe Lake, where an upturned canoe is considered the wilderness equivalent of a city fire alarm. Blecher's explanation for not investigating was that he and his sister presumed the canoe was one that the Colsons, owners of the Algonquin Hotel on Joe Lake, had reported

missing. Martin and Bessie Blecher determined to catch the canoe later and return it to its rightful owners.

This, if anything, seems more plausible. Had the upturned—no one has ever said "swamped," which would look different—canoe been Thomson's, they would instantly have identified it as his, since Thomson's dove-grey canoe with the metal strip on the keel would be as recognizable among the Canoe Lake regulars as the Royal Carriage might be in London. The Blechers—who knew Thomson well and who lived only one cabin beyond the Trainor cabin and dock, where Thomson's canoe was regularly pulled up and turned over—never said it was Tom's canoe. In fact, they specifically said that they took it to be the Colsons' missing canoe, and this perhaps highly significant detail seems somehow to have been overlooked or dismissed in all the retellings of the Thomson legend. In Little's book, for example, the Blechers' decision not to investigate is portrayed as a negligent act and as one more dramatic piece of evidence in the case Little was building against Martin Blecher, Jr. Surely if Blecher had been the murderer, the last thing he and his sister would do would be to motor past Thomson's overturned canoe—or, for that matter, later report that they had seen it and done nothing.

It is far more likely that the canoe they spied was *not* Thomson's. And rather significantly, later in the week, during the search for Thomson, Robinson made note in his daily journals that he and his son Jack had found the Colson canoe on the Gill Lake portage.

The confusion regarding canoes does not end here. Thomson's dove-grey canoe was said by one of the guides to have been found later the following day (Monday), drifting upright. It was also said by Mark Robinson to have been found upside down. It was even said, by one of the tourists there at the time, who later wrote about the incident, to have been discovered stashed in the Blecher boathouse. There is simply no firm and accepted version of exactly where or how the canoe was found or in what position, though it is certain that the distinctive canoe was indeed located on Monday, July 9th, with Thomson nowhere near it. It was not, however, until the following morning,

Tuesday, July 10th, that this was reported to Mark Robinson at his quarters on nearby Joe Lake. Shannon Fraser brought the news, as Robinson reported it in his journal, "that Martin Bleacher had found Tom Thompsons Canoe floating upside down in Canoe Lake and wanted us to drag for Mr Thompsons body."

Given the ambiguity of Robinson's note in his journal, it could have been either Martin or Shannon wanting park authorities to drag for Thomson's body. If Blecher was indeed the murderer, as partially believed by Robinson later and fully believed by author William Little, why would he send the authorities in search of evidence? The ambiguity remains.

No wonder, following the brief coroner's inquest held at the Blecher cottage, Mark wrote in his journal, "There is Considerable Adverse Comment regarding the taking of the Evidence among the Residents." Annie Fraser, for example, was not even at the inquest carried out by Dr. Ranney of North Bay. Only two women, Bessie Blecher and her mother, were there, and they were present only because the inquest happened to be held in their place and they prepared the meal that seems to have taken precedence over all else. If Annie had been there, she might have been able to corroborate her husband's claim that he'd seen Thomson leave the Mowat Lodge dock at exactly 12:50 p.m. on Sunday, July 8th. If, in fact, that statement was true.

No one has ever questioned this most specific reference to time. To Mark Robinson, it seemed to fit with his sense that Thomson had paddled away from Mowat Lodge at around one o'clock, stopped over at the empty Trainor cabin to gather whatever else he needed for his brief trip and then paddled away for the very last time.

But what if Thomson had proceeded straight down Canoe Lake and over the portage to Gill Lake or through the narrows into Bonita Lake and on through the next narrows into Tea Lake? He had all afternoon and early evening to fish. He would have trolled, not fished at the dam, as widely presumed, as he was after a lake trout and the trout, in July, were in the deeper water. He could have covered both Gill Lake and Tea

Lake that afternoon and into the long light of the early July evening, as both bodies of water are small and easily accessible. He could even have taken the time to stop and prepare a meal, perhaps even using the supplies that Fraser claimed to have given him. Maybe he had a small trout or bass to fillet and cook as well. That he seems not to have taken his axe with him from Mowat Lodge is unusual, but its absence does not make a fire impossible. He would have had to have an axe if he was going on a longer trek, but not necessarily for a shore lunch. Instead of splitting logs, guides and expert woodsmen knew to collect dead branches from under the spruce and tamarack that line the shores and portages of the area. All Thomson would have needed was a match to start a fire that would burn quickly, providing ready cooking heat, and that could be easily put out.

Perhaps Tom did catch the trout Mark Robinson maintained he was looking for, perhaps not, but he might have fished into the evening—considered the best time for trout by park oldtimers—paddling back to Mowat Lodge under cover of dark. He would not have been "sneaking" back but merely travelling in a way and at a time that was common at Canoe Lake. As Mark Robinson's journals of these days continually make reference to rain and wet, it is safe to assume that there was cloud cover and that it was darker earlier than might have been the case under a clear evening sky. The silence of a well-paddled canoe would have allowed him to pass by unnoticed, even in the middle of the day, unless someone was specifically looking for him. Let us assume, then, that it was dark when Tom came back on Sunday, July 8, 1917, and that no one noticed his return. As it was a weekend, perhaps Mr. and Mrs. Trainor were now at their cabin—no mention one way or the other exists in Robinson's journals—so Tom would have gone to the lodge, which was mostly empty. The weather, the blackflies and the mosquitoes that week were making a stay at the lodge uninviting. Tom could easily have gone to his room unnoticed. And perhaps it was only then that he opened and read the letter from Winnie that Annie Fraser later told Daphne Crombie about. *"Please, Tom, you must get a new suit because we'll have to be married."*

Perhaps Tom thought about it a while and decided he had to go through with it. So he would then have gone to see Shannon Fraser to try to get back the money still owed on the canoes Fraser had bought for the lodge, using Thomson's generous loan.

It could even be (for those wondering about the intriguing claim by the Trainors' young Huntsville neighbour Brad McLellan) that Fraser had been asked, surely by Hugh Trainor, as this would be considered the business of men in that time, to teach Thomson "a lesson." The request could even have had a different take on the business of *having* to get married. Hugh Trainor, still working in the bush, could have heard from others in the area lumber business that Thomson had a reputation as a bit of a philanderer (an exaggerated reputation, in the opinion of Thomson researcher Iris Nowell). Given the social mores of the time—conservative, backwoods Ontario in the post-Victorian period—there might not even have been a pregnancy, just a promise, even a misleading one, that Thomson would marry Winnie, who, at age thirty-three, was on the verge of dreaded spinsterhood. Being "jilted" would have been humiliating to her and greatly insulting to the proud Trainor family.

The Trainors might also have learned that Thomson planned to sneak away to the West soon, having secretly shipped his camping gear off to Tom Wattie in South River. It is even possible that Shannon Fraser, who spent considerable time around the train station, might have just learned of this himself, put two and two together, and decided entirely on his own to teach Thomson "a lesson."

If there was a fight and it happened as Annie Fraser told Daphne Crombie—Shannon Fraser striking Tom hard, Tom falling and striking his head on the fire grate—it may be that Thomson was still alive when he sank in Canoe Lake. But the Frasers might have believed he was dead. All Annie said to Daphne was that she had been forced to help her husband cover up what had happened.

Shannon Fraser would have panicked. Thinking he had killed Thomson, or certain he had done so, he determined to make the artist's death appear to have been caused by accidental drowning. With Annie's

help, he got Thomson into his canoe, tied the portaging paddles in place, badly, stashed some supplies to make it appear Thomson was heading out and then used fishing line to attach some sort of weight to the body to keep it down.

In Annie's tale, her husband then towed Thomson in his canoe out on the lake and easily dumped it, setting the canoe free to drift. As Thomson had, of course, not been paddling, the missing working paddle was likely still on the Mowat Lodge dock when Fraser returned. If he noticed it, he would have destroyed it, likely by burning, to protect the story of Thomson falling from his canoe while out on the water. It didn't occur to him that people would search for it for years and that the missing paddle would become an essential part of the mystery. If Thomson wasn't paddling, how did he get there?

This entire procedure would have taken some time. In that season of the year, the sun sets after 9 p.m. Perhaps Thomson didn't get back until 10 p.m. or even later. Shannon and Annie Fraser would have been working on the cover-up of the assault until about midnight and perhaps even past midnight.

If so, then Tom Thomson did not die on Sunday, July 8, 1917, as has always been presumed. He might have died on Monday, July 9th—perhaps shortly after midnight.

Could this have happened?

It could well have. Shannon Fraser, remember, made much in his testimony at the inquest of the fact that, when he had checked his pocket watch as Tom Thomson was paddling away from the Mowat Lodge dock on Sunday, the time was *exactly* 12:50 p.m. And that was the last time, it has always been said by subsequent investigators, that anyone saw Tom Thomson alive.

Yet seventeen years later, on April 23, 1934, when George Thomson wrote to Blodwen Davies in response to various questions, he said he was in possession of much of his brother's property from Canoe Lake, including his sketches. "I have his watch," George added, "and it stopped at 12:14."

12:14.

Shannon Fraser swore in testimony that Tom Thomson had paddled away from the Mowat Lodge dock at 12:50.

Had Tom Thomson's watch mysteriously stopped thirty-six minutes earlier? Had it merely wound down while sitting on the dresser of his room back at Mowat Lodge? (We don't know whether George gained possession of the watch during his trip to Canoe Lake before Tom's fate was known, or whether the watch had later been returned with their property.) Or had it stopped on entering the waters of Canoe Lake? (The first waterproof watch would not be marketed by Rolex for another nine years, and such watches did not become popular until the 1930s.)

And if so, is it possible that the painter's watch stopped at 12:14 *a.m.*— fourteen minutes past midnight on Monday, July 9th?

Stopped suddenly when a panicking Shannon Fraser turned that canoe over under cover of dark?

TWELVE DAMAGE CONTROL

Shannon Fraser moved with remarkable speed in the days following the discovery of Tom Thomson's body. He was directly involved in the move to bury Thomson before Coroner Ranney's arrival and appears to have ignored a telegram from the Thomson family asking that the body not be buried at Canoe Lake but be returned to them. He was part of the hasty inquest that seemed to ask next to no questions before declaring the artist had drowned, with the unstated presumption being that it had been an accident. And when so many groused about the expediency of the inquiry and the slack "taking of evidence," it was Fraser who began the rumour that Tom Thomson had taken his own life.

Thomson's artist friends moved quickly, and with sincerity, to ensure that their colleague would be warmly remembered. A.Y. Jackson, still overseas with the war effort, wrote to MacDonald in August 1917, saying that "[w]ithout Tom the north country seems a desolation of bush and rock. He was the guide, the interpreter, and we the guests partaking of his hospitality so generously given." Jackson felt indebted to Thomson

for showing him "a new world, the north country, and a truer artist's vision because as an artist he was rarely gifted."

In September 1917, the Toronto painter friends of Thomson erected a cairn at Hayhurst Point, near his favourite Canoe Lake camping spots, with J.W. Beatty contributing the stonework and MacDonald creating a bronze plate that read:

To the memory of Tom Thomson, artist, woodsman and guide, who was drowned in Canoe Lake, July 8th 1917. He lived humbly but passionately with the wild. It made him brother to all untamed things of nature. It drew him apart and revealed itself wonderfully to him. It sent him out from the woods only to show these revelations through his art. And it took him to itself at last.

MacCallum, who footed much of the bill for the hagiographic plaque and cairn, was first off the mark to write fond remembrances of Thomson. He contributed a long article to the *Canadian Magazine* that appeared at the end of March 1918. "With the tragic death of Tom Thomson in July, 1917," his essay began, "there disappeared from Canadian art a unique personality. Thomson's short and meteoric career, the daring handling and unusual subjects of his pictures, the life he led, set him apart. Living in the woods and even when in town avoiding the haunts of artists, he was to the public an object of mysterious interest. He lived his own life, did his work in his own way, and died in the land of his dearest visions."

MacCallum praised Thomson's painting and his woodsmanship equally. The painter's "knowledge of the appearance at night of the woods and lakes was unrivalled," he wrote in prose so purple it would itself rival the northern lights:

He was wont to paddle out into the centre of the lake on which he happened to be camping and spend the whole night there in order to get away from the flies and mosquitoes. Motionless he studied the night skies and the changing outline of the shores

while beaver and otter played around his canoe. Puffing slowly at his pipe, he watched the smoke of his campfire slowly curling up amongst the pines, through which peeped here and there a star, or wondered at the amazing northern lights flashing across the sky, his reverie broken by the howling of wolves or the whistling of a buck attracted by the fire. In his nocturnes, whether of the moonlight playing across the lake, or touching the brook through the gloom of the forest, or of the tent shown up in the darkness by the dim light of the candle within, or of the driving rain suddenly illuminated by the flash of lightning, or of the bare birch tops forming beautiful peacock fans against the cold wind-driven blue skies, one feels that it is nature far apart, unsullied by the intruder man

MacCallum saved his strongest words, however, for the critics. "It has not been the fortune of any of our artists to have had during their lifetime a vogue with the Canadian public," he claimed. "Thomson was no exception. To the art critics of the daily press he was an enigma, something which, because beyond the pale of their experience, it seemed quite safe to ridicule. Yet in one magazine a courageous writer ventured to say, 'Tom Thomson can put the spirit of Canada on a piece of board eight inches by ten inches.'

"The intelligent public rather liked his work, but was not quite sure whether it was the safe and proper thing to say so. He found recognition, however, among his fellow artists, who looked forward with pleasure and curiosity to see what he would show at each exhibition. It is to the credit of the Ontario Government and the trustees of the National Gallery of Ottawa that they recognized his value. He never exhibited at the Ontario Society of Artists without having one of his pictures bought for the Province or the Dominion. These will remain for succeeding generations, the ultimate arbiters of the reputation of all artists. Confidently we leave to them the fame of 'Tom Thomson, artist and woodsman, who lived humbly but passionately with the wild.'"

Many years later, in a 1930 letter to a friend, MacCallum would boast that his magazine piece had set a tone that remained unsullied. The article, he bragged, "has been the source from which all the articles written about him have been drawn."

For decades such pristine treatment of Thomson rendered him only as the man described on the Canoe Lake plaque, the words of which MacCallum chose to end his article. This Thomson was as pure as the waters he paddled. His art friends might not be quite so pure as the driven snow—Varley was renowned for his drinking and woman-izing, and Harris's marriage collapsed—but Tom Thomson's image was burnished.

MacCallum was protecting not only his friend but also the estate holdings and his own investments in Thomson's work. Daphne Crombie said that she had tried to talk to MacCallum about what had really happened at Canoe Lake, but MacCallum would hear nothing of it. He wished only to hear what Daphne thought of the rumour spread by Shannon Fraser, which had quickly reached the city. Did she think that Tom had killed himself? MacCallum asked Crombie.

"I said, 'Utter bosh rubbish,'" she later told the park archivist who interviewed her in the late 1970s. "[Tom] was getting all excited about his paintings because they were being recognized. He told me with great big round eyes that he'd just sold one to the government for five hun-dred dollars. He was all up in the air about his painting." MacCallum seemed deeply satisfied to hear this, she later said, but he showed no interest in any other of her opinions on the artist and his end. She did not attempt to raise the issue again.

The Thomson family worked through MacCallum when it came to selling Tom's paintings and some of the many sketches that George Thomson had brought back from the Trainor cabin at Canoe Lake. This might not have been a very happy arrangement. When researcher Iris Nowell went to Owen Sound in 1973 to talk to the family about the upcoming Silcox and Town book, *The Silence and the Storm*, she was told by Jessie Fisk, Thomson's niece, that MacCallum had once asked for a

specific painting Thomson had done at Go Home Bay and that the family had given it to him only on condition that he one day give it to the National Gallery.

"Tom owed him nothing," the niece said of MacCallum. "He got plenty."

In 1924 MacCallum approached Eric Brown, then director of the National Gallery of Canada, urging Brown to buy more Tom Thomson works to establish Thomson's place in the Canadian art world. The gallery had already purchased three canvases—*Moonlight*, *Spring Ice* and *Northern River*—before Thomson's death and had since picked up two more major canvases, *The Jack Pine* and *Autumn's Garland*, as well as some two dozen small sketches. MacCallum wanted even more. He had, Brown later wrote, "almost a paternal concern for the painter."

MacCallum was able to sell one painting, *In the Northland*, to the Montreal Museum of Fine Arts, but his hopes that the Art Gallery of Toronto (later Art Gallery of Ontario) would buy several paintings were not realized. The gallery had purchased *Northern Lake* many years earlier and, in the mid-1920s, was given *The West Wind* as a gift from the Canadian Club. The apparent lack of interest infuriated MacCallum, and he held a grudge against the gallery. When the protective art patron died suddenly in late 1943—dropping dead at eighty-three in his medical office—he left a will stipulating that most of his vast art collection go to the National Gallery. Of the 135 works he gave to Canada, 83 were Tom Thomson works.

MacCallum's concern that no one think his beloved painter had killed himself was certainly shared by the Thomson family. They were angry with Shannon Fraser, even before Fraser's gossip got back to them. Tom Harkness sent a sharp letter to Fraser on September 12, 1917, about the money he still owed the painter's estate. Harkness was also concerned about payments requested for the two guides who had found Thomson's body, as well as demands from the undertaker who had come for the

initial burial. Harkness, who had already taken strong issue with the undertaker's bill, wrote back in obvious anger:

Dear Sir,

Your letter received tonight with five dollars enclosed brings the balance on two canoes you claim due the estate of the late Tom Thomson. Also the letter from Flavelle about his account. I had to go to Toronto to look after some affairs of the estate and get the balance due the estate at the bank. I was then ready to pay Flavelle's account but was waiting to hear from you in answer to my letter of Aug. 9th. Now Mr. Fraser there are some things I don't understand. In your letter to me Aug. 7th you claimed to have paid Mr. Rowe $5.00 and Dickson $3.50 for finding Tom's body. Tonight you send receipt from Rowe for $5 and from Dickson $10.00. Then Dr. MacCallum told you to send the account for finding Tom to him which you did and he paid you. We do not understand this. Why should you send any account to anyone out of the family & why did you not let me know that you collected from Dr. MacCallum? You told Geo Thomson that you owed Tom a small amount—but you have not given me any information about it. Now Mr. Fraser the Estate demands a full account of everything. Surely Tom had some personal property. Had he no trunk or grip or clothes except what you showed Geo. Thomson and how do you account for Tom only having .60 cts when found. I knew what he drew from the bank when he went away . . .

I tell you frankly Mr. Fraser I am suspicious that you are not dealing square and I hope you will be able to give me a satisfactory explanation on everything. Another question I would like to ask did you pay Tom for the canoes he bought for you? And when.

Now I am ready to pay Mr. Flavelle's account just as soon as you can give me a satisfactory explanation for everything.

I am waiting your reply.

T. J. Harkness

The Thomson family never forgave Fraser for his behaviour. When Iris Nowell interviewed Jessie Fisk in 1973, Fisk referred to Fraser as a "crook" and dismissed him as "ignorant" and "an ignorant liar"—a man who could not even write a proper letter. She was not much easier on Annie Fraser, saying Shannon's "poor wife was a snoop."

The family had also been disturbed by Winnie's comments to Margaret when they ran into each other at the CNE in August 1917. During that conversation, Winnie not only claimed that Fraser had not fully paid back Tom's loan to him, but also said he'd ignored George Thomson's telegram of instructions and allowed the Canoe Lake burial to take place before the coroner could arrive from North Bay. "Sometimes I wonder," Margaret speculated in a letter she wrote to MacCallum on September 9, 1917, "if the man did do anything to harm Tom. I suppose it is wicket [sic] to think such a thing but if anyone did harm him it was not for the little money they could pocket."

Winnie Trainor certainly shared the family's disenchantment with Fraser, who in the years that followed always liked to portray himself as Thomson's good friend. She had told Margaret that Tom had not liked Fraser because he "hadn't a good principle." And in letters Winnie wrote to the Thomson family in the weeks after Tom's death, she railed several times against Fraser.

Mark Robinson's daughter, Ottelyn Addison, who died in 1998 at age eighty-nine, once told me her father believed that Shannon Fraser had owed Thomson significant money for four or five canoes and Thomson had "repeatedly asked for it." It is not known how much was still outstanding at the time of Thomson's death. Fraser's gesture in his letter to Harkness would seem to suggest a mere $5. Winnie believed the original loan was for $250 and had been made two summers earlier but did concede that, to her knowledge, "most of it" had been paid back. The Thomsons remained suspicious, however. They believed Fraser had even tried to sell Tom's snowshoes, which had not been returned to the family in the bundle of belongings that was shipped to Owen Sound following his burial.

Addison recalled Fraser as "such a devious person" and had long wondered why it was that Fraser had so often told people that Thomson had killed himself rather than face the prospects of marriage and settling down. "I now think," she said, "it may well have been a cover-up—that Shannon Fraser was trying to make sure nothing came back to him."

The suicide gossip—if that's all it was—worked to a degree. J.W. Beatty was the first of the group of artists to become convinced that Thomson must have killed himself. But when Beatty expressed this opinion, he faced the wrath of others. "I cannot for the life of me," Tom Harkness wrote to MacCallum, on November 3, 1917, "know how he, claiming to be a friend of Tom's, can so easily swallow all Fraser's bunk and knowing that Tom was one who had a high moral sense of duty to his fellow man, and he must know perfectly that he had nothing to run away from. I've thought the thing over from every viewpoint, and the more I think of it, the more fully I am convinced that Tom had no hand in taking his life. But it makes me feel sore to think Fraser, who claimed to be a friend of Tom, would make all those suggestions and Beatty ready to take them all in."

More than a month later, MacCallum received another letter from the Thomson family, this time from Tom's brother George. Again, the subject of possible suicide was raised, but quickly dismissed. George Thomson was of the opinion that Winnie would not be likely to "influence him one way or the other." He also speculated that perhaps Fraser's continued whispering about suicide was strategic, intended to get others thinking that Tom might have done himself in "and thereby throw off any suspicion of foul play against himself."

George shortly after vented his anger in a letter to the Frasers saying, "You have apparently done your utmost to fasten this terrible stain upon his memory using as evidence for this purpose some trivial incidents, innocent enough in themselves, and fashioning them to suit your theory." The fact that George would take time out on Christmas day to

write such a letter demonstrates just how much this gossip was infuriating the Thomson family.

Six days later, MacCallum received a letter from Fraser complaining about George Thomson, saying the artist's brother was "accusing me and Mrs. Fraser of telling the coroner that poor Tom committed suicide. My wife wasn't at the inquest and never spoke to the Doctor as the inquest was held at one of the neighbours and at midnight. No one ever mentioned such a thing at the inquest"

That much apparently was true, but then the lies began. "I am feeling very badly about this terrible thing," Fraser told MacCallum, "as I thought so much of Tom and would be the very last to mention such a thing. However several people have said to me it was no accident and I have always assured them it was an accident . . . He also accuses me of keeping the money you sent to pay the men which I returned to you as soon as the cairn was finished . . . George Thomson ought to be the last one to say anything as he came up here and did not do anything to find Tom's body did not even get men to grapple went back home and left everything up to me and the people were talking about him wondering if he had no money."

The Thomsons were anxious to quash any such talk that might spread beyond Canoe Lake and Huntsville to the city and, perhaps, do irreparable damage to Tom's reputation. On January 2, 1918, George wrote to J.E.H. MacDonald, the most influential of Tom's art friends. "At first," George began, "I classified Fraser as an ignorant sort of fellow, but honest. In light, however, of what has occurred more recently in his dealings with Harkness and Dr. MacCallum, I have to place not the slightest dependence in his word. I believe he has come near to manufacturing this evidence to suit his purpose, which was to show that Tom had committed suicide." Such loose talk, George feared, could have the undesired effect of "fastening upon Tom's memory a stain that would be difficult if not impossible to wipe out."

The effort to shut Fraser up became almost a mission for the family. "I really don't know what to do about J.S. Fraser," Tom's sister Elizabeth

Harkness wrote to MacCallum on February 19, 1918. "I feel such a horror of him to think he is deliberately undermining all Tom's lovely character at a blow when he was not here to defend himself. I wanted to go down to Canoe Lake as soon as I heard it—but the family did not want me to go so things are just allowed to drift—much against my will."

Elizabeth called Fraser's continuing gossip nothing but a "bread and butter yarn" and told MacCallum that its purpose "puzzles me. He is certainly ignorant and without principle. His whole story from beginning to end is a muddle of contradictions, what is the underlying meaning of it all is what I would like to penetrate."

There was certainly an attempt, largely successful, to put an end to any talk of suicide. But there was also, at the time, little speculation concerning murder, even if many of those close to the situation had their thoughts on the possibility. Ottelyn Addison came to believe that just about everyone who had been there at the time, or who had some connection with the story, had deliberately turned quiet about what might or might not have happened. When Blodwen Davies wrote to J.E.H. MacDonald to ask for information, he responded, "I feel sure that it is best for me to associate myself with the silence of an old friend."

Art historian Joan Murray claimed the Group of Seven came to treat Tom's death as a "taboo subject." Their view of him rarely varied from the sentiments behind the saintly words MacDonald had chosen for the Canoe Lake cairn. Murray argued that the group felt it had a vested interest in maintaining and grooming that reputation. "Fighting for his art," she wrote, "was a way of fighting for their own ideals."

This constant polishing carried on for more than half a century. In a letter A.Y. Jackson wrote on September 15, 1966, he mentioned the Blodwen Davies biography and said there were "many people who thought she was too positive about foul play in Thomson's death. She got all that from old Mark Robinson.

"Dr. MacCallum," Jackson continued, "said they believed it was sui-
cide and they brought in a verdict of accidental drowning to make it
easier for the family. MacCallum had received a letter from Tom written
the day before. quite cheerful and looking forward to starting painting
again—I think Lawren [Harris] always had the feeling there was foul
play, but there was no evidence. I think perhaps influenced by the feel-
ing he was of no importance as a painter and probably up there to avoid
military service."

Jackson himself would play a part in the silence of Thomson's old
friends. When he finally got around to delivering on a promise to write a
foreword to the re-publication of Blodwen Davies' original work, he took
advantage of her recent death and his access to the original manuscript
to expunge the three critical questions Davies had asked back in 1935:

"Who met Tom Thomson on that stretch of grey lake, screened
from all eyes, that July noon?

"Who was it struck him a blow across the right temple—
and was it done with the thin edge of a paddle blade?—that sent
the blood spurting from his ear?

"Who watched him crumple up and topple over the side of
the canoe and sink slowly out of sight without a struggle?"

When the new version of Blodwen Davies' book appeared in 1967,
her three powerful and suggestive questions were missing—with no
answers provided to replace them.

Why Jackson would do such a thing to Davies' book is itself a mys-
tery. A.J. Casson, the last surviving member of the Group of Seven—he
died in 1992—once told Tom's great-grandniece Tracy Thomson that
"Alec [Jackson] knew exactly what had happened to Tom. He knew—
but whatever he knew he took it to his grave."

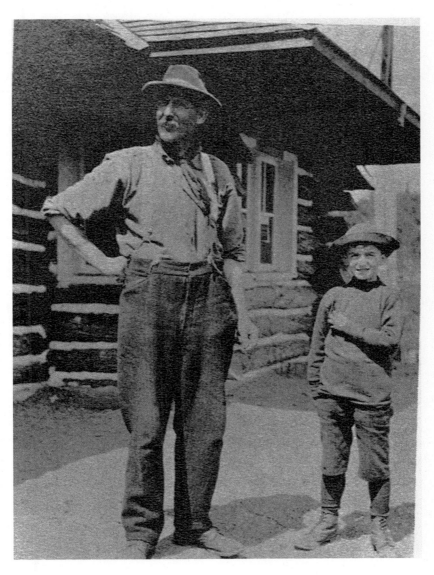

Ranger Mark Robinson and son Jack.

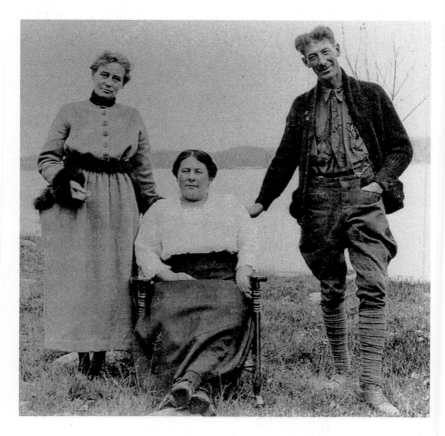

Shannon and Annie Fraser (sitting), with unidentified woman, Smoke Lake, Algonquin Park.

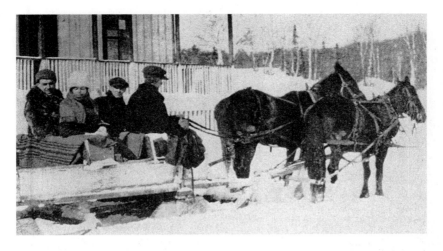

Daphne Crombie and Robin Crombie in sled driven by Shannon Fraser.
The fourth person seated beside Fraser is unknown.

Shannon Fraser.

Algonquin Park Super-
intendent George Bartlett.
He was determined that there
be no trouble reflecting on
him or his park in 1917.

Dr. Noble Sharpe of the Ontario
Provincial Criminal Laboratory led the
investigation into the bones discovered
at Canoe Lake in the fall of 1956.

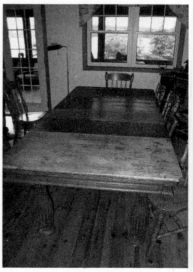

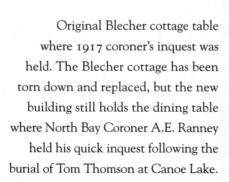

Kelso Roberts, Attorney General of
Ontario in 1956.

Original Blecher cottage table
where 1917 coroner's inquest was
held. The Blecher cottage has been
torn down and replaced, but the new
building still holds the dining table
where North Bay Coroner A.E. Ranney
held his quick inquest following the
burial of Tom Thomson at Canoe Lake.

THIRTEEN **A CHILD?**

There were two lost lives at Canoe Lake that damp July week in 1917 when Tom Thomson went missing. One, of course, was the life of the artist—dead but certain to live forever as a Canadian icon that was half art, half mystery. The other belonged to Miss Winnifred Trainor, the life she might have had.

Winnie Trainor is the one who disappeared far more than Tom Thomson. Initially dismissed as an insignificant figure—the subject of ordinary boy and girl letters, as ranger Mark Robinson put it, between herself and the artist and long unmentioned in the many studies of Thomson and his art legacy—she became "a person of interest" only after her own death in 1962.

In the first publication to mention Winnie, a photograph of another woman, still unknown, became the image that would come to identify her for the next half century or so. The CBC documentary of 1969 and William Little's bestselling book of 1970 both referred to her as a possible fiancée but no one ever dared suggest she might have

been left with anything but a broken heart and a few of the painter's original sketches.

The first tenuous public hint of the possibility of a pregnancy or child did not occur until 1972, when Charles Plewman was interviewed by the Canadian Press regarding a short article he'd written for *Canada Camping* magazine. Reporter Gord Wainman, the brother of longtime Algonquin Park ranger Dave Wainman, filed a story that ran on Valentine's Day and contained the first hints in print that there might have been a pregnancy involved. Plewman, eighty-two years old at the time, said that he had come to believe Shannon Fraser's interpretation of death by suicide and said that Thomson "may have taken his own life because of the desperate situation in which he found himself with his fiancée, Winnie Trainor." The CP report suggested that Plewman had "diplomatically" suggested that the Huntsville girl could have been pregnant at the time and "was pressing him to go through with the marriage."

A perturbed Plewman immediately sent a letter of complaint to the *Star*, one of many newspapers that had printed the wire story, saying he was "shocked and stunned" to find that the press and radio were saying that "I said Trainor was pregnant—that I said Thompson [sic] committed suicide. Both were untrue—I never made such statements to the media." It seemed Plewman was trying to have it both ways. He might not have made such actual "statements," but he certainly had dropped all the necessary hints.

To have it known back in 1917 that Tom Thomson had left behind a pregnant girlfriend, and a potential unwed mother, would have been a far larger scandal than suicide. It would likely have destroyed forever the artist's image in the eyes of prudish Canadians. Pregnancy in wedlock was to be hidden and not spoken of—pregnancy without a husband was, on the other hand, spoken of in the harshest of terms.

The Thomson family faithfully kept letters and scraps of information that came out of those sad events of 1917. But we do not have the luxury of such information where Winnie Trainor is concerned. Terence McCormick, my mother's first cousin, was the nephew who inherited all

of Winnie's property: the house on Minerva Street in Huntsville, the cottage at Canoe Lake, the dozen or more Tom Thomson sketches and a cluttered upstairs apartment that I recall was filled with old newspapers, magazines and kept letters and postcards. Terence told William Little that his aunt and Tom Thomson had been engaged to marry, and certainly my own family always believed this, but no documentation has ever been produced that might confirm her betrothal to Thomson.

The Thomson family, according to Tracy Thomson, always felt there might have been "a verbal agreement" between Tom and Winnie. "They probably talked about it," she told me in the spring of 2010, "but there wasn't a date set." Tracy counts herself as "unusual" in the widespread Thomson family in that "I don't fall into the camp of 'Winnie as odd.' I always gravitate toward people who others think odd and I think interesting."

There is a Tom Thomson painting in the McMichael gallery in Kleinburg, Ontario, that has always been identified as *Figure of a Lady, Laura*. This portrait, of a woman sitting on a rock overlooking water, has long been presumed to be of Laura Meston (sometimes spelled "Weston") Worsfold. It was donated to the gallery by William Pfaff, who said it was a portrait of his aunt Laura. "Unfortunately," McMichael archivist Linda Morita says, "there is not much information in the accession file on this work." For years the gallery dated the portrait as 1916, but it is now believed that Thomson actually painted it in the fall of 1915. The Thomson family has also long been convinced that the figure in this painting is Winnifred Trainor. "Yes, I feel it is Winnie," Tracy Thomson told me in 2010. "That's my opinion anyway, from an artistic point of view based on my study of the figure."

Thomson rarely titled his paintings and sometimes he even failed to sign them. Following Thomson's death, J.E.H. McDonald designed a stamp with the initials "T.T." and the date "1917" enclosed within its palette, to be used as a method for authenticating the work that Tom Thomson left behind. Titles were also assigned to works that had previously been without one. If this painting was indeed of Laura Meston Worsfold, it seems

rather strange that it would also be titled *Figure of a Lady*. It is possible the painting was named *Figure of a Lady* by someone other than Thomson, and that the name "Laura" was added later, either to show possession or to signal that it was given to the gallery in her memory, as the McMichael gallery feels. We cannot, however, ignore the possibility that the painting is of Laura Meston Warsfold, as her nephew claimed.

Victoria Lywood, the internationally known forensic artist from John Abbot College, in Montreal, studied the few available photographs of Winnifred Trainor and the painting *Figure of a Lady, Laura* and was able to conclude that the proportions are very much the same in the faces of the photographs and in the face in the painting. So, too, is the dark unwieldy hair. Lywood also cast her professional eye on the available Canoe Lake landscapes painted by Thomson and determined that it is also possible that the background of *Figure of a Lady, Laura* is Canoe Lake. If the setting is indeed Canoe Lake and if the portrait is now believed to have been painted in the fall of 1915, then the painting fits with the period in which a romantic link between Tom and Winnie was generally accepted around Huntsville and Canoe Lake.

But that, of course, is conjecture and not proof. Research to find Laura Worsfold eventually uncovered a grainy photograph of new brides, which appeared in the January 21, 1928, edition of the *Toronto Daily Star*. On the far right is, "Mrs. T.J. Worsfold, formerly Miss Laura Weston, daughter of Mr. And Mrs. Weston of Guelph." Though this photograph is of the same poor quality as the rare photographs of the "real" Winnie Trainor, Victoria Lywood again cast her expert eye on the *Toronto Daily Star* photograph and the *Figure of a Lady, Laura* painting to see if she could find any agreement between the subjects. Lywood found similarities in proportion, in cheek and jaw bone structure and in the elongation of the neck, concluding that she could not rule out Laura Worsfold as the possible subject of the painting. Because of the hat in the wedding picture, no comparison of hair could be made; however, the photograph in the newspaper strongly suggests an impressive hawk nose on Mrs. Worsfold, whereas Winnie Trainor's nose is much more in line with the subject of

the painting. Even so, it could be that the painter was merely flattering his subject by performing a little plastic surgery with his brush. "Right now this is arguable," Lywood concluded, "but if I had to argue it, I'm still leaning toward Winnie."

"I think the two of them were pretty sympatico," Tracy Thomson said of Tom and Winnie, "and that the only thing standing in the way of their union was his total and complete devotion to his craft. That was his sacrifice. I don't think he could have achieved the sublime level of genius in his painting if he had familial distractions which took him from his intense focus. He had to live and breathe and immerse himself so completely in nature to produce these perfect paintings.

"I feel he really did love her, but he was just *consumed* with his work."

We know from Mark Robinson that some letters Winnie had sent to Thomson were found, likely in his room at Mowat Lodge, and that these were given to her father to be returned to her. We know from Tom Harkness that the Thomson family asked about certain letters that had been produced at the shoddy inquiry, but it seems Harkness never did get any satisfaction from his query. Winnie herself said in a letter to Harkness that she had lost earlier letters in a fire.

In her few letters to the Thomson family, far more questions are raised than answered. Winnie seems reluctant to spell out her concerns on paper, yet at one point tells Harkness, "If I see you I can tell all." What "all" entailed is open to endless speculation.

Her letters contain few references to Tom and the tragedy, yet the letters that do are heartfelt. In writing to Harkness at his farm in Annan, east of Owen Sound, on September 17, 1917, she says she would have a hard time enumerating the various costs she incurred on behalf of the family, as "It seemed like two years instead of just two months to-day since Tom was drowned." The letters were far more about finances and property than heart. However, she was mostly answering Thomson family inquiries regarding possible loans to Shannon Fraser, the possible overbilling by the original undertakers and personal items the family wanted to have returned to them from Canoe Lake.

That she is reaching out to the Thomsons is clear in the letters, but her overtures were not reciprocated. Margaret never did go to Canoe Lake with Winnie, as Winnie had believed Margaret had agreed to do when they'd met briefly at the CNE in late August. The Thomson family, which had been quick to accept her offer of help during the discovery of the body and the burial, was just as quick to distance itself from her afterwards. When Margaret wrote to Dr. MacCallum following her brief encounter with Winnie at the CNE, she said that Winnie told her Tom "had warned her not to put anything in her letters that she wouldn't care to have them [the Frasers] read, as they always seemed to know his business."

Winnie gave the family the first hint that Tom was on the verge of heading somewhere else when he disappeared. "She said that he was intending to leave in a week or so," Margaret wrote to MacCallum, "and that he didn't want them [the Frasers] to know where he was going as they were so curious about everything."

Why would Winnie say such things? What would Tom fear her putting in a letter that a snooping Annie Fraser might find? the wedding plans? But how could she be speaking of a wedding day—as Daphne Crombie claimed—and now be talking vaguely about Tom heading out for some unknown destination? Could it be because she knew some of her letters had been read and was determined that no one think there had been any pressing need for a wedding? She might even have been selflessly protecting Thomson.

Very quickly, the Thomsons of Owen Sound severed any connection between themselves and Miss Winnifred Trainor of Huntsville. In a December 23, 1917, letter to MacCallum, George Thomson simply dismisses her by saying, "I spent a few hours in her company, and I think that even in that short time I formed a fairly accurate estimate of her worth and attractions." He does not say when, exactly, he met her. They did not cross paths at Canoe Lake during the search, and George did not attend the Canoe Lake burial, where she was present, so, presumably, it was at some point following the death of Tom.

George Thomson did not think she could have held much "influence" with Tom. "His relations with the Trainor girl," he wrote, "I don't consider to have much bearing upon the case."

Such a strange choice of words—"case." Whatever did he mean?

"I met her once and wasn't terribly impressed by her," Jessie (Harkness) Fisk told researcher Iris Nowell in 1973. Nor had the Tom Thomson niece taken great notice of Winnie in their one meeting, as it was Fisk who wrongly identified Winnie as the woman in the long-lost "Winnie Trainor" photograph Tom had taken back in 1912.

Fisk showed Nowell a letter the family had received from Winnie in September 1917 regarding Tom's loan to Shannon Fraser and the clothes he'd purchased that spring. Nowell was struck by the visual impression of the letter, which she noted "starts off fairly rationally and by the time you get to page two the writing is getting all tightened up and squinched together and on the reverse, for no reason at all, one little column of tight, heavily written words, goes vertically sideways on the page."

Once Nowell had looked at the second page of the letter, Fisk pointed to it and said, "She was unbalanced, you can tell here."

This sense that Winnifred Trainor was "unbalanced" took solid hold in the Thomson family. When Nowell interviewed Tom's sister Margaret Tweedale in the fall of 1973, Margaret said that she "didn't like being interviewed about Tom, that there were so many wrong things that were coming out and a lot of lies being told and if anyone wants to find out the real truth all they have to do is look at the old articles and newspaper stories written about the accident. Tom had a fine character, nobody had a finer character than he did and there was no mention of suicide. I get so peeved it really makes me sick—and a person seems so helpless against it, there are a lot of people trying to make money out of the articles they sell." (Mrs. Tweedale was likely referring to a recent article I had written in *Maclean's* magazine on the relationship between Tom and Winnie.)

Tom's sister believed that Winnie Trainor was not a significant force in Tom's life, even though she had never been to Canoe Lake to see her brother in his element and with his northern friends. In the sad letter Margaret wrote to her sister Minnie less than a week after Tom was found, she expressed sorrow that "He was alone and no one else was taking his affections."

In 1973 a much older Margaret said that she had received three letters herself from Winnie following Tom's death, as somehow Winnie had perceived that she was also curious about exactly what had happened. Margaret confirmed this curiosity by writing back—"at the dismay of her family," Nowell noted, "who told her not to write back because Winnie was not in her right mind."

"I never saw such confused letters in all my life," Margaret said. "I didn't know what she was getting at, I was anxious to find out anything I could, but I couldn't make head nor tail of it. I didn't keep them. I suppose I should've but I didn't. You couldn't understand what she was driving at, she was anxious to be a friend of Tom's. I knew some of the girls that Tom used to see and they were very nice in every way. But he wouldn't hold anything against her if he knew she wasn't in her right mind."

Tracy Thomson has seen the letters that were kept and can appreciate how her older relatives might have thought that Winnie was out of her mind. However, she thinks it possible that Winnie was under such severe trauma—her life's love lost, her marriage lost, perhaps pregnant—that her "confusion" and "anxiety" are all understandable. "She lost so much," Tracy says. "It would have been such a strain on a person's psyche."

Another relative, Elva Henry, who married Tom's nephew George, told Nowell that neither she nor her husband had ever met the painter, but the family was convinced that Tom had drowned accidentally. In her version of events, Tom had sprained his ankle and had wrapped support about his ankle with the fishing line that was found, had "lost his footing" while stepping out of his canoe, fallen and struck his head. As for Margaret Tweedale's fiery defence of Tom's character, Mrs. Henry suggested that her aging relative "gets things all mixed up" and you had

to be careful to check anything she might say. "Mrs. Tweedale," she said, "has become rigid in her beliefs about Tom and has got to the point where she's holding him in a sacred light."

With regard to Winnie Trainor, Mrs. Henry said the family had been upset by the lack of consultation with them both by the CBC for its 1969 documentary and by Little for his book. The family wanted to ensure that "from now on," only the truth would be told. And the truth, as the family saw it, was that there had been nothing significant between Tom and Winnie. Tom, she said, "probably had a good friendship with Winnie Trainor, that he'd been used to girls at home, having sisters, and that it would be natural for him to like her and her family." And then she added what had become the common line on Winnie: She had surely once been a very nice person, but "after Tom died, she did go a little strange."

According to Margaret, Winnie had approached their father, old John Thomson, after Tom's death and "wanted a share in Tom's estate. No one in her right mind would do a thing like that." Margaret said other letters from Winnie came to the family and, finally, a Thomson nephew set out to find out more about this strange woman from Huntsville.

"Somebody got him in touch with her guardian," she told Nowell, "and he said her mind was gone." At another point, Margaret insisted, "She was entirely out of her mind, the guardian said."

What "guardian"? At no point in her entire adult life, right up until her death in 1962, was Winnie under anyone's guardianship. She could be abrupt, but her lifelong friends and neighbours and even her enemies in Huntsville, Kearney and Canoe Lake would all agree that she was sharp, bright and, as they often said, certainly knew her own mind. She was never "out" of it.

Margaret claimed that a letter had come from Winnie to the Thomson family insisting that she be given consideration in the settling of the estate. Could this, in fact, be the "case" that George Thomson had referred to in his letter to MacCallum? It is intriguing to note that the estate was not fully settled until 1923—an inordinate amount of

time, given that Tom Thomson was virtually penniless and had limited material possessions beyond the sketches.

If Winnie truly did approach Tom's father in search of some portion of the estate, that could well have been the trigger for the cold manner in which the family treated her, conveniently dismissing her as mad. Jessie Fisk told Iris Nowell that there was a great discrepancy between the number of sketches Tom had supposedly completed that spring— Mark Robinson claimed 62 over 62 straight days; Audrey Saunders 35 over an unknown period of time—and the roughly 40 that were found. She believed that the missing paintings had gone to Winnie Trainor. Elva Henry told Nowell that Winnie Trainor said in a letter to the family that she had six paintings when Tom died and that she took six more, for a total of twelve. Again, this letter was not produced for Nowell to see for herself.

It may well be that Winnie Trainor did believe she was owed something more. George Thomson, in one account, had relieved the Trainor cottage of as many sketches as he was able to collect during his brief foray up to Canoe Lake during the search for his missing brother. He entered a dwelling that neither he nor his brother owned and took items that he deemed belonged to his brother, whose fate was still unknown. By what authority had he acted? None, it appears, apart from claiming possession on behalf of the family. Mark Robinson, the only "authority" on the lake, had not prevented him from gathering up his brother's "belongings" and might even, according to a later version told by Robinson himself, have helped him. And all this was done before it was even known what had become of the missing painter. Given his death, given the possibility that Tom and Winnie were engaged and given the reality that the paintings were found in the Trainor cabin, could not a legal argument be made concerning some legitimate claim by Winnie?

George Thomson, of course, was the responsible one, the first born, the one the family turned to when word arrived that Tom was missing. The two Thomson boys could hardly have been more different. George was educated; Tom had little use for school. George was responsible;

Tom was carefree. George had been financially successful early in his life; Tom was always struggling for money and, when he had it, was quick to spend it. But most of all, undeniably by the summer of 1917, Tom was hailed as an artist of merit, while the acclaim George surely craved as an ambitious artist would largely elude him. George was competent, even very good, while Tom was brilliant. George obviously felt a responsibility to preserve his brother's work as much as possible, but given Tom's recent successes, his financially savvy older brother would also have known the current and future value of the string of daily sketches Tom had left behind from that spring.

There is another mystery around George's activities. It is difficult to figure out why he would deny making a second trip to Algonquin Park when there was a letter from him that had been postmarked "Mowat" on the very day Churchill loaded his sealed casket on the train. The Owen Sound papers said George accompanied the casket home. His sister wrote a letter saying the same. Yet he denied that this had ever happened.

It may be that George felt he had failed the family. He had, after all, been the one dispatched to the park when Tom went missing but could not find him. He had left just days before the body was found. He had failed to prevent the Canoe Lake burial and do as his father had requested: bring Tom home to rest. Having let Winnifred Trainor take charge of the exhumation by Churchill, he must have felt betrayed in the fall of 1956, when a body turned up in the grave and it appeared—at least at first, and still to many from then on—that his brother's body had never been moved. It would have deeply disturbed him that the casket he was said to have accompanied home to Owen Sound might have been empty.

A proud, organized and dependable man, George Thomson would have felt the fool for letting all this happen on his watch. No wonder the family would have nothing to do with the opening of the Leith gravesite to prove whether or not Tom was there. Better, perhaps, to insist he was there and that he had been seen by witnesses to have been lying in that casket.

William Little wrote that, not long before George's death in 1965, he was beginning to come around to the necessity of having his brother's grave opened. It could be he felt guilty; it could also be that he hoped he would be proven to have acted properly, as first sons are expected to act, back in July of 1917.

It seems hard to portray a woman who denied herself hot running water as a money grubber, but it may be that Winnifred Trainor felt herself under pressures that she did not dare speak of, given the temper and order of the times. If she was indeed pregnant, as Daphne Crombie claimed and Charles Plewman certainly hinted at, then what became of the baby? As Crombie said, "The baby never materialized."

However, if one did "materialize" and either did not survive or was given up for adoption, the possibility raises certain questions of timing. In first bringing up the issue of a full-term birth in an author's note to my novel *Canoe Lake* that gives a fictionalized account of that abandoned child, I suggested that Winnie might have been three months along when, as Daphne Crombie had claimed, she sent the letter to Tom, asking that he get the money from Fraser to buy a suit for the necessary wedding. That, I guessed, could mean a baby born anywhere from December 1917 to February 1918.

In *Algonquin Elegy*, Neil Lehto took this theory and tried to refine it. He found that Mark Robinson's invaluable journals suggested Winnie Trainor left Mowat on May 25th, and it is possible that she did not return between then and the time she arrived at the Canoe Lake train station on July 17th, after the body had been found. Of course, Robinson did not report on every single arrival and departure, and the Trainors regularly came and went, since Huntsville was relatively close. Thomson could also have gone to visit her in Huntsville, as he often did. If the demanding letter truly existed, it would have been written before Tom went missing, as it was reportedly found in his room. Lehto therefore presumed the pregnancy would have begun before May 25th and not

been confirmed until Winnie had missed at least one, more likely two, menstrual periods. He concluded that if there was a baby, it would have been born sometime in February 1918.

Lacking relevant letters, interviews and, certainly, a birth certificate, I did some research in the late 1970s, using the only source readily available to try to trace Winnie's whereabouts in the months following Tom's death: the "Personals" section of the Huntsville *Forester*. Each week the newspaper reported the comings and goings of the local readership. It covered the church socials, the out-of-town visitors, the anniversaries, births, deaths and often even the visits of the townsfolk.

When I first began examining old issues of the newspaper, there was no microfilm at the *Forester* to thread through machines and there were no search engines. There was only a concrete "bunker" off the cellar of the old *Forester* offices on Main Street. I had the good fortune of having my parents live kitty corner to Peter Rice, then manager of the paper and a member of the family that had owned the weekly through three generations. He said I was welcome to pick through the "archives" so long as I was careful and did not rip anything. I spent a week there, sneezing and dusting myself off at every turn of the page. But I thought it would be worth it. Perhaps by accident, the Huntsville *Forester* would suggest a story that might itself equal the mystery of Tom Thomson's death.

The *Forester* had duly noted Thomson's passing—"the deceased was well known by several in Huntsville"—and remarked upon the local undertaker, Churchill, being called to Canoe Lake to oversee shipment of the body to Owen Sound: "Strange to say, prior to his arrival the body had been buried, and it was his unpleasant task to exhume it."

The paper reported during the first week of August that Winnie's sister, Marie, had come home from her training at St. Luke's Hospital in New York for a visit. Nothing was said about any connection with the tragedy, however. Winnifred then went to Toronto to stay for several weeks with her friend Irene Ewing. We know from her letter and the letters and remarks of the Thomson family that she attended the CNE in late August. The November 12th edition noted that Miss

Winnifred Trainor had returned from yet another journey away from Huntsville, this time having passed several weeks in northern Ontario. She had stayed with Mrs. James Bradley (her mother was a Bradley) in New Liskeard and with Mrs. Jago in Haileybury and had spent time in North Bay with Miss Lottie Laing, who had been ill.

In that same edition of the *Forester*, it was noted that Mrs. Trainor and her daughter Winnifred had departed for Philadelphia on Thursday, November 8, 1917, "where they will spend the winter."

Hugh Trainor had lived in upstate New York before leaving the farm where he'd been born, to find work in Ontario, but no one in Huntsville knew of any Trainor connections in Philadelphia. Marie had been training at St. Luke's in New York City, and she and Roy McCormick would later settle in upstate New York, but at the time of Thomson's death, Roy was still serving in the army. (He would graduate from McGill in 1922, intern at Royal Victoria Hospital in Montreal and then serve a year as resident physician to the New York City Cancer Institution and Neurological Hospital. Roy and Marie would marry in January 1924.)

In early 1918 the *Forester* again mentioned Winnie and her mother, saying they remained with "friends near Philadelphia," but there was no indication of the friends' names or the location near Philadelphia, as easily New Jersey as Pennsylvania.

There were, apparently, some rumours about town concerning this vanishing act. Shortly after I wrote my 1980 novel speculating on the possibility of a child, one of the town's most respected citizens, Frank Hutcheson—scion of the family that partially owned Muskoka Wood, a hardwood operation that had existed during the same years as the pine-based Huntsville Lumber Company Hugh Trainor worked for—asked to speak with me. It was at the end of the Christmas midnight service at All Saints' Anglican Church, which I had attended with my family and my mother. We met out back, fresh snow falling, and I remember being particularly nervous, as Frank Hutcheson was known not to suffer fools gladly, and I have certainly been known, at times, to be a fool.

"That book you wrote?" he began, his breath clouding in the cold.

"Yes, sir?"

"Well," he said, "that's pretty much the way it was."

Many years later, Huntsville's Connie Spiers, then living in British Columbia, contacted me to tell me that her mother, Jane Edrie Demaine, whose family had worked in lumbering in and around Huntsville, and who died in 2004 at age one hundred, had always claimed that Winnie Trainor had "left town" to attend an "Unwed Mothers' Home" somewhere in the United States. Hearsay evidence all, but at this late date, there's not much else.

Intriguingly, the Thomson family had long considered this possibility—one even doing some genealogical research on Winnie's side out of curiosity. But no solid evidence has ever been produced. "Certain members feel there is/was a child out there somewhere," says Tracy Thomson, who counts herself among those who look at the circumstantial evidence and see the possibility. "But no one knows who or where."

In the spring of 2010, I travelled to Pittsburgh, Pennsylvania, and visited the branch office of the Bureau of Vital Records. I went with the documentation the bureau's website said would be sufficient to request a search for a birth anywhere in the state of Pennsylvania and was granted an interview with one of the officials. If there had been an illegitimate birth, I was told, such information would be made available only to a "direct" relative, meaning sibling, child, grandchild. A niece or nephew was not sufficiently direct, nor was a relative by marriage.

In the summer of 2010, a different approach was taken by Ottawa's Chris MacPhail, a retired engineer and amateur genealogist. Working from available U.S. Census data on Ancestry.com, MacPhail uncovered in the 1920 census the existence of an "Edwina Trainor," then two years old and living with the Brady family in Philadelphia. The Bradys were listed as a family of eight—parents and six children ranging in ages from nine to twenty-seven, the children all single and all still living at home. Edwina Trainor is listed in the census as a "granddaughter" and was the only member of the household with a different surname.

MacPhail's discovery certainly seemed promising, as it had been two years earlier that Winnie and her mother had wintered over in Philadelphia. There was even some initial consideration that the names "Brady" and "Bradley" share the same Irish root, and Winnie's mother had been a "Bradley." However, any such thoughts evaporated when MacPhail, a diligent researcher, decided to return to the 1910 census just to make sure he had not missed any Brady children. Sure enough, the prolific Bradys had nine children at home in 1910, including Mae M. Brady, age fifteen. Further research indicated that Mae had been a dressmaker and at a very young age—twelve or thirteen—had married Edward Trainor and had a daughter at some point in 1917. Edward died in a truck fire on August 16, 1918 and Mae was missing from the Brady family census of 1920 because she was then twenty-six years old and living in Alleghany, Pennsylvania.

The search continues.

It is difficult from a century on to realize what a pregnancy outside marriage would have meant in the Ontario of those days. It was a time when orphans from Great Britain—often "bastards" and "illegitimate children" but referred to as "Barnardo" boys and girls—were shipped by the thousands to the colonies and in many cases treated as slaves and chattel by those with the God-fearing "mercy" to take the wretches in. It was a time that saw the rise of children's aid societies with power to take children away from mothers who could present no fathers. What later became known as "social work" was originally considered "salvage work." Pregnant girls were usually shielded (when not shunned) by their own families. Those from small towns were forced by fear of public outrage to go somewhere else for the duration of the pregnancy, do the proper thing by giving up the child for adoption and return home in shame, the unwed mother now considered unworthy and unable to land a husband. As for men who left unwed women in such a "condition," when it was known—which was not often, as men, of course, do not "show"—they, too, were shunned and ostracized.

Ontario passed its Children of Unmarried Parents Act in 1921, four years after Thomson's death and three years after any possible child might have been born. The impetus was to ease the consequences of illegitimacy for "bastards"—essentially mandating the Children's Aid Society to act as investigator, judge and ward for children not being properly cared for by the society's definition of "family." Nothing was done, however, to improve the lot of unwed mothers. Lori Chambers, associate professor in the Department of Women's Studies at Thunder Bay's Lakehead University and author of *Misconceptions: Unmarried Motherhood and the Ontario Children of Unmarried Parents Act, 1929–1969*, has argued that the effect was to institutionalize the sharp prejudices against young women who became pregnant out of wedlock. Errant women were to be punished.

So prudish was Ontario society at the time of Thomson's death that the board of Taylor Statten Camps resigned in the early 1920s over the potential scandal of the Stattens deciding to have both a boys' and a girls' camp on the *same lake*. And while sexual mores did relax over the coming decades, attitudes toward unwed mothers lagged significantly. In Huntsville in the 1950s and early 1960s when I was growing up, the stigma of being pregnant and unmarried was severe. In some quarters of North American society, this attitude would never change: in the 1992 U.S. presidential election, vice-presidential candidate Dan Quayle assailed a *fictional* television character, Murphy Brown, for exhibiting a "poverty of values" for having a baby on her own. Choosing to do so, he argued, was "mocking the importance of fathers, by bearing a child alone, and calling it just another 'life-style choice.'" The *New York Daily News* came out with a headline—"QUAYLE TO MURPHY BROWN: YOU TRAMP!"—that not everyone saw as satirical. To many, unwed mothers remained "tramps."

But the world was so very much harsher on unwed mothers back in 1917–18. Queen Victoria might have died in 1901, but in backwoods English Canada, her stern gaze still very much ruled. In *The Age of Light, Soap and Water: Moral Reform in English Canada, 1885–1925*, Mariana Valverde says that a community such as Huntsville would have been

caught up in what was called the "social purity movement"—a powerful cause taken up by churches, educators, doctors and concerned individuals to "raise the moral tone" of all Canadians. And, she says, sexual mores were the main target. One member of Parliament, John Charlton, even tried to criminalize seduction, introducing one of his bizarre bills saying, "No vice will more speedily sap the foundations of public morality and of national strength than licentiousness."

In no small part, the movement was fear driven. There was general panic about the vast loss of life in the Great War. Young Anglo-Saxon men were being sacrificed by the thousands, and wild fears were rampant: young women said to have been taken from their families for the white slave trade, immigrants overrunning the country . . . Irrational, but powerful, forces were at work.

In parallel with this concerted, often twisted, effort to raise the puritanical standards before and after the turn of the new century, bizarre notions sometimes took hold. A female doctor published a book through the Women's Christian Temperance Union suggesting dishwashing as a cure for the menstrual cramps of young women. "This hot water represents truth, heated by Love," wrote Dr. Mary Wood-Allen in *What a Young Girl Ought to Know*. "The soiled dishes represent myself, with my worn-out thoughts and desires." One renowned moral watchdog, C.S. Clark, led a Toronto campaign against summer lovers, claiming, "The whole city is an immense house of ill-fame, the roof of which is the blue canopy of heaven during the summer months." In Clark's terminology, lovers who met in the parks were committing a form of "prostitution," and one 1915 report by the reformers made little distinction between prostitution and going out on a date. Young women who went with their boyfriends to ice cream parlours and parks, and perhaps occasionally engaged in sexual activity with their beaus, were called "occasional prostitutes."

"Toronto the Good" was at the forefront of the movement. In the years leading up to the outbreak of the First World War, the Canadian Purity Education Association was extremely influential. It talked the provincial government into placing a complete ban on Sunday shopping

and any commercial leisure activity on the Sabbath. It lobbied the government to create a "provincial bureau of purity." Methodists and Presbyterians established councils for temperance and moral reform. The Methodists wanted the federal government to "raise the age of consent, ban liquor, criminalize adultery" A Presbyterian leader, the Reverend John G. Shearer, called on Ontarians to join a "crusade" against slipping morality, urging his followers to fight on "unterrified by all sneering cries of 'puritanical legislation' raised by caviling newspapers that would cater to an evil-minded crowd." Winnie Trainor's mother was vice-president of the local Women's Christian Temperance Union, the highly conservative women's movement that opposed drinking, smoking and "social impurity" (including sex outside marriage and illegitimacy).

What, then, would happen to a child born out of wedlock in a small Ontario town like Huntsville? Such a child was to be considered a bastard, nobody's child. The ultimate social stigma of its time. In Ontario men were not held responsible for children they might have fathered out of wedlock. Nor did the community assume any responsibility. It was assumed the fallen mother would give up the child to an orphanage, where the child would often be adopted by those merely wishing to gain some free labour.

When it became known that the Canadian Expeditionary Force had the highest venereal disease rates among the Allied troops fighting in western Europe, society showed no disgust for the soldiers but came out with a wholesale condemnation of the "guilty" women who had carried this disease to the "innocent" men. There seemed little or no contrary opinion at the time. Dr. R.H. Patterson, writing in *The Canadian Public Health Journal* in 1920, posed the rhetorical question, "Who is really to blame?" when a young, unmarried woman becomes pregnant. His answer? "The mother." Even the widely recognized social pioneer (and future mayor of Ottawa) Charlotte Whitton was of the opinion, at the time, that "most unwed mothers were of 'low mentality' and consequently unable to successfully raise their children for the state."

If, then, Winnie was indeed pregnant, the trips away from Huntsville in the early stages and the fact that she and her mother spent November through April—a span of roughly five-and-one-half months—staying with "friends near Philadelphia" do suggest the possibility of a pregnancy carried to term. That no child ever "materialized," as Daphne Crombie put it, does not prove no child ever existed.

However, proving that a child *did* exist is far more complicated than merely stating the obvious. Efforts continue to this day, using both genealogical expertise and by going through the appropriate state channels regarding such information, if in fact there is information to be found.

Easter of 1918 fell on April 22nd. It marked the return of Miss Winnifred Trainor to Huntsville after she had left the small town in the fall. If she had borne a child over the winter, she would have been completely recovered by this date. She returned in the company of her friend Irene Ewing of Toronto, the *Forester* reported. The two friends attended the Easter service at All Saints' Anglican Church down on the banks of the Muskoka River, and one can only imagine the emotions that ran through Winnifred as the choir stood and launched into the hymn Rector Law had chosen for this special occasion: "O Death! Where Is Thy Sting?"

FOURTEEN LIFE AFTER TOM

Following her Easter weekend return to Huntsville from her long sojourn near Philadelphia—165 days stretching from November 8, 1917 to April 22, 1918—Winnie Trainor soon left town for another stretch, this time in Toronto. In the third week of May, she returned home again, this time with her sister, Marie, and Irene Ewing. They did not stay long. Mrs. Ewing had her husband in Toronto; Marie had her nursing studies in New York; Winnie seemed to be spending little time in Huntsville. Her father, too, was rarely around, having found work with a timber operation in the Magnetawan River area north of Muskoka.

In September 1918, Winnie came back to Huntsville once again from Toronto and, this time, the paper noted, Hugh Trainor was also "back from the North." Her father had decided to move the family of three—himself, Margaret and Winnie—to Kearney, a small village on the Magnetawan River, which was a stop along the rail line running west from Algonquin Park to near Parry Sound. Here, he could continue working in the bush with his family nearby, and they would be closer to

their summer cabin on Canoe Lake—a train ride of approximately an hour. They would also be a good distance away from Huntsville. They rented a simple bungalow from Arthur Hurd, camp foreman for the Shortreed Lumber Company of Kearney, and moved in to stay.

While her father continued working in the bush, Winnie herself went to work for Shortreed's, a local timber operation dealing in various hardwoods, pine, hemlock, tan bark for the Huntsville tannery, cedar shingles, posts and poles and pulpwood. She was hired by J.D. MacNeill and was soon basically operating as office manager, handling everything from orders to pay packets. She was also in charge of the accounting and was said to be extremely good at keeping the books. In the small "Trainor" collection at Muskoka Heritage Place is a letter dated October 27, 1923, from Scully and Scully Accountants in Kitchener, Ontario. It is addressed to Miss Winnifred Trainor, Kearney, Ont.:

Dear Madam:

We have much pleasure in writing you to say we have audited the books of account of The Shortreed Lumber Company Limited, for the years 1922 and 1923.

The accounting during such periods had been done by you, and we found the books well and satisfactorily kept.

Yours very truly,
Scully and Scully

Winnie made a lifelong male friend in Kearney, but this relationship was never anything but professional and social and, later, somewhat businesslike, as the friend became her adviser and, ultimately, executor of her estate. He was Dr. Wilfred T. Pocock, ten years younger than Winnie and a native of a small village in Quebec's Eastern Townships. Before he began school, his family moved to Brockville, Ontario, on the St. Lawrence River.

Pocock was thin, small and moustached, retaining the look he'd acquired while serving as a captain in the Canadian Medical Corps, spending one of his two years in uniform overseas in England. He graduated from Queen's University in 1918 and then briefly did some postgraduate studies in women's surgery at Johns Hopkins University. In the fall of 1919 he answered an advertisement and was hired, at one hundred dollars a year, to assist one Dr. Mason, who served both the Kearney area and the western part of Algonquin Park. (The eastern part of Algonquin would be the domain of Dr. Gilbert "Gib" Post in Whitney, who was the doctor present when I was born in 1948 at the village's Red Cross station.) Dr. Pocock, who bought the retiring Dr. Mason's practice in 1920, had been the doctor for my mother and family while they lived at Brule Lake, the railway depot located between Canoe Lake and Kearney. Both Dr. Pocock and Dr. Post were legendary and beloved figures in the park. Stories were told about them walking miles through the bush to save a life or deliver a baby and, as often as not, never even being paid for services—because so many families didn't have the money to pay them.

Dr. Pocock would stay twenty-five years in Kearney and then another twenty-three in nearby Emsdale before moving to Huntsville for another two years of medical practice, followed by a long retirement. He died in 1987 at age ninety-two, having outlived his great friend Winnifred Trainor by twenty-five years.

In his later years, Pocock was interviewed by Algonquin Park archivist Ron Pittaway, and as the elderly doctor was in the midst of describing this great friendship, his third wife, Clara—his first, Audrey, and second, Helen, had both died—jumped into the taped interview with her own impressions of Winnie. She'd known Winnie when she'd been married to Courtney Amm, an engineer with the Department of Highways who also served on town council.

"She made our lives miserable," Clara Pocock said. "She was a cranky old maid. When we first lived here we lived almost next door to her and the children would play ball. The ball would go over on her lawn and oh boy could she cuss and swear."

But Clara's husband would not join in. "I was her doctor there until almost the last," Pocock added softly. "I found her a very great friend and that's all I can say."

Dick Pocock, the country doctor's son, recalled in 2010 that he first encountered Winnie when he was about six years of age and that she often stayed with them. He thought her "kind and a very good-looking woman with dark hair." He recalled, as only the young will, how she would often do the laundry while visiting and how she would let him help put the clothes through the wringer. "She loved to do laundry," he said.

In his later years, Wilfred Pocock and I talked often of Thomson, whom the country doctor had never met, and of Winnie, whom he called his "intimate friend." He could tell you the exact day he met Winnie—October 29, 1919—and it was a friendship that would last forty-three years, until Winnie's death in 1962.

I eventually ended up with a thick file of letters from Dr. Pocock. Something would jog his memory, and he would put pen to paper, recording his thoughts and memories from those Kearney years. He wrote about the then-bustling village with its two hotels, only one of which, he said, permitted men to sit around and smoke and drink. He also described the Shortreed mill, located on a widening of the river known as the "lake." He recalled sleigh rides, the horse-drawn democrats used in the good weather, church socials, card games, square dances and round dances to gramophones—and the latest novelty: the radio. He and his wife especially enjoyed days out picking blueberries or raspberries with Winnie.

"We loved her for herself," he said in a letter he wrote to me on January 6, 1976, "and she treated us the same way. She was really a part of our family and came and went as she pleased, eating her meals often with us at Kearney or on a common holiday. She often slept in the spare room we kept for visitors—a custom in those days."

It was Wilfred's opinion that the move to Kearney had been Winnifred's idea and predated her father's getting work there. Hugh Trainor had a weakness for drink, Pocock said, and did not continue

working for many years following the family's relocation to Kearney. He was often ill with stomach ailments that Pocock treated as best he could. "I believe her only idea in moving to Kearney," he wrote in a February 8, 1977, letter, "was to have her parents near her work and where she could care for them."

She cared for them well, he said. She was an instant success at her new job and quickly became considered all but irreplaceable at Shortreed. The manager of the mill was Jack MacNeill, who had married into the Shortreed family, and soon he was concentrating on the mill and leaving the office to her. "Winnie knew as much about the business as MacNeill did," Pocock wrote. "She was in on many a consultation on business affairs.

"She paid the wages and heard the complaints of all. She kept her office clean and neat. She was always treated with respect about the mill—she could put any of them in their place. She was called 'Winnie' for short. I know of no practical jokes played on her. She could take her part. I believe she had a way of reminding a few if they did not behave better, they would be out of a job—and nobody wanted that."

In Pocock's opinion, the Winnie Trainor of middle age was anything but reclusive. She was friendly with the Pococks and many other families, including the Hurds, Grooms, Whites, Murdys and Harknesses. There were times, he said, when she would leave the office and travel with him and Jack MacNeill as they made their rounds of the winter bush camps. She carried her weight, he said, and kept up easily on the long bush walks from where the trains would drop them off.

When Dr. Pocock eventually moved to Huntsville, he became a familiar figure around town in the 1970s and early 1980s: a small man, badly stooped, who had to walk oddly, with his back bent almost parallel to the ground. His head stuck up, birdlike, and through his mane of white hair and smiling white moustache, he nodded to everyone he passed. He studied French as a retirement hobby and hoped to translate his own

memoirs, which he was continually writing. He had previously self-published a historical novel, *The Three Gifts*, and could not understand why it had never become a national bestseller. Its failure to find an appreciative audience had become something of an obsession with him in his retirement years, and he often wrote long letters to me, by hand, about his book troubles. In those letters, however, he also spoke of his life travelling about the lumber camps, caring for sick and injured men, delivering babies in isolated depots along the rail lines and even performing as veterinarian when necessary. He set bones, pulled teeth, sewed gashes and dealt with porcupine quills and sick workhorses.

He knew of all the grumblings claiming there had been an expedient inquest and convenient death and burial certificates and suspicious undertakers at Canoe Lake in the summer of 1917, but he put no stock in such talk. He was a friend of Roy Dixon, the undertaker who had done the embalming, and considered him "an honourable man" who "was up in the Masons." As for Churchill, who mysteriously chose to work alone in the dark to dig up a grave, Pocock said: "There's nothing unusual in those times of working in the dark digging graves. I did it myself burying premature babies. At that time I worked with the undertaker myself after dark, holding the lantern. In those days they didn't even register miscarriages. No need for an investigation. I was the coroner. When you're the only doctor, you're everything."

Dr. Pocock certainly had his strong opinions. In his mind, there was never the slightest doubt that Winnifred Trainor had been engaged to marry Tom Thomson. He told me his patient and friend "never complained to me of any pregnancies or abortions or anything" and did not even care to imagine that any such thing could have taken place. His own opinion of Thomson's demise, which he claimed Winnie shared, was that Tom had suffered a heart attack while paddling and fallen from his canoe. Winnie herself never made any such claim, but rather believed all her life that something "foul" had happened that July day back in 1917.

"As far as I know," Dr. Pocock wrote in one letter, "Winnie was never romantically involved with anyone else. She loved Thomson. She thought

that it was a terrible thing." In a taped interview I did with him in 1973, he said that Winnie "did say that she didn't think it was suicide." He also said that there were rumours around that Martin Blecher had a grudge against Thomson for what Pocock called "inveigling the women."

Pocock said his family's close friendship with Winnie was somewhat out of the ordinary in little Kearney, as while she was friendly with many, she was close to very few. "You wouldn't say that she was popular," he told me. "She was often outspoken and didn't make too many friends." At another point, he wrote: "She was always well supplied with the latest gossip and gossiped herself. She liked with a stubborn loyalty and disliked with vigor."

In a letter he sent to me in January, 1976, he wrote, "I should like to have you dismiss the thoughts that she was as eccentric as others would lead you to believe. She was wide awake to all that was going on and sometimes very outspoken in a way that made her some enemies. She was a kind, unselfish and deeply concerned person for the happiness of others. Gossip never troubled her, and she never ran away from it."

His impression of Winnie in her mid-thirties was of a striking woman, instantly noticed. "I wish I had a good photo of her," he wrote to me on February 8th the next year, "but I do remember how she looked and how beautiful she was. Winnie was tall, well built. She wore her hair short. Her face was round and plump with brown hair straight, not curled. She had a very athletic body, a pleasant smile—well-kept teeth and spoke in a clear voice and a self-confident manner. She was not overweight—very active on her feet. She had a great mind.

"The eccentricity is a word attached to her by folks who did not like her for her outspoken manner. Winnie impressed our family very favourably—yes, she was eccentric, but not foolishly so."

Pocock's impressions of Hugh and Margaret Trainor were equally fine. "When I knew Hugh Trainor in 1919," Pocock wrote, "he was not ill nor his wife. I often visited them because Winnie and I became close friends . . . It is probable that Hugh drank a little when he was camp foreman for Muskoka Wood Company and perhaps he had a time

keeping his men in line and even fought . . . His talk was free of cursing and gutter language and in all ways he was polite and congenial. He was a man of medium height, thick set, fair and clean shaven. His wife was quiet, too, and very pleasant to talk to. Winnie took charge of her parents and there was harmony in the household."

He later said Winnie put on weight while in Kearney and became significantly heavier. "Plump" was the word he used. "I can remember," he said in one letter, "when she had to use the chamber [pot] in her room in the middle of the night. Suddenly, we were aroused to find she had put her full weight on the pot which had split into fragments, spilling all over the floor. Fortunately, she was unhurt."

Though Dr. Pocock himself had not met Tom Thomson, he felt he had gotten to know him through her. "Winnie did not mention Tom Thompson [sic] to many," he wrote to me in one long letter, "but she often talked to me, as her intimate friend and her doctor, and the executor of her will. I shall never forget how she cried when she was showing me the first painting sketches from which the artist painted the large finished paintings."

Dr. Pocock described a scene in Huntsville in which she held up one of the sketches and broke down. "We were in love," Pocock quoted Winnie as saying, "but he said 'How could he be my husband?' He said 'I have my art but no money.'" She shook the sketch as if it were now somehow to blame. "Now," she said, her voice breaking, "*these* mean a fortune."

Pocock said she began to sob. "'How,' she wailed, 'could fate be so unjust to us?'"

The Trainors moved the forty kilometres north from Huntsville to Kearney in 1918, just as the Spanish flu was sweeping the world—attacking the young and healthy and leaving twice as many dead as the Great War had killed. Fortunately, the family avoided being listed in "Death's Tragic Harvest," a weekly feature that for a time figured more prominently than the happy "Personals" listings in the local paper.

The Huntsville *Forester* even offered a home remedy: "6–10 onions, chop fine, put in a large spider [pan] over a hot fire, then add about same quantity of rye meal and vinegar, enough to make a thick paste. Stir 5 minutes. Put in cotton bag, big enough to cover lungs. Apply as hot as can bear." Schools and churches closed. Streets were empty. People avoided social gatherings. The carefree release from war that had been anticipated for so long was sadly postponed.

Some of the theories defied reason. A German U-boat was said to have surfaced in Boston Harbor, releasing vials of the germ. The germ was said to be imbedded in Aspirin (Bayer being a German company). A vaccine was sought utilizing the blood and mucus of those already afflicted. In Rebecca Atkins's memoir, *My Childhood in the Bush*, she says Dr. Archie McMurchy of North Bay concocted a rum and quinine treatment that was, to no surprise, popular with the men working the bush around Algonquin Park.

The flu eventually passed, and the Trainors settled into regular village life: work, church and quiet social gatherings, usually connected to the Anglican church. Canoe Lake was so much easier to reach from Kearney that they could catch a morning train in and an evening train home if they wished. Weekends in good weather were spent at the lake, as were summer holidays. Winnie often made the trek up to the cemetery, some saying she went because she knew, as so many others were convinced, that he was still there, others saying it was because she resented campers placing flowers on an empty grave. She knew it was empty, of course, because she had been the one who had arranged the exhumation of Tom Thomson, and when Winnie took on a task, she took pride in completing it.

Kearney was much quieter than bustling, fast-growing Huntsville. It was all dirt streets and few automobiles. Travel by horse, and horse and buggy, was still common. Water came from wells. Homes had outhouses. Livestock and chickens would have been found on the outlying farms and on properties right in the village. The most prominent house in Kearney, out on a small point at a twist in the Magnetawan River, was a two-storey frame building belonging to the Bice family—Ralph Bice, being the

renowned Algonquin Park guide who had known Tom Thomson and ran traplines in the area. The sale of pelts was, in fact, the park's second major source of revenue in those days, after timber-cutting rights, with staff assigned to check traplines and rangers themselves often skinning and stretching the pelts before they were taken to North Bay for the annual fur auction. Buyers from around the world would come to bid on the best furs, and Ralph Bice's were judged the best in the auction time and time again.

Algonquin Park was run much differently in the early days than it is now. Ralph and his father, for instance, had been hired to shoot park deer during the later months of the Great War, and hundreds of deer had been quickly dressed and frozen and shipped off to feed troops stationed around the country. Trapping by staff members was not stopped until 1920, but when it was, ranger operations became cash strapped. The park then had to impose a hiring freeze, as headquarters could no longer afford taking on additional help. The rangers were furious to lose what had become a welcome source of income, and many workers in the park—my father included—continued to trap illegally during the Great Depression. Reduced wages and relief payments could not compare with the windfall of a well-dressed mink, marten, otter or beaver.

There were changes around Canoe Lake, as well. In the spring of 1918, around the time Winnie and her mother were returning from Philadelphia, the two guides who had found Tom's body, George Rowe and Lawrie Dickson, struck a deadhead when they were paddling during a storm and dumped their canoe. Molly Colson heard their cries for help and Ed Colson rescued them and brought them back to Algonquin Hotel, where George quickly recovered but Lawrie steadily worsened. He was rushed to hospital in Toronto where he died in the first week of May. Locals claim George Rowe never touched strong drink again following the tragedy.

In November 1920 Mowat Lodge burned to the ground. Shannon Fraser was there, but Annie and their daughter were fortunately away. Shannon managed to save the livestock and chickens, but most of the furniture and most of the family's other personal belongings were lost.

The Frasers did manage to purchase a relatively new cabin that had been built by George Rowe near the old Gilmour mill site, and Shannon was then able to arrange, presumably with insurance money as a base, to put up a new Mowat Lodge. But this time the place would be built on the abandoned mill's footings, with a better view out over Canoe Lake. The first section was completed in time for the next summer season, and a second section added later. The lodge remained popular, and the tourist trade was increasing summer by summer. By 1927 Canoe Lake again had enough permanent residents that a school was opened. The local high-light of Canada's Diamond Jubilee celebrations of that year was a huge dance put on by the Frasers of Mowat Lodge.

The new Mowat Lodge, however, also burned to the ground, in May of 1930. The fire took out the Rowe cabin, too, and the Frasers decided to retire from the lodge business. They lived in Kearney for several years before moving on to Huntsville, where, eventually, the widowed Annie Fraser and the spinster Winnie Trainor ending up living on the same block of Minerva Street in early 1950s.

Winnie would have known about the increasing interest that was being shown in Tom Thomson's work in the years following his death, but she might not have been aware of the changes taking place in the Thomson family at Owen Sound. In 1924, shortly after the estate he had been overseeing was finally settled, Tom Harkness died. Less than a year later, Margaret Thomson passed away. The family said she had never been the same after her son's tragic death.

John Thomson lived on, later marrying his sister-in-law Henrietta, who had lived in the Thomson household for many years. It was believed he did so in order to quell any talk there might be about Henrietta living there with a widower. He was written up in a February 4, 1926, Toronto newspaper feature that also discussed his dead son, the old man being described as having "a head that might inspire a Rembrandt . . . His face . . . [revealing] some of the secrets of his son's

art. It is a living canvas which records the healthy ruggedness of [the] Northern Ontario landscape. He is a man of the out of doors, as his son was a painter of the out of doors." On September 1, 1930, John Thomson passed away at the age of ninety.

Mark Robinson—often referred to as the "G'neral" following his war service—continued on as chief ranger of Algonquin Park for a few years after Thomson's death. But he fell ill around 1924, underwent serious surgery and required more than a year to recuperate. At the end of 1925, Robinson received doctor's permission to return to his job, as long as he worked only outdoors, for his health. The park was glad to have him back and assigned him to Brent, a small railway depot and village on Cedar Lake in the northeast of the park. His primary duty there was to watch for poachers. He twice returned to Cache Lake headquarters to serve as interim superintendent and then as superintendent before he retired in 1936.

Hugh Trainor rented out the home in Huntsville for the thirteen years he and his family lived in Kearney. The weekly paper makes no mention of return visits, though surely there would have been some, at the very least to deal with tenants and the property. Life for Winnie in those years would have been much as described by her Kearney friend Wilfred Pocock. She had her small circle of friends. She attended church, played cards and worked hard at her job at Shortreed's. She spent good-weather weekends and most holidays at Canoe Lake, where she remained a mysterious, almost silent figure. Increasingly, the other residents—both full-time and summer-only—began to think of her as eccentric and difficult, and largely avoided the cottages across from Little Wapomeo Island that belonged to the Trainors and the Blechers, who could be, they thought, equally eccentric and difficult.

"Living next door to them Blechers is enough to make anybody odd," longtime Canoe Lake resident Leonard "Gibby" Gibson told me during an interview back in the 1970s. "They used to fight like bulldogs,"

Gibby said. "Martin [Jr.] did have a violent temper, and he liked to fight," but added that Bessie was often a match for her brother when it came to temper tantrums. He recounted a long tale of Martin Blecher, Jr., marrying (for a second time) and planning to spend the winter at Canoe Lake with his new wife, Carolyn. Previously, Martin had lived mostly in the boathouse, leaving the cottage to his mother, Louisa, and Bessie. (By this time Martin, Sr., had passed away.) Then, without warning, the newly married couple arrived with brand-new furniture for the cabin. Gibby helped haul it from the station to the Blechers' place by boat. "By Geez," he said, "about a week later, Martin came up and wanted us to go down and pick up the furniture. Bessie'd threw half of it in the lake. We went down and fished chesterfields and chairs out of the lake, hauled it back in the old boat and put it back in the storehouse. Two weeks later the warring was all over and everything was going smooth. Bessie went back down to Smoke Lake, where Martin and his wife were camping, and talked them into coming back down again. Next thing you know [the furniture] was back in the lake again. We hauled that stuff back and forth all summer and fall."

Martin Blecher, Jr., died at the cottage in March 1938. Canoe Lake resident Everet Farley met the undertaker near Highway 60 with his sleigh and horses, and the two of them returned to the Blechers' cottage to collect the body. Farley claimed that when they were carrying the casket out, they stumbled, and the body fell out, and he never again set foot in the Blecher home.

From that point on, the Blecher cottage, with its "NO TRES-PASSING" sign and fence, became known on the lake as the "Ghost House." And there was a story, often told, especially by the nearby campers around a fire, that a marble eye in the trophy head of a huge bull moose that Martin, Jr., had shot decades earlier (and that still hangs on the wall) fell to the floor one July 8th at midnight, the accepted anniversary of Tom Thomson's disappearance.

Martin Blecher, Jr., however, was far from the lake's most famous ghost. Campers at Taylor Statten Camps were regaled with tales of Tom

Thomson to the point where they romanticized his death and often made treks up to the cemetery, where they would place wildflowers on the old grave.

Winnie, very much alive, was often seen walking the trail up to the cemetery, always alone. Who can know what she was thinking? About the life together she and Tom had lost? About the child, if indeed there was one—the baby that might have been left behind in Philadelphia with another family, lost forever to the birth mother? She may have felt she was the only one still dwelling on the tragic events of the summer of 1917, unaware that her Tom was becoming the subject of growing interest to a woman who had no connection to Algonquin Park or Huntsville and who had never even met the painter, but had become so fascinated by the possibility of his murder that she was determined to solve the never-opened and therefore never-closed case of one of Canada's greatest artists.

Blodwen Davies, who began gathering material on Tom Thomson in the late 1920s, worked mostly by letter, looking for new information and new leads. On March 23, 1930, Mark Robinson responded to a letter from Davies from his station in Brent. He spoke of his own experiences with Thomson and ended with a short list of others Davies might like to contact:

1. Miss Trainor of Huntsville Ontario to whom it is said Tom was engaged could tell you a lot of fine things about Tom if she will talk.
2. Ed Godin Park Ranger Achray Stn CNR Ont via Pembroke Ont Tom put up with Ranger Godin when in that section of the Park.
3. J. Shannon Fraser and wife of Canoe Lake Ont and daughter Mrs Arthur Briggs all knew Tom extra well and if Fraser will tell the truth much could be got from him but weigh well his remarks.
4. You might interview Martin and Bessie Blecher but again be carefull. They possibly know more about Toms sad end than any other person. Canoe Lake PO Ontario.

5. Edwin Thomas and wife Kish Kaduk Lodge [Govt?] Park Station
 Ont knew Tom very well and were reliable friends of Toms.

Either Davies never contacted Winnie, the first person on Robinson's list, or Winnie refused to be interviewed.

By 1930 interest in Tom Thomson was once again on the rise. That summer the "pirate ship" of Taylor Statten Camps—a large, cumbersome boat flying the skull and crossbones—was cruising the lake and stopping so the youngsters on board could explore various trails and portages, when eight-year-old Lionel Robert of Toronto reportedly found the remains of what had once been Thomson's beloved canoe.

Apparently, the familiar, dove-coloured, canvas-covered canoe had been used for years by Shannon Fraser as a guest canoe for Mowat Lodge—without payment to, or permission from, the Thomson family, though the canoe should have been considered part of the painter's estate. It had at one point been left at a small lake for the use of those who hiked in. It had long been the subject of Taylor Statten searches but, like the painter's paddle, had never been found.

The camp and others also organized what was called "Tom Thomson Day" (August 16th). A representative of the Algonkin tribe, Matt Bernard of Golden Lake, came for the ceremonies, which included filling a birchbark canoe with wildflowers and floating it about the lake. Almost unbelievably, the National Gallery shipped in twenty-five original Tom Thomson sketches for the event, allowing the camp to display them in the dining hall while the campers ate. Most unusual of all, however, was that a West Coast–style totem pole was solemnly erected next to the Thomson cairn on Hayhurst Point. What the connection was—Thomson's brief time in Seattle?—no one ever explained, yet to this day, the incongruous marker stands on the shore opposite the cemetery on the hill.

At some point after Hugh Trainor became ill with stomach problems in 1931, the family returned to Huntsville and their two-storey frame home

at the corner of Centre Street and Minerva. Hugh had not worked for several years, apparently, and forty-six-year-old Winnifred was the breadwinner of the family. The *Forester* "Personals" from November 1931 mention her as a "visitor" to Kearney, so the family would have moved back to Huntsville at some time before that date. Winnie easily found a job in one of the stores along Main Street.

Hugh died on February 29, 1932, at Toronto Western Hospital, four days after having surgery for stomach cancer. His funeral was held from the Minerva Street home the following Friday afternoon. In the obituary in the March 31st issue of the *Forester*, Hugh was described as an "expert timber cruiser and evaluator," who had spent nearly a quarter of a century in charge of bush operations, mostly for Huntsville Lumber Company. He was said to be "A man of quiet, but jovial disposition, whose friendships were sincere, and who enjoyed the respect and confidence of all who knew him."

The weekly newspaper also carried a report of the Easter service at All Saints', which Winnie and her mother would have attended. The altar had been covered in snapdragons and carnations, and Mayor Frank J. Kelly, himself a native of Bermuda, had given a bouquet of Bermuda lilies to be placed over the organ. Rector Smith, who had recently buried Hugh, had the children line up to present their Lenten mite boxes. He then delivered a moving sermon on "the uncertainty of life, as evidenced by recent bereavements."

It seemed there was no escape to be had. The movie playing that week at the King George theatre on Main Street was *The Silent Witness*.

Winnie had returned to Huntsville to stay. She would live another thirty years, her only move being to the upstairs of the big house on Minerva, so she could earn some income renting out the lower floor. She rented to various tenants, including a high school vice-principal, Norman Massie, who gave drum lessons in the house, and longtime renters the Bulls and the McEowns. She would tell prospective renters that they were not allowed to paint the dining-room walls, as they would be eating in the only room in the world that had been painted by Tom Thomson. There

were those in town who took this as evidence of Winnie's madness. A precious few—such as Addie Sylvester, Winnie's lifelong neighbour who had met Thomson and seen him paint—knew it to be true.

On October 17, 1935, the Huntsville *Forester* announced on its front page that "Our readers will regret to learn that Mrs. Hugh Trainor, one of our highly-respected citizens, passed away at her home Tuesday" Winnie's mother was seventy-seven years old. It was the middle of the Great Depression, and the country was in a foul mood. Prime Minister R.B. Bennett, who was largely blamed for economic conditions vastly beyond his control, was tossed from office, along with a dozen of his cabinet ministers. Mackenzie King's Liberals were returned with the largest majority in history: 168 Liberals, 41 Conservatives, 8 CCFs, 17 Social Credit and 10 others of varying political persuasions. Muskoka had elected its first Liberal since 1878, sending a retired farmer, Stephen Furniss, off to Ottawa. He was, the paper noted, a man of "iron integrity."

Less than two weeks after Mrs. Trainor died, the corner of Minerva and Centre Streets was struck again when Mrs. Hanna Sylvester, Addie's mother, dropped dead of a heart attack in her home. Her husband, Richard, had died twelve years earlier, so Winnie Trainor and Addie Sylvester were now twins of a sort, two spinsters living alone in large, wooden homes directly across from each other.

Addie stuck to her job as the night operator at Huntsville's Bell Telephone switchboard. Winnie worked in various places, including, at one point, running the laundry at Grandview Inn, out on Peninsula Lake. She occasionally visited her sister in Endicott, New York, and sometimes had two or more of Marie's four children staying with her in Huntsville or at the cottage on Canoe Lake.

For a while she found company in a small dog, name forgotten by those who still remember her pet. There was an unfortunate incident involving this dog—the story recounted by H. Eleanor Wright, the daughter of Joe Lake ranger Bill Mooney and granddaughter of Ranger Albert Patterson, who had been dispatched to Huntsville following Tom Thomson's disappearance. In the late 1930s Winnie was

walking with her dog near the Mooneys' cottage on Joe Lake when the dog suddenly charged the Mooneys' kitten and shook it to death. "She was a very strange, unfriendly and embittered woman," Wright later wrote in her self-published *Joe Lake: Reminiscences of an Algonquin Park Ranger's Daughter*, "who didn't have the courtesy to apologize for this unfortunate incident. Of course, I was heartbroken, but eventually got another cat."

"She used to take long walks by herself," Eleanor told me in the fall of 2009 during an interview. "She'd come along the old tracks and go down through our place and past the ice house and on through Calverts' property. In those days, you could walk across the dam if you were careful and she'd sometimes take that as a shortcut back. She was always moody. She wasn't very conversational."

Winnie had a knack, however, of turning up at mealtime. Wright said she would strategically arrive at the station agent's house, then home to the Armstrongs, on the pretext of borrowing sugar and stay to eat with the family. She especially liked to arrive at the home of the Stringers (whose son Jimmy would later claim to have Tom Thomson's shinbone in his woodshed), knowing that Mammy Stringer would always invite her to stay. "She was a great moocher," remembered Wright.

There might have been more to it than a free meal, though. She was obviously lonely in the years following her mother's passing—the little dog a brief substitute for companionship. And there would be no more great romance in Winnie's life.

Joe Runner, an Aboriginal actor from Treehorn, Manitoba, once went to Winnie's home in Huntsville with the idea that he would make a movie about Tom Thomson. Runner had worked for many years in CBC drama and also for a small summer theatre company in High Falls, New York. He had become entranced with Thomson while staying at Taylor Statten Camps on Canoe Lake and listening to Ranger Mark Robinson tell the Thomson saga around the campfire. He asked his Canoe Lake friend Leonard "Gibby" Gibson whether an introduction could be made, and Gibby said he would try. At first, Winnie refused,

but Gibby persisted and, finally, she agreed to speak to the actor, who was quite young at the time.

"She knew as soon as I got in that I was there for something," Runner told me in 1973. "There was a strangeness in her face that has always haunted me."

He recalled that while he was nervously trying to break the ice, there were sounds from outside like someone banging on her door. "She went running out of there like a bat out of hell," he laughed. "And I think she had a bat! There were kids on her porch and she didn't like kids and she chased them halfway up the block."

I might well have been one of them.

Runner's overall impression was far from the one those kids would have had—those kids racing up the street with their hearts in their mouths. "I thought she was very attractive," he said. "And she seemed very soft and quiet.

"I think she was a young woman who decided when she wanted something and went after it. Once she met Tom she decided, 'That's it for me. I want him.' And I think her mistake was that she wanted too much. I think he felt he was sort of being forced into getting married."

She was polite to Runner but not helpful. The actor persisted with his film idea, at one point even doing a screen test at Canoe Lake with his hair combed in Thomson's style, and those who saw the photos thought the resemblance "eerie." The CBC's Warner Troyer, who had a summer home on nearby Smoke Lake, was also interested in the Thomson saga and agreed to produce the film. At the time, Runner estimated he'd spent $7,000 to $8,000 of his own money on development. The film, however, was never made and both men have since passed on.

Increasingly, Winnie withdrew from any outside interest in Tom Thomson that would surge periodically as a result of an exhibition or a magazine feature. Though she saw Joe Runner as a favour to Gibby, she refused all other interview requests and requests to see the sketches she was rumoured to own. Her friend Wilfred Pocock became concerned about her after she sent those sketches to a dealer in Toronto for appraisal.

There were originally fourteen, he said, but when they were returned to Winnie, "one of the best sketches was missing." It's not known whether she'd allowed one or two of the sketches to be purchased during this transaction—to pay for a new roof and furnace, as neighbour Brad McLellan has said. Pocock thought it outrageous that a painting sent in good faith might not be returned in equal faith, yet there seemed no way of proving that anything untoward had taken place.

"I remember once coming to see her and she talked about her will," Pocock wrote to me in 1977. "I asked her where she kept it and she rolled back the sheets of her bed in the old home on the second storey . . . then rolled back the mattress and between the mattress and the springs of the bed was her bundle of valuable paper and her will. I immediately arranged everything with her lawyer and had the papers put in a safety deposit box at her bank."

Winnie turned seventy in 1955. She was now considerably overweight and concerned about her own health. Her brother-in-law, Roy McCormick, had died three years earlier, and her sister, Marie, was struggling with diabetes. Even the seemingly indestructible Mark Robinson was soon gone—he'd died the day after Christmas 1955, at the age of eighty-eight.

In the fall of 1956, just a few weeks after Thanksgiving, there was a knock at the door of Winnie's home on Minerva Street. She slowly made her way down the stairs and stared out the small window in the storm door to find Gibby Gibson from Canoe Lake standing on her porch. He told me he'd intended to surprise Winnie but that he didn't realize how badly she would take his little joke.

He asked her to open up, that he had something to show her.

When she did, Gibby put his hand in his jacket pocket and pulled out a brass handle—a carrying handle from a casket.

"Winnie," he said, grinning from ear to ear, "we found Tom."

The look on her face was one of total shock. And pain. She went white, and Gibby thought for a moment that she was going to faint.

FIFTEEN THE DIG

In 1956 Canadian Thanksgiving fell on Monday, October 8th. Winnie had been in New York, visiting her sister. She knew nothing about the now-famous "dig" until she was confronted with Gibby's rather sick joke at the front door after she'd returned home.

The "dig" had taken place at the Canoe Lake cemetery on the weekend before Thanksgiving. William T. Little, a family court judge, and Jack Eastaugh—friends since university days, when both had worked as counsellors at Taylor Statten's Camp Ahmek—had come to Canoe Lake for a weekend of sketching and exploring their old college-days summer grounds. They paddled to the cairn on Hayhurst Point, checked out the footings where the mill and then the second Mowat Lodge had stood and took a hike up the hill that led them, eventually, to the formidable birch tree towering over the two marked graves and the rickety picket fence of the little cemetery. The treeline was lower then, and from various points, they could see out over the lake in the distance. So they sat and sketched for a while.

As Little sketched, he remembered the tales Mark Robinson had told about Thomson around the Ahmek campfire. He'd once asked Robinson exactly where Thomson was buried, and Robinson had pointed just north of the fenced-off area holding the grave of the Hayhurst child and the larger stone over J'as Watson, the millworker. Then, as Little subsequently wrote in his book, "like an echo from the past," Robinson said, "'I don't believe they ever took Tom's body from Canoe Lake.'"

Little and Eastaugh began exploring the surrounding terrain in search of a depression that might indicate where the original grave was. Heavy growth to the north suggested it could not have been that far from the picket fence, but there remained a good stretch of tangled forest floor that might once have been a final—or even temporary—resting place. Then Little suggested they could check and see whether the old stories were true. What if Tom's body was still there?

After they decided to investigate, Eastaugh and Little returned to Ahmek, which was almost deserted, and chatted with Gibby and Frank Braught, a retired teacher from Guelph, about their cemetery musings. Both were also keen on the adventure. If they found nothing, the official version of Tom Thomson's reburial in Leith would be true, just as the Thomson family and all government agencies claimed. They could put an end to the rumour mongering of the unbelievers—though all four men counted themselves among the many who were convinced that Thomson's body had never been moved. So if they found a casket and bones . . .

Next morning, as Little wrote, Gibby took the initiative by asking the others: "You fellows ready to solve the mystery of Tom Thomson?" They all were. So, after breakfast, they gathered up the necessary tools and headed across the lake. They hiked up the hill to the little cemetery and, once there, paced out what they felt might be an appropriate distance from the other graves, keeping to the north as Mark Robinson had suggested. It started to rain as they began clearing underbrush in preparation for the dig.

Except where they hit tree roots, the earth moved easily. They tried one spot but stopped when they got six feet deep. If they'd struck nothing by the six-foot level, they assumed, there was nothing to strike. They started digging a second hole another three feet or so to the north, but this also proved fruitless.

It had begun to rain hard, the work difficult and the results discouraging. Little was becoming convinced that the body had, in fact, been exhumed and taken to Owen Sound for burial. The digging was therefore pointless and no fun at all. Then Jack Eastaugh called Little over to look at a spruce tree, somewhat farther yet to the north. Under its boughs he thought he could make out a depression nearly three feet across. The spruce, Eastaugh estimated, could easily have reached its impressive height in the nearly forty years since the grave had been dug.

However discouraged they'd become by the rain and the sweaty work, the four men were now enthusiastic about the new possibility. They decided that if they found nothing in this third attempt, they would quit and accept the official line. They took turns digging, using axe as much as shovel. The spruce roots were extremely difficult to deal with, and the hole, wide at the top, kept narrowing.

"It was my turn," Little wrote. "I worked steadily, knowing that the hole was now of a depth and size that only a smaller-built person like myself was likely to be able to effectively continue this operation. Frank was showing visible signs of fatigue and Gibby and Jack watched with mixed feelings as I made slow progress at the five-foot level.

"I pushed the shovel down as far as I could, removed a shovelful of dirt and saw a piece of wood in the soil. Picking it out, I handed it up to Jack, who examined it. Without comment he passed it to Gibby, who looked at it and, glancing around, pointed to an old stump a few feet away saying, 'I think that's a piece of the root of that old white pine stump; they stay in the ground a long time before they disintegrate.'

"I resumed digging and finally reached down to pick up another piece of wood and stopped to examine it closer. 'This is the first root I've seen with a beveled edge!'

"The others agreed, 'It's a piece of pine—part of a box or something.'

"It was Jack who said, 'That's a mortice from the corner of a box—likely a casket or rough box you've found!'

"Digging with my hands I felt a smooth piece of board. As I pried it free from the soil a hollow space that could only be the exposed end of a coffin was revealed. I jumped out of the hole and handed over the piece of board which was in an advanced state of decay but readily recognizable as a machine-finished piece of wood. I explained what had been exposed at the bottom of the pit. Gibby jumped down head first to explore the opening. He thrust his hand into the aperture and pulled out a bone which appeared to be a foot bone of a human body.

"'At last we've found the grave and body of Tom Thomson!' shouted Frank.

"'We have really hit it,' exclaimed Jack.

"Gibby rejoined, 'This is it, fellows!'"

Gibby's account, which he gave to me during a visit to Huntsville on February 4, 1973, was somewhat different. At this point in his life, Gibby was having trouble getting around—both legs had been amputated below the knee due to circulation failure—but he remembered vividly that wet fall day when the men went up the hill to see what might be found in the graveyard at Canoe Lake.

"When we dug down I hit this board . . . and I got down on my hands and knees and I went down head first into the hole digging with my hands and I felt something so I grabbed a hold of it and pulled it out and it was a foot. And there was still part of an old blue woollen sock on it. Well, that was fine. We had the grave and he was there, so we just put a few old shingles on top and covered it up again and took the foot with us and went back to camp."

Little claimed in his book that they'd dug until they could determine for certain that the hole held the remains of a rough pine box that had caved in on an oak casket, which had itself eventually caved in from the weight of the earth. The bones were covered in dirt, of course, following the collapse of the rough box and casket. But they

also found casket handles in good condition—Gibby pocketed one of them for his practical joke on Winnie Trainor—and a metal inscription plate that read "Rest in Peace." Little noted that at one end of the coffin the soil held the impression of a woollen sock, but there was no other evidence whatsoever of clothes or buttons, buckles or anything. The body appeared to have been wrapped in a light canvas shroud and nothing more.

The men headed back to camp with their bone. Dr. Harry Ebbs was staying at Little Wapomeo and Ebbs confirmed the bone to be a tibia from the left leg. Ebbs matched the bone to his own left leg and concluded it had belonged to someone "approximately my own height"— Ebbs being a lean man around six feet tall.

Realizing that they were now into the territory of possible ramifications, the men all agreed that they needed to call in the authorities. There were laws, after all, protecting graves. In the meantime, however, several from the camp decided to return to the gravesite to see for themselves, and take some photographs. One Canoe Lake cottager, Graham Matthews, told me recently that he and others also visited the grave after the authorities had carted away the bones for examination. In the surrounding dirt, Matthews found a decorative brass piece, which he believes came from the original casket Thomson was buried in.

More than a half century after the 1956 dig, Dr. Taylor Statten, then into his nineties, said he still shivered to remember "the sound the shovel made on the casket" when they took that second look at the grave that was supposed to be empty.

He was not surprised by the discovery, though. He believed then, and believes to this day, that the bones dug up by the four men that rainy Sunday in the fall of 1956 belonged to none other than Tom Thomson.

Not everyone, however, shared that opinion.

"We agreed to notify the proper authorities," Little wrote in his book, "and that it was not appropriate to advise the press at this point. Such information without proper authenticity would be both premature and mere sensationalism. We carefully replaced the tarpaper and

covered it with soil, finally completely filling in the grave pending fur-
ther study of the contents."

Further study was almost immediate. Harry Ebbs went to Toronto that
week and met with officials of the office of the provincial attorney general.
It was decided that Ebbs should return to the gravesite with an Ontario
Provincial Police officer, who would oversee the exhumation, and it was
further decided that Dr. Noble Sharpe, the ranking medical official in the
crime detection laboratory of the attorney general's office, should be pres-
ent. Gibby returned to his digging under the eye of the authorities. "We
dug him up and sifted every inch of it through fine, fine screen," he remem-
bered. "And there wasn't a button. He was buried with just a shroud on,
that's all. Anyway, they took it all away with them."

Almost instantly, the story of the grave discovery was leaked to the
press. The *Globe and Mail* of October 10, 1956, ran a long story by Don
Delaplante, headlined "Long a Mystery of Art World: Body May Answer
Riddle of Tom Thomson's Death":

Algonquin Park, Oct. 9 – A body dug from a wilderness grave on
a hill overlooking picturesque Canoe Lake may answer the riddle
of the death of Canadian painter Tom Thomson 39 years ago.

The body was discovered by four men, William Little,
superintendent of the Ontario reformatory at Brampton, Jack
Eastaugh, principal of the Norseman public school, Etobicoke,
and Leonard Gibson and Frank Braught of Guelph.

The discovery is being investigated by the Attorney-
General's Department. It is reported there was a hole in the
skull of the exhumed body, which was found in a rotted coffin
in a pine box.

The death of Thomson, one of Canada's foremost painters
and a contemporary of the famous Group of Seven, has been a
mystery of the Canadian art world for nearly four decades.

The discovery was made 10 days ago during a sketching trip by the four men. It was done on chance, said Mr. Little from his home in Brampton.

The men were not convinced that the artist died accidentally. They favored the theory that Thomson was a victim of foul play.

"We had paddled across the lake looking for a place to sketch. The north shore looked attractive so we pulled up near the site of the old Mowat Lodge. We gravitated up to the well-known place where residents of the lake believed Thomson was buried."

There were two marked graves on the hill about a half a kilometre inland from the west shore. One was the grave of Alexander Hayhurst, 8, who died in 1915 of diphtheria. The little boy's family had a cottage at the lake and because of the nature of the disease authorities forbade his body to be carried from the bush.

The other is that of James Watson, a lumberjack employed by the Gilmour Lumber Co. who died May 25, 1897.

The mystery grave was found between 12 and 15 feet north of Watson's grave. According to an old story here Thomson had been buried a few feet north of a tall white birch tree which now towers about 150 feet in the air.

Mr. Little said they had no thought of searching for the grave when they left on the trip but once in the area they decided the opportunity was there for them to make an attempt, just to satisfy their own curiosity.

"We found it on the third try," he said.

There were three depressions in the ground. The party dug the conventional five to six feet in the first two depressions, and found nothing.

"The other was a chance discovery. We had practically given up our digging. Then I caught hold of what I thought was

a small root but it turned out to be a pine plank. This led us to believe that we had discovered something."

They soon unearthed what seemed to be the remains of a rough pine box and a coffin and some bones. They got in touch with Dr. Harold Ebbs of Toronto, who was holidaying at the lake at the time.

"We got him to view the bones we had. I think he realized the significance of the discovery. We then closed the grave immediately. We were satisfied that we knew what we had found. Dr. Ebbs then advised the proper authorities."

Mr. Little said the Attorney General's Department has stepped into the case and a pathological examination of the bones was to be made.

He said Dr. Ebbs believed the bones belonged to a white man about 40 years of age.

Dr. Noble Sharpe, medical director of the Attorney-General's crime detection laboratory said last night he is currently examining the bones.

"However, I would be very surprised if these were Thomson's bones. That story is only a local legend."

He confirmed there was a hole in the skull, but from a cursory examination he did not feel it was caused by a blunt instrument or a bullet.

"It is more likely perfectly normal erosion."

Dr. Sharpe said he received the bones, making up a complete human skeleton, during the weekend. In the next two or three weeks he will try to determine the age, size and racial origin of the person and check for [some words illegible] thought the bones had been interred for at least 50 years . . .

Thomson was staying at Mowat's Lodge, about half a kilometre from the grave when he met his death. He is reported to have been on poor terms with a man at the lodge, which was burned to the ground about 30 years ago.

> However, some residents think the body may be that of an unidentified lumberjack who worked for the Gilmour firm many years ago. . . .

Two days later, the *Toronto Daily Star* advanced the *Globe* story by publishing a testy letter from the undertaker, M.R. ("Roy") Dixon, who had embalmed Thomson and now, thirty-nine years later, was living in Parry Sound, about an hour west of Huntsville. Dixon was reacting to the news concerning foul play. "I was the undertaker who embalmed and interred the remains of Tom Thomson at Canoe Lake in 1917," Dixon wrote, "and have a very distinct recollection of all the official proceedings at that time. I beg to take issue with reports that appeared last week suggesting death by foul play.

"I was called from Algonquin park headquarters to remove the body from the water and prepare it for shipment. When I arrived at Joe Lake Station I was met by Mark Robinson, ranger. His first question was, 'Is the coroner from North Bay on the train?' He was not and I informed him I could do nothing without a death certificate. He got in touch with Mr. Bartlett, the superintendent of the park, and he sent over a certificate of accidental death by drowning.

"As superintendent, he said, he was ex officio a coroner. We brought the body to the island and proceeded to embalm it.

"There was certainly no blood on the face or any indication of foul play, just the usual postmortem staining that is on the body of any person that is in the water of a small lake for 10 days in the heat of the summer.

"No one else assisted us. The relatives or friends did not arrive on the next train so Mr. Bartlett gave me a burial permit to inter the remains in the burial ground there. A tourist who was a minister conducted the service. The casket was not a cedar coffin but a good hardwood one.

"I cannot believe Mark Robinson said, as reported by Mr. Little, that the body was never removed. He [Robinson] told me they removed the body some time later and that it was in a remarkable state of

preservation and must have been well embalmed. If these people wanted to make sure of these 'old wives tales' why didn't they get an exhumation order and examine the casket that was alleged to be empty instead of desecrating the cemetery at Canoe Lake? In British Columbia they put them in jail for that kind of thing."

Dixon's letter to the editor again raises the issue concerning park superintendent Bartlett sending over a burial certificate that already officially declared the cause of death. It is not difficult to imagine the situation faced by the real coroner, Ranney, who arrived on the scene after a body had already been buried and was handed a signed burial certificate declaring that the death had been by drowning. That Ranney held such a quick and cursory "inquest" becomes rather more understandable, including the lack of interest he showed in pursuing any possible evidence to the contrary.

That same day, October 12th, the Canadian Press moved the story quoting the Huntsville undertaker who might or might not have exhumed Thomson's body during the night of July 18, 1917, in the Canoe Lake cemetery. F.W. Churchill was now seventy-three years old and living in Kirkland Lake. His confused letter claimed Blodwen Davies had engaged him and Mark Robinson had assigned four men to help. Neither statement was true.

A few days later, on October 19, 1956, the bombshell landed. "ALGONQUIN PARK BONES NOT THOSE OF THOMSON," screamed the headline in the *Toronto Daily Star*. Ontario attorney general Kelso Roberts announced that forensic scientists had determined that the bones found by the four grave diggers three weeks earlier were not those of the famous artist, but of "a male Indian or half-breed of about 20 years of age." Officials, added the attorney general, were continuing to investigate the hole found in the skull the men unearthed.

The *Globe and Mail* carried even more detail: "Scientific investigation has established that a skeleton dug up by amateur artists in an unmarked Algonquin Park grave was not that of the great Canadian painter, Tom Thomson, who thirty-nine years ago died." According to Dr. Noble

Sharpe, the paper declared, the bones were of a man roughly 5'8", aged 20–30 and "Mongolian type, either Indian or nearly full-breed Indian."

Those involved in the digging of the Canoe Lake grave were stunned. Gibby told me in 1973 that when he was down in the hole and grabbed hold of the skull, Dr. Sharpe had watched carefully as Gibby pulled the skull free and examined it.

"I was talking to him about it," remembered Gibby, "and he said, 'That's Caucasian.' Well, the next thing you know he had turned 'Indian.'"

The *Toronto Daily Star* quoted William Little at length, with Little saying he had been told by Ranger Mark Robinson a quarter of a century earlier that Thomson's body had never been moved to the Thomson family plot. The reason they had gone exploring with their shovels and picks, said Little, was to "prove to our satisfaction that Robinson was wrong." This, of course, was a convenient fib. It was, in fact, exactly the opposite of their real reason—to prove Robinson was *right*—but Little was media savvy enough to know the public would be far more receptive to the one purpose than the other. The four men had already suffered enough criticism for their "desecration" of hallowed ground.

For the determination of race, Sharpe had relied on the expertise of Professor J.C.B. Grant of the Department of Anatomy and Anthropology at the University of Toronto. To determine the cause of the hole in the skull—said to be round, approximately three-quarters of an inch in diameter and on the left temple—Sharpe had consulted with Professor Eric Linnell of the Department of Neuropathology at the University of Toronto. Linnell reported back that the opening was consistent with trephination—a rare surgical procedure sometimes used to relieve pressure in the event of a brain injury or severe hemorrhaging.

The hole in the skull, whether created by accidental injury, intentional injury or erosion, was on the *left*, not the *right*. However, Dr. Howland, the medical practitioner who had first sighted Thomson's body after its discovery by the guides (and whose expertise had been accepted during Ranney's inquiry) had declared in his affidavit of July 17, 1917, that there had been a bruise on the *right* temple. Mark Robinson,

on the other hand, always maintained—and had even noted in his personal journal the very day Thomson's body was found—that the injury had been to the *left* temple. Dr. Howland may have had the credentials, but it is important to point out that he also maintained that the cause of Thomson's demise had been "death by drowning" despite the serious curiosities of bleeding from the ear and no water being in the lungs. And in a much later letter in which he repeated his official declaration, Howland reported that the damage to the temple was on the left side.

As for the "trephination" argument, this suggests that a male Aboriginal, half the age of, and slightly shorter than, Tom Thomson just happened to be passing through Canoe Lake and died, perhaps following a brain hemorrhage that required an immediate operation that failed to save his life but had been performed at precisely the same spot in the skull where Ranger Mark Robinson said Tom Thomson had been injured.

Dr. Harry Ebbs could not believe his ears. Surely what he was being told by the provincial authorities was a mistake. He had, after all, been the "attending physician" when the remains were recovered from the grave and he believed that they had uncovered a Caucasian skull and leg bones that suggested a man who would have been Thomson's height. Ebbs had long been fascinated with the painter's story, as his own connection to Canoe Lake went back to the 1920s, when he had first gone to Taylor Statten Camps as a young counsellor. He'd returned as a medical student and stayed on permanently following his marriage to Adele Statten, Taylor's sister.

On November 26, 1975, Ebbs agreed to an interview for the Algonquin Park archives with oral historian Rory MacKay. But he requested that any material from the interview not be released until he'd completed the book he hoped to write. And if the book was not completed, he asked that the information not be made available until after his death. He passed away in 1990, the book never undertaken. The Statten family graciously agreed to release the full contents of the Ebbs interview for

the purposes of this book. I was stunned by what he had to say about the events that followed the discovery of the bones at Canoe Lake.

On the day of the early October 1956 dig, the Ebbs family was just sitting down for a meal at their cabin on Canoe Lake when William Little and Jack Eastaugh, both wet and dirty, arrived and called Dr. Ebbs outside, to discuss an important matter.

"I went out the back," Ebbs recalled, "and they had a little box and they opened it up and said, 'We'd like you to tell us what this is.' I looked at it and said, 'Well, you've got the bones of a human foot, where did you get it from?' And they said, 'Well, would you like to come over to the cemetery and see whether you think it's Tom Thomson's grave.'"

Ebbs was keen. He had, unbeknownst to nearly everyone at the lake, twice before been involved in seeking out the grave. He had even gone to the cemetery with biographer Blodwen Davies in the 1930s with the intention of digging up the remains, but they'd run into such a tangle of roots and rocks that they'd given up. Ebbs had returned much later with Charles Plewman, a pallbearer in 1917, and Plewman, then an elderly man, tried to point out where, exactly, the original grave had been. Ebbs figured he knew the location as well as anyone now that Mark Robinson was gone.

The men had crossed the lake by boat and hiked up to the graveyard where Ebbs found a rectangular depression in the ground under a small tree at approximately the position he believed the original grave to be. They examined the grave and Ebbs was able to come up with two more bones from a lower leg, which he packed up. As the Ebbs family was shortly to leave for their home in Toronto, he volunteered to handle matters from that point on.

"On Tuesday morning," Dr. Ebbs went on, "I went into the attorney general's office." The attorney general would have been Kelso Roberts, who had been brought into cabinet the year before by the new Ontario premier, Leslie Frost, Mark Robinson's fellow soldier and good friend. Ebbs also called in Frank MacDougall, who had gone on to become deputy minister of the Department of Lands and Forests after serving as

superintendent of Algonquin Park—nicknamed "the flying superintendent" because he piloted his own float plane about the park.

"We had a little conference for a few minutes," said Ebbs. "They said, 'Would you go back up, if we gave you one of our inspectors, and investigate the whole thing?'"

Ebbs agreed. He returned to Canoe Lake, and on Thursday morning, picked up Dr. Noble Sharpe of the Ontario Provincial Crime Laboratory and Ontario Provincial Police officer A.E. Rodger at the docks by the Portage Store, a small grocery and outfitting operation at the south end of the lake near to Highway 60, and took them back up the lake. Along with Frank Braught, the retired teacher who was still at the lake, they hiked back to the graveyard, Gibby Gibson bringing the camp Jeep up the trail and using it to haul down the troublesome tree with a chain. The men then went to work with shovels.

"It was very easy to dig," Ebbs remembered. The sand was soft and rock free, and they were down approximately three and a half feet when they came to the remains of a box.

"We carefully removed that," Ebbs said, "and there was a perfect skeleton, clean except for there was nothing on it except the remains of ankle-length deerskin moccasins, pieces of that and little pieces of gray ribbed wool sock which hadn't rotted completely. The hinges and clasps were beautiful metal, you know, well finished, but the wood was pretty well all rotted. We took out the bones and put them in the box . . . and I did an estimate of making sure we had all the bones which was quite easy to get.

"But when I got the skull out, the roots of the tree had gone through the orbits and into the ears and mouth and so on. But I just brushed the sand off it and there was this hole on the left hand side and so I held it up, on the very side to the inspector"—this would appear to have been Dr. Noble Sharpe, rather than the OPP officer—"and I said, 'What do you think that is?'

"Without any hesitation, he said, 'That's a .22-calibre bullet. Nothing else could do that.'"

From that moment on, Ebbs was convinced that Tom Thomson—for these *had* to be his remains, he also believed—had been shot by someone as he was paddling down Canoe Lake that wet July day. He believed to the end of his life that the murderer had been Martin Blecher, Jr., the same suspect Little had named and the man Mark Robinson always suspected of being a spy and worse. While a young man at Camp Ahmek, Ebbs himself had had a number of unsavoury run-ins with the ill-tempered Blecher, including one close call on Potter Creek, near where the Stringers lived, when Blecher, convinced that Ebbs was cutting too close to him in the camp motorboat, angrily swung his paddle at Ebbs's head.

"If I hadn't ducked," Ebbs said, "he would have crowned me right there on the spot."

Ebbs knew the story of the July 7, 1917, drinking party and the threat supposedly uttered by Blecher toward Thomson. He believed, as did others on the lake, that there were two sources of possible conflict between the men: the course of the war (with Thomson presumed to have been despondent over being unable to enlist and Blecher presumed to be a German sympathizer as well as an American draft dodger) and Winnie Trainor (with Blecher jealous of Thomson's effortless success in gaining her affections).

Ebbs would spend countless hours during the years to come thinking about how the killing might have happened. He knew that when he'd cleared off the face of the mud-coated skull, he saw that the upper-right incisor (the eye tooth) was missing but that all the other teeth were in excellent shape. With the policeman, he had sifted the surrounding sand carefully in a search for the bullet that they figured should have been inside the skull—but found nothing.

The missing tooth and absence of a bullet puzzled Ebbs terribly. He conducted his own experiments at the lake, carefully calculating how Blecher could have hidden in his boathouse—thereby muffling the sound of the shot—and lain so low that he would have fired slightly *up*, the .22 bullet striking Thomson (who would have been at an angle, paddling on the left side) in the mouth area. The eye tooth would then

have been dislodged as the bullet burst *out of*, not *into*, the left temple. This, Ebbs reasoned, was why no bullet was found within the skull. The bullet would have been at the bottom of Canoe Lake.

Ebbs was saying all this, it should be noted, in 1975, two years before Daphne Crombie stepped forward with the version Annie Fraser allegedly told her—that Annie's husband, Shannon, had fought with Thomson and Thomson had fallen into the fire grate, which caused the puncture to the left temple. Had Ebbs heard this explanation, he might have changed his mind about the .22 bullet.

Ebbs was hardly alone among Canoe Lake regulars convinced that a serious crime had taken place there in July 1917 and had been either covered up or ignored by the authorities. He knew of Mark Robinson's suspicions, and he was also convinced that Winnie had always believed that her Tom had been murdered. He claimed that she "continued to write letters to the prime minister, to the attorney general, right up until she died demanding that an investigation be held into the death of Tom Thomson; she persisted." Whether such letters exist or not, he certainly believed that they did.

Ebbs had walked away from the graveyard in October 1956 firmly convinced that they had a murder, or at least manslaughter, on their hands, and that an investigation would be required, even if Ebbs's most likely suspect, Blecher, had been dead nearly twenty years.

"We closed it in," Ebbs recalled about filling in the gravesite with the Ontario Provincial Police officer, "and I took him down to the Portage Store and loaded the Sunkist Orange box with all the bones in it in the trunk of the car and sent him off."

He could not believe what then happened. "About five or six weeks later," Ebbs said, "when I talked to the attorney general's office, they said that Professor Grant had reported that it was probably a 22-year-old Indian because of the measurements he'd done of the bones and that the cause of death was not known. The hole in the skull, he said, could have

been due to a trepanning operation which is boring a hole through the bone in order to probe the inside of the brain."

Ebbs was flabbergasted by what he took to be an absurd contention. Had he and Dr. Noble Sharpe, the province's forensic medical expert, not discussed the hole and Sharpe declared it caused by a .22 bullet? Why would Sharpe have changed his mind? Angry and confused over the news reports he was reading, Ebbs returned to Toronto and took direct issue with the provincial government's scientific conclusion that this Aboriginal person had undergone a trephination: "I countered that by saying I didn't think that in 1917 there was very much of that kind of operating being done and that it was hard to believe that an Indian would have had an operation like that and go up to Algonquin Park without anybody knowing anything about it."

He met with Professor Grant, the scientist who had determined the skeleton was Aboriginal, and the two men argued. "I asked him," Ebbs recounted, "if he even looked at the photograph of Tom Thomson, the one of him standing with his canoe in which I pointed out the cheek-bones were high and that I didn't know of any Indian ancestry in Thomson, in his family. On the other hand, there was certainly a resemblance in that regard, but that as far as I was concerned, the facial contour in the photograph would certainly fit that particular skull."

But Grant would not even concede that he ever looked at *any* Thomson photographs. Grant so adamantly "stuck to his guns" that Ebbs quickly came to the conclusion that the eminent scientist "was a person you didn't argue with."

"So then," Ebbs continued, "we had a meeting with the attorney general and Frank MacDougall [the deputy minister of the Department of Lands and Forests] and agreed that because of the family, the Thomson family, [we] did not wish to have the thing opened up and any more fuss. They were satisfied with the verdict of accidental drowning and they would like it just left alone."

Harry Ebbs did not know what to do. Here were Attorney General Kelso Roberts, Premier Leslie Frost's chosen lawmaker, and Deputy

Minister Frank MacDougall, who had previously been the highly respected superintendent of Algonquin Park, telling Ebbs that they did not wish to have "any more fuss."

The attorney general, surely, would have believed he was acting in the best interests of the Thomson family. It is highly debatable, however, whether it could be said that the attorney general of Ontario and a ranking deputy minister were acting in the required interest of the law.

Still, they had Grant's report that it was an "Aboriginal" who had once had an operation who had been found in the grave, despite Ebbs's strong protestations to the contrary. And they could use this to quash any further suggestion that Thomson's remains had been found and the hole in the skull suggested foul play. With scientific "proof" that the body belonged to an Aboriginal person with an explainable hole in his skull, they could put an end to the "fuss." And the Thomson family would not have to suffer more disturbing questions concerning the whereabouts of the remains of its most famous member.

Ebbs reluctantly agreed. He felt powerless against such forces. He gave Kelso Roberts one photograph of the skull, gave Frank MacDougall a second and, later, lent a third to Robert McMichael of the McMichael gallery in Kleinburg, Ontario, where several Thomson originals hang, along with a remarkable collection of Group of Seven paintings. A fourth photograph remained with the Statten family before being passed on to me in 2009 for the purposes of further scientific study.

A discouraged Ebbs returned to Canoe Lake and was sickened to read the *Toronto Daily Star* headline that landed on October 19th: "Kelso Roberts, ALGONQUIN PARK BONES NOT THOSE OF THOMSON." Ebbs felt he had been party to a fraud—worse, to the deliberate and intentional cover-up, by no less than the attorney general of Ontario, of either murder or manslaughter.

In early 1967, undoubtedly alerted that the CBC was preparing a documentary on Thomson's mysterious demise, the office of Ontario's

attorney general asked Dr. Noble Sharpe to prepare a report on the remains found at Canoe Lake. His memorandum, which he delivered to F.L. Wilson in the office of the attorney general on February 20, 1967, stated he was present at the exhumation virtually by accident, as he had been asked along by OPP corporal Rodger, whom he had encountered at an inquest in Ahmic Harbour, a small community outside the park, north of Huntsville. He also indicated that, as they drove away with the remains, "We assumed it had been necessary to rule out foul play." He does not explain, but seems to tie this decision to considerable "local feeling about prohibiting the artist group [Little and his accomplices] from Algonquin Park as a result."

Sharpe said he was now "quite satisfied that this was an unknown Indian and that [there] were no signs of foul play. I think it quite possible he was buried in Tom Thomson's original empty grave and the coffin could have been the one used for him at the first burial."

Some three years following the 1956 dig, Sharpe noted, he and colleague Dr. Ward Smith met with William Little for lunch and "We came away convinced that the artist group would still believe our Indian was Tom Thomson. They think he was not removed to Leith. At the time of the removal, a local man said the undertaker did not have time to do it and the coffin was too light. The undertaker indignantly denies this. Tom Thomson's brother is so convinced the body was removed to Leith that he will not consider having the Leith grave opened. I have read a lot about Tom Thomson and I feel it is no use contacting him by a medium as he would not care where his bones are now."

Sharpe appears not to be joking. It seems, rather, that this scientist working for the Government of Ontario gave serious consideration to attempting to reach Tom Thomson's spirit in the afterworld to ask where, in fact, his own bones were hidden.

Dr. Sharpe said that the Ontario Provincial Police officer assigned to the "case," Corporal Rodger, had later returned the "Indian skeleton" to the grave and erected a marker. (If that marker was where the white cross currently stands, then Corporal Rodger missed the site of

the original grave by several paces.) Sharpe said he had reported his findings to the necessary officials in the fall of 1956, including then attorney general Kelso Roberts.

Sharpe was also interviewed in the late 1960s by Peter Kelly and Hugh Kemp for the CBC documentary *Was Tom Thomson Murdered?* He said that the lack of water in Thomson's lungs was not the proof of foul play people might think it would be, since in almost one of ten drownings, throat spasms will prevent water from entering the lungs. When asked about Winnifred Trainor, Sharpe replied: "The lady you refer to phoned me several times in 1956–57. She was very indignant and insisted she and her father were present when the undertaker returned and are positive the body was in the casket, but I couldn't get her to say she had actually looked in." This would seem to underscore the belief that Winnie was adamant that Tom had been moved, as she herself had asked the undertaker Churchill to perform the task. It was Sharpe's opinion that the body had indeed been removed, though he added, in parentheses, "But no one looked in and I don't blame them; the body would have been a very, very disagreeable sight due to decomposition." However, he also said he wished the point had been settled years earlier by a proper viewing of the body.

Sharpe told the CBC that he thought "Tom Thomson may still be buried somewhere in the Park but I also think we may have opened his original grave and he was not there." This, so far as I have been able to determine, is the only time, apart from Jimmy Stringer's musings at the Empire Hotel that spring day, that a third grave has ever been mentioned as a possibility. If Thomson's body was still in the park and if Sharpe's conclusion was correct (that the original grave had been opened in 1956 and did not contain Thomson's remains), then another factor would have come into play. Someone would have had to remove, and hide, the body sometime between the hasty burial in the summer of 1917 and Churchill's presumed exhumation.

Once the CBC two-part documentary aired, there was a brief push to open the grave at Leith, but the initiative did not gain any support

from the Thomson family or from the provincial government of the day. "I have no intention of ordering that the grave be opened at all," Attorney General Arthur Wishart told the legislature in response to Opposition questioning. "Perhaps if I were to get a request from some close members of the family, I would consider it, but I would hope that nobody would disturb the situation any more than it has been disturbed."

Still, the case continued to fascinate Sharpe. In June 1970 he penned a long article in the *Canadian Society of Forensic Science Journal*, in which he began looking more deeply into the circumstances and motivations surrounding the case. He almost certainly wrote the article without knowledge of Little's book, which was also published that year. Given the "lead time" of learned journals, the essay would have been submitted many months prior to publication. It also seems unlikely Sharpe was consulted by Little or given an advance manuscript, as Sharpe is one of the few involved figures not personally thanked in Little's long list of "Acknowledgements."

Sharpe said that, in 1956, he had had a telephone conversation with a woman, obviously Winnie Trainor, though not identified, who said she had been engaged to Thomson. Sharpe had found her "charming." He recounted the rumours of the so-called "rival" and the quarrel between the two, without mentioning Martin Blecher, Jr., by name. And Sharpe even added his own slightly bizarre ingredient to the mix—considering he was the forensic scientist on the "official" side—by saying "it was rumoured a shot had been heard coming from the direction Tom had taken when he was last seen."

This is most strange. Mark Robinson had never mentioned any such thing. Nor had Annie Fraser ever mentioned a shot in her talks with Daphne Crombie. And nothing about a "shot" was mentioned at the coroner's inquest. In her two works on Thomson's mysterious death, Blodwen Davies covered every imaginable scenario but failed, somehow, to mention this amazing "rumour" that was now being described by the Ontario government's own forensic expert, the man who had declared, in his official capacity, that it was not Tom Thomson's body in the grave.

Instead, Sharpe had declared the remains of some shorter Indian who just happened to be in the area when he died and was buried in exactly the same plot and who, even more remarkably, just happened to have had surgery in exactly the same spot where Ranger Mark Robinson noted Thomson had been injured. Now Sharpe was himself suggesting something might have happened to Thomson.

Sharpe said he could not criticize Dr. Howland for the lack of any internal examination of the body. He argued that decomposition would have "masked indications of drowning as the cause of death. Even the absence of water in the lungs would not rule out the possibility. I am, however, puzzled by the bleeding from the ear. If this, whatever the cause, occurred in the water, it would in all probability have been washed away. Dried blood implies a time lapse before immersion."

In more detail than in the earlier report he prepared for the attorney general's office, Sharpe recounted the 1956 dig. With him and the OPP officer on hand, several men dug the skeleton out, finding bones about four and a half feet down. They found wood fragments of oak and cedar, coffin handles, a metal plate marked "Rest in Peace," a small fragment of canvas and part of a sock. As for the hole in the left temple, "A superficial examination left one with the impression it was not a bullet hole." Sharpe then concedes that "[t]he feeling among us at the grave was that these were Tom Thomson's remains; that we had found them in his original grave; and by outward appearances that he may have died of a gun-shot wound."

Dr. Sharpe went on to detail the forensic examinations he carried out with Dr. A. Singleton and Professor Linnell, the three agreeing that the hole bore more resemblance to "a trephine opening rather than a bullet hole of entrance." While Sharpe admitted that trephination was not very common in 1917, he wished that his examination had taken place a decade later, when he could have used a more sophisticated method of analysis.

"To add to the mystery," Sharpe wrote, "we found the skull was not the Caucasian type one would expect Tom Thomson to have.

I consulted with Professor J.C.B. Grant of the Department of Anatomy and Anthropology at the University of Toronto. He was given no information but was asked to examine the remains and express an opinion regarding (i) Race; (ii) Height; (iii) Sex; (iv) Age; and (v) probable time of death and/or burial. In due course, Professor Grant reported the skull was of the Mongoloid race and, under the circumstances, that of a North American Indian, full blooded, or nearly so; five feet eight inches (plus or minus two inches) in height; male; under thirty years of age and buried at least ten to fifteen years, but how much longer he could not say."

Sharpe was becoming convinced. Photographs of Thomson suggested he was approximately six feet tall and nearly forty years old. "His family knew of no Indian blood in their family tree." Sharpe did say, however, that the material he had to work with in 1956—photographs— was rather "unclear" and he could find "no evidence of Mongoloid bony parts nor of agreement of bony parts." Later, working with superior photographs supplied to him by the CBC, he became certain. "The skeleton was not that of Tom Thomson. I suggested Mr. Walter Kenyon of the Royal Ontario Museum be consulted. He agreed with my opinion."

So, too, did Dr. Philip Hall, the forensic specialist who ruled out suicide as the cause of Thomson's death. He was still teaching at McMaster University in Hamilton when he wrote to me in 1977. Hall praised Professor Grant as being beyond reproach, the author of *Grant's Atlas of Anatomy* and *Grant's Method of Anatomy*, both standard texts. He said he and a colleague were in complete agreement with the revered Grant's claim: "[T]here is not much if any doubt that the skeleton was as reported by Dr. Grant that of a North American Indian, whose height was within two inches of five feet eight inches . . . Thomson was more than six feet in height, and certainly not Indian."

Many years after he had left Hamilton for Winnipeg, Hall remained adamant that the scientific evidence from 1956 was irrefutable. Grant, he said, was "internationally respected as a forensic anthropologist" and had done his job properly. As for Sharpe, Hall added that he, too, was a

professional to be trusted: "[H]e was Canada's most experienced forensic investigator at that time."

It all sounds definitive and incontestable. And yet, in Sharpe's article in the *Canadian Society of Forensic Science Journal*, he seems to express some doubt. Sharpe noted that the OPP had been unable to link the skeleton with any missing Indian. Nor could police find any record of a missing or deceased Native person who had once been through a trephination procedure. "The teeth," he pointed out, "were in excellent condition. They were the typical shovel type usually associated with Mongolians. Photographs of the jaws were shown to the artist's family but they were not able to help. Dental charts were not kept in 1917 to the same extent as they are to-day."

Sharpe referred to the "facts" he and the other scientists had gathered but added that many refused to accept them as "facts." He mentioned "the report that one or more of the local folk had heard a shot fired"—the "shot" that he himself first mentioned now transforming itself into fact, with collaborative backing of perhaps a second or third person hearing the rifle shot. Sharpe then recounted all the arguments—Thomson being an expert canoeist and swimmer, the fishing line, the poor job of lashing the portaging paddle, Mark Robinson's suspicions that the undertaker couldn't have done all that work alone and so quickly, the light casket—and returned again to the issue of the mysterious "Indian."

"It was also emphasized," Sharpe wrote, "no Indian could have been buried there without someone witnessing the occurrence and, furthermore, it must be remembered the nearest portage Indians might use is a mile and a half distant."

Sharpe made some excellent points, such as noting that even the best canoeists can slip on a portage and that the fishing line around the ankle could have resulted from Thomson fastening a line as he trolled. The sixteen to seventeen wraps could then have been the result of the body rolling in wave action, though it is hard to imagine that, since the line was apparently so deliberately wrapped.

Sharpe conceded that "criticism of certain aspects of the investigation may be justified." However, he believed there could be no doubt that Thomson was buried at Leith, as the official line had it. He said the second undertaker, Churchill, had been "indignant" regarding any suggestion that he had not done his job. "He stated he had only to dig at the end of the grave," Sharpe wrote, "by the slope of the knoll, break open the end of the coffin and pull out the body. He did not have to expose the entire length of the coffin top."

This image is, nonetheless, impossible for anyone who has been at the cemetery to imagine. The area of Thomson's burial was in flat ground north of the picket fence, with the knoll not beginning for some distance. There was no "end of the grave" and no convenient slope to work with. Sharpe, who had visited the site, should have realized this.

But it seems that Sharpe was very much a man to take people at their word. He even placed Winnie Trainor at the station when the body was transferred, whereas she was not even at Canoe Lake at the time but in Huntsville. "The lady whom we believe was engaged to Tom Thomson told me," Sharpe wrote in this particular version of his encounter with Winnie, "when I questioned her, that she and her father were at the railroad station when the casket was loaded aboard the train and they were certain the body was in it. Though I tried I never did determine by what means, or when or where, she learned Tom's body was, in fact, in the casket."

Sharpe accepted the undertaker's word without question, though such a recovery of the body would have been impossible without first excavating the end of the grave closest to the other two graves. He accepted Winnie's conviction that the body had been moved, though, in fact, she was not a witness. And, finally, he accepted the word of some member of the Thomson family who claimed "they were satisfied the body was in the casket at Leith. The odour was strong."

Sharpe returned again and again in his article to the matter of the "Indian," seemingly changing his mind with every sentence. "And," he wrote, "as for burial of an Indian at this particular site, it seems to

be the logical locale for a secret burial, particularly following a brawl or a fight. What better place could one find than over or beside another grave? Location of the settlers' gravesite [referring, obviously, to the Watson and Hayhurst markers] was common knowledge in the area. Besides, the depression marking the location of the settler's grave would make for easier digging. An Indian burial with a coffin built of oak and cedar, without the knowledge of others in the district, would be nigh impossible. I have personal knowledge of Indians passing through the area—even at my cottage on Lake of Bays I had Indian visitors as late as 1940. So friendly were they, one left his dog sledge with me one Spring and picked it up again the following Winter; and, I might add, no one saw him come or go."

Sharpe said he was personally satisfied that Thomson was buried at Leith, but proof could come only by opening the grave, which the family was refusing to do. "Perhaps," he said, "a descendent at some future date may grant permission. If I am wrong in my belief, and if and when the grave is opened no body is found, then, if circumstances so warrant, the investigation should be reopened in the Canoe Lake district."

But if Tom Thomson was indeed buried at Leith, he concluded with another air of mystery, "[W]hat of the Mongoloid skull with the three-quarter inch round aperture in the lower left temple area? Was the bone removed in surgery? Is it evidence of some foul deed, of murder? Who were involved? How did the Indian die and at whose hands?"

By the time Sharpe had completed his own meanderings and speculations, the very mystery he had supposedly officially solved on behalf of the attorney general of Ontario was as confused as ever, perhaps even more so. He claimed that "the skeleton was not that of Tom Thomson." Even if determining age was an inexact science, as Dr. Philip Hall argued, there was the matter of height. The scientists had concluded that the skeleton was that of a man within one or two inches of five feet eight inches, whereas Thomson was said to be somewhat around six feet tall. According to Dr. Harry Ebbs, the tibia shown to him in the fall of 1956 suggested a man his own height, which was roughly

Thomson's six feet. The toughest argument put forth was, as Sharpe put it, that there "was no bony point agreement between the skull found in the Canoe Lake grave and Tom Thomson's head," meaning that, in Sharpe's opinion, Thomson's face and head would not have fit the found skull.

Sharpe was certain: the skeleton was not Tom Thomson's but that of "an unknown Indian." And "there were no signs of foul play."

It was an official conclusion that would not be seriously challenged for another forty years.

SIXTEEN **REVELATION**

In mid-October 1956, Winnifred Trainor returned from her short trip to New York to Gibby's little joke with the casket handle and continuing news reports concerning the dig. She was angered, says her good friend at the time, Dr. Wilfred Pocock, "that such a horrid thing could have occurred." Gibby says she was absolutely "furious" with him, both for his gag on her doorstep and for having anything to do with such a ridiculous thing as digging up a grave when everyone knew that Tom Thomson's body had been removed, in no small part because of her own involvement.

Gibby would have none of it. Like so many of the Canoe Lake regulars, he was convinced Thomson's body had never been moved and that the bones they had discovered were, obviously and undeniably, the remains of the painter. "Certainly it was him," he told me. And he was equally certain that Winnie herself knew this.

"Personally," he said, "I figure she knew darn well he was there. There was no way any grave digger could go up there and dig up the

remains and keep it all straight and put them in a casket and not get a spot of anything on his clothes. He'd be stinking like a polecat."

As for the forensic report that the body they'd dug up was an "Indian" aged twenty to thirty and shorter than Thomson, Gibby roared with laugher. "Oh, that was a lot of malarkey," he said. "Cripes, come on!

"A lot of them tried to say that the Indians had been portaging by there. Well, I don't know where they were portaging to."

Gibby said at one point that Winnie had tried to explain away the "Indian" side of the grave story. "I told her exactly what I thought," he said, meaning that he insisted the remains they found were Thomson's and the official report had been a "whitewash" convenient for a government not keen in upsetting a well-connected and respected family by disturbing yet another grave.

"She told me that she gave permission to the Indians to use the casket that Tom was buried in to bury this Indian.

"I said, 'Well, where did he come from?' and she said, 'Well, they were just going by and he died.' Anyway, there was people living there. Do you think that you could go and dig up that grave and bury somebody else in the casket without somebody knowing about it?

"You can't even go to the backhouse 'ceptin' everybody knows about it. You can't."

Others, however, believed you could. In his notes that were published in the *Gull Rock Gazette* camp magazine in 1977, Charles Plewman said he disagreed with those who "say that no Indians had ever been buried at the site. I disagree with this statement, for on good authority I have been told that one was buried in that same Thomson site about 1894." But he fails to identify his "good authority."

Given that Mowat was a thriving village in 1894, it seems highly unlikely that others would not have noticed such an occurrence. It would, after all, have been the *first* burial in the cemetery, with Watson the mill-worker not joining the "Indian" until 1897. The idea of the village unknowingly establishing a graveyard right where an "Indian" had been buried only three years earlier is a coincidence impossible to accept; but,

on the other hand, if Watson was buried where people knew an "Indian" had been, then most of the village would have been aware of it. Yet no one ever made mention of an earlier burial in any known document.

In the notes Philip Hall kept for his Winnipeg presentation on the Tom Thomson mystery, it is obvious that he was certain that Thomson's body had been removed and buried again at Leith. Hall slammed William Little for his continued reluctance to accept the findings of the investigation conducted by Sharpe and other medical experts, some of whom Hall knew personally. "It might be worth noting," Hall wrote of Little, "that his expertise was in juvenile delinquency and family discord."

Hall also accused the CBC of sensationalism in its speculation in the 1969 documentary that Thomson might still be at Canoe Lake, saying the public broadcaster chose to ignore the statement by Tom's sister Margaret Tweedale that "the family had always known that Tom was in the Leith grave and had hoped to shut down all the rumours by simply refusing to discuss a private family matter." He also repeated the family's claim that Tom's father and an old neighbour, John McKeen, had viewed the body.

Hall endorsed art historian Joan Murray's belief that family statements and reports in the Owen Sound newspaper confirmed beyond doubt that Thomson's body had been sent to Leith. As for the "Indian" found in Thomson's grave, Hall said, "Although this remains unpublished, Joan Murray told me that she found in the Ontario Archives a burial certificate of an Aboriginal male buried in the Mowat cemetery in 1913, who had a previous trephination."

This possibility absolutely floored me. I had never heard of such a certificate and was stunned to think such an important document could remain "unpublished." Given the decades-long interest in the Tom Thomson story, proof like this—that an Aboriginal person had, indeed, been buried at the site—would have been a major news discovery. In March 2009 I contacted Joan Murray, and the noted art historian confirmed in part the statement attributed to her by Dr. Hall. She did, however, say that she'd found the reference at Library and

Archives Canada in Ottawa, not at the Archives of Ontario in Toronto. "I did not note down the file," she wrote back to me. "I am sorry." If such a file could be located, it would provide the best proof possible that an Aboriginal male who had had an operation on his skull had indeed been buried where people thought Tom Thomson had originally been laid to rest. I immediately contacted Algonquin Park archivist Ron Tozer, who knew of no such certificate. I then contacted archivists at both Library and Archives Canada in Ottawa and the Archives of Ontario in Toronto. Neither archivist was able to find the documentation that might confirm this.

If an "Indian" had been buried in 1913, it would have been noted by a community, where, as Gibby put it, "you can't even go to the backhouse 'ceptin' everybody knows about it." But even more telling is the fact that a grave dug only four years before Thomson was laid to rest would have been impossible to miss when the grave for Thomson was dug in 1917 (it would most assuredly have been much more obvious than the supposed "Indian" grave dating from 1894, which Plewman claimed existed). Out of respect alone, the grave diggers would have avoided the 1913 grave, if one ever existed, when preparing Tom Thomson's resting place.

The only conclusion that makes sense is either that there was no Indian buried in that spot in either 1894 or 1913 or that the "Indian" and Tom Thomson did not share a grave. This would require two separate graves: one for the "Indian" that Plewman and Murray believed had been buried at the Canoe Lake cemetery, albeit at different times (and that the Ontario attorney general's office claimed had been dug up), and one for Tom Thomson, whose body Churchill claimed to have exhumed and which some others claimed had been "viewed" prior to reburial at Leith. Since the 1956 diggers did find a skeleton, the official declaration that it was *not* Tom Thomson's would mean that the diggers had missed the spot where Thomson had been buried and simply happened to find another skeleton in another casket.

So there remained two final possibilities:

One: the investigators connected with the office of the provincial attorney general and the Government of Ontario were wrong.

or

Two: Tom Thomson's body and the "Indian's" were one and the same.

Intriguingly, art curator Andrew Hunter, in his fine essay "Mapping Tom" in the art book *Tom Thomson*, suggests that "the inference that Thomson was 'Indian' was certainly common." There was also a possible connection between Thomson and Grey Owl—a British Caucasian who fooled the world into thinking he was Aboriginal. It has been stated that the two met in the Mississagi River country in northern Ontario during the summer of 1912, though there is no documented or photographic evidence that Tom Thomson and William Broadhead met Archie Belaney at this time. In a letter I received in 1973, Canadian historian Donald Smith, Grey Owl's biographer, said, despite all the claims that the two knew each other: "I still don't know for sure."

Respected art critic William Arthur Deacon, writing in the Toronto *Mail and Empire* on November 9, 1936, told his readers that he'd had lunch at the Toronto Book Fair with Grey Owl, who was in from Prince Albert, Saskatchewan, and Albert H. Robson, author of *The Literary Map of Canada*. Robson, Thomson's former art director at Grip, greeted Grey Owl as if they already knew each other, but the great "Native" author had no recollection of having met Robson. "You came down from the north more than 20 years ago," Robson protested, "and got me to do some phoning for you to locate Tom Thomson."

Grey Owl was said to be "incredulous," not realizing until this moment that the fire ranger had been the renowned painter. "I saw a lot of those rangers on Lake Minnissinaqua," Grey Owl said. "The one who painted made especially good doughnuts. He sent me some of his pictures."

Robson said that was the one, that he remembered when Tom worked as a fire ranger—"and I well remember you, Grey Owl," he added. "You and Thomson are almost exactly the same size and build."

Yet while it might have been argued that Thomson "looked" somewhat Aboriginal, as Grey Owl certainly did, the scientific evidence had proved otherwise. The key, anatomy and anthropology professor J.C.B. Grant had argued, lay in the shovel-shaped incisors found in the 1956 skull, teeth that could belong only to someone of Aboriginal heritage.

Dr. Noble Sharpe, in his later writings, did hint at just the slightest self-doubt years after he officially declared that the skeleton uncovered at Canoe Lake in 1956 was not that of Tom Thomson. He had worked from photographs, he said, most of them grainy, many of them taken at a distance. "Had I been able to obtain a full-face and profile pictures of Tom Thomson," he said when pressed about how absolute his conclusions were, "I could have made those to scale and compared them with bony points on the skull."

This statement—even though Sharpe was certain the scientific conclusions of 1956 were correct—long intrigued Dr. Bob Crook, an Ottawa dentist who had taken over the Blecher lease on Canoe Lake, torn down their old home and built a handsome new cottage. Crook searched out all available photographs of Tom Thomson and eventually found one that gave a fair profile of the painter—a shot of Thomson in a canoe, leaning with one elbow on a shoreline stump, as he gets ready to head off fishing with fellow artist Arthur Lismer.

In the summer of 2009, Dr. Crook began working with Ottawa orthodontist Dr. Jim Hickman, who has done extensive study of facial bone structure, and the two compared the photo of Thomson in profile to the various photos of the skull that was dug up in 1956. They found that the supraorbital ridges (eyebrow ridges) in the Thomson photograph were similar to those on the skull, and they noted that "the extent of ridge development is relatively rare."

Crook and Hickman also did facial proportioning and concluded that Thomson's head revealed "an excessive mandibular development resulting in an imbalance between the lower and the middle face heights." In most skulls, these heights are roughly equal, but in both the photographed skull and the photographed profile of Thomson, the lower face

height is more than one and a half times that of the middle face. Such a degree of imbalance, Crook and Hickman believe, occurs in less than 5 per cent of the population. Both investigators were also struck by the "very prominent anterior chin point" they found in the skull photographs and felt this feature correlated to the "forward sweeping" chin Thomson's photographs show. In addition, shadows in photographs of Thomson indicate "a very prominent cheek bone"—similar to the features of the skull found in 1956. Such a "degree of prominence," Crook told me, "is not apparent on most people.

"For the individual in the photo to have developed the same relatively rare facial characteristics to the same degree as the individual represented by the skull, and for both persons to have been interned in the same gravesite, is unimaginable," Crook wrote to me. At the end of their examination—restricted, it is important to point out, to photographs of Thomson and the recovered skull—the two "agreed that . . . [they] could find no features on the facial or skull photos which would indicate a negative correlation between the two individuals."

In other words, as far as they were concerned, the skull that had been returned with the bones of the "Indian" for reburial in the Canoe Lake cemetery had to be the skull of Tom Thomson.

This admittedly amateur forensic work of the two Ottawa dentists suggested that errors might have been made by the lead provincial investigator Dr. Noble Sharpe and, even more so, by the man whose decision had carried the greatest weight in 1956: esteemed Professor J.C.B. Grant of the Department of Anatomy and Anthropology at the University of Toronto. Yet to challenge their conclusions, whether as dentists familiar with bone and jaw structure or as an author who simply suspected, would be folly. A challenge from an irrefutable source would be required.

In late 2009 I contacted Ronald F. Williamson through a friend. Dr. Williamson is one of North America's leading archaeologists—an adjunct professor in the Department of Anthropology at the University

of Toronto—and he is the founder of Archaeological Services, a Toronto-based company that has some 3,500 projects to its credit. Archaeological Services was involved in the discovery and exhumation of the bodies of twenty-eight American soldiers who had fought in the War of 1812 at the Snake Hill Cemetery in Fort Erie, Ontario—and this led to the subsequent repatriation of the soldiers' remains. Williamson and his team were also involved in the exhumation of the bodies of fifteen hanged men at Toronto's old Don Jail. But Archaeological Services also has particular expertise in the identification and exhumation of Aboriginal remains.

At Dr. Williamson's behest, I supplied him and his staff with as much photographic material related to Thomson as I could locate. I was also able to give him access to the various photographs of the remains found at Canoe Lake in 1956 and a never-before-published photograph owned by the Taylor Statten family of the skull as it had come out of the ground that autumn day. Dr. Williamson, who has long been passionate about Thomson's art, asked various staff members and colleagues to compare the Thomson photographs, using sophisticated modern measures and analyses that at times seem straight out of *CSI*.

But Dr. Williamson himself began by using a time-honoured method of scientific investigation: looking with his own eyes. "My first step was to study the photographs [of the skull] myself," he wrote to me on November 5, 2009. "I thought immediately that the individual looked European based on general cranial morphology, orbit morphology in particular and the good shape of the teeth. This, however, is not my area of expertise but on that basis was agreeable to distributing the photos for a couple of opinions that count."

It would have been preferable to work with the actual skeletal remains, of course. "In these times," Williamson said, "actual DNA is the only truly reliable evidence for personal identity." And yet, within this reality, today's science can do a great deal with sophisticated instrumentation, photographic analysis and computer software that simply was not available to Sharpe or Grant in 1956.

With this understanding, Williamson turned first to Alexis Hutcheson, a biological anthropologist who works for Archaeological Services and has expertise in the excavation and identification of both Aboriginal and European remains. She was asked to work "blind," with no other reference but the photographs of the skull, to identify ethnicity, age and gender. She soon reported that, in her expert opinion, the skull belonged to an adult male European.

Next to study the skull was Dr. Susan Pfeiffer, an internationally respected physical anthropologist with a particular interest in forensic archaeology. Dr. Pfeiffer had just completed a five-year post as dean of Graduate Studies at the University of Toronto and was returning to her first love, research. (Coincidentally, she is responsible for the Grant collection in the university's Department of Anthropology.) She worked directly with the photos of the skull—including the recently discovered close-up that shows the teeth particularly well—without the advantage of any previous research directed specifically at connecting the skull with Tom Thomson.

"The skull appears to be from a north European/British Isles population, based on shape of vault, jaw and nose," Dr. Pfeiffer reported back. "Based on the complete teeth, he is clearly a mature adult." As there were no indications of advanced age, she concluded he was "middle aged." (Thomson was nearly forty.) Pfeiffer concluded that the skull belonged to "a 50-ish northern European (let's say Scottish) male who died sometime in the twentieth century."

Dr. Pfeiffer did not think the cranium was that of an Aboriginal person, as Grant had argued. While acknowledging Grant's previous work in the area of Aboriginal anthropological study—he once delivered academic papers on the Cree and Saulteaux First Nations of northeastern Manitoba—Pfeiffer added that "modern scientific methods can contribute new perspectives." The university's Department of Anthropology did not have a faculty member with osteological [bone structure] expertise until several years after Grant had reported to the Ontario attorney general's office that, in his opinion, the remains

belonged to an Aboriginal male half Thomson's age who had once had an operation performed on his brain.

"If Grant placed strong emphasis on shovel-shaped incisors," Dr. Pfeiffer said in a later note to me, "that would have been consistent with scholarly practice in those days, when racial groups were seen as distinct, and certain anatomical features were seen as diagnostic."

Grant, of course, had done precisely that. He was correct in saying that shovel-shaped incisors were indicative of Mongoloid or Aboriginal origins but wrong to exclude origins in the British Isles. Ron Williamson was able to provide learned studies that showed shovel-shaped incisors common in the British Isles, including one study that found such teeth in 95 of 622 nineteenth-century Irish Catholics—"a very significant percentage and a good sample," he says, "and has contributed in our discipline to changing views of this attribute and its role as an indicator of Aboriginal ethnicity."

Dr. Pfeiffer also took issue with Grant's claim that the "Indian" had once been operated on, hence the hole in the left temple of the skull. It seemed a most unlikely spot for a cranial trephination if, in fact, one had taken place. "This," she wrote, "is because there are two layers of bones at this location (temporal bone overlying sagittal) and there are significant vessels immediately beneath the bone, so placing a hole there is dangerous to the health of the patient. Also, I know of no tradition for this kind of surgery among any of the First Nations of Ontario."

As for the hole itself, Dr. Pfeiffer had several thoughts: "The images do not show radiating breaks as might be created by a powerful projectile, but there are various other scenarios that could be explored if the image were better or the skull itself was available, including a breaking away of the bone from a glancing blow (before or after death), the postmortem erosion of the bone from a significantly sized, acidic plant root, even a healed area from a wound obtained much earlier in life (cranial holes do not normally 'grow over'). All I can say is that trephination is improbable."

Dr. Williamson agreed that the 1956 investigators put too much emphasis on the shovel-shaped incisors. "At the time," Williamson says, "that trait was thought to be far more indicative of Aboriginal ancestry than today." In Williamson's opinion, Grant had made "an honest mistake."

At the end of this phase of the investigation, the scientists reported that, in their opinion, the skull belonged to a European male, not an Aboriginal person, as the government authorities had reported. Further, they believed that the injury to the skull was caused by a sharp object, not a bullet or trephination.

Having established this, Dr. Williamson turned his attention to the actual identification of the skull. The firm was able to use a photogrammetric comparison of the skull with various images of Thomson taken from a variety of profiles. The work was carried out by Andrew Riddle, who was just completing his doctorate in archaeology at the University of Toronto and joined Archaeological Services in 2007.

Riddle used photogrammetric software to compare facial structure in frontal and profile views, employing distances and angles between the eye orbits, maxilla, glabella, auditory meatus and mental eminence. Working with two-dimensional images, he was able to match and examine facial features from the photographs and compare them to the facial features that would be produced by such a skull. "Based on these results," Riddle reported back, ". . . in combination with more general observation of cranial form, there is no morphological characteristic that suggests the skull belongs to anyone but Tom Thomson."

In other words, even lacking the absolutely conclusive evidence DNA would provide, these scientists believe that Tom Thomson lies where he was originally laid to rest at the Canoe Lake cemetery.

Williamson had one final suggestion. He wanted to send the skull photos—including the new, extremely clear one from the Statten family—to Victoria Lywood, a Montreal-based forensic artist who boasts a long résumé of successful reconstructions for criminal investigations. Williamson requested that Lywood attempt a two-dimensional facial

reconstruction of an unidentified cranium he called "John Doe." She was given the photographs of the skull, none of Thomson and the following extra information: "John Doe" would likely be a Caucasian approximately forty years of age. He would have lived in the early twentieth century and worn his straight black hair medium length, parted on the left.

Several weeks later, Lywood delivered her professional illustrations to Williamson, who emailed me immediately: "SIT DOWN, TAKE VALIUM, OPEN SLIDE." I skipped the Valium but did sit down before opening the slide as instructed.

And found myself looking at Tom Thomson.

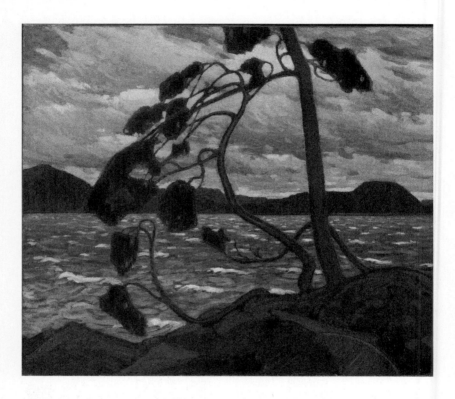

The West Wind, c. 1916–17. There is much debate about the precise location of Tom Thomson's best-known work, painted over the winter of 1916-1917.

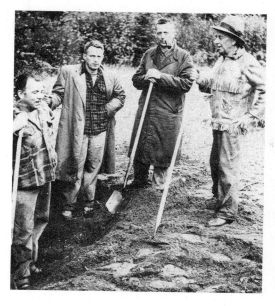

In the fall of 1956, four men—left to right: Leonard "Gibby" Gibson, William Little, Jack Eastaugh, Frank Braught—decided to check the Canoe Lake cemetery and see if Tom Thomson remained buried there, as locals had long claimed. They uncovered a skeleton—but a far bigger shock followed their discovery.

Dr. Wilfred T. Pocock was a close friend of Winnie Trainor's during the years she lived in Kearney, Ontario, and later in Huntsville. Pocock was executor of her estate.

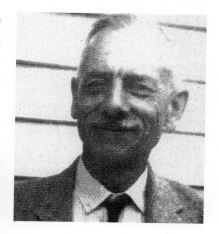

Dr. Harry Ebbs of Taylor Statten Camps oversaw the 1956 exhumation. He left behind papers not to be revealed during his lifetime that suggested the Ontario Attorney General's office engaged in a cover-up to ensure that there not be "any more fuss."

In September 1917 Tom Thomson's artist friends erected a memorial cairn at one of Thomson's favourite camping spots on Canoe Lake. J.E.H. MacDonald wrote the tribute that appears on the bronze plaque: "…He lived humbly but passionately with the wild. It made him brother to all untamed things of nature…."

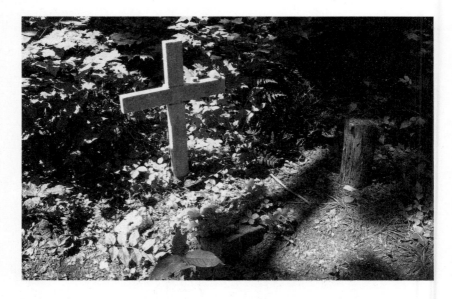

This small white cross was placed in the Canoe Lake cemetery in the late 1960s to mark the spot where Tom Thomson was buried. The marker misses by several feet the actual grave where the painter still lies today.

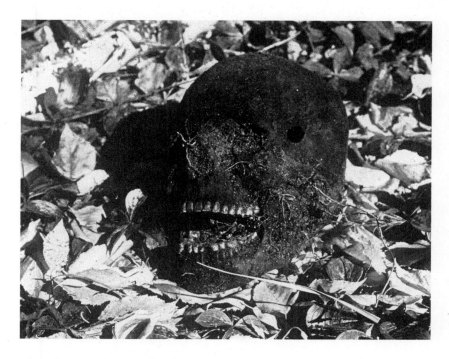

This close-up photograph of Tom Thomson's skull as it was removed from the Canoe Lake grave in the fall of 1956, provided by the Statten family, has never before been published.

Photograph taken by the Ontario Centre for Forensic Science of the skull unearthed in 1956 and cleaned in Toronto.

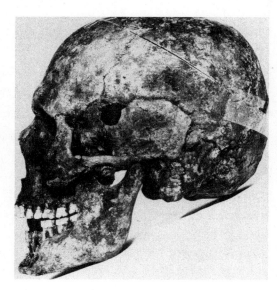

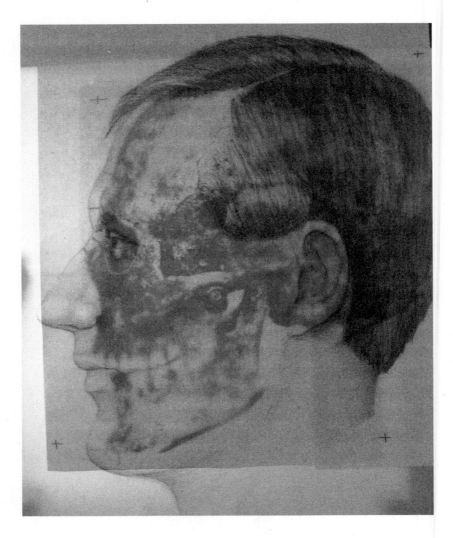

Internationally recognized forensic artist Victoria Lywood worked with the various photographs of the skull, including the previously unpublished photograph provided by the Statten family, to produce this overlay of features. She worked blind, unaware of the origins of the skull or to whom it might belong.

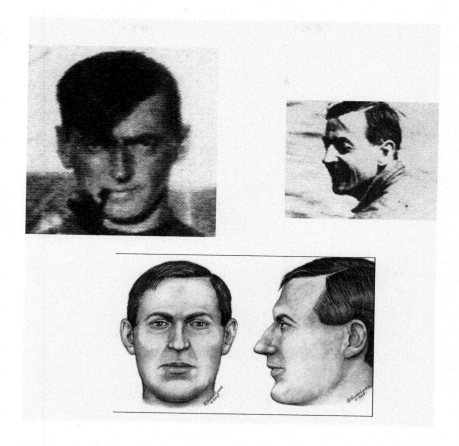

This comparison of photographs of Tom Thomson to forensic artist Victoria Lywood's interpretation of the face belonging to the skull was compiled by Dr. Ronald F. Williamson, adjunct professor in the Department of Anthropology at the University of Toronto and founder of Archaeological Services, an internationally recognized company that specializes in the identification of long-buried remains.

SEVENTEEN THE POWER OF SILENCE

As Dr. Harry Ebbs later told Ottelyn Addison, Mark Robinson's daughter, they all just wanted "to put an end to the furor" that the digging up of the grave had set off in the media. And the authorities—acting, no doubt, in the belief that doing so was in the best interests of the Thomson family—did so, Ebbs adamantly believed, knowing full well that the body uncovered at Canoe Lake had been that of Tom Thomson and that the hole in the skull strongly suggested foul play, perhaps even murder. It bothered him terribly that he had been unsuccessful in challenging the "official" story—one he sensed was a lie—that the Ontario government produced. In his view, it made him party to a cover-up. Dr. Noble Sharpe, the main official scientific voice of the provincial government, understood the implications. Years later he would write that the day might come when the Thomson family would wish to prove once and for all that the body was buried in the family plot at Leith. He, for one, was certain Tom lay there. But, "If I am wrong in my belief, and if and when the grave is opened no body is

found, then, if circumstances so warrant, the investigation should be reopened in the Canoe Lake district."

No body at Leith, a body with a hole in the skull at Canoe Lake—certainly that of Tom Thomson. The implications are obvious. There would need to be a proper murder investigation. And yet, if Dr. Harry Ebbs's words are to be taken as truth, the attorney general of Ontario and a deputy minister, acting in the belief—well-intended and surely accurate—that the Thomson family did not need to be put through "any more fuss" in the media, acted to ensure that all would go away quietly. So no proper investigation was ever initiated, despite requests that dated back to Blodwen Davies in the early 1930s.

And this, essentially, is the story of Tom Thomson's death: stop the fuss, put an end to the furor, protect reputations, at every possible step. Superintendent Bartlett didn't want trouble, so he embraced the possibility of accidental drowning and signed the papers allowing for a hasty burial. Coroner A.E. Ranney walked into a situation where a fuss could only ensue—the papers already signed, the body already buried—so he washed his hands of the entire thing, never examined the remains, let Bartlett's decision stand and got out of Canoe Lake on the first available train. I doubt Ranney ever even filed the report that has always been described as "missing."

The sole voice of authority at Canoe Lake, Ranger Mark Robinson, knew there was "considerable adverse comment" about the taking of evidence, but he kept his suspicions to himself at first and began voicing them only in later years. Dr. James MacCallum, Thomson's great patron and the man assigned to sell the works George Thomson had brought back from Canoe Lake, refused to listen to Daphne Crombie when she tried to tell him what Annie Fraser had told her. The Thomson family, keen to rely on Winnie Trainor during the confusing days of the burial and supposed exhumation, quickly distanced itself from her, turned down her written promise to Tom Harkness ("If I see you I can tell you all") and soon dismissed her as being "not in her right mind" and under the care of a "guardian," which was never the case.

Thomson's friends who went on to form the Group of Seven all had their concerns and suspicions, yet they all took J.E.H. MacDonald's approach: "the silence of an old friend." A.Y. Jackson deliberately exorcized Blodwen Davies' leading questions concerning Thomson's fate when he oversaw the re-publication of her 1935 biography. One attorney general of Ontario refused Davies' entreaties to have the investigation re-opened in the 1930s; another attorney general of Ontario sought to "stop the fuss" in the 1950s by embracing the suspect findings of a forensic scientist who refused to countenance any argument from Dr. Harry Ebbs. Dr. Noble Sharpe, according to the statement Dr. Ebbs left behind following his death, went from declaring with certainty that the hole was caused by a bullet wound when the skull was first uncovered at Canoe Lake to embracing Dr. Grant's highly contentious declaration that the skull belonged to an "Indian" who had once had a brain operation. The elderly McKeen sisters brought out their remarkable story of a cousin supposedly viewing the remains with Thomson's father, hoping to quiet yet another "furor" brought about by the 1969 CBC documentary and the 1970 publication of William Little's book . . .

It didn't much matter what anyone else said, though, the locals around Canoe Lake were certain that Thomson had never been moved and lay buried where he had been placed on July 17, 1917. Thomson's friends Taylor Statten, the camp owner, and Ranger Mark Robinson never believed otherwise. Robinson had died the Christmas before the 1956 dig, but Statten was still around at the time. On Halloween night, 1956, Statten sat down in his log cabin on Little Wapomeo Island and typed a letter to Ottelyn Addison, Robinson's daughter. The dig, Statten wrote, "has created some excitement in this neck of the woods. It is too bad that it did not break while your father was alive."

Statten mentioned, and contradicted, the just-published claim by Churchill, the Huntsville undertaker, that Robinson had assigned four men to help him with the exhumation of Tom Thomson's body in 1917: "Both your father and Shannon Fraser told me that Shannon met him at the station, took him to the cemetery, asked him to come with him to

Mowat Lodge for the night, but he said he would stay all night and do the job. In the morning Shannon picked him up along with the casket and shipped it on the morning train."

As for the wild new story that some "Indian" had been buried in the cemetery and dug up instead of Tom Thomson, Statten clearly believed otherwise. "Pete Sauvé has been around Canoe Lake since the Gilmours came in the early 90s," he wrote, concerning his camp's longtime cook, "and he is sure that there were only two burials in the cemetery. Watson, the mill hand, and the Hayhurst boy. So it goes!"

The next morning, November 1, 1956, Taylor and Ethel Statten, "Gitchiahmek" and "Tonakela," went to work on their little island garden, lifting and moving some large stones that they wanted to position before spring planting. "I'm bushed," Taylor told his wife and said he was going into the cabin to lie down. He died in his sleep.

Nearly a month later, Ottelyn Addison wrote to Roy Dixon, the original undertaker who had buried Thomson in the Canoe Lake cemetery, to thank him for the letter to the editor he'd written to the *Toronto Star* in which he took issue with all the reports that there had been "foul play." He said he knew the body had been removed because Mark Robinson had told him later that the body "was in a remarkable state of preservation and must have been well embalmed." We know, of course, that Robinson never saw the body after it was buried at Canoe Lake and was, likely, merely offering comforting words, a little white lie, to ease the concerns of his cousin the undertaker.

"Dear Cousin Roy," Addison's November 27, 1956, letter began. She said she had been following all the Tom Thomson publicity and was "wondering just what could have been the purpose for starting it all. Mr. Little and Mr. Eastaugh called one evening but I did not find out the answer. I also felt it was not going to help anyone to have the situation 'probed' further so I was most grateful to read your letter to the *Star*. I do hope it has put an end to their investigating."

Addison then condemned Churchill's story that Robinson had assigned four men to work with him, referring to Taylor Statten's October

31st letter and also to her father's daily journals. "But," she added, "there was going to be no actual good to come out of disproving the second undertaker's statement, so we are keeping very quiet."

And yet, despite this commitment to "keeping very quiet," Mark Robinson's daughter then went on to tell their cousin: "But between ourselves, Dad always felt Tom had met foul play. Jack was 12 when he helped Dad, every day, to look for the body and he has a very clear insight into the whole picture. But all this is past history and is best to remain that way."

How similar this sounds to J.E.H. MacDonald's call for "the silence of an old friend."

In fact, it is just possible that much of the Tom Thomson story became so confused over the years because of such convenient silences. Given that Bartlett had declared the death by drowning in his park capacity as "ex officio coroner" when no true coroner was available, who was Ranney, the real coroner, to cause a problem by allowing his little inquiry to suggest otherwise, no matter how he might have felt about Bartlett jumping the gun and permitting the body to be buried? Bartlett certainly felt he was in a position to decide it had been a drowning and to approve the burial. His first obligation, he believed, was to make sure his superiors had no trouble. After all, Premier Arthur Hardy had specifically requested that Bartlett make the new park "a credit" rather than "a blot."

The silence of friends and others. The undertaker, Churchill, claims four men were assigned by Robinson to help him and Robinson's daughter, knowing full well this is untrue, decides to remain silent on the matter as it is "past history and is best to remain that way."

And the convenient white lies, perhaps intended only to give comfort. What harm, after all, could there be in the elderly sisters saying their cousin and Tom's father had viewed the body prior to its burial at Leith?

Not nice, but saying the body had been seen was not only easy but also awfully convenient if you wished to put an end to disturbing chatter. Same for the skeleton dug up in 1956. Once the scientists said they believed it was an "Indian," we suddenly find people stepping forward

saying an "Indian" was buried there in 1894 or 1913 or, as Winnie herself is said once to have claimed, some time after 1917 in Tom's now-empty plot.

Surely we can now accept that Thomson's body still lies in the Canoe Lake cemetery, which is where many believe he would most wish to be. But one part of the great mystery is still not known—that is, exactly how Tom Thomson died and who, if anyone, was responsible. While I believe I can make a pretty fine guess about what happened and who killed him, I admire the attitude taken by the painter's great-grand-niece, Tracy Thomson, who several years ago told the *Toronto Star*'s Ellie Tesher that she feared "that once people know the truth, that's the end of the intrigue and the chatter about it."

Let the chatter never end.

But let it also spare a few kind words for the second tragic victim of whatever happened that cool, wet July day in 1917 at Canoe Lake: Winnie.

EIGHTEEN AFTERMATH

W innie Trainor never said a word in public about the dig, but she did express her outrage to friends and family. "They can do all the digging they like," she told neighbour Minnie Carson. "They won't find him up there." She told Ray and Jean McEown, her downstairs tenants, that she would speak to Leslie Frost, the premier of Ontario, with whom she claimed a friendship, about the grave tampering. She may have felt she could call on the premier, as Frost and Mark Robinson had remained in contact from the days when they had served together in Europe during the Great War. She had also met Frost when he visited Canoe Lake, but there is no evidence to suggest she ever did attempt to make contact.

She did, however, speak to Dr. Noble Sharpe a couple of times. Sharpe said she claimed to have been at the Canoe Lake station with her father when the casket containing Tom Thomson's exhumed body was being shipped to Owen Sound. There is no evidence whatsoever to suggest that she returned to Canoe Lake from Huntsville on July 18,

1917, for the exhumation she had arranged with Churchill on behalf of the Thomson family. And Mark Robinson made no mention of her or her father being at the station when he noted in his journal that he was surprised to find Churchill waiting there, alone, with the casket when Robinson had not even been informed of the exhumation. Churchill also made no reference to either Winnie or Hugh Trainor being there, though he did claim Robinson had given him four men to assist with the digging. Winnie's statement to Sharpe was likely just one more of the multiple white lies told in the hopes of putting an end to distasteful speculation.

In late 1956 Winnie was not well. Dr. Pocock had her moved to Toronto General Hospital in the New Year. (At some point she underwent surgery for a growth in her left breast, and it might well have been during this time.) On January 30, 1957, Winnie sent Pocock a pink card with a floral front from hospital room 602:

> Dear Dr. Pocock,
>
> Dr. Shier was just in and said I could go home anytime—and to go to the hospital at home under your care—so would you please tell me what to do—and what train to arrive on—I'll see about my bills here today when my friend Mary Summers comes in—she looks after my bills.
>
> I am so glad I am so well.
>
> Best wishes to yourself & Mrs. Pocock,
>
> Sincerely,
> Winnifred Trainor
>
> P.S. I have 92 days Blue Cross, I think.

Winnie returned to her flat on the upper floor of the big brown house on Minerva Street and gradually regained her health. She was in her seventy-second year, overweight and surviving on a small pension

and the rental income from the downstairs apartment. She put in a new furnace for Ray and Jean McEown, finally replacing the coal furnace that Ray so hated. The cost may have been covered, as her neighbours the McLellans believed, by the sale of one or more of the Thomson sketches she owned. Winnie refused, however, to pay the added cost of having the heating pipes extended upstairs to her own apartment. Instead, she had a space heater installed for herself, a noisy contraption that reeked of oil when you visited in cold weather.

Huntsville was in the midst of the postwar boom, its population soaring above three thousand. The Bell Telephone Company needed to expand and came to Winnie's prized double lot at Minerva and Centre but could not persuade her to sell, not even at a bonus price. "She said she wouldn't sell," said Jean McEown. "She said she'd give it away to a religious order of sisters before she'd ever sell it to anyone."

Winnie still told people that Tom Thomson had painted her dining room. She would not allow the McEowns to paint over it, even though they were eager to redecorate to their own liking. "One time I had to paint the kitchen," Ray recalled. "There was six doorways into it. It was a monster. She gave me a *quart* of paint to do the whole thing."

But the McEowns were good tenants and helpful to her as she grew older, despite the odd misgiving. "I used to hide when I seen her coming to cut her god-darned toenails," Ray remembered with a laugh. "I used to hate that."

Addie Sylvester, from across the street, continued to visit and often wondered why Winnie didn't sell off more of those little paintings she never seemed to look at, so she could have a comfortable retirement. Addie heard the periodic rumours that Winnie had been pregnant with Tom Thomson's child, but she put no stock in them. "Talk about her being pregnant is stupid," she told me. "If anyone had a large family, she thought it was disgraceful. I don't know why."

Winnie kept to herself in those years and was mostly quiet, though she did speak up when something upset her. When a bypass was announced for Highway 11 that would skirt the town to the west and

pass over the Narrows between Hunter's Bay and Lake Vernon, she told people she would have it stopped—she would personally speak to her friend Premier Leslie Frost—because the route was going to pass over an Indian burial ground. But the bypass was put through without any public issue, and by 1959 it was possible to travel from Toronto to North Bay and roar past the small town across the new bridge, barely even noticing Huntsville's Reservoir Hill in the distance.

The aging woman was also upset about a new taxi stand that was set up on Minerva Street, directly across from her home, in an empty lot back of Parker's Bakery. The taxi dispatch office faced her and was noisy, with cars coming and going and headlights sweeping along her windows at all hours of the night. Nothing could be done about it, though, and it would be hard to imagine that she took any pleasure when her warnings that it would come to no good actually came to pass. In late June of 1959, two drivers from C&H Taxi went missing, and two local "toughs," Mervyn McKee, twenty, and Calvin Wayne Sluman, only sixteen, were later arrested and charged with their grisly murder. The jury took forty-eight minutes to find them guilty, Sluman receiving fifteen years for manslaughter and McKee sentenced to hang at the Parry Sound jail.

It was a time of fallout shelters and debate over whether movies could be shown on Sundays in Toronto the Good. Any mention of Miss Winnifred Trainor in the now sharply reduced "Personals" section of the Huntsville *Forester* were rare. Her nephew Terry won a scholarship in early 1960, and Winnie was identified as "the latter a daughter of the late Mr. and Mrs. Trainor, pioneer citizens of Huntsville." Terry came to visit Winnie at Easter, and his sister Marilyn—spelled "Merlyn" in the paper—came for the following Christmas.

I saw Winnie only periodically during these years. I was a youngster and, to me, she was a very old woman, usually cranky, of very little interest. She seemed to come from another time, also of no particular interest, whereas I was caught up in the now and in what was to come. It was a wonderful community to grow up in—for a kid who loved sports, there was hockey all fall and winter, lacrosse and baseball in

spring and summer. And the town was booming, with 3,241 people, including 700 students in the various elementary schools and one high school. Skilled labourers, the town bragged, could make $1.25 to $1.75 in town, while women were making $0.50 to $0.85 an hour.

Huntsville sounded modern in the Chamber of Commerce brochures intended to attract new business to the town, but horse-drawn ploughs still cleared snow from the sidewalks, and many of the houses, including ours, were heated with furnaces fed with kiln-dry—the loose ends and waste from the Hay & Company's hardwood flooring plant down on Hunter's Bay. And that wood was delivered by horse-drawn wagon. But soon bread was delivered in a truck, and not long after that, the Huntsville Dairy followed suit. Eventually, home delivery would stop altogether, and there would be no coming home from school to find milk bottles on the stoop, their lids riding on white top hats of frozen cream.

Modernization also meant that television was coming to town. The T. Eaton Co. at the corner of Main Street and West Road sold the first sets, though Huntsville could pick up only one channel, CKVR Channel 3 in Barrie. The picture was snowy and sometimes disappeared altogether, yet people were mad for the new shows they could see. Winnie often invited herself over to the home of her Centre Street neighbours, the Eastmans, on Monday evenings, when *Don Messer's Jubilee* was on, and she went to see *The Tennessee Ernie Ford Show* on Thursdays.

She liked the news and she particularly liked a Thursday night Canadian game show, *Live a Borrowed Life*, where guest actors pretended they'd lived another life and panelists had to identify the persons the actors were pretending to be.

Perhaps it made her think of what might have been.

These were the only years in which I personally knew Winnie. Her home was less than three blocks from ours, a short walk up Minerva to Lorne, then left along Lorne past Mary Street to the corner of Lorne and

Lansdowne. That was where our white clapboard house stood—the place we'd moved to from near Whitney, on the eastern edge of the southern extension of Algonquin Park, in 1950. Winnie often came to visit us at Lorne Street because we were her closest "family," as her sister, Marie, had married into the McCormick family. She also visited the family place at Lake of Two Rivers, where my grandparents Tom and Bea McCormick had built their two-storey log home in the early 1940s and where they had once lived year round with my mother before she'd married and started her own family. After my grandfather's retirement from the Department of Lands and Forests, the McCormicks still spent more than half the year at the lake, and we spent every moment there from the day school let out until it went back in September, my family living in three small cabins built along the rocks of the Lake of Two Rivers point.

Winnie would sit in one of the brightly painted wooden lawn chairs my grandfather made and work her beads like a rosary. Sometimes she'd twirl her glasses—perhaps they were sunglasses—and run down the tourists for a vast variety of crimes that included blocking the roads every time a deer wandered out of the woods to feeding the bears through the wire fences at the dump. One afternoon she got so wound up that her glasses flew out of her hand and high into a nearby spruce tree. I had to retrieve them for her, getting pitch on my hands in the process.

She'd kept her parents' small cabin on Canoe Lake, a few rolling and twisting kilometres down Highway 60. We all knew that Tom Thomson had once sat on the wide front porch and painted a storm breaking over Little Wapomeo Island. And family lore had it that he had hand-painted some of the old tea cups in the cupboards.

And then, of course, there were the Thomson sketches Winnie kept at her Minerva Street home in Huntsville. "My mother believed she never looked at them," Addie Sylvester told me in the spring of 1973, shortly before Jimmy Stringer broke through the Canoe Lake ice and drowned. Addie and her mother often stored those sketches when Winnie would travel, keeping them in back of the wood stove, but they had no sense of what they'd one day mean. "I don't know why [she]

thought they'd be safer over here," Addie said. "We didn't value them, you know. They weren't anything more to us than the pictures on a postcard. I didn't realize what they were till later. If only I'd stolen one . . . but I guess Winnie would have had them counted," she added with a high-pitched giggle, "and I never would have gotten away with one."

Addie was also eccentric. She worked nights and, like Winnie, never married—the two spinsters living alone directly across the street from each other. Addie was a tiny woman with long, curling yellow-white hair and a little girl's voice that often surprised people making calls after midnight. After her retirement from Bell, she had stayed on in the large house her father had built to house a photography studio that no longer existed. Fancy wallpapered rooms that in the years before the Great War would have been filled with family and customers were now portioned off with blankets and plywood, with small openings cut in the bottom so Addie's dozen or more cats could come and go as they pleased. She also had a small collection of old dolls she arranged in the sitting room as if they were quietly visiting, oblivious to the scurrying, scrapping animals.

Addie sang in the Anglican church choir for sixty-five years—she died in 1975 at age seventy-three. My sister, Ann, also sang in the choir, often sitting next to Addie, but Addie was so much shorter than everyone else that when the choir stood, she looked like a child whose hair had gone white. My mother was probably her closest friend. I would sometimes walk down from the hill with my mother to play with the cats while the two women visited over tea, and I would hope that Addie, who giggled like a little girl, would stand on her kitchen stool and reach up for the cookie tin she kept filled with Peek Freans. She seemed almost a doll herself, so tiny that her legs, like mine in those days, did not even brush the floor when she sat rocking slightly in a kitchen chair while the two women talked. Meanwhile, I kept watching the cats come and go and hold their constant elections to decide relative order.

Sometimes Winnie Trainor, another good Anglican, would join them. But even when she wasn't there, she was a presence, the two often

laughing, at times cruelly, at other times affectionately, at her various eccentricities. Addie believed it would have been such a simple matter for Winnie to sell off a painting or two so she could live more comfortably. But, in another way, she understood Winnie's reluctance to change anything. "After you've lived alone for a while, you just get tired," she said. "You don't care what people think. I know; I'm that way."

Addie would giggle as she remembered more of Winnie's oddities. "She'd do a wash and she wouldn't hang her clothes on the lines as long as the people living below had stuff on their lines," Addie remembered. "She had great big, long lines you know. She'd bring her things over and hang them on my line. And what is funny is I didn't have much of a line, so I would take my things and have them hanging over on one of hers. Mine'd be on *hers*—and hers on *mine!*

"She'd come into your house, pick up something you might have bought two years ago and want to know how much you paid for it, where you got it and when. And, of course, you'd have forgotten—and she'd get mad.

"She was snoopy and she'd talk about everybody. Even her best friends she'd talk about. She'd be over one afternoon visiting you and all friendly and then leave and go right out and tell everybody you were the worst person around. I think she only got that way when she got older."

Winnie kept great bundles of keys, Addie said, all carefully tagged. There were padlocks on doors within the house and locked trunks behind the padlocked doors. In the years after Tom's death, Addie claimed, Winnie grew increasingly frightened of the dark. "She was afraid to stay alone when her parents would be away. I'd have to go over and stay with her and leave *my* mother alone. And she always checked to make sure the doors were locked. She'd check about eighty times. She was *terrified* of the dark. She could get on your nerves."

Like Addie Sylvester, Winnie's other close neighbours, the Eastmans— Art Eastman kept a working stable into the 1960s—sometimes took guardianship of the Tom Thomson sketches. "Winnie would bring them over,"

the Eastman's daughter, Minnie Carson, remembered. "And we'd put them up in the attic."

Mrs. Carson believed Winnie held some bitterness about the way Thomson's value as an artist seemed to increase after his death. "She always said, 'We would have married if he would have had this fame in the first place rather than later,'" Mrs. Carson told me. "She could have sold the house, of course, but it wasn't worth too much then. She only had her Old Age pension." We'd say, 'Sell some of them pictures and buy yourself one'—but she wouldn't. 'Well,' we'd say, 'you can't take them with you, you know.'"

Given that Thomson's small sketch *Birches and Cedar* sold for approximately $1.4 million during the economic downturn of 2009, it's safe to say that Winnie Trainor's dozen or so sketches would have been worth roughly $20 million on today's market. Yet to Winnie, they seemed to hold little more than sentimental value. She never did frame the ones she kept or put them on her walls, either in her Huntsville home or at the Canoe Lake cottage. And she also never did sell them, despite endless suggestions from her neighbours that she do so. They puzzled as to why she would continue to live in that dreary old upstairs apartment with no central heating, television set, or running hot water.

Curiously, as the decades passed following her death in 1962, Winnifred Trainor became an increasingly central figure in a mystery in which, at first, her role had barely registered. Today, screenplays, musicals and works of fiction have been written about her. She's even featured in The Tragically Hip's song "Three Pistols" as the woman who hides in the shadows as young girls come to place flowers on the grave, sweeping the flowers away once they've gone. And yet her name doesn't even appear in the ongoing Tom Thomson story until 1969, when Ottelyn Addison, Mark Robinson's daughter, joined with Elizabeth Harwood to produce a slim volume called *Tom Thomson: The Algonquin Years*. Addison, accepting the identification provided to the National Gallery by Jessie Fisk,

printed the misidentified photograph of Winnifred Trainor in that book, and the photograph of the mystery woman has been "Winnie Trainor" ever since. "Winnifred," Addison and Harwood wrote, "comely elder daughter of Hugh Trainor, took a great interest in Thomson and his work. Tom visited her at Huntsville and gave her some of his sketches. One or more of these are reportedly of houses on the street in Huntsville where the Trainors lived."

There was no suggestion that there might have been more to this relationship than friendship. The authors used only a back-of-book footnote to add: "It was rumoured around Mowat Lodge in 1916–17 (chiefly by Annie Fraser) that Tom Thomson and Winnifred Trainor were to be married. A letter left carelessly lying on a dresser gave some substance to this rumour."

And yet, in the four decades since this first small mention, Winnie Trainor has increasingly emerged as a character of tremendous intrigue and interest. Sherrill Grace, author of the 2004 study *Inventing Tom Thomson*, sent an email to me in 2009 after I'd suggested to her that Winnie Trainor's life might represent a greater heartbreak than Tom Thomson's death. "I absolutely agree," she said, "Winnie is the real tragedy. Tom Thomson's death is a tragedy for our art, but the human pain, surely, is Winnie."

Part of the tragedy was that Winnie did not enjoy much sympathy in her lifetime. As Winnie grew older, she became known as "an opinionated woman." Joe Cookson was a local Huntsville historian whose family owned Grandview Farms on Fairy Lake, a tourist lodge where, in her later years, Winnie worked in the laundry. He wrote to me in the fall of 1976 and said, "I was acquainted with this lady, so much so that I avoided like the plague any verbal controversy with her. Anyone who dared cross her trail, especially in money matters . . . [was] subjected to her caustic tongue, be it ditch digger or mayor."

Winnie's sharp tongue and strong opinions may have been the cause of frequent rifts between her and her younger sister, Marie. "They didn't get along," said Addie Sylvester. "They used to scrap." All the same,

Marie and her family would come to visit, usually in summer. When Winnie knew that her three nephews and niece—Robert Roy, Hugh, Terence and Marilyn—were on their way to Huntsville from Endicott, New York, she would ask the Eaton's delivery men to drop off two empty appliance boxes, which she would then set up on her front porch. As each rambunctious boy would be dressed and cleaned for a trip down-town, he would be picked up and dropped into one of the boxes to keep him clean and quiet until the others were ready. When she had a third boy and Marilyn ready, she would then release the others so that all four, sparkling clean and groomed, were ready to go out.

"I can manage two," Addie remembered her shouting from the Trainor verandah, "but I'll be *damned* if I can manage three!"

"Winnie was A-number one as far as we were concerned," said neighbour Minnie Carson. "No one had a better character. When it came to writing letters or filing for pensions or finding out about any-thing, she was always there. This was the Winnie Trainor that we knew. She was very outspoken, didn't mince words and didn't bother to go behind your back. I never thought of her as being odd."

Minnie remembered her old neighbour as being capable of great charm, when she wished to show it, and as a very attractive woman when she took the time to look her best. "Winnie was a very, very good-looking girl—good looking until she died," Minnie said. "When she'd go to Endicott, she'd stay here until the train came and Art would drive her down around 2:00 a.m. She'd look like a million bucks."

"She could be a fine-looking woman when she wanted to be, but she just looked like a hobo most of the time," said Jean McEown, Winnie's downstairs tenant. "She'd have her socks rolled just about to her knees. But she was a good looking woman, even when she was older. She dyed her hair as blue as the sky sometimes."

We youngsters had our own thoughts about who Winnie Trainor was, and they differed sharply from those who befriended and defended her. For

months around the time of Winnie's death in the summer of 1962, a large brown squirrel had been frozen between two wires leading into the green hydro box that sat on a pole directly in front of her bedroom window. It had been zapped and mummified in a crucifixion position until, eventually, time and the elements caused the carcass to rot to a point where the animal's remains finally fell to the curb and vanished in the runoff headed for the river. Because of this bizarre coincidence, among others, neighbourhood children considered her a bit of a witch and avoided her house.

She had been the bane of my existence when I was younger. My mother would often cringe when she looked out and saw "Miss Trainor" making her way up Lorne Street to our house a block higher along Reservoir Hill. She was a sight never to be forgotten: a large, dark, sullen figure moving slowly and deliberately, black hat over dark, scowling eyes, her black stockings slipping and rolling down thick legs under a dark dress, an umbrella held in one hand to deal with wandering dogs or teasing children as much as the possibility of rain. She seemed to have no smile in her, thin lips set in permanent disapproval. That darkness permeates my memory of her is no surprise, for she almost always wore black or various shades of grey and her deep-set eyes were quick, judgmental—missing nothing.

She would climb the steps—always using the front door (the Stringer brothers always came to the back door)—plunk herself down in the best porch chair or, in colder weather a chair in the kitchen, and spend several cups of tea complaining to my mother about everything from the altar decorations at the Anglican church they both faithfully attended to the near-criminal behaviour of certain children she had seen in the recent company of my mother's children. The visits were never relaxed.

I was terrified of Winnie myself. My friends loved to play tricks on her—nicky-nicky-nine-doors usually—and I nervously went along with whatever was proposed. Once we filled a brown-paper bag with dog excrement, doused the bag with lighter fluid, then set it on her porch, lighted the bag, pounded on her door and ran. We then dived into a

bush on the far side of the street and tried to stifle our snorts and hysteri-cal giggles as she came out in her heavy black shoes, stomped out the fire and quickly realized what we had done to her. I spent that entire eve-ning back home, waiting in dread for the phone to ring.

There was never any doubt that Winnie was watching. Once, while walking home from the Huntsville Memorial Arena, which stood on flat ground near the river—stick slung over shoulder, skates tied and hung over stick, duffel bag full of sweaty hockey equipment hanging off the stick like a hobo's belongings—I saw her hobbling in her slightly arthritic way along Centre Street. Our trajectories were in line for a confrontation, so I slowed down, the way someone on a portage might slacken their pace on sighting a bear in the distance, but she saw me and called me over.

She was smiling, her rather yellowed teeth surprising in their wel-come, and she asked me if I'd just come from a game. I had. Since it was Saturday morning, the squirts on the town all-star team had been allowed to play with the peewee house league, even though we were one age level below—eight- and nine-year-olds playing up against ten-, eleven- and even some twelve-year-olds.

"You're doing well with your hockey," she said.

I mumbled something, surprised she would even recognize me, let alone know that I was on the travelling squirt team that was sponsored by the town doctors and went by a sports moniker you could never even imagine in later years: "The Pill Rollers."

She removed a glove, unclasped her large, black purse and fumbled about inside until she pulled free a roll of clippings from the weekly Huntsville *Forester*.

"You're quite the little goal scorer, aren't you?" she said, unfolding the clippings in her hands so I could see they were the same weekly sports roundups I so carefully pasted into a red scrapbook each Thursday after the *Forester* came out. (One entire page of that scrapbook was devoted to my practising a spectacular variety of autographs that no one would ever seek.)

"Thanks," I mumbled.

"One day you'll be in the NHL," she predicted, quite inaccurately. Still, it was the nicest moment I ever recall having with her. As I remember it, she reached out and tousled my head, but surely imagination has pasted that one into the scrapbook too.

We used to "hitch" outside her home. It had nothing to do with her but everything to do with the intersection of Minerva and Centre. In winter, cars had to come to a full halt at the stop signs on Minerva before pulling out onto Centre and gunning the engine to make it up the steep hill heading toward the town line. In winter, this meant spinning tires, even if they had chains on, and since this was in the days before the streets were salted, a fresh snowfall would leave the backstreets smooth, hard and slippery until the sander got around to them.

My two best friends, Eric Ruby and Brent Munroe—my accomplices in the paper bag caper—would hide with me in the bushes near the taxi stand and wait until a car slowed at the corner. Fresh snow also meant snow-covered windows, something that drivers rarely bothered to brush off apart from a large enough peephole in the windshield. We would hurry to the back of the car and crouch down, holding fast to the back bumpers. We wore mukluks (grey leather winter moccasins with no tread), and they slipped effortlessly over the smooth surface as the cars— especially those with jangling chains wrapped around the rear tires— picked up speed. We'd hitch up the hill to Florence Street and then catch rides back down on cars that had to slow for the stop signs on Florence. Halfway down the hill, we'd let go and see who could skid the farthest, sometimes covering several blocks on the long hill—three kids sitting happily back on their heels as they flew down the hill at forty kilometres an hour or more. If another car was coming fast up the hill, the wise thing to do was bail out into the opposite snowbank.

Brent and I bailed just this way one dark evening, and when I crawled back out of the snowbank I was struck right across the side of my

head by Winnie Trainor's umbrella. She'd been watching from her kitchen window and had dressed and come out to put an end to such "nonsense." She hit me once, twice, and as I crouched, continued to beat on my back with the big, black, still-furled umbrella, pausing only to whack Brent a couple of times as he dived and slid on his mukluks out of reach and quickly slipped away into the dark night. *"Your mother is going to hear about this, young man!"*

But I was smarter than Winnie. I raced home, in tears, and immediately confessed everything before Miss Winnifred Trainor could call, naturally blaming most of the sorry episode on Brent.

But Miss Trainor proved to be even smarter.

The phone never rang.

I have spent half a century trying to square the Winnie I knew slightly with the Winnie I could know even less—the young Winnie who fell in love with Tom Thomson and, I have to believe, with whom Tom Thomson fell in love. That the two Winnies seem so different should come as no surprise, as I myself am much different from who I was as a boy, when she died. I carry this image of her as dark, large, sharp-tongued, eccentric, to be feared, yet capable of great charm and surprising humour when she chose to deploy those characteristics. I have sought out the few available photographs of her as a young woman: tall, slim of waist; perfectly erect; a smile teasing her lips; high cheekbones; soft, dark eyes that seem to challenge and welcome the world at the same time, the barely tamed dark hair. There is no hurt yet in those eyes: these photographs were all taken before the summer of 1917. Yet in knowing what was to come, it is impossible to look at the pictures of young Winnie and not feel great sadness for her.

In 1961 Winnie Trainor fell ill again and Dr. Pocock sent her to a local internist, Dr. Lynn Sargeant. Sargeant wrote to Pocock on August 16th, reporting on the health of "Miss Winnifred Trainor (age 76)." He called

her a "friendly, elderly lady" who was seen in the small Huntsville hospital in mid-July. She was given a full battery of tests, and Sargeant reported back that she was overweight at 170 pounds and had a slight heart murmur but was otherwise fairly healthy. She was taking medication to control her high blood pressure and also to help her sleep. As her late sister, Marie, had suffered from diabetes, Winnie was tested and found to be diabetic as well, but the condition was nothing that could not be "controlled quite nicely" through prescription.

In the fall of that year, a quiet burial took place at the Trinity United Church Cemetery. Little Cora Shay was laid to rest. She had been living in Chatham with her sister, Florence, and had come down with pneumonia. Nothing was said of Princess Coritta or the miniature train or the performances before royalty. Cora was described as the daughter of an original pioneer, Allan Shay. If the newspaper knew of her glorious past, it said nothing. Most likely, she had simply been forgotten.

On March 14, 1962, my mother took a long-distance telephone call from North Bay. Her father, former chief ranger Tom McCormick, was dead at seventy-eight from a stroke. I was thirteen, perhaps the worst possible time to understand the death of someone who had always seemed so indestructible. His many grandchildren saw him as both a god and a good friend—a man who, in uniform, commanded the respect of everyone he met but who, out of uniform, had a child's gift of absurdity. Even into his seventies, he could hike all morning through the park trails, split wood all afternoon and still be available for play in the evenings. His death stunned us all. The funeral was held at All Saints' Anglican Church in town, and the Department of Lands and Forests sent six uniformed rangers to serve as pallbearers. They saluted his coffin. I do not know if I have ever been so proud.

On August 12, 1962, the world went into shock as it learned that the Soviet Union had successfully launched the "Soviet Space Twins": Major Andrian Nikolayev, in *Vostok III*, and Lieutenant Colonel Pavel Popovich, in *Vostok IV*. They were travelling so close they could see each other, the two spaceships whipping around the world every eighty-eight minutes.

Back on earth, Winnie Trainor's world came to a complete stop. She had suffered a stroke and been sent to the North Bay hospital by Dr. Pocock, who regretted that he could not accompany her and oversee her treatment. While there, she suffered a massive stroke and died. Again, my mother got the news by telephone. No wonder she was forever wary when answering a long-distance ring.

What he viewed as his failure to be there for his friend continued to haunt Dr. Pocock. But his circumstances were difficult too: his wife was in the last stages of the cancer that would kill her. "Another doctor cared for her [Winnie's] terminal illness," Pocock wrote to me. "I have always been very sorry for the circumstances that denied me my chance to be of help to her, because I shall never forget this remarkable woman and most loyal and lovable friend."

"There weren't very many at her funeral," Jean McEown remembered. "We were pretty upset to think that for a woman who'd lived in this town for so long and knew so many people that so few would turn out."

The *Forester* ran her obituary in the August 16, 1962, edition. It mentioned her time at Huntsville Public School and at the business academy in Lindsay. She had worked as a bookkeeper at Tudhope's grocery store halfway down Main Street on the north side, the obituary continued, and then at Stephenson and Anderson's Store farther up the street on the same side. From 1918 to 1931, she'd worked for Shortreed Lumber Co. in Kearney, Ontario, as secretary and bookkeeper. "Her summers were spent on Canoe Lake in Algonquin Park."

Not a single mention was made of Tom Thomson.

Her will, dated January 2, 1957, was simplicity itself. Dr. Wilfred T. Pocock would serve as executor. Annie Winnifred Trainor left everything—Minerva Street property, Canoe Lake cottage, Tom Thomson sketches and all contents of the buildings—to her youngest nephew, Terence Trainor McCormick, then married and a college science teacher in Binghampton, New York. Provision was made in the will for an annual floral offering for the altar at All Saints' Anglican Church in honour of her parents and herself, a tribute that continues to this day.

Terry McCormick retired from teaching and still lives near Binghampton. It is believed he has, over the years, put most, if not all, of the inherited sketches on the market. His family continues to cottage at Canoe Lake in the old Trainor cabin.

The settling of Winnie's estate, however, was not as simple as she would have wished. Dr. Pocock felt he should have been included in the distributions of her property, perhaps given one of the sketches he said he could have had at any time previously. He said she had several times offered him sketches as a gift but that he'd never taken her up on the offers. He was quite surprised to have been left out of the will. He said she had not always paid her medical bills to him and so owed him money at the time of her death. It angered him that everything went to Terry and nothing to him.

"She said, 'Never mind,' he told me a decade later, "'even if I do owe you a whole lot, I'll look after you in my will.' But I guess she was too sick to ever bother. And Terence never bothered. Terence should be thankful that I did nothing to support her intention to change the will in one of her moods."

Upset as he was by the contents of the will, Pocock nonetheless served faithfully as her executor. The legal details were handled by Douglas Bice, Kearney trapper Ralph Bice's son, who later became a provincial court judge. Once the bills had been paid, Pocock said, there was about $1,000 left in cash. He battled her heir for that amount, and according to Pocock, they settled for "about $500." By the end of the proceedings, he had grown quite bitter about the financial reckoning.

Terry gave some of Winnie's clothing and a couple of photographs of his aunt to the town museum, and they were later switched over to the Huntsville Pioneer Village, now known as the Muskoka Heritage Centre.

The following summer, 1963, Terry and I spent weeks cleaning out the old Minerva Street home. As previously mentioned, some of the furniture was sold off but the greatest part of the contents—yellowed newspapers, old magazines, trinkets from Winnie's few trips—ended up being taken to the town dump. We also emptied out the shed on the

Centre Street edge of her large town property, known as "the barn." Again, apart from a few keepsakes and some items taken to the town museum, most were tossed.

The Canoe Lake cottage was cleaned up but few things from that property were thrown away. Terry, who now had the Thomson sketches, returned to his home in upstate New York and said very little in the subsequent years to those who showed interest in the Tom Thomson story and, by extension, the untold story of Winnie Trainor. When William Little was doing research, he contacted Terry, who indicated that his aunt had been engaged to Tom Thomson. He also said there were letters to prove this, but Little did not see any actual correspondence.

In the end, we are left with an image of Winnifred Trainor that is woefully inadequate. The "Winnie Trainor" photograph that has been presented as her so many times—the one certain biographers have even used to imagine what she might have been thinking—turns out to be of some other woman we cannot trace. And where are her letters—or at least those that were not, as she said, lost in a fire? And given the times, even if we had letters, would they even hint at anything that might or might not have taken place that long winter she and her mother spent "with friends near Philadelphia"?

What would she have said when she promised to "tell all" in that letter written so long ago to Tom Harkness, Tom Thomson's brother-in-law and executor?

And why did the Thomson family quickly shut her out after they had so willingly taken up her offer to arrange the exhumation? Why did the Thomsons never make an effort to contact her to discover what she had to "tell"—if only they could meet face to face? Why did some of them later feel they had to brand her as mentally unstable and invent a nonexistent "guardian" as proof of her not being in her right mind when, according to all available evidence, including my own memories of her, she remained very much in her right mind to the end of her long life?

And beyond the Thomson family, why did the great art patron, Dr. MacCallum, refuse to listen to Daphne Crombie when she went to him knowing what Annie Fraser had told her about Tom Thomson's demise and the possibility of a child being left behind? Why did Thomson's artist friends, the future Group of Seven, fail to seek answers to the questions that had been raised in the Canoe Lake community from the moment Thomson's body had surfaced? Instead, they chose to embrace J.E.H. MacDonald's silence for one and all. They always acted as if they were protecting their friend, but it seems they were also protecting their own reputations—and in MacCallum's case, his investments as well.

Tom Thomson left behind few letters of his own, but he did leave us his paintings, vivid portrayals of a beauty he saw that others did not, but that now all Canadians are able to enjoy. He left behind his friends and the stories they told, as well as the ones they could not or would not tell. And he left behind a mystery that, thanks to the passage of time and the passing of all connected individuals, is more compelling today than ever.

Winnie Trainor left behind a sad and tragic life story that can be only partially pieced together and must be largely imagined. She was the eccentric woman so many, including many of her relatives, preferred to avoid when possible. She was the lonely old woman who died alone, to whose funeral almost no one came. But she was also the young woman who might once have believed that she had everything she would ever want. And then lost almost everything. She lost the opportunity to marry and have a life she had only been dreaming of until she met and fell in love with Tom Thomson. She might or might not have lost their baby. She lost the paintings to which she might have had a legitimate claim or at least a partial claim.

We do have one letter from Winnifred Trainor that remains to this day—containing the single most revealing thing she ever had to say about Tom Thomson and herself. Harry Orr McCurry of the National Gallery in Ottawa had contacted her, politely inquiring about her relationship with the famous artist. Usually, she would never even have acknowledged such a request, but in this case she decided to answer McCurry.

"I do not know what to write," she began, "as Tom Thomson was the man that made me happy then vanished. If I saw you I could say things that I will never write—His friendship to me was as true as ever when he went on to the great beyond—I still have his small pictures (gifts)—and what I gave up for him I should have had some of his others—but I was not treated fair, and had nothing to do with his death—now my time will soon be in too."

She never did get to say the things that she would never write.

And yet, in this one ninety-three-word paragraph, she said it all.

NINETEEN **ICON**

"Someday they will know what I mean," Tom Thomson said not long before his untimely death in the summer of 1917. But even in the painter's wildest imaginings he could not have guessed what "someday" would bring.

Perhaps no one saw the future as clearly as his sister Minnie Henry, who wrote to her aunt Henrietta Matheson, who was still living in the Thomson family home in Owen Sound, two weeks after Tom's body had been found. "I can see you yet stroking his hair when he was only a growing lad," Minnie wrote, "and you always had such hopes that he would do something great and as usual you were right. He not only did great things, but he lived such a big grand life."

Bigger and grander than even his aunt had dreamed. Thanks largely to Dr. James M. MacCallum, the self-appointed "patron" of the late Tom Thomson, sales of Thomson's works continued on, though hardly with the wild fanfare that would mark each sale nearly a century on. "I'm only a bum artist, anyway," Thomson supposedly once said to MacCallum,

but MacCallum would prove critical to ensuring that no one else would ever dare suggest, let alone reach, such a conclusion.

First came the buffing of the then-unknown Tom Thomson persona, and it began in the fall of 1917, when Tom's friends constructed the cairn at Hayhurst Point and Jim MacDonald inscribed those poetic words on the bronze plaque: ". . . He lived humbly but passionately with the wild. It made him brother to all untamed things of nature"

To those more familiar with life in the bush, Thomson would have seemed more than adequate in the wild and eager to learn, but there were others who—perhaps through envy, perhaps because they disagreed with a lifestyle that seemed to them to be based on work avoidance— openly disparaged his skills with paddle and fishing rod. My own sense is that he was just fine as a woodsman and, by comparison with others moving about Algonquin Park in those years with canoe and backpack, he was an excellent swimmer. Many park visitors could not swim at all.

Still, there was a romancing of Tom Thomson, some justified, some strained, that continues to this day. One of the most familiar photographs of the artist—which appears on the cover of this book—is often identified as Thomson "tying a fly" when, in fact, it is clear to anyone who has done much fishing in this part of the country that he is merely attaching a heavy trout lure, known as a "spoon," to his line. Fly fishing, with its artistic swirls and its own poetic language, is much more esoteric than simply dropping a weighted, triple-hooked, metal lure off the back of a boat or canoe and hauling it about the deep waters in hopes of a strike. Fly fishing, however, which lends itself magnificently to the cowslip-shouldered streams of Britain and the wide, shallow rivers of Atlantic Canada, is largely a futile exercise. The small hooks of flies that must be tossed back and forth would become hopelessly tangled in the tangle of vegetation that encroaches on Algonquin waterways and surrounds the deep lakes where the lake trout hide. Had Norman Maclean been writing about trolling, rather than fly fishing, in A River Runs Through It, it's doubtful that he would ever have found a publisher—and unimaginable that Robert Redford and Brad Pitt would have turned the book into a classic movie.

But once the wilderness hagiography of Tom Thomson was launched, it was soon set in stone as surely as MacDonald's fanciful words on Hayhurst Point. The rather condescending full-time guides and rangers thought Thomson showed "average" ability as a canoeist and fisherman, and this would have been a generous and inclusive compliment to a man who spent his winters back in the city. But there was never a chance that he would be regarded by most as simply average. "He knew the woods as the Red Indian knew them before him," F.B. Houser wrote in *A Canadian Art Movement: The Story of the Group of Seven,* published nine years after Thomson's death. The myth was already well under way.

Arthur Lismer, writing in the *McMaster Monthly* in 1934, called his late friend "the manifestation of the Canadian character." A decade after Lismer's comment was published, Lawren Harris claimed, "There was nothing that interfered with Tom's direct, primal vision of nature. He was completely innocent of any of the machinery of civilization and was happiest when away from it in the north." Eighty-five years after Thomson's death, this mythology was put into perspective by artist and curator Andrew Hunter in the lavish 2002 art book, *Tom Thomson,* which accompanied a major Thomson exhibition presented by the National Gallery of Canada and the Art Gallery of Ontario. The myth, Hunter said, was so carefully groomed by all that everyone eventually bought into the notion that Thomson was "untrained, at one with nature, innocent."

The artistic legend had taken hold as early as 1930, when the renowned artist David Milne, himself a Canadian infatuated with the landscapes of the North, suggested that Canadian art "went down in Canoe Lake. Tom Thomson still stands as *the* Canadian painter: harsh, brilliant, brittle, uncouth, not only most Canadian but most creative. How the few things of his sticks in one's mind."

By the time Milne was writing, Canadians had become familiar with the Group of Seven—particularly the work of Jackson and Harris—and most references to the Group included some mention of the darkly handsome young artist who took them north and who lost his life there before he himself could find the fame and success his friends were now

enjoying. In the November 11, 1933, issue of the *Toronto Daily Star*, a comparison was made between Thomson and a play appearing at the Royal Theatre, *The Late Christopher Bean*. Bean had been a real-life New England artist who'd painted village scenes and became famous only after his demise, when his suddenly valuable paintings were found hanging in hen houses and barns.

"An enterprising playwright who thinks Chris Bean is a great play," suggested the *Star* critic, "might try his hand at Tom Thomson for a better one."

The newspaper account then went on to talk far more about Thomson than Bean, telling readers that Vincent Massey—long before he became Canada's first Canadian-born governor general—owned Thomson's famous *West Wind*. The story also included an account about the unidentified writer meeting with a "hotel-man" at Algonquin Park's Mowat Lodge, who had "several of Thomson's finest little pictures" in his possession and had things to say about the late artist.

"They belong to me," the hotel man told the newspaperman. "Tom used to board here. He never had any money, because he never had enough business brains to sell his own pictures. He paid his bills in pictures. Quite a few of his paintings could be dug up around here, owned by people who boarded him on his lonsome [sic] expeditions. None of us knew how fine they were. We only knew that he had a knack of making this country look mighty wonderful in a picture. Yeah—there ain't a scene worth a brush around here that he didn't do something with. He was a darn nice fella, sociable and friendly, but he was one of the most mysterious men I ever saw in these parts—and I've seen a few."

The "hotel man" is obviously Shannon Fraser, though Mowat Lodge no longer existed. The quotes seem more like bad movie dialogue from the 1930s than anything accurately recorded by the article writer. Fraser, in fact, was known for his careful articulation and for rarely being caught without jacket and tie. Still, the contrived dialogue between the "hotel-man" and the newspaper reviewer communicated the notion of Thomson being romantic, rustic and, most of all, *mysterious*.

"I can think of no other modern Canadian, in any field of endeavour, who has been as obsessively invented and re-invented as Tom Thomson," says Sherrill Grace, author of *Inventing Tom Thomson*. "Louis Riel comes close as the hero of novels, poetry, films and an opera." But Tom Thomson, she believes, stands alone in the collective imagination of this country.

In *Inventing Tom Thomson*, Grace says the manufacturing of the icon began almost immediately after the artist's death. MacCallum, of course, was first off the mark with his fawning remembrance of Thomson's abilities in the art studio and the bush. But Grace dates the true launch of Tom Thomson's iconic image to the work of Blodwen Davies. Davies' first effort, a slim pamphlet called *Paddle and Palette: The Story of Tom Thomson*, described a possessed painter and bushman "who lived like a priest tending to the fire in his own soul."

In 1935 Davies' self-published biography appeared, *A Study of Tom Thomson: The Story of a Man Who Looked for Beauty and Truth in the Wilderness*. Winnifred Trainor is not mentioned and either was never interviewed or refused any involvement. But Davies made plenty of suggestions about the possibility of foul play. Until his book was published, it had been generally accepted that Thomson had "drowned," which suggests he'd died by accident. There were the rumours, spread mostly by Shannon Fraser, that he had committed suicide, but nothing much was made of such talk beyond the private outrage of the Thomson family and Tom Thomson's artist friends. Davies asked questions and received answers from most of those directly involved, from Ranger Mark Robinson, who had led the search, to the doctor who'd examined the body and the coroner who'd held a short inquest without seeing the body—and she emerged from her research "with the conviction there had been foul play."

From this point on, Tom Thomson was always seen as both artist and mystery, each image feeding off the other. The mystery made the

artist more compelling, more saleable; the artist made the mystery more intriguing, more romantic. Soon enough, the mystery side of Tom Thomson had *become* part of the art. The two essential elements of Thomson were inseparable.

The influential *Canadian Forum* put its stamp of approval on the mystery in its March 1941 issue. "[I]n Canadian history," the journal declared, "the sphinx of the unknown land takes its riddle from [Simon] Fraser and [Alexander] Mackenzie to Tom Thomson." Thomson, in other words, stood with the great explorers when it came to knowing the country, even though he himself had seen so very little of it. "In several pictures," the journal continued, "one has the feeling of something not quite emerging which is all the more sinister for its concealment . . . What is essential in Thomson is the imaginative instability, the emotional unrest and dissatisfaction one feels about a country which has not been lived in; the tension between the mind and a surrounding not integrated with it." It would be years before literary scholar Northrop Frye would make his famous pronouncement that the fragile Canadian imagination held "a tone of deep terror in regard to nature"— a rather contentious issue, I would argue, but it may well have been that Frye was trying to envision what lay beyond the frames in some of Thomson's works when he came up with his theories about the "garrison mentality."

When it came to Tom Thomson, Frye considered nature a demanding, devouring female, suggesting that "when she was through with him . . . [she] scattered his bones in the wilderness." While the great biblical and literary scholar richly deserves the praise he gained in his lifetime, the experience of nature and the affectionate relationship most Canadians have with it was beyond Frye's ken. City-born and city-bred, he suffered so badly from hay fever that he avoided the outdoors whenever possible. "The Lord's work for me," he once wrote in his diary, "is sitting still in a comfortable chair and thinking beautiful thoughts, and occasionally writing them down." Frye's notion that nature, the insatiable woman, destroyed Thomson, nature's dedicated lover, might be

an entertaining thought to pass through a head—but perhaps not one to be written down by a hand.

The Tom Thomson we know today—dark, mysterious, brilliant, a lover of nature and romantically tragic—was largely born in the 1960s. It was a time of great awakening in the country. Canada acquired a new flag in 1965; 1967 was the year of the Centennial celebrations; 1968 brought a canoeing, buckskin-wearing prime minister who captured the imagination of youth and the attention of the world. It was a time of enormous romance in music and lifestyle. Thomson, with his bare-essentials pack, his love of the wilderness, his supposed pacifism and, of course, his attractiveness all led to instant interest in his art and the enduring mystery.

"Which was the real Tom Thomson?" asked Jim Poling, Sr., in his short 2003 book, *Tom Thomson: The Life and Mysterious Death of the Famous Canadian Painter*. "A sunny new-century artist eating the best fare offered at the Arts & Letters Club in what was then the country's second largest city? Or the brooding woodsman dressed in fishing clothes and boiling water on the portage to Tea Lake. He was probably both. Most of us have two different sides, and Thomson's are exaggerated by the exasperation of people who want to know more about him but can't because his time in the spotlight was so brief and so long ago."

The public did indeed want to know more about him. And it seemed that the more time passed, the more interest he held for Canadians. The National Film Board and the National Gallery had produced a film about Thomson in 1944: *West Wind: The Story of Tom Thomson*. But it was little more than war propaganda, dwelling on Tom the "good Canadian" and avoiding anything contentious. In 1969, however, the CBC produced its documentary *Was Tom Thomson Murdered?*, narrated by Thom Benson, which was based largely on research by Judge William Little, who would publish his book *The Tom Thomson Mystery* a year later. The CBC film, using re-enactment scenes, would leave no doubt that Thomson had been murdered. The only remaining question was:

By whom? When Little's book appeared, there was a flurry of publicity that served only to heighten interest, including an October 1970 appearance by the judge on the CBC's popular *Front Page Challenge*. Little told panelists Pierre Berton, Gordon Sinclair and Betty Kennedy that the only way to solve the issue was to open the family plot at Leith and establish, once and for all, whether Thomson had indeed been buried there. Little said that he had finally convinced George Thomson, Tom's older brother, that there were now "enough grounds to warrant an investigation"—but, Little added, George Thomson had unfortunately passed away before he could gain the permission of others in the family. (And the Thomson family today, it should be noted, is not convinced that George would ever have agreed to such a thing.)

Little's book did much more than Blodwen Davies' work to convince the general public that there had indeed been foul play at Canoe Lake in the summer of 1917. His was a national bestseller; hers, a self-published book with limited sales.

Little's "circumstantial evidence" (as he himself called it on *Front Page Challenge*) pointed strongly, he believed, to Martin Blecher, Jr., as the main suspect, though the passing years have seen Blecher's name move somewhat down the list of potential murderers. He firmly embraced nearly all that was said in Mark Robinson's rambling 1953 interview, in which certain incidents and descriptions appear to contradict Robinson's own journals of 1917. Little compiled his book in an unconventional manner—using letters, long appendices and even "simulations" to recreate such scenes as the dubious coroner's inquest. And while his work was clearly popular, not everyone was impressed. Sherrill Grace eventually came to believe that "Little appears not to have solved the mystery, but to have further complicated it."

Little's book had barely moved to paperback when Charles Plewman, the pallbearer, suggested in an interview with the Canadian Press that Tom might have committed suicide because he was under pressure to marry Winnie. Plewman said he already had "one foot in the grave—so I thought I should throw more light on the situation." He was, in fact,

throwing gasoline on the fire Little and the CBC had ignited earlier. Yet the various suggestions that came out of the TV documentary, Little's book and Plewman's interview had a far different impact in the late sixties and early seventies than such talk would have had around the time of Thomson's death.

In 1917 the artist's reputation would have been deeply tarnished by the notion that Tom had jilted a woman he was to have married, or worse, had abandoned a pregnant girlfriend. But such talk now merely added a salacious dividend to a mystery that was growing larger and more intriguing as the years went by. Public interest in Tom Thomson's life and death now matched public appreciation of his art. They were, from this point on, intrinsically connected.

Not all members of the public found the new speculations fascinating. The insinuation of pregnancy, however carefully couched in vague words, threw Winnifred Trainor's still-living friends into a fury and led to an outraged letter to the editor, published in both the *Toronto Star* and the Huntsville *Forester* and signed by scores of citizens who had known her. "Who'd have said that to her face when she'd be alive?" her longtime neighbour Minnie Carson asked in 1973. "There was never any thought of such a thing from any of the people around here then."

The letter did nothing, of course, to stop the speculation. If anything, the mystery merely took on a more romantic and tragic edge.

In 1976 the first full-length movie on Thomson appeared. Called *The Far Shore*, it was the creation of well-known Canadian artist Joyce Wieland. Magnificently photographed by legendary cinematographer Richard Leiterman, it suffered from a weak script, poor acting and, in an odd way, the times. The 1970s in Canada were characterized by a desire for independence from the industrial powers of America, the rise of feminism and the continuing conflict between French and English—and all three of these themes were crowbarred into the story. Though the main character was called "Tom McLeod," played by well-known Canadian actor Frank Moore, there was no doubt who it was supposed to be: McLeod was even filmed painting Thomson's *Jack Pine*.

In the most memorable scene from the movie, McLeod/Thomson and Eulalie/Winnie make languid love in the waters of Canoe Lake—a symbolism that would surely have delighted Northrop Frye. Yet for reasons that only she could know—Wieland died in 1998—the filmmaker chose to focus as much on the suppression of Quebec culture by an overbearing English Canada as on the simple love story. There had been no conflict between French and English at Canoe Lake, as the only French blood would have been in the genes of a few Métis guides, whose forefathers had lost their first language, and the odd bushworker and cook at the surrounding lumber camps. Wieland also insisted on putting a stunningly long chase scene into the movie—featuring canoes—and though she later said it was meant as a satirical tribute to the old-style silent movies of the time, complete with pounding piano, it came across only as ridiculous, especially when characters stopped to take quick energy slugs out of their whiskey flasks. It had no feeling for the Canoe Lake of Thomson's time or, for that matter, of any time.

Of far greater significance to the expanding world of Tom Thomson was the publication, in 1977, of Harold Town and David Silcox's extravagant coffee-table book *Tom Thomson: The Silence and the Storm*. The then pricey book—$29.95 to the end of the year, $42.50 thereafter—held 177 full-colour reproductions of Thomson's work, with art commentary by the flamboyant Town, himself a well-known Canadian painter, and a lengthy biographical treatment of the subject by Silcox.

The book was to accompany a major upcoming exhibition of Thomson's work, and the story of its production was itself worthy of a chapter. Publisher Jack McClelland was so concerned that his expensive coffee-table production might be usurped by another Thomson book by Joan Murray, who had already written extensively about the painter, that for years McClelland & Stewart kept the research, writing and periodic payments under a code name: "The Terry Thomas Cook Book." Researcher Iris Nowell was sent out into the field to gather material somewhat covertly, while Town and Silcox spend a great amount of time working on the text at Town's Peterborough-area farm. A close neighbour, Orm

Mitchell, an English professor at Peterborough's Trent University and the son of distinguished Canadian author W.O. Mitchell, often visited. The beloved author of *Who Has Seen the Wind* also came by once and saw a proof of the spectacular cover. Town proudly announced the sub-title would be *The Silence and the Storm*, and the elder Mitchell shook his head saying, "A little purple, isn't it?" Purple or not, the book went on to become a major national bestseller and has been reprinted several times in the more than thirty years since it first appeared.

The lasting legacy of the sumptuous work should have been the glorious reproduction of so many paintings and the addition of numerous found photographs taken by the painter—including one misidentified as "Winnie Trainor," in which Town describes her as showing "the bony angularity of Katharine Hepburn." But equally memorable was Town's bizarre dismissal of Thomson as a "bore," so far as personal life went, when he was interviewed on CBC radio during the book's promotion. It was also suggested in the book that Thomson died while standing up in his canoe to relieve himself.

Town and Silcox's book once again increased the public's appetite for Thomson's work—and for the story of his life and death. On any day at Ottawa's National Gallery, it is possible to see people standing in awe before Thomson's well-known work *The Jack Pine*—almost as if they had just encountered a familiar celebrity. The gallery was quick to purchase the painting in 1918, when, through MacCallum, gallery director Eric Brown was able to arrange the purchase of more than two dozen Tom Thomson originals.

Many of those works are but sketches, what some would see as the poet's rough copy of the great verses to come. But to think this about Thomson is to do him a disservice. His great works are his small ones, quickly dashed off while fighting everything from frostbite to mosquitoes, a moment captured that, in fact, cannot be improved upon by enlargement and time.

Silcox believes Thomson's sketches are "the only true indicators of his achievements as an artist." He found Thomson's large works

"over-painted and ponderous." His small, nearly instant works, on the other hand, held a promise that was sadly never fulfilled. "When he died," writes Silcox, "his work only just begun, a definition of Canada that might have told us who we were died with him. Our coming of age as a country had to be rescheduled."

The Jack Pine and the sketches remain on permanent display at the National Gallery, but the Tom Thomson story seems in a near-constant state of change. Every few years, something new is added to the growing legacy. A 1986 *New York Times* article by Joanne Kates, who herself has deep Algonquin Park connections, quoted Arthur Lismer calling Thomson "a sort of Whitman, a more rugged Thoreau if you will, but he did the same things, sought the wilderness, never seeking to tame it but only to draw from it its magic of tangle and seasons."

A more rugged Thoreau? Who could resist? Given the increasing connection between Thomson's lifestyle, his mysterious death and his lasting landscapes, "it was as if," the critic Robert Fulford wrote, "he had disappeared into one of his own pictures." Tom Thomson, artist, would soon become the stuff of stage productions, Sherrill Grace listing among the many productions Jonathan Welsh's *Letter to the West Wind* (1980), Bryan Wade's *Breakthrough* (1986), Geoff Kavanagh's *Canoe Lake* (1997) and Jim Betts's *Colours in the Storm* (2000). Betts's play, which I saw in Muskoka one summer evening, made much of Winnifred Trainor's role in the story, setting the scene in 1957, on the fortieth anniversary of Thomson's death.

Tom Thomson also began showing up in poetry, from bad long narratives to the works of such celebrated Canadian poets as Dennis Lee and Robert Kroetsch. Kroetsch's "Meditation on Tom Thomson" opens with:

Tom Thomson I love you therefore I apologize
for what I must say but I must say
damn your jack pines they are beautiful

Thomson has been the subject of art projects by Joyce Wieland and by Andrew Hunter. He has appeared in numerous short stories, including Barbara Smith's "Tom Thomson and Winnifred Trainor" in *Passion and Scandal: Great Canadian Love Stories*, in which Winnie's pregnancy is an issue. In "Have You Seen Tom Thomson?" by Wayne Wright, Winnie Trainor appears again, but this time as an exquisite ghost in search of her lost love. Thomson is even the subject of children's books: Larry McCloskey's *Tom Thomson's Last Paddle* and Patrick Watson's *Ahmek*, a tale narrated by a Canoe Lake beaver and featuring an illustration by Thomson's great-grandniece, Toronto artist Tracy Thomson.

Every year seems to bring another article, perhaps a book or two, a new documentary (the most recent being *Dark Pines: A Documentary Investigation into the Death of Tom Thomson*, directed by David Vaisbord and produced by Ric Beairsto). The popular Canadian rock band The Tragically Hip included Thomson in a popular song ("Tom Thomson came paddling past / I'm pretty sure it was him"). And Canadian folksinger Ian Tamblyn even wrote a song ("Brush and Paddle") that dovetails perfectly with Sherrill Grace's theory that this country is forever reinventing the artist:

> Brush and paddle—stroke by stroke
> The northern rivers of your public schools
> I was seen down every hall
> Can you see me clearly now?
> I come to you alive as any colour ever splashed upon a canvas
> The promised greens of springtime,
> the threatening grays of fall Algonquin
> There seems so little time to paint it all . . .
> . . . I am your invention
> I am your great need
> And Thomson—why Thomson is my name.

Sometimes the various "inventions" take unexpected twists. A 2009 exhibition by Winnipeg multimedia artist Diana Thorneycroft at the McMichael Canadian Art Collection in Kleinburg used Tom Thomson and Group of Seven backgrounds to poke a little fun at—some would say "ridicule"—the artist legends. The show, called "Canada, Myth and History: Group of Seven Awkward Moments," included twenty-two thematic photographs, including one of *Saturday Night Live* hosers Bob and Doug McKenzie drinking beer and barbecuing with Thomson's *Early Snow* as a backdrop. Another used Thomson's famous *Jack Pine* as backdrop to a camping scene in which two plastic toy men are seen in embrace inside a tent while another toy man stares from behind the rocks, Thorneycroft's "awkward moment" suggesting that Tom Thomson was murdered by a jealous boyfriend.

The effect of all this attention, of course, has been to make Thomson increasingly famous in his own country. Like countless other cultural flames that seem to have been extinguished far too quickly, the afterburn has become even brighter with the passage of years.

The ever-increasing fame at home also had its international effect, highlighted by an exhibition of Thomson's work at the famous St. Petersburg Hermitage in the fall of 2004. Russian critics raved about the fifty-eight works that were sent—including *The West Wind* and *The Jack Pine*. A review in the daily *Vedomosti* said the first thing visitors would notice "is that the landscapes of the founder of Canada's national artistic school have much in common with our own masters of the Russian landscape." Another reviewer said the scenes felt so familiar to Russians that "[p]erhaps this is why we feel such a bond with this work." Yet another, writing in Moscow's daily *Kommersant*, thought the easy comparisons not quite right. "Thomson's gloomy, slightly wild-eyed vision is alien to the formal, academy-trained landscapes of our Russian painters," wrote art critic Kira Dolinina. "Thomson represents the unique national artistic heritage of a still very young country, Canada."

Canada was indeed "young" when he painted—Thomson died on the fiftieth anniversary of Confederation and in the same year as Vimy

Ridge, the World War I battle that is so important to Canada's history. By the country's Centennial year, 1967, Thomson had become an icon in a former colony that was now flying its own flag. And by the start of the twenty-first century, his "unique" art was more prized than ever. In late May of 2008, a small Thomson sketch, *Pine Trees at Sunset*, sold for $1,957,500 at a Sotheby's auction held in Toronto. That price beat the old record for a tiny Thomson sketch, set only six months earlier at a Ritchie's auction, when *Spring Thaw* sold for $1.46 million. A week earlier, his sketch *Tamarack Swamp (Sketch No. 5)* had sold at Heffel's in Vancouver for $1 million. Other Canadian paintings had sold for more, but these, remember, were sketches done virtually on the run, Thomson often working as quickly as he could because of the bugs. The oils were slapped fast onto boards smaller than a sheet of office stationery. "When it comes to bang per buck per square centimetre," wrote *Globe and Mail* critic James Adams, "he's the undisputed champ."

With such incredible sales for tiny sketches Thomson often gave away to people he barely knew, it today seems incredible that Thomson, self-proclaimed "bum artist," would ask little or nothing for his own work. He once contacted MacCallum to see whether his longtime patron might sell one of the little sketches he'd taken back to Toronto with him.

"If I could get $10 or $15 for it," Thomson wrote, "I would be greatly pleased—if they don't intend to put in so much, let it go for what they will give."

Just prior to the Sotheby's auction that saw one of those "$10 or $15" sketches go for nearly $2 million, Winnipeg-based art dealer David Loch suggested that "the legend of the man and romance of the story" have likely had as much to do with prices as the magnificent art itself. "He's really our van Gogh."

TWENTY JIMMY'S TRUTH

I still think often of little Jimmy Stringer sitting in that nine-dollar-a-night Empire Hotel room back at the end of March 1973. Yes, he had been drinking—polishing off that second bottle of $2.20 Brights President sherry—and yes, he might well have been pulling my leg, along with Tom Thomson's, when he claimed to have had the painter's shinbone back in the Stringer shed on Potter Creek at the north end of Canoe Lake.

But he said something that was inarguably true that day before he himself would drown in Canoe Lake when he broke through the ice and went down with his groceries. "The truth's still not told, Laddie."

The story of Tom Thomson and Winnifred Trainor is one of circumstantial evidence, missed opportunity, speculation, theorizing, wild guessing and, in the case of some who have become caught up in this tantalizing mystery, blind prayer that what they said might actually have been what happened. I myself may be guilty, though I have always tried to keep an open mind to whatever the truth may be, wherever it may lie.

And yet, over the years and decades, various pieces have fallen into place. Some have even fit together perfectly, while others have been forced together and yet others will apparently never find their place in the solution to this Rubik's cube of Canadian history, which seems forever just out of reach.

There have been pivotal moments that have changed the landscape as dramatically as if Thomson's own brush were still at work: Blodwen Davies' 1935 study, which first openly raised the possibility of foul play; the 1956 dig that initially raised as many questions as bones; the 1969 CBC documentary and William Little's 1970 book, which actually pointed a finger at a suspect, even if the wrong one; Daphne Crombie stepping forward in 1977 to say what Annie Fraser had told her about the events of July 1917 and the letters that suggested Winnie Trainor and Tom Thomson *had* to get married; the revelations from the Huntsville *Forester* "Personals" section that raise so many questions concerning the winter Winnie and her mother spent "staying with friends near Philadelphia" . . . I can hope only that within the pages of this book there is more to consider, perhaps even at times enough to persuade.

To state what may already be the obvious, here are some thoughts on what I believe happened:

Winnifred Trainor truly believed, or had been led to believe, that she and Tom Thomson were to be married. She was at an awkward age for the small-town society in which she lived—unmarried at thirty-four, a spinster whose only prospect was to spend much of the rest of her life caring for aging parents. So Thomson's arrival at Canoe Lake was the answer to her dreams if not her actual prayers. He was handsome, charming and single at thirty-nine; it was time for a man to settle down.

I have always puzzled over the attitudes of two men I knew well concerning Thomson. In all that was said about Tom Thomson early on—his good looks, his athleticism, his charm, his brilliant talent—he strikes

a heroic and highly attractive pose. Yet my grandfather Tom McCormick was so contemptuous of the man that he could barely bring himself to speak his name. The same was true of Ralph Bice, the legendary Algonquin Park guide and trapper. Both McCormick and Bice were cut from the same cloth: God-fearing, upstanding, hugely admired men who neither drank nor smoked nor swore. Bice claimed Thomson had girl-friends all over the park. Even Winnie Trainor's dearest and most loyal friend, Dr. Wilfred T. Pocock, said he had quickly learned of Thomson's reputation for "inveigling the women" once he himself arrived in the park not long after Thomson's passing.

Those two men—McCormick and Bice, who was something of a surrogate grandfather to the McCormick family—quite disliked Thomson for reasons they never spoke of. Was it simply because he drank? because he didn't appear, to them, to have a real job? because he kept various romances sparking about the Algonquin Park area and who knows where else? or because of something he had done to Winnifred Trainor, sister-in-law to McCormick's brother and close friend of the Bice family?

Did Thomson plan to follow through with the alleged promise of marriage? I suspect not. Winnifred Trainor's family and my own family were convinced that they were truly engaged, but there was no official proof and no ring exchanged. It was always said, as proof, that Thomson had booked "the honeymoon cabin" at Billie Bear Lodge, but there is no evidence of any such booking, even though Billie Bear lore maintains it did happen.

The key to Thomson's intentions, I suggest, lies in the camping equipment he shipped to South River under care of his friend Ranger Tom Wattie. It included a small, high-quality tent manufactured by Abercrombie & Fitch of New York, a sleeping bag, waterproof pants, a brand-new sleeping cot (still in the shipping box) and other camp-ing items.

The tent appears to be the one Winnie Trainor told the Thomsons that Tom had purchased in 1915. The camping gear had been quietly

kept by the Wattie family for decades and donated to the Algonquin Park archives in 1997 by Gord Wattie through his nephew Ken Cooper of South River. This intriguing information was not available to the writers and documentary makers who tried to unravel the Tom Thomson mystery in the 1930s, the 1960s and the 1970s. It fits, however, with the letter Thomson wrote in April 1917 to his brother-in-law Tom Harkness, saying, "I may possibly go out on the Canadian Northern this summer to paint the Rockies but have not made all the arrangements yet. If I go it will be in July and August." It may well be that Tom had no intention whatsoever of following through with any promise that might or might not have been made to Winnifred Trainor—or of following through with what would have been considered his "duty" to her if, in fact, a child truly was coming.

This is not to suggest that Tom had no feelings for Winnie. They did indeed get along and, obviously, shared a great many letters—though not necessarily all "boy and girl" notes as Ranger Mark Robinson believed. Winnie was good company for Tom when both were at Canoe Lake, and when he was travelling through Huntsville, the Trainors were friendly and inviting. They provided him not only with company, but also with meals and often accommodation—a boon for a painter with little money of his own. When Tom was at Canoe Lake and they were not, the Trainor cabin was a wonderful place in which to hang his sketches to dry. He often gave sketches as gifts to Winnie and might well have wished her to have some of the forty or so spring sketches that were removed from the Trainor cabin that day in July 1917, even before it was known what had become of the missing painter.

It may even be that Tom Thomson saw in Winnifred Trainor his future wife, but not just yet. He had places he still wished to paint. His life had a pattern—head for the bush in spring, paint in Toronto in winter—and he liked it fine. From his few letters and the accounts of those around at the time, he was in a happy state in the days before he went missing. Though his amazing spring output had a manic air to it—and I agree with those who say Tom was manic-depressive—I do not believe

he committed suicide, as Shannon Fraser claimed in the gossip he immediately began to spread after Tom disappeared. I do not believe he fell out of his canoe while taking a pee. I do not believe he was drunk and fell out of his canoe and drowned.

I do not even believe he was in his canoe when he died.

Daphne Crombie is pivotal to any understanding of what happened. I believe her to be as true a witness as she could be, given the passage of time. She was, of course, passing on information she claimed was given to her by Annie Fraser, and this raises the obvious question as to whether or not Annie was telling the truth. I believe Daphne, and I believe the Trainors' young Huntsville neighbour Brad McLellan in their respective claims that Winnie had written to Tom to say they had to get married and that the Trainors had asked that someone at Canoe Lake "teach Tom a lesson" for not living up to his commitment to Winnie. As a result of believing Daphne, I also have to believe Annie, since she would have derived no benefit whatsoever from confessing her husband's assault of Thomson and the subsequent attempt to cover up the result—because she portrayed herself as being an accomplice after the fact.

Daphne Crombie's memory of Annie Fraser telling her that the letters were pushing for marriage is surely accurate, though we do not know for certain whether Winnie was pushing Tom merely to live up to his word or whether she was pushing him because, as Daphne Crombie believed, "a baby was coming." All we have to consider is the mysterious winter of 1917–1918 that Winnie and her mother spent near Philadelphia. We know they stayed with "friends," perhaps relatives, but do not know the names. We know there were rumours spreading at Canoe Lake and Huntsville that there was more involved than an unfortunate drowning, yet though the content of the gossip is known, the reality remains, at this time, beyond grasp.

However, if there was indeed a pregnancy, then the rather hasty

Trainor family move to Kearney in 1918 fits. An unwed mother bore a stigma in 1917 that is next to impossible to appreciate fully a century later. That Winnie's mother was active in the local WCTU would have a bearing on the decision. That Winnie's father appears never to have set foot again in Huntsville until he was ill and dying is also telling.

Daphne said that Annie had told her that Shannon Fraser and Tom Thomson got into a fight. (She believed it was over money that Fraser owed Thomson.) Fraser, a big strong man, had struck Thomson a blow that knocked the painter down and into the fire, where his temple was punctured by a prong on the fire grate. Whether Thomson was barely alive or dead is not known, but Daphne accepted Annie's word that she had helped her husband dispose of the "body." She believed that Annie had helped pack the canoe, and perhaps had helped as well to attach a weight to Thomson's leg, and that Shannon had towed the canoe out into the lake and dumped the body.

Daphne was sure the fight had happened after the much-talked-about party at the guides' place, the one at which William Little claimed Martin Blecher, Jr., had issued his warning to Thomson to stay out of his way if he knew what was good for him.

If the fight happened after the Saturday night party, the Daphne Crombie–Annie Fraser version had problems. Mark Robinson claimed to have seen Fraser and Thomson walking on Sunday morning and said he had even overheard them talking by the Joe Lake dam about Tom wanting to play a trick on Robinson by catching a large trout elsewhere and then claiming it was the one from the dam area. Two others also claimed later to have seen Tom and Shannon together that morning. And, of course, Shannon Fraser said he had seen Thomson paddle off from the Mowat Lodge dock at exactly 12:50 on Sunday afternoon. He knew, he said, because he had checked his timepiece and remembered perfectly.

For a long time, I believed Fraser had made this up—being so utterly specific about the time—to cover for himself. But even if Fraser had concocted this "evidence," it still left the problem of Mark Robinson's sighting and the other possible sightings that Sunday morning. Robinson's

detailed description of the Sunday morning encounter first surfaced in a letter he wrote to Blodwen Davies in 1930, thirteen years after the event, and became even more descriptive in the long interview he did in 1953, when he was well into his eighties.

Certain details differ from the accounts in his daily journals of 1917, which I take to be far more reliable than his remembrances in old age. The morning he later claimed to have seen Tom Thomson and Shannon Fraser is written up in his journal as a cold, rainy morning, during which he, his son Jack and the station master, Ed Thomas, took a rail car to Source Lake to check out some cut timber that lay near the siding. It's possible, of course, that both incidents could have happened the same morning, but it's at least equally possible that they did not. Robinson was a hugely admirable man and a greatly respected ranger, but even his own daughter later said she herself wondered if he had recalled that Sunday morning accurately.

But even if he had not, what of the others? In an interview for the Algonquin Park archives in 1976, cousins Rose Thomas and Jack Wilkinson, who had lived in the park at the time of Thomson's death, claimed to have seen Tom Thomson and Shannon Fraser walking together that same Sunday morning. They were, however, claiming to recall an incident from sixty years back that would not have been remarkable in its time—Thomson, after all, was not then missing—and from when Rose was ten years of age and Jack, five. The vividness of this memory, and an additional vivid memory of the undertaker Churchill digging through the night, which they could not possibly have witnessed, strongly suggests they were recalling televised dramatizations of those events that had been aired only a few years earlier by the CBC. I cannot regard these two young children to be reliable witnesses.

And what of Shannon Fraser's time check?

What if Shannon Fraser was truthful about the time and about Tom paddling away? What if Tom was seen by several different people that

Sunday morning? The only sensible conclusion is that he could not possibly have been struck by Fraser late Saturday night and disposed of, as Daphne Crombie's tale seemed to suggest.

Thomson supposedly paddled away that Sunday afternoon and collected some gear at the Trainors' cottage. Not long afterwards, Martin Blecher, Jr., and his sister Bessie said they had seen a canoe floating but had not investigated. The presumption has always been that it was Thomson's canoe. But they would have recognized his very distinct, dove-grey canvas canoe and would have investigated, no matter whether it was right side up, as some later claimed, or upside down, as others claimed. That is the first law of the lake. Yet Blecher said he thought it was just a canoe from one of the lodges drifting and he would see to it later. Mark Robinson's journals make it clear that a canoe was lost briefly on Canoe Lake by the Algonquin Hotel and later retrieved during the search. This is the canoe the Blechers saw Sunday afternoon. If it had indeed been Tom's canoe that was floating empty, whether upside down or not, it is impossible to imagine how others on that small lake would have missed it. Tom's actual canoe was not found until sometime Monday, July 9th, by all accounts.

Instead of dumping his canoe shortly after leaving Fraser standing at the dock staring at his watch, what if Thomson did go down to Gill Lake and fish and come back under cover of dark, unnoticed? This would be common practice for anyone on the lake, not just for Thomson. And what if, at some point, Fraser had gotten it in his head that someone needed "to teach Thomson a lesson"—and who better than he to do so? He could have come to this decision a variety of ways, perhaps in conversation with a concerned or even outraged Hugh Trainor, perhaps in discovering on his own that Thomson had shipped his camping equipment off to South River and was planning to slip away unnoticed from certain commitments, perhaps in being told by his wife that she had discovered something alarming in snooping through Thomson's letters from Winnie Trainor.

Brad McLellan, the young neighbour of both Winnie Trainor and the

widowed Annie Fraser on Minerva Street in Huntsville during the 1950s, told me shortly before his death that he had overheard Annie tell his parents the story of Fraser teaching Tom "a lesson" only to have the lesson go tragically wrong. The question would then be when that "lesson" occurred.

According to all the analysis so far, Tom Thomson would have died on Sunday, July 8, 1917. The last he was seen being 12:50 p.m. that day.

Yet George Thomson, in a letter sent years later to Blodwen Davies, who was then researching her book on Thomson, says that among the personal effects that came back from Canoe Lake was Tom Thomson's watch.

It is stopped, George Thomson writes, at 12:14.

P.M. or A.M.?

The time-frozen watch is by no means proof that it stopped as a result of falling into the lake at the time of Thomson's death or the time in which his body hit the water. It could have wound down on his dresser as easily as having been stopped by the water, but George may even have retrieved it before Tom's body was found. Still, it seems unusual that George would note the precise time it had stopped. This suggests—but certainly does not prove—the watch was on Thomson's body when he went to the bottom of Canoe Lake.

The timing, 12:14, also suggests the possibility of another scenario. It is conceivable that Shannon Fraser and Tom Thomson fought late in the evening of Sunday, July 8, 1917, after Thomson had returned from his fishing trip down the lake. This would be consistent with Mark Robinson's 1953 claim to have seen Tom and Shannon Fraser that morning. However, this consistency does not constitute verification, as I do not believe there was any Sunday morning rendezvous between Shannon and Tom at Joe Lake dam, with Mark Robinson looking on through his binoculars and eavesdropping on them. The big trout story is extremely unlikely for the time of year. But let us accept, just for the sake of argument, that Thomson was indeed around Canoe Lake on Sunday morning. In that case, Daphne Crombie's belief that Tom and Shannon had fought after the drunken Saturday night party could not have happened.

And yet the fight doesn't need to have happened after that drinking party for Daphne to be correct in her interpretation of the fight—her error may have lain only in the timing.

I do not believe that Shannon Fraser carefully checked his watch as Tom Thomson paddled away from the Mowat Lodge dock, noting that the painter had last been seen at 12:50 p.m. that Sunday. It seems an unlikely thing to do—or at least to recall so accurately. His report of so carefully noting the time seems convenient for someone who could do with such a time reference as an alibi.

It is possible Shannon saw Tom Thomson *for the last time* later that day.

Between the time Fraser saw Thomson off at about noon and Tom's return under cover of dark, something may have happened to fire Fraser's well-known temper. It has never been established whether Winnie's parents were at the lake at this point or not—though Hugh Trainor was certainly on hand when the body was found—but if the Trainors were there, perhaps a visit from Hugh Trainor convinced Fraser that he was the one to "teach him [Thomson] a lesson." Less likely is the possibility of a telegram reaching Mowat or a letter arriving on the train. Given the moral strictures of the time, and the potential delicacy of the subject, it just doesn't seem possible that any such suggestions of jilting or, even more unlikely, pregnancy would ever be put down in print or telegraph code. It is, however, possible that the necessity of a "lesson" could have arisen out of Fraser's own discovery, by whatever means or method, that Tom was planning a quick exit from Canoe Lake, whereas Winnie Trainor and her family had been led to believe they were to be married.

According to Mark Robinson, one unopened letter from Winnie Trainor had been found among Tom's possessions. It might have arrived when Thomson had already steeled himself to leave. Robinson said he opened it, read it, and gave it to Hugh Trainor, dismissing it as insignificant. It's hard to imagine his reading a personal letter in front of the

letter writer's father, but Robinson did say he read it. The letter might have held nothing important, as he concluded, or it might have contained another request from Winnie for Tom to buy a new suit. Robinson might have missed the implication of that request, whereas the snooping Annie Fraser, reading the letter she found lying in Tom's room at Mowat Lodge, may have understood it. Annie Fraser had become convinced, in reading the letter or letters she'd found, that Winnie was pressing hard for Tom to get back the money he'd lent to Fraser, so he could buy a suit for the wedding. Possibly even a *necessary* wedding.

It is even possible that Thomson arrived back at the lodge that evening and deliberately left the letter unopened, fully aware of its contents. If Thomson and Fraser then fought over money—and not because Fraser wanted to teach him a "lesson"—it could have been either that Thomson was going to go through with the marriage, feeling a gentleman's obligation, or that he wanted the money so he could head for South River and points west as quickly as possible.

Daphne Crombie believed the fight was based on money owed, rather than the honour of the Trainor family, and that seems the simpler, and also plausible, explanation. Fraser did owe Thomson money. Both men could also have been drinking, as Daphne also believed. There was obviously a great deal of drinking around Mowat Lodge at the time, as in the coming days, Superintendent Bartlett instructed Mark Robinson to bring an end to the alcohol supply coming in by train. Whatever the reason for the argument, Fraser and Thomson fought, and Fraser struck the blow that sent Thomson sprawling into the fire grate and caused the grievous injury to the painter's left temple. Not the right side of the temple, as Dr. Howland wrongly recorded and later changed to "left." The blow could even have been struck with a fire poker as the fight turned nasty.

Whether Thomson died instantly or not, Fraser panicked. To cover up, he had Annie help him dispose of the body. One or both of them tied a weight to Thomson's left ankle, using fishing line. They did not place the portaging paddles in their correct position as Thomson would have placed them. And as Thomson would not be using them, they left

behind at the dock his axe and working paddle, which Fraser would deal with later by tossing them into the fire.

Under cover of dark, Fraser, possibly aided by Annie, towed Thomson in his own canoe out toward Little Wapomeo Island and dumped it over, leaving the empty canoe to drift and be sighted and instantly identified when light came to the lake that Monday morning.

With the weight attached to his ankle, Tom fell fast to the bottom, his watch quickly stopping once the water got into it.

At fourteen minutes past midnight, July 9, 1917.

It is possible—just as it is possible they fought after the Saturday night party and the questionable Sunday morning sightings never took place.

We can only speculate as to how Tom Thomson met his death. The mystery, however, has always contained two critical elements: one, what happened to Tom Thomson, and two, what happened to his body?

He lies, still, at Canoe Lake. The undertaker, Churchill, had no desire to do the job in the first place, and didn't. There was no "viewing" of the body at Owen Sound, as the McKeen sisters wished us to believe. Winnie Trainor insisted all her life that he had been taken to Leith and buried because she had to believe this, having personally made the arrangements. George Thomson insisted that the body was at Leith, as well, because he, after all, had been the family member charged with bringing his brother home and, if there was no body in the grave, he would have failed.

The Thomson family feels strongly that they have a duty to respect George's decision not to exhume the body at Leith. "I know it angers some people who feel our family is pulling a power play," says Tracy Thomson, "but since we do have the legal right in these decisions, why not try and make the right decision for Tom and the gift he gave all Canadians? It has always been my family's position, beginning with George Thomson (my great-grandfather) not to exhume the grave at Leith. And his descendants have to honour that decision."

Tracy does admit to wishing there were some very private way that a DNA test might be carried out and the family "keep a lid on it"—but that would be impossible, given the fame of the painter and the interest in the mystery. "I would love to know as much as anyone what became of him," she told me in the spring of 2010.

I asked her how she would feel if it turned out that he had never been exhumed and lay buried, still, at Canoe Lake?

And she answered, "It wouldn't bother me at all."

There was never any "Indian" buried at Canoe Lake in either 1894 or 1913. Nor was there any "Indian" dug up by the four men in the fall of 1956. There was no "Indian" discovered who had once had a complicated medical procedure performed on his left temple—precisely where Ranger Mark Robinson had noted in his journal that Tom Thomson's body appeared to have been struck.

What remains alarming about the "Indian" story is not so much that Professor Grant made mistakes in his science—an "Indian" or "half-breed" half Thomson's age and shorter than he was?—but that Attorney General Kelso Roberts and Deputy Minister Frank MacDougall turned aside the protests of Dr. Harry Ebbs, the first medical doctor who saw the 1956 bones. As Ebbs said in the notes he left behind to be seen only following his death, they decided that because the family "did not wish to have the thing opened up and any more fuss."

In other words, assuming that Ebbs was right in concluding that the skeleton was Thomson's (and it turns out he was right), they would hush up and, in effect, cover up evidence that would suggest a criminal investigation must follow, regardless of the thirty-nine years that had passed since Tom Thomson's death.

Ontario has no statute of limitations on murder.

Ebbs claims he was told by the ranking lawmaker of Ontario that the Thomson family "were satisfied with the verdict of accidental drowning and they would like it just left alone."

Such is not an option where murder is concerned.

In the fall of 2009, I asked the Ministry of the Attorney General what had become of the skull that had been kept for examination, even after the remaining bones—surely including both shinbones—were returned to Canoe Lake for re-burial. "Our best information," the attorney general's office responded, "is that the skull in question was not retained by the Centre for Forensic Sciences. It was examined in the mid-1950s and returned for re-interment at Algonquin Park."

So Tom Thomson, whole, is buried where he should be: at Canoe Lake.

EPILOGUE

It is again summer at Canoe Lake. More than ninety summer seasons have gone by since guides Lawrie Dickson and George Rowe towed Thomson's bloated, damaged body from the deep waters of the lake to the edges of the nearest island. It will soon be forty years since Jimmy Stringer, emboldened by that second bottle of Brights President sherry, announced, "The truth's still not told" and, within days of striking a pact with me to correct that shortcoming, broke through the early spring ice and drowned in the same waters that Tom Thomson sank into fifty-six years earlier.

So much has changed since Jimmy Stringer claimed to have Tom Thomson's shinbone in his shed. Jimmy and Wam are gone, and the old Stringer home on Potter Creek has long since been torn down and replaced with a new summer home. The Empire Hotel has been converted to apartments and has suffered fire damage. The "Snake Pit" became a lounge, the Formica tables and beer-sticky floors gone and no longer any separation between "Men" and "Ladies & Escorts." The Liquor Control Board of Ontario store has moved twice since those days, and the place where you would fill in your form and slip it over the counter to Babe Malloy is now the Huntsville Public Library. Brights President sherry is selling for $8.25, when you can find it.

The house at No. 3 Minerva Street, where Tom Thomson had once painted the living room and where Winnie Trainor lived out so much of her long and lonely life, is also now long gone, replaced initially with a low, brick building that held the North Muskoka Medical Clinic. That building is now occupied by Portage Promotionals, a small business dealing in sportswear and gifts.

A twenty-first-century town beautification project has brought murals representing the works of Tom Thomson and the Group of Seven to various downtown walls. The wall of the building where Winnie Trainor lived is now painted with a giant canoe, dove grey in colour. The mural, *The Canoe*, Tom Thomson's painting of his own canoe, empty. Those who organized the mural paintings could not possibly have intended to create such sad irony.

The shoreline along Canoe Lake has also changed greatly since 1917. The water level is higher. Beaches have long since been cleared of stumps and deadfall. The Taylor Statten Camps, Ahmek for boys and Wapomeo for girls, dominate the northeastern shore and one of the islands. It takes some looking to identify newer buildings, for discretion is the guideline for Algonquin Park as much as garish ostentation is the rule of the day in the nearby Muskoka Lakes. Only those who know precisely where to look can find signs of the mill that once stood along the northwestern shore. Newcomers have no idea that the gravel road that brings them around the northern edge of the lake and past the Joe Lake dam was once a busy rail line, carrying singing troops from the West off to the front in Europe; they see paths where once there were spur lines. As for the busy lodge where Tom Thomson stayed, they see nothing in the place where it once stood.

And yet there are also those things that never seem to change. Loons still float on the water and, for those few who know where to look, red-fleshed lake trout swim far below the surface of the lake. Purple pickerelweed grows along the feeding creeks. The most striking feature

of the islands is still their sudden outcroppings of Precambrian Shield granite, often with mica-holding white quartz sparkling in the sun. Seen from a distance, the water seems impossibly blue; seen up close, it appears to be the colour of lightly steeped tea. Pine and cedar grow down to the water's edge in places; scruffy spruce and tamarack, tall hemlock, poplar, aspen, bear-scarred beech, white and yellow birch and maple seem to climb the surrounding hills. Every so often, along the high horizons, a magnificent white pine stabs so far above the forest ceiling that it reminds the eye of what brought loggers to this rugged country in the first place and how, when the white pine was mostly gone, the mills and the train soon followed. The cottagers, the campers and the summer visitors—now as likely to be from Asia as America—all stayed.

Out on the water, the chop is mild, thanks in part to a park restriction to twenty-horsepower or less outboards. There are no Sea-Doos here, no wakeboarding. In the deep waters out from Taylor Statten Camps, the lake is filled with white sails, some rippling from learners' hands, some billowing tight as skin as the small sailboats tempt tipping in the deliberate hands of bronzed, teenaged instructors who may never again be so admired in the lives they will spend in the three seasons that make up the "real world" of Canada.

Everywhere there are canoeists, some slipping so silently along you can almost hear the kiss of water on lacquered cherry as the J-stroke—said to have been developed on this very lake—is deftly turned to maintain direction. Most canoes, however, are moving erratically from side to side as they zigzag between the Portage Store docks and the Tom Thomson cairn. This summer scene, in fact, has not changed much since the early 1960s. Tourists are still unfamiliar with the tippy canoes, the instructions brief but sufficient to send them off through the channel and out onto the lake. In fair weather, they usually make it far enough to visit the popular site and photograph their party standing by the stone cairn and the incongruous West Coast Native totem pole.

The locals, the couple of hundred people who, in summer, either vacation in the dozens of cottages that line Canoe Lake or work in the

camps, at the store or for the Ontario Ministry of Natural Resources (previously known as Lands and Forests), take great pleasure in all this canoe traffic and are also greatly annoyed by it. There are stories told of foreign visitors sitting *facing each other* in canoes as they try to figure out how to make this strange vehicle move. They make their way down the lake, hugging the shoreline if it is windy; reach the Tom Thomson Memorial cairn; take their photographs beside it; and leave.

On this lovely August day, Canoe Lake cottager Don Lloyd picks me up in his tin boat at the leaseholders' dock on the shore opposite the Portage Store. Don is a retired high school geography teacher with more than sixty years of interior tripping to his credit. He is also author of *Algonquin Harvest: The History of the McRae Lumber Company* and the definitive *Canoeing Algonquin Park*. Duncan MacGregor, my father, worked for McRae's for more than half a century, finally "retiring" at age seventy-three after a tractor-trailer hauling woodchips skidded on the ice, caught him under the swinging rear wheels and slammed him into the snowbank that finally stopped the sliding truck. The crash broke his pelvis, and we were told he would likely never walk again. But the doctors in Toronto, it seems, didn't realize the powers of necessity. For the next fifteen years of his life, Duncan rarely missed a day at the Empire Hotel lounge, slowly hobbling down Main Street with his cane and even more slowly hobbling back.

It had been cool and brisk earlier in the day, but the wind has died down considerably since the sun came out and the clouds cleared. Don heads us down the lake at full throttle, the wind pushing back his beloved red floppy hat and sending ashes from his cigarette dangerously down onto the grey sweater he is wearing. But nothing catches fire. He keeps to the far shore and as far as possible from the traffic jam of day canoeists and camp sailors. A fellow cottager, he says, had recently marked his hundredth rescue on Canoe Lake, plucking a couple of hapless trippers out of the lake before they'd even reached the first portage

with their rented equipment. He shakes his head: having canoed this lake every summer since the end of the Second World War, when he first came to Taylor Statten Camps, he has long ago ceased to be surprised by the entirely predictable results of inexperience.

We stop briefly along the northwestern shore, where, more than a century ago, the Gilmour mill and the village of Mowat stood. We push through the brush but can find only a few broken foundations and the odd fence post in the tangle. The bugs are still bad—so bad, in fact, that if all summers were equal to this one, cottages and summer camps might never have been invented. After swatting a few hundred mosquitoes and blackflies, we re-emerge and, grateful for the breeze along the open water, boat down to the cabin that once belonged to Winnie Trainor.

I had not visited the old Trainor cottage in years. I had paddled by on the way to deeper trips into the interior but had not stopped or walked up onto the wraparound porch since the summer of 1963, when I'd helped my cousin open up the old summer home and clear out the mess. I can still recall the stale, musty smell that came at us as the solid plank-board door gave way. I remember a six-pack of old green Coca-Cola bottles was in the cabin, and somehow they had not exploded during the many winter freezes they had endured. I didn't see the china set that Tom Thomson had supposedly painted for Winnie, or if I did see it, I had no interest in it then. I was fifteen years old, an age when anything not singularly about you simply does not exist.

The old ranger cabin that Winnie's father purchased back in 1912 has not changed much since that summer of 1963. The form remains the same, including the old boathouse with the ramp where a winch could haul up a boat for winter storage. But now there are flowerpots hanging from the porch rafters, with red mums in glorious bloom. And instead of boards baked black by the summer sun, the cottage is now painted a soft white-blue.

The colour of a dove. Like the dove grey Tom Thomson had found by mixing his colours—including an expensive tube of cobalt blue—and

then using it to paint his beloved Chestnut canoe, the one they found floating empty more than ninety years ago on these same waters.

There was once a clear trail back of Winnie's cottage that led to the little Canoe Lake cemetery on the hill. She used to walk the kilometre or more herself on summer days, some locals saying she would go to tidy up the grave where she knew, in her heart, her fiancé still lay. The real reason, however, was that she resented any suggestion that he might still be lying there, which would mean she had failed her lover in the last act she was to do for him.

Don and I find the trail easily enough and, with a bit of secondary bug spraying, head back into the bush, glad for a couple of stretches of old boardwalk that carry us, dry, across the swampy sections. We come to the old road that ran to Mowat Lodge and trek through more swamp, then along a sandy isthmus with open water to the right and bush to the left, take a left fork in the road and finally come to a break in the bush to the right, with a rough trail heading up the hill to the cemetery.

It is difficult going at times, the trail muddied from recent rain and the rocks slippery. In places the trail is blocked by recent windfall we have to work around, or over, or even under; in other places raspberry canes slow our progress by catching our clothes with barbs or catching our eyes with ripe, red berries.

Finally, we come to the ridge of the hill and can see the birch tree that marks the cemetery. This birch is unlike any you have ever seen. The rule of thumb in the landscaping world is that birches last about thirty years before they begin falling apart. This birch, however, now thick as an oak, was here in 1917 when they buried Tom Thomson in the shade of its midsummer leaves, and it stands in the cemetery still, its branches grown into giant "arms" that seem cocked and ready to defend the ground.

The massive birch, now more than a century old, is inside a picket fence that has been kept in slight repair over the years. The fence surrounds the two earlier graves, one small stone marking the resting place of eight-year-old Alexander Hayhurst.

Tom Thomson was not buried within the confines of the fence back in 1917. The unmarked grave, which was intended to be temporary, was dug about ten to fifteen good paces to the north, and it was here, in 1956, that William Little and his curious band of gravediggers found an old casket containing the skeletal remains that were later determined by provincial authorities to be that of an unknown Aboriginal.

There is another unmarked grave off to the side. It holds Hugh Statten's beloved Labrador-mix, Zack, who was killed Easter weekend of 2008 when Hugh and his family went cross-country skiing on the lake. Zack, a great roamer, somehow ended up wandering into a wolf pack that attacked and tore him to pieces. It is understandable why Statten would choose to bury his dog here, as each year on the anniversary of Thomson's death he is host to "Tom Thomson Night" on Little Wapomeo Island. That evening, staff from the nearby Portage Store visit the painter's grave at midnight before returning to a celebration in his memory at the original Taylor Statten cabin, which Hugh now owns.

Just to the north of the fenced cemetery sits a small, white, wooden cross. On this late summer day, no wildflowers are placed near it, but there is a small candle, burned out, and two pennies that have been placed on top of the cross. One is a 1967 Canadian Centennial penny; the other is new and still shiny. Locals believe the cross was left behind by the film crew that came to Canoe Lake for the CBC's documentary, *The Mystery of Tom Thomson*, back in the late sixties.

The small, white cross is a fiction—a prop set placed in a clearing beside the little cemetery for dramatic purposes. The place where Tom Thomson lies today, in the very grave he was buried in back in 1917 and where his bones were re-buried sometime after 1956, is farther north of the spot where visitors believe he was once buried.

There is no marking at all where he truly lies. He is somewhere in the tangle of raspberry canes, dead spruce, rotting leaves and pine needles, somewhere beneath the saplings fighting for light and the lovely yellow wildflowers that grow all along the trail up to his grave and have found

the space and determination to bloom amid the choke and tumble of the fallen trees and branches that make penetration of the actual gravesite all but impossible.

The yellow flowers are called jewelweed in botany books. *Impatiens capensis*. But in Algonquin Park, they have always gone by their more familiar name.

Touch-me-nots.

ACKNOWLEDGEMENTS

It is hard to know where to begin when the debts go back nearly half a century—more, in fact, if I were simply to thank my parents, Duncan MacGregor and Helen McCormick MacGregor, for the privilege of being born into an Algonquin Park family with connections to Tom Thomson and Winnifred Trainor.

So many of those interviewed over the years have now passed on: Daphne Crombie of Toronto; Addie Sylvester, Winnie's lifelong neighbour in Huntsville; Brad McLellan, another neighbour; Dr. Wilfred T. Pocock, Winnie's doctor and great friend; Huntsville historian Joe Cookson; Trapper Ralph Bice of Kearney. So many with roots in the Canoe Lake area are also gone: Jimmy and Wam Stringer, Moon Stringer, Aubrey Dunn, Joe River, Jean McEown, Leonard "Gibby" Gibson and author Ottelyn Addison, daughter of Algonquin Park ranger Mark Robinson.

I owe a huge debt to Ron Tozer, retired Algonquin Park naturalist and archivist supreme, who never tired of my queries and was always eager and helpful, as was Kevin Chute of the Algonquin Park Archives. I am also grateful to my friend and fellow Lake of Two Rivers' child Rory MacKay and to Ron Pittaway, for work they did in past years collecting the oral memoirs of Algonquin Park oldtimers, all now since departed. I am equally indebted to the Statten family of Canoe Lake, who have

always been kind and helpful and who gave me access to material, much of it new, that would prove to be of great significance to this story. I thank Dr. Taylor Statten and Hugh Statten, in particular, for their insights and help. As well, I owe the Huntsville *Forester*, especially the late Peter Rice, for giving me complete access to the fragile *Forester* files in the years before they could be saved electronically.

Several longtime Huntsville residents were helpful with memories of Winnie Trainor in her later years. They include Bob Hutcheson, Ed Terziano, Norm Avery and Winnie's longtime neighbour Eve Beatty. I thank Mern Parker, as well, the greatest grade 3, 4 and 5 teacher of all time.

I could not have completed this book without access to enormous research done by others. I found the website Death on a Painted Lake (http://www.canadianmysteries.ca/sites/thomson/home/indexen. html) to be of great help as a quick reference, and I thank Dr. Gregory Klages and his colleagues for the work they have done in this wonderful project. I am grateful to the National Library and Archives, particularly to my friend Jim Burant, for checking out photographs and files and for assistance searching in the Ontario Public Archives. Ottelyn Addison's sons, Ed and Bill, were kind to give me complete cooperation regarding the precious journals of Mark Robinson, their grandfather. Barbara Hall of Winnipeg provided access to the research and notes compiled on Tom Thomson's death by her late husband, Dr. Philip Hall. Tom Thomson expert and art curator Joan Murray was always helpful whenever I had questions, as was artist and weather expert Phil Chadwick.

Researcher Iris Nowell granted me full access to her personal files on the Thomson family, gathered back in the early 1970s for McClelland & Stewart's art book *Tom Thomson: The Silence and the Storm*. Interviews she did with Thomson family members no longer alive were invaluable.

I cannot express how much appreciation I have for Tracy Thomson in all of this. The painter's great-grandniece, herself an accomplished artist, was helpful throughout, and continually kept an open mind on

matters that she fully realized might upset some of her family and could, in the end, disprove the family contention that Tom Thomson lies buried in the family plot at Leith. I like to think her great-great uncle would be proud of her.

I thank Park historians H. Eleanor (Mooney) Wright, Don Beauprie and Don Lloyd for their interest in the project. Don also was a most courteous host for visits to Canoe Lake as were longtime cottagers Bob and Mary Crook. Bob Crook and Jim Hickman, Ottawa dentists, were crucial at the beginning of the forensic investigation into the skull unearthed at Canoe Lake in 1956. I am grateful to Bob, as well, for his work in scouting out locations for various Tom Thomson sketches of the area and for insight into the Blecher family, who once lived where Bob and Mary now have their summer home on Canoe Lake.

I am also grateful to another area historian, Doug Mackey, who helped me track down the tale of the Wattie family and their quiet possession of Tom Thomson's camping equipment for 80 years. I thank Ken Lyons, telephone historian, for his invaluable information on how telephone billing worked in 1917. I thank the *Toronto Star*, the *Ottawa Citizen* and the *Globe and Mail* for access to their libraries and archives and also my brother Tom MacGregor for help he provided at *Legion Magazine*.

Help with photographs and illustrations came from a variety of sources. I thank those at the National Gallery of Canada, the Art Gallery of Ontario, the Tom Thomson Art Gallery in Owen Sound, the McMichael Canadian Art Collection in Kleinburg, Ont., and the Algonquin Park Archives for help in tracking down various illustrations. Thanks to my friend Jack Hurley, ace canoe builder of Dwight, Ontario, for the photograph of Jimmy and Wam Stringer. Thank you to Ellen MacGregor for the map of Canoe Lake, circa 1917, as well as great many other matters—not the least of which was indulgence.

Nancy Lang and Rebecca Middleton, two researchers working on *The West Wind*, an upcoming documentary by Peter Raymont's White Pine Pictures based in part on this book, were helpful and encouraging over the past year.

Acknowledgements

Patrick Boyer, author of *A Passion for Justice*, the definitive biography on Justice James McRuer, and Marion Howe of the McRuer family were helpful in my efforts to track down the identity of the woman falsely identified all these years as Winnie Trainor. The investigation continues. I am grateful to genealogist Les Bowser for advice and help in investigating the Tom Thomson portrait of "Laura."

I thank Neil J. Lehto, a Michigan lawyer who became fascinated with the Tom Thomson mystery and who wrote *Algonquin Elegy: Tom Thomson's Last Spring* after spending years studying the story. Neil and I began exchanging emails when he was writing his book, and we continued throughout the research and writing of mine. He used his legal training and his natural skepticism to challenge me at every turn. His was a tough, fair court and I appreciate every discussion we had concerning our mutual passion. We both believed, at all times, that truth mattered far more than personal preference.

The conclusions of this book would not have been possible without the work and scientific expertise of Dr. Ronald F. Williamson, adjunct professor in the Department of Anthropology at the University of Toronto and founder of Archaeological Services, Inc. Dr. Williamson involved archaeologist Dr. Andrew Riddle and biological anthropologist Alexis Hutcheson, both with Archaeological Services. He also arranged for Dr. Susan Pfeiffer, former Dean of Graduate Studies at the University of Toronto, to bring her expertise in Aboriginal archaeology to the project.

Special mention must be made of Victoria Lywood, the internationally respected forensic artist from John Abbot College in Montreal, for her professional contributions. Her work was pivotal, important and hugely appreciated.

All along the writing of this book, I was challenged by Edie Van Alstine, an Ottawa editor who shares an Algonquin Park and Huntsville background. She was invaluable in every aspect, from facts to grammar to the book's structure and re-structure. I am forever indebted. It was also Edie's family connections—Marion St. Michael of Toronto and

Helen and Doug Gurr of Guelph—that gave access to the deck of playing cards calling 1916 "Best summer ever was known." Thanks, as well, to Ottawa artists and photographers Michael Zavacky and Darren Holmes for their exceptional work in creatively photographing the antique cards and giving them new life. Anne Collins, publisher of Random House Canada, believed that the time was right for this book and supported the project from the beginning. Senior Random House editor Angelika Glover and editor Kathryn Dean were demanding but always professional. I also thank my agents, Natasha Daneman and Bruce Westwood, for their patience, their good humour, their faith and their friendship.

I have written far too many books and worked far too long in journalism not to be acutely aware that mistakes happen. This book recounts a virtual litany of errors and misconceptions that are as much a part of the Tom Thomson story as the artist's mysterious death and his remarkable legacy of art. I accept that not all can be known about this nearly century-old mystery and that mistakes will continue to be made, some in this book. All I can say is that I have tried to be faithful to the facts and respectful of the circumstantial and the speculative. I accept full responsibility for the claims herein and happily embrace Tracy Thomson's belief that if we ever reach the absolute truth in this story "that's the end of the intrigue and the chatter about it."

We never wish for that . . .

SELECTED BIBLIOGRAPHY

This is far from a complete record of the various books, periodicals, newspaper accounts and archival interviews and material consulted over the years. It is, instead, a general list of publications I found particularly useful and one that readers interested in Algonquin Park and Tom Thomson's story and art might find of further interest.

Addison, Ottelyn, and Elizabeth Harwood. *Tom Thomson: The Algonquin Years*. Toronto: Ryerson Press, 1969.

_____. *Early Days in Algonquin Park*. Toronto: McGraw-Hill Ryerson, 1974.

Bice, Ralph. *Along the Trail with Ralph Bice in Algonquin Park*. Toronto: Consolidated Amethyst Communications, 1980.

Chambers, Lori. *Misconceptions: Unmarried Motherhood and the Ontario Children of Unmarried Parents Act, 1921–1969*.Toronto: University of Toronto Press for The Osgoode Society for Canadian Legal History, 2007.

Clemson, Gaye I. *Algonquin Voices: Selected Stories of Canoe Lake Women*. Bloomington (Indiana): Trafford Publishing, 2007.

Cookson, Joe. *Roots in Muskoka*. Bracebridge: Herald-Gazette Press, 1978.

Davies, Blodwen. *A Study of Tom Thomson*. Toronto: Ryerson Press, 1935.

Edwards, C.A.M. *Taylor Statten: A Biography*. Toronto: Ryerson Press, 1960.

Garland, G.D., ed. *Glimpses of Algonquin: Thirty Personal Impressions from Earliest Times to the Present*. Whitney: Friends of Algonquin Park, 1989.

Grace, Sherrill. *Inventing Tom Thomson: From Biographical Fictions to Fictional Autobiographies and Reproductions*. Montreal and Kingston: McGill-Queen's University Press, 2004.

Landry, Pierre B. *The MacCallum-Jackman Cottage Mural Paintings*. Ottawa: National Gallery of Canada, 1990.

Lehto, Neil J. *Algonquin Elegy: Tom Thomson's Last Spring*. New York: iUniverse, Inc., 2005.

Little, William T. *The Tom Thomson Mystery*. Toronto: McGraw-Hill, 1970.

Littlefield, Angie. *The Thomsons of Durham: Tom Thomson's Family Heritage*. Ajax: Durham West Arts Centre, 2005.

Lloyd, Donald L. *Algonquin Harvest: The History of the McRae Lumber Company*. Whitney, Ontario: Robert D. McRae, 2006.

Murray, Joan. *The Best of Tom Thomson*. Edmonton: Hurtig Publisher, 1986.

_____. *Tom Thomson, The Last Spring*. Toronto: Dundurn Press, 1994.

Pryke, Susan. *Huntsville: With Spirit and Resolve*. Huntsville: Fox Meadow Creations, 2000.

Reid, Dennis. "Photographs by Tom Thomson." *National Gallery of Canada Bulletin* 16 (1970): 2–36.

_____. *Tom Thomson: The Jack Pine*. Ottawa: National Gallery of Canada, 1975. + Charlie Hill

_____, ed. *Tom Thomson*. Toronto and Ottawa: The Art Gallery of Ontario and National Gallery of Canada, 2002.

Standfield, Donald (photography), and Liz Lundell (text). *Algonquin: The Park and Its People*. Toronto: McClelland & Stewart, 1993.

Saunders, Audrey. *Algonquin Story*. Toronto: Department of Lands and Forests, 1947.

Shaw, S. Bernard. *Canoe Lake, Algonquin Park: Tom Thomson and Other Mysteries*. Burnstown: General Store Publishing House, 1996.

Town, Harold, and David P. Silcox. *Tom Thomson: The Silence and The Storm*. Toronto: McClelland & Stewart, 1977.

Valverde, Mariana. *The Age of Light, Soap & Water: Moral Reform in English Canada, 1885-1925*. Toronto: University of Toronto Press, 2008.

Wright, H. Eleanor (Mooney). *Joe Lake: Reminiscences of an Algonquin Park Ranger's Daughter*. Eganville, Ontario: HEW Enterprises, 2000.

_____. *Trailblazers of Algonquin Park*. Eganville, Ontario: HEW Enterprises, 2003.

PHOTO PERMISSIONS

1. Tom Thomson's parents John and Margaret (Mathewson) Thomson. Library and Archives Canada, accession number 1943-082, C-027122.
2. The Thomson brothers, Tom, Ralph, George, Henry, with Tom Harkness. Photograph reprinted with permission of the Thomson family.
3. Photo of Tom Thomson around the age of fifteen. Gibson, Library and Archives Canada, accession number 1981-254, PA-211294.
4. Member of the Group of Seven – Tom Thomson. Library and Archives Canada, accession number 1976-036, PA-121719.
5. Jimmy and Wam Stringer. (Photograph courtesy of Jack Hurley.)
6. Chief Ranger Tom McCormick. (Photo courtesy of Jim MacGregor.)
7. "Miss Winnifred Trainor, II" – "Winnifred Trainor" in a plaid dress, standing and facing the viewer. Tom Thomson, Library and Archives Canada, accession number 1995-133, PA-193567.
8. Winnie Trainor and Irene Ewing. (Source unknown.)
9. Winnie Trainor at Academy. (Photograph reprinted with permission of Muskoka Heritage Place Collection, Huntsville, Ontario.)
10. Winnie Trainor. (Photograph reprinted with permission of Muskoka Heritage Place Collection, Huntsville, Ontario.)
11. Tom Thomson, 1877-1917, *Figure of a Lady, Laura*, c.1915, McMichael Canadian Art Collection.
12. Winnie, portrait by Victoria Lywood, black-and-white. (Photograph reprinted with permission of Victoria Lywood.)

13. Tom Thomson, 1877-1917, *The Jack Pine*, 1916-1917, oil on canvas, 127.9 x 139.8 cm, National Gallery of Canada, Ottawa, photo © NGC.
14. *Portrait of Dr. J.M. MacCallum ("A Cynic")*, 1917, oil on canvas, 67.5 x 54.9 cm, Bequest of Dr. J.M. MacCallum, Toronto, 1944, National Gallery of Canada (no. 4734).

15. Guide George Rowe on far right. (Photograph reprinted with permission of Algonquin Park Archives.)
16. Tom Thomson, a member of the Group of Seven. Blair Laing, Library and Archives Canada, accession number 1976-036, PA-125406.
17. Winnie Trainor's cottage. (Author photograph.)
18. Tom Thomson Shaving. Library and Archives Canada, accession number 1943-078, C-007900.
19. Tom Thomson (painter and associate of the Group of Seven) engaged in an outdoor activity—paddling canoe. Library and Archives Canada, accession number 1991-002, PA-212472.
20. Tom Thomson [standing on a rock]. Library and Archives Canada, accession number 1991-002, PA-187135.
21. Tom Thomson and Arthur Lismer, Smoke Lake. McMichael Canadian Art Collection.

22. Ranger Mark Robinson and his son Jack. (Photograph reprinted with permission of Robinson-Addison family.)
23. Shannon and Annie (sitting) Fraser, with unidentified woman, Smoke Lake. (Photograph reprinted with permission of Algonquin Park Archives.)
24. Daphne Crombie and Robin Crombie in sled driven by Shannon Fraser. (Photograph used with permission of Robinson-Addison family.)
25. Shannon Fraser. (Photograph reprinted with permission of Algonquin Park Archives.)
26. Algonquin Park Superintendent George Bartlett. (Photograph reprinted with permission of Algonquin Park Archives.)
27. Dr. Noble Sharpe, (Photograph reprinted with permission of Boris Spremo/Getstock.com.)
28. Kelso Roberts, Attorney General of Ontario 1956. (Photograph reprinted with permission of the *Globe and Mail*.)
29. Blecher cottage table. (Author photograph.)

30. Tom Thomson, Canadian, 1877-1917, *The West Wind*, c.1916/1917, oil on canvas, 120.7 x 137.9 cm, Art Gallery of Ontario, Gift of the Canadian Club of Toronto, 1926.

31. The four gravediggers (Photograph reprinted with permission of Algonquin Park Archives.)

32. Dr. Wilfred T. Pocock. (Photograph reprinted with permission of Algonquin Park Archives.)

33. Dr. Harry Ebbs. (Photograph reprinted with permission of the Statten family.)

34. Tom Thomson Memorial Cairn, Canoe Lake. (Author photograph.)

35. Tom Thomson's grave. (Author photograph.)

36. Tom Thomson's skull. (Photograph reprinted with permission of the Statten family.)

37. Tom Thomson's skull, 1956, Ontario Centre for Forensic Science. (Photograph reprinted courtesy of Chief Coroner's Office of Ontario.)

38. Face overlayed on skull, Victoria Lywood. (Portrait reprinted with permission of Victoria Lywood. Original photo reprinted courtesy of Chief Coroner's Office of Ontario.)

39. Forensic artist Victoria Lywood's interpretation of face belonging to discovered skull. (Portrait reprinted with permission of Victoria Lywood. Thomson close ups credited elsewhere.)

INDEX

ROY MacGREGOR is the acclaimed and bestselling author of *Home Team: Fathers, Sons and Hockey* (shortlisted for the Governor General's Literary Award); *A Life in the Bush* (winner of the U.S. Rutstrum Award for Best Wilderness Book and the CAA Award for Biography); and *Canadians: A Portrait of a Country and Its People*, as well as two novels, *Canoe Lake* and *The Last Season*, and the popular Screech Owls mystery series for young readers. A regular columnist at the *Globe and Mail* since 2002, MacGregor has received four National Magazine Awards and eight National Newspaper Award nominations for his journalism. He is an Officer of the Order of Canada and was described in the citation as one of Canada's most gifted storytellers. He grew up in Huntsville, Ontario, and has kept returning to the Tom Thomson mystery all his writing life. He lives in Kanata, Ontario.